D1545242

British Landscape Painters

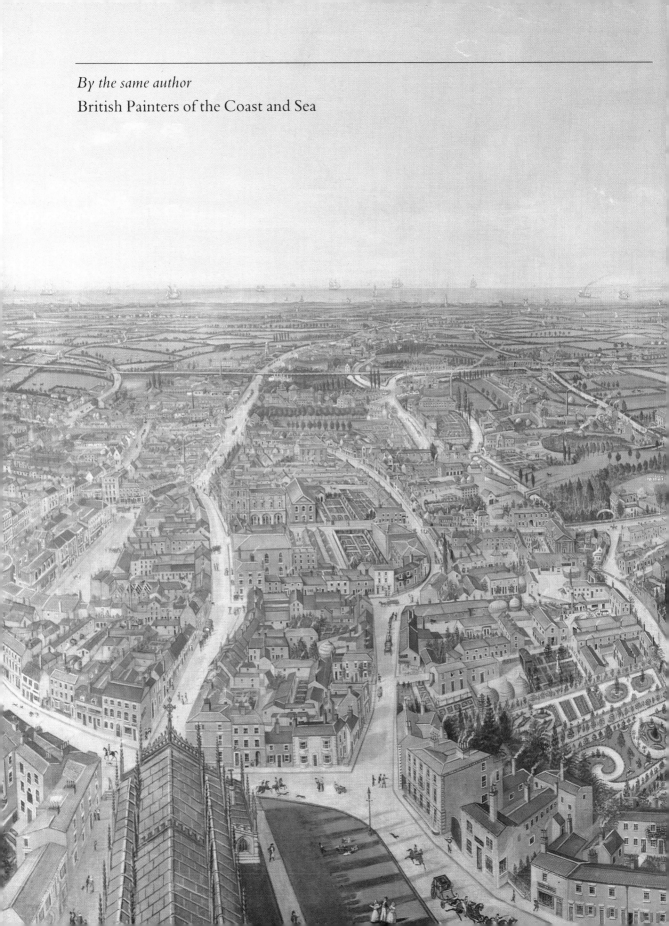

By the same author
British Painters of the Coast and Sea

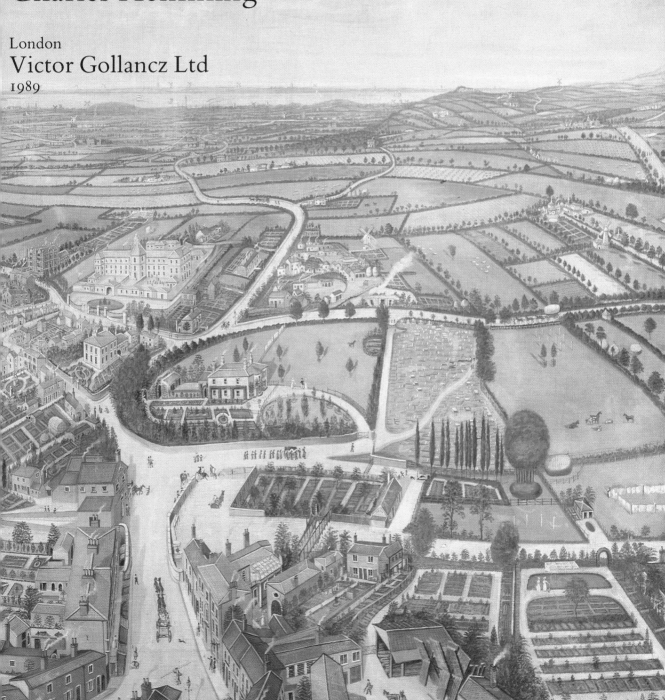

British Landscape Painters

A History and Gazetteer

Charles Hemming

London
Victor Gollancz Ltd
1989

Acknowledgements

The author and publishers are most grateful for the help of all those who have supplied pictures, the sources of which are listed below the illustrations. Where copyright differs from these, we would like to thank the following: Richard Eurich for *Men of Straw*, David Inshaw for *She Did Not Turn*, Angela Verren-Hunt for Ben Nicholson's *1930, Cumberland*, John Armstrong for his uncle John Armstrong's *A Farm in Wales, 1940*, Victor Pasmore for *The Snowstorm* and Kyffin Williams for *Gwastadnant*.

First published in Great Britain 1989
by Victor Gollancz Ltd
14 Henrietta Street, London WC2E 8QJ

© Charles Hemming 1989

British Library Cataloguing in Publication Data
Hemming, Charles
 British landscape painters:
 a history and gazetteer.
 1. British landscape paintings to 1980.
 Critical studies
 I. Title
 758'.1'0941

 ISBN 0-575-03957-4

Designed by Harold Bartram

Typeset by Rowland Phototypesetting Ltd
Bury St Edmunds, Suffolk
Printed and bound in Great Britain by
Butler and Tanner Ltd, Frome, Somerset

ON PREVIOUS PAGE
William Brown (1788–1859) *Panorama from the Spire of St James Church, Louth*, c.1844–55, left hand picture of two Oil on linen 72in × 108in each (Town Council, Louth)

Contents

List of Illustrations

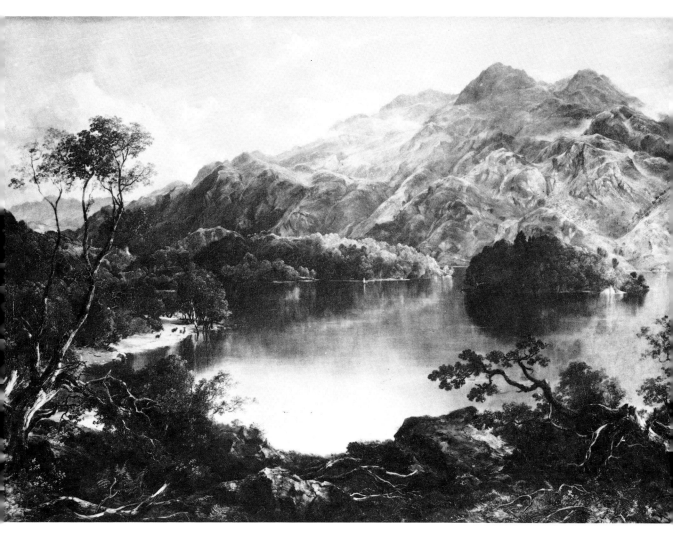

Horatio McCulloch (1805–67) *Loch Katrine* Oil on
canvas 44in × 72in (Perth Museum and Art Gallery)

OVERLEAF Anon *Prospect of Worcester from the East*,
c.1850s Oil on canvas 37¾in × 60¼in (Worcester
Museum)

Introduction

'What greater pleasure can there be', wrote Robert Burton in 1621, 'than . . . to peruse those bookes of Cities'. For such was how British landscape painting began, with portraits of towns drawn by Dutch mapmakers. For centuries English maps had shown only pictographs of towns, as the hearts of trade and culture, and the course of roads which joined them, as the arteries of commerce and learning. Towns and roads were the symbols of educated humanity raised above the natural world of crops and beasts. By contrast, the landscape, the open land, remained featureless – unportrayed. It was the province of the illiterate mass tied to the earth by their husbandry. Artists – engravers and portraitists – did not waste their time drawing this void around civilization. Great tracts of it were common land, which was still largely unenclosed by the seventeenth century, when the first 'Prospects' were painted in Britain.

Englishmen might 'sketch a Prospect' on times; on 30th September 1644 John Evelyn was confronted with a view so seductive he admitted: 'I could not forbeare to designe it with my Crayon.' But he was in southern France at the time, and the sight which tested his forbearance was the Jesuit College and castle at Tournon. Military adventurers, with the topographical eye of tacticians, often drew with some facility. A suave little sketch in black lead and wash by the many-talented Prince Rupert is still extant, but at the time he drew it the English had no word to describe the pictorial result. They adopted *Landschap*, 'from a people that are noe great Lenders but upon good Securitie, the Duch. For to say the truth, the Art is theirs.'

But in the seventeenth century English art was a stunted tree, with one branch – portraiture – and after the civil wars of the 1640s the oppressive puritanism of the Commonwealth pruned even that. The mortal sin of pictorially *representing* material objects, however, was apparently no impediment to acquiring more of them, and the Commonwealth prosecuted a successful naval war with Holland over trade, opening lucrative markets which after 1660 Restoration England fully exploited. As a result, between 1660 and the accession of George I in 1714, a vigorous ruling class of landowners, with a redoubled confidence and no qualms about displaying wealth, asserted itself culturally through patronage. Many of them were new aspirants to the aristocracy, having made their fortunes through trade, and typically sank their money in big building and land; that this boom led to the flowering of the English Baroque, such as Vanbrugh's Blenheim or Hawksmoor's Easton Neston, shows that, when art interested them, it was art imposed on the land as a regulating symbol. These houses dominated the land and the people on it, and celebrated a settled social order. The 'Prospect', the portrait painting of the great benevolent house lying in the lap of the land, evolved to record it.

In this Prospect, and the true landscape painting which developed from it, the proud owners of these great houses created a seductive and sophisticated advertisement for themselves and their England. Their product, the pictures say, was a prosperous pastoral land with all things in their appointed place, all things grown

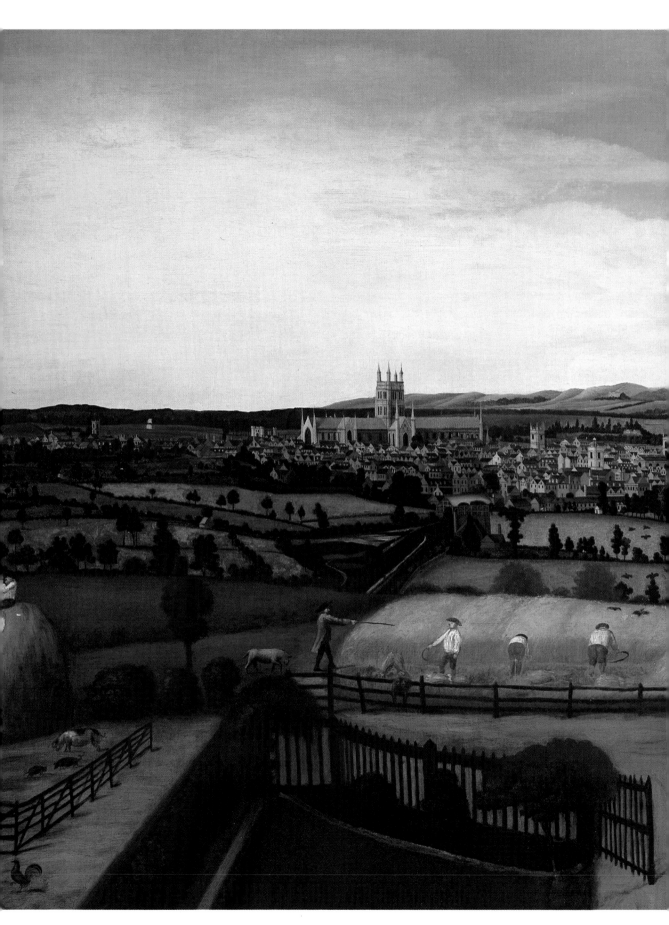

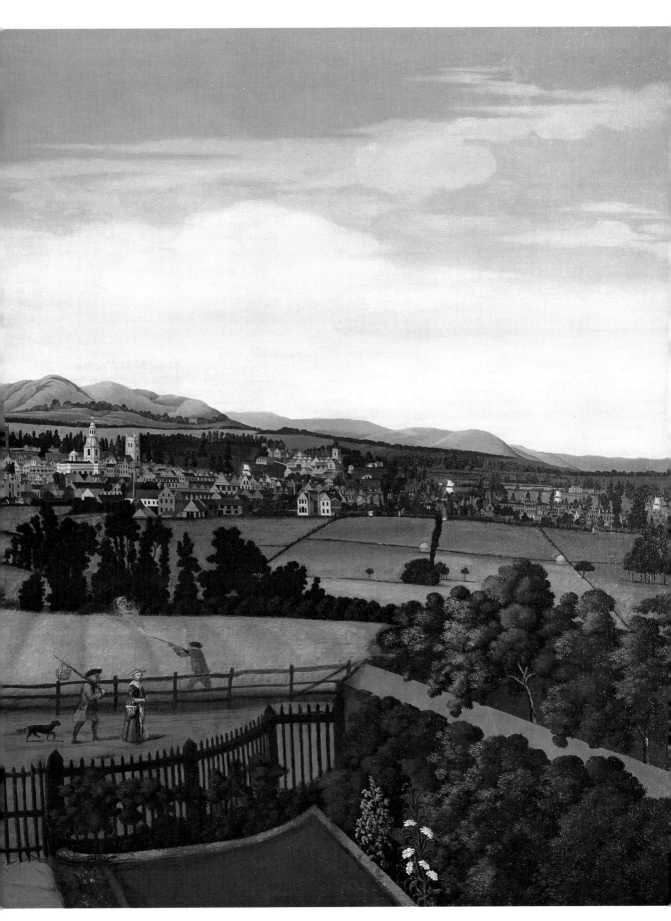

and harvested in their season. But it is startling to realize that this mythic rural idyll of England is primarily the creation of words. The English aristocracy of the seventeenth century were visually uneducated, but highly literate. Restoration drama more than rivals the architecture of the age, and poetry sprang from a well of encouraged natural talent. Painters, by contrast, were usually journeymen Dutch. Part of a rich man's education which had a particular relevance for him were John Dryden's translations of Virgil's *Georgics*, four tracts addressed to Rome on the husbandry of the land, harmony and order, and consolidation after a savage civil war, written with consummate grace and meticulous detail. Beauty meant harmony, so a beautiful landscape meant a cultivated, orderly one.

The pictures they commissioned therefore advertised an England healed of civil war, which rose to world power in the eighteenth century, popularized as the high-fed, rollocking days of *Tristam Shandy*, *Count Fathom* and *Tom Jones*, and still stood serene for Constable to encapsulate in its maturity. The sheer staying power of this image, which made poetry out of agrarian necessity, is worth exploring, as it remains so potent today, when the British landscape has changed so greatly.

Typical of these early eighteenth-century landowners who commissioned these Prospect pictures was Sir Robert Walpole, Prime Minister, and member of the gentry; cynical and jovial, with a firm belief in the policy of 'wait and see', and a very shrewd sense of what was practicable. In Prospects, and later in narrative landscapes, men like Sir Robert, and his wife, canter on horseback with hawks on their arms and hounds at heel. In harmony with the season, crowds of their tenants make hay or harvest corn, while servants of the house and garden tend the well-greened orchards and lawns of the self-sufficient great house which rises upon the sunlit land beyond. The foreground of the picture is in shadow. This not only balances the composition, but it implies that the further from the house, the wilder and less civilized the land becomes. The field workers are usually casual in their labour in these pictures. There is no notion of the steady, almost military system of haymaking that is revealed in very rare naïve painting.

In reality, the long dry grass was cut in rigid swathes like corduroy, by long lines of men with sickles or scythes; the rounded bales were gathered in grids by women, while other teams of women raked the gleanings over and children gathered that. The carts moved in order along the lane-side edge of the field, crossing the cut grass, and the resting work-teams lay out of the way, usually in an ajoining field.

But in prospect and landscape painting, the whole scene has the appearance of a drowsy or boisterous game. By the 1740s Hogarth, a superb urban satirist, could picture haymaking as a game completely lacking the urgent need to gather in the bales by sunset. The prime object of the haymakers appears to be to dalliance. Obviously, as the temperature rose on summer days, some of them did indulge, but they did it out of the field when their team was resting, not in the middle of a very precise working group. The idea of agricultural labour in professionally painted georgic landscape is idyllic; these people worked because they wanted to, as part of their place and role in the world, not because they had to.

The enclosures of the land in the eighteenth century, when great tracts of common grazing were bought up by the large estates, vastly increased production and set the dominating pattern of the English, Irish and Welsh lowland landscape which was to remain almost unchanged until the 1850s. This agrarian in-filling closed the world into intimate and respectable divisions, granting to all those who tended them the element of decency and belonging, particularly in their own

estimation. But beyond the enclosures lay wide areas not easily accessible, lacking harmony, and therefore ugly in their desolation. The high moors of the south-west, Exmoor and Dartmoor, the Welsh mountains and the Scottish highlands, usually poverty-stricken and frequently treacherous, had no claim to beauty and their inhabitants were credited with the features of the land.

Ruins, however, as opposed to hovels, had a place in civilized landscape. They bespoke antiquity, and an heroic tradition of rulers. The erection of follies – artificial ruins – could 'complete' a pleasing vista. Early in the 1700s, the painter Richard Wilson, well acquainted with Italian Renaissance painting, had begun to incorporate the indigenous medieval ruins of the English and Welsh landscape in his work. By the 1750s a taste for a more dramatic landscape developed along with an increasing appetite for novelty among rising financial groups less isolated than the country gentry. These mercantile aspirants to the 'politer society' so lampooned by Hogarth were scarcely likely to have read Edward Burke's soberly entitled *Philosophical Enquiry into the Origin of Our Ideas on the Sublime and Beautiful* but they had a great taste for the first true novels, Swift's *Gulliver's Travels* – an immensely successful satire on corruption, and Defoe's *Robinson Crusoe*, an implicit panegyric on self-assurance and individualism, while Fielding's *Tom Jones* amused their ambitions. The lending libraries fed the taste for travel and novelty in a pre-Romantic manner, and by the early 1770s landscape which thirty years before was considered unfit for the eyes of the discriminating gentleman had become a major tourist attraction. In 1773 the Laird Lord Breadalbane wearily observed: 'We have a great deal of company here this summer . . . many of them from England . . . being on a tour of the Highlands which is becoming *Le bon ton* . . . being always in a crowd is not agreeable.'

What these people sought – with or without knowing it – was what Burke had termed the 'sublime', a quality possessed by objects and scenes of a magnitude that cannot be contained by beauty, which grants a pleasurable sense of uplifting fear or awe.

The taste for the 'sublime', which was the keystone to the Romantic movement, coincides with the rise of industrial rather than agrarian power in England. The first trade union was formed in 1776, and the 'wild' landscapes of the sublime counter-poised the appearance of urban slums. In 1750, Britain had been an agrarian country which exported grain; by 1790 grain was imported, and the manufacturing urban centres in the Midlands and the North opened an expanding road network, making north Wales and Scotland accessible as well as desirable. Even so, it was not enough for the young southern tourist to know what was fashionable touring country, he or she had to know how to look at it.

By the end of the century the landscape most admired ideally possessed a blend of the georgic and sublime, and the most admired painters were Nicolas Poussin and Claude Lorrain. The most 'picturesque' tourist set out with a 'Claude glass' which in the manner of the painter gave a bluish cast to far distances reflected in its slightly convex tinted mirror. The tourist turned his or her back to the view and stared into the glass screened from the sun. To look directly was not done. Michael Clarke has pointed out how the Rev. James Plumptre satirized the whole thing in his comic

OVERLEAF Philippe Jacques de Loutherbourg (1740–1812) *Coalbrookdale by Night* Oil in canvas 23⅞in × 42in (Science Museum, London)

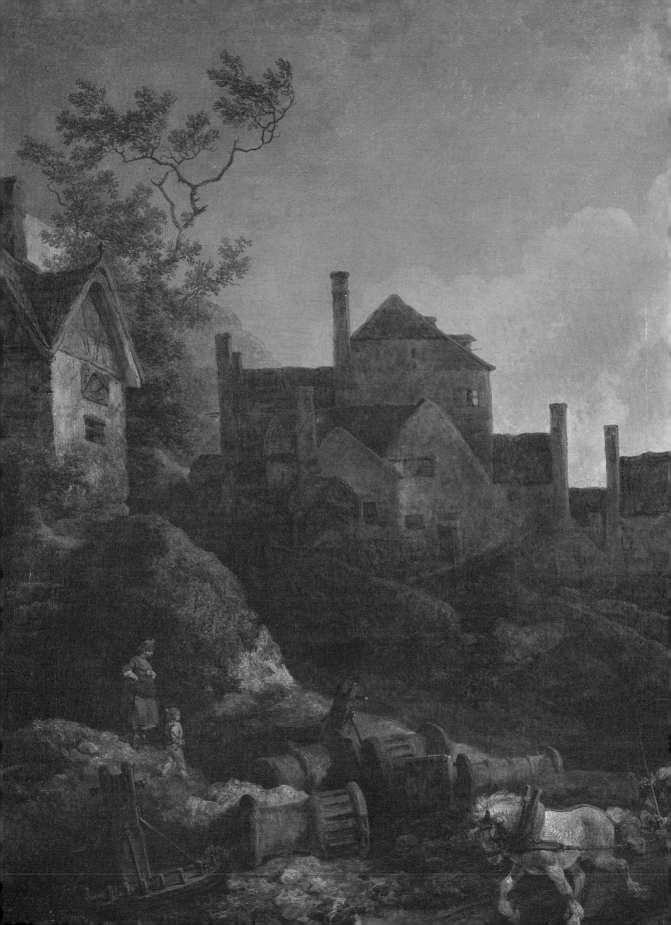

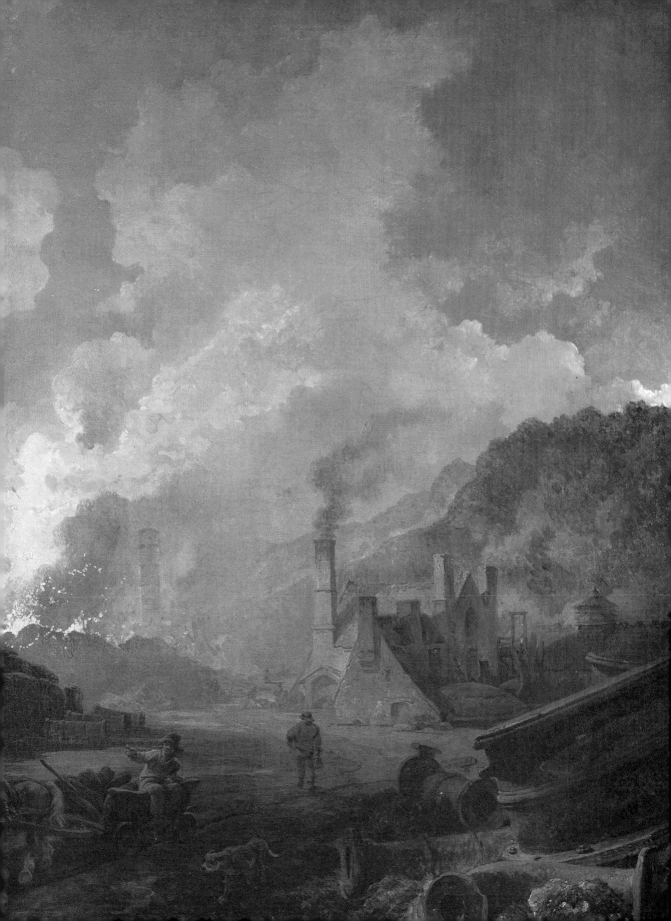

opera, *The Lakers*, of 1798. If a view did not conform satisfactorily, it could always
be enhanced by the discerning, Miss Beccabunga Veronica explained: 'I have only
made it picturesque. I have only given hills an Alpine form, and put some wood
where it is wanted, and omitted it where it is not wanted: and who could put that
sham church and that house into a picture? It quite *antipathizes*. I don't like
meretricious ornaments . . . so I have made the church an abbey, the house a castle,
and the battery an hermitage . . .'

One of these viewing glasses was named after the poet Thomas Gray; a testament
to the power of word-painting.

The Lake District was an almost mandatory part of the tourist's itinerary. In
1792, in a *Fortnight's Ramble in the Lakes*, Joseph Budworth remarked caustically, 'It
is now so meritriciously in fashion to make this tour I dare say it will be thought
want of taste not to be able to speak about it.'

British landscape painting gives small clue at this time to the towns sprouting
dismally on land of equal grace and the wretched crowds of people tied there.
Philippe Vacques de Loutherbourg's *Coalbrookdale by Night* (1801) and Paul Sanby
Munn's *Bedlam Furnace* (1803) are rare exceptions, and show the difficulty the
painter had with the subject. Loutherbourg's training added an almost poetic
quality, evoking the powder-clouds of marine battle-painting, or the veil-like
qualities of mountain mist.

The Napoleonic Wars did nothing to disrupt the English idyll in landscape
painting: they reinforced it. Regency England's golden corn at its inflated wartime
price is the subject of some of the finest landscapes in the harvest genre. As usual,
war increased the symbolic quality of land. Harvest and rural landscape exhibits
rose steeply in number at the Royal Academy around 1790. And the pictures
reaffirmed the land of milk-maid, free-labourer, yeoman, small farmer, substantial
farmer, up to the gentleman, village-centred, healthy and integrated, with a clear
chain of command and responsibility: the old firm of British Georgic Inc. In John
Constable's idyllic 1816 canal-bank of *Flatford Mill*, it seems indestructible.

It was ironic but inevitable that the golden age of watercolour painting in Britain
should be contemporary with the rise of urban industry. In itself, watercolour
painting is probably the finest English contribution to painting, but that it
embraced so many talented amateurs and major professionals alike testifies to its
foundations in the educated middle class: the professionals like Constable and
Turner being the last group of painters with intimate knowledge of the land, and
the amateurs, members of the Romantic movement, reacting against the urban
slums.

But the change in the land is exemplified in the oil painting of J. M. W. Turner,
arguably Britain's greatest painter of landscape. In the year of Waterloo, 1815, his
painting *Crossing the Brook* is a view of the Tamar valley with a Claudian grace and
infinite topographical clarity; in 1844 in *Rain, Steam, and Speed*, one looks into a
different world: there a fiery ghost of a steam train looms out of an opaque,
indefinite world where nothing seems certain, and the drifting shade of a reaper
seems on the point of vanishing.

While writing his survey, *The Rural Life of Britain* in 1838, William Howitt
sensed the growing visual distortion in British life, caused by rapid urban expan-
sion. He noticed that the smoke of London could be seen 40 miles away on a clear
day, and used it as a metaphor for a moral and physical blight spreading over the

land. On northern farms, where, under landowners intent on maximum profits, many small-holdings were merged into one vast sweep of cornfields, the very size of which was shocking to southerners, he foresaw an image of 'all our population cooped up in large towns in shops and factories, and all the country thrown into large farms . . . rural life would be annihilated; the . . . cottages and gardens, the open common, and the shouting of children would vanish . . . to be replaced by a race of stupid and sequacious slaves tilling the fields of vast landowners.'

In 1831 agriculture had directly engaged 275,000 families in Britain. By 1850 the number was roughly the same; but the population had risen by 4½ million in the intervening 20 years. Out of a larger population urban industry, trade, and the great new occupations of communication and transport had virtually absorbed the whole increase. This led to a drastic change in commercial policy. The Corn Laws, introduced to protect the price of home-grown wheat by keeping it high, stood in the way of Free Trade, which was enthusiastically urged by the urban industrialists eager to exploit non-industrialized foreign markets. To the town-dwellers this implied the idea of cheap food, and was a simple, popular slogan. The Corn Laws were abolished in 1846, after an acrimonious ten-year campaign which culminated in riots and rick-burning. A bad harvest in 1845 and a devastating disease that ruined the potato crop fuelled abolition, and in Ireland, where potatoes were the staple diet, acute famine demanded the repeal of laws which kept out cheap imported food while families were starving to death.

Ironically, this repeal led to great short-term agricultural prosperity in England in the 1850s: aided by vastly improved transport and better soil conditions resulting from a change of crops, mixed farming prospered, and this perpetuated an image of the pastoral idyll that became the stock-in-trade of one school of Victorian landscape painting, a realism that was soon a parody of reality. By contrast, the 'Hungry Forties' had seen a ragged influx of thousands of Irish into the new mining valleys of south Wales and the North. Cheap terraced housing turned these narrow valleys beloved of watercolourists into some of the worst industrial slums in Europe.

At the same time, Scottish landowners were systematically evicting and deporting crofters from the well-populated highlands to run more profitable sheep for the woollen mills of the North, and contributing much to the lands 'awesome deserted grandeur untrod by the foot of industry'. As part of this industry, Sir Walter Scott had churned out a welter of Romantic effluent of Highland tales which conveniently pretended that it was really the English army who had caused this depopulation a century earlier.

The Welsh and Scottish highlands remained sublime, the craggy foundation of the Romantic movement, by then the 'official' aesthetic of the art establishment. Even so, by 1840, as Margaret Drabble has pointed out, Charles Dickens's description of the industrial landscape between Birmingham and Wolverhampton satisfied Burke's criterion of the fearful sublime, in sheer magnitude and frightfulness: 'a long flat straggling suburb passed, they came by slow degrees upon a cheerless region, where not a blade of grass seemed to grow; where not a bud put forth its promise in the spring; where nothing green could live but on the surface of the stagnant pools, which here and there lay idly sweltering by the black roadside.'

So by 1850 a new and distinct landscape existed in Britain to be assimilated by landscape painting and to be added to the two other kinds: as well as the well-established 'natural' sublime of 'untamed' land, and the pastoral landscape of

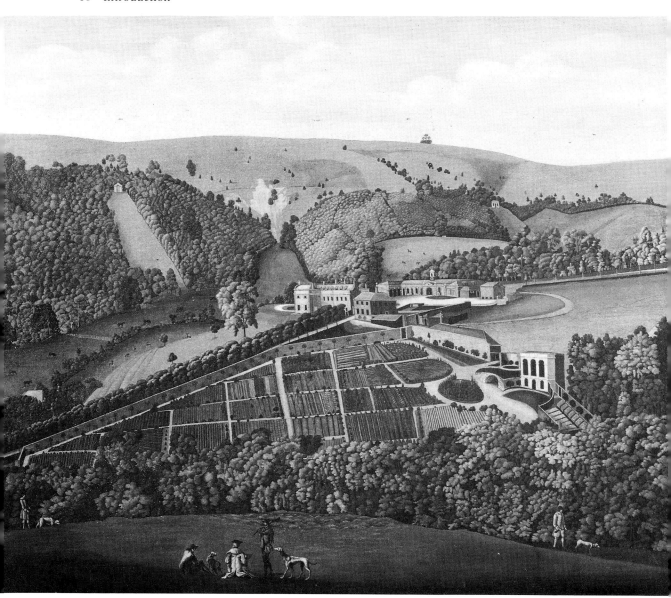

Anon *A Panoramic View of Ashcombe, Wiltshire*, c.1770
Oil on canvas 35in × 50in (Salisbury and South
Wiltshire Museum)

order and tradition there was now the man-made and hideous landscape of the industrial cities. These regions were joined by the artificial umbilical cord of the railways, whose main trunk system was complete by mid-century. The railways affected the way people perceived the land. John Ruskin realized that they often made landscape a vicarious experience. 'Going by rail,' he said, 'I do not consider travel at all; it is merely being "sent" to a place, and very little different from becoming a parcel.'

Ruskin believed that landscape art should do more than merely divert the eye. He condemned '. . . the utter inutility of all that has hitherto been accomplished

(before Turner) by painters of landscape. No moral end has been answered, no permanent good affected, by any of their work.' It was, paradoxically, a view shared by the prime beneficiaries of the Industrial Revolution: the urban middle class and the mercantile grandees.

If it is possible to view such an unprepossessing group of people objectively, the Victorian industrial nouveaux-riches can be seen as one of history's hybrids, and the art that came into being to thrill or seduce them was a hybrid too. Until about 1850, artists were men who had lived in, or had close contact with the country, and so were their patrons, the old landed gentry; but after that date, visits to the country by city or town-based artists had replaced that earlier intimacy. Like their new patrons, these artists were among Ruskin's 'parcels' delivered to rural Arcady by rail. By return, these 'art parcels' produced landscape images which by the 1860s fall roughly into two categories: what one may, without undue cynicism, call 'Hard' and 'Soft' landscapes.

The Hard landscape was the genre of awesome wild nature – usually the Welsh or preferably Scottish highlands, the latter now conveniently cleared of unprofitable crofters. It was all the more popular since Prince Albert had bared his royal knees under the fashionably re-invented clan tartans, for whose accommodation history had been re-written. The beautifully modulated landscapes of Horatio McCulloch, such as *Loch Katrine* (1866) exemplify the best of these pictures, whereas the strange anthropomorphism in the title of Landseer's justly famous *Monarch of the Glen* (1851) almost implies the stag has something in common with the Prince Consort.

The Soft landscape, by contrast, was a frequently decorous idyll, set in a pastoral corner of England, untouched by the technology of the day. It could be executed with great technical skill, and the best of this genre, such as Ford Madox Brown's *The Hayfield* (1855), rank among the finest European landscape pictures of the nineteenth century. All too frequently, though, the Soft landscape was characterized by artists like Myles Birket Foster, a man of consummate technical skill and even greater facility for the market main chance, who could and did produce lines of merry rural urchins scampering across hayfields headed by their Disney-like spotty dog. Helen Allingham, another technician of great sophistication, appeared to see England as an endless vale of flower-encrusted cottages where innocent children strolled under a benign summer sky. If the naïve nostalgia and myth-mongering of these pictures were often cynical opportunism to exploit the urban market, they can be seen too as a penny peep-show into the spiritual barrenness of the monetarist, mercantile philosophy of the people who bought the pictures. The more hideous the urban slums of their employees, the more they craved a pretty vista from a land that time forgot, where there was no trace of telegraph, rail or steam – or of themselves. The obsessive detail in these pictures, too, is witness to an obsessive materialism. The structurelessness of their opportunist philosophy, the sheer aimlessness of their life – as Ruskin remarked – of wishing to get more and more objects to fill up the space around them, led the Victorian industrial nouveaux-riches to desire pictures which showed a stable world of squire, parson, farmer and village of the lost past, where every minute detail had place and purpose.

The rural landscape was seen as a realm of health and purity; a place which contained a higher moral tone than the industrial inner cities. But there was some real substance to such nostalgia at mid-century. The 1851 census revealed that for the first time the urban population was larger than the rural; but it also showed that 20% of the British national income was still derived from farming, and indeed,

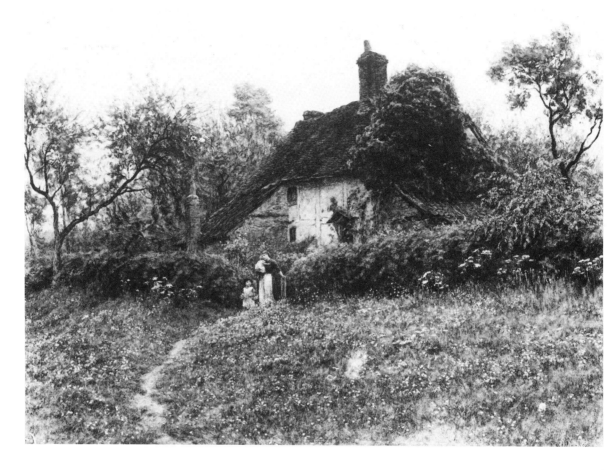

Helen Allingham (1848–1926) *Old Cottage at Pinner*
Watercolour 21in × 16½in (City of Birmingham
Museum and Art Gallery)

British agriculture between 1851 and 1868 flourished in an Indian summer, a
Golden Age of about a generation. Coming after the 'Hungry Forties' high inputs
of capital had led to high returns. Mixed farming prospered, and emigration,
running at 0.84% in 1853, fell to 0.48% by 1861. Mechanical threshers came into
increasing use, agricultural journals flourished, and advances in farming were no
longer the province of rich landlords; enterprising tenant farmers prospered. In
1867 an Act of Parliament forbade the employment of women and children in
agricultural gangs, part of a general trend toward more humane – if less picturesque
– working conditions. Only severe cattle-plague in 1868 foreshadowed the lean
years to come.

But beginning in 1870 a series of disasters struck rural Britain, and it is a measure
of the art establishment that the misery of the next 30 years scarcely registers in the
landscape painting of the nation. Basically, city-dwelling buyers preferred not to
look.

Between 1870 and 1876 education authorities began their long history of
blunders in rural areas which continued to the present day. School boards took

thousands of young people off the land, precipitating the collapse of small-holdings and adding to a subsequent tide of jobless drifting to towns where working conditions offered a lower life expectancy than on the land. On top of this came a run of bad harvests, local taxation, and above all cheap grain from the United States – a result of Free Trade and a delayed result of the repeal of the Corn Laws. In 1846 Europe had little grain to spare and American production was in its infancy. But with opened prairies, rail, and refrigerated cargoes in the 1880s, the British market was flooded: dairy products from Denmark, meat from South America, and wool and mutton from New Zealand struck one after the other. British emigration figures rose steadily. The crowded harvest scenes which so typified landscape genre pictures of the eighteenth century are partly replaced in gallery art by middle-class ladies with sun parasols strolling through standing corn. Trade unionism appeared in the South and Midlands in 1871, new in farm areas, but met with little success. Workers in rural areas had no vote until 1884.

Serious depopulation of the countryside continued steadily. But this period also bore witness to a greater environmental awareness. In 1873 the word 'ecology' had made its first appearance, and Thomas Hardy's first novel of 'character and environment' *Under the Greenwood Tree*, appeared in 1872. The Royal Forestry Society was formed in 1882, officers for Environmental Health were created, and the Selborne Society established for the preservation of plants and birds.

This was the period when British landscape painting forked off into three directions. One road led to Impressionism and abstraction. The second way led to the established genre painters of the day, such as Birket Foster, consolidating their position and to forging a cosy style, which by the mid-1930s had crystallized into a view of England aptly described by Ian Jeffrey as 'the house style of Great Britain Inc.', the rustic England of calendars and beer mats. And the third way led to the growth of many artists' colonies in the country, from Scotland to Cornwall, such as the Newlyn School, whose painting styles varied from French Impressionism to more conservative forms. From these various schools and colonies came most of the major British landscape painters of the twentieth century.

The landscape these young painters inherited had changed radically from the Indian summer of the 1850s. The corn-growing disasters of the 1870s and ruinously unfair foreign competition had led to greater specialization: horticulture, poultry, pedigree livestock and particularly dairy farming, all demanding fewer hands, more pasture, less cereal cropping, making for a general 're-greening' of the land. Hedges and copses flourished; it was typical that William Robinson's *Wild Garden* appeared in the 1870s, and by 1899 Gertrude Jekyll was publishing books on growing 'natural gardens'.

By the 1890s, photographers, who had been posing rustic characters in painterly attitudes in pursuit of artistic respectability, realized that their subjects were fast vanishing, along with a whole way of life. They could get rusticated friends to pose as harvesters, but unlike painters, they needed a real harvest to portray. Every summer of the 'Gay Nineties' except 1891 and 1894 was stricken with drought, and by 1900 the world of Constable and Howitt was nothing but a memory.

The opening years of the twentieth century, which are so often referred to as the 'long summer of Edwardian England', mark a change in the relationship both of artists to the land and artists to the public.

After the death of Ruskin in 1900 – news of which was greeted with cheers by the painter Roger Fry and his clique – the mood of Impressionism pursued by Whistler

in the 1880s led Fine Art along a highly sophisticated but increasingly abstruse path where the general public could not follow. Landscape painting can be seen to step aside slightly from this development, but the most noticeable features of British landscape painters in the twentieth century are privacy and reticence, and their wholly different means of communication from the predecessors. Their reaction to the fast-changing landscape was that of observers and illustrators, both of what other people were trying to preserve or what they were attempting to escape from. Many of them were eye-witness war artists, from the inventor of dazzle camouflage to the creators of memorial murals, though many galleries declined to hang their work for fear it might offend the public stomach when it touched too close to reality. And, above all, their work appeared more often in books and magazines than in art galleries. In the first half of the century these books they illustrated were frequently motor guides to Britain. As such, they are a visual testament to a war fought over the British landscape for more than 50 years; and by mid-century, they mark the watershed of agricultural revival and urban decline.

Painters had celebrated semi-mythical rural values or monumental grandeur right through the nineteenth century, usually to their own if not the landscapes' profit but, at the turn of the century, other artists, particularly writers and musicians, were acutely aware of the vanishing folk-culture of rural Britain as its communities disintegrated under the onslaught of drought, Free Trade, indifference and urban encroachment. There is something almost frantic in the way composers like Ralph Vaughan Williams and Percy Grainger (an Australian) scoured the country to record genuine folk melody; but they did succeed in raising British music from the relative doldrums of the nineteenth century. But some writers showed more concern for the landscape than for the people. It is useful to see the British landscape between 1900 and 1939 through the eyes of some of these writers, for writers dictated the manner in which the work of many landscape painters reached the public, and to a certain degree, even how they painted.

In the late 1890s that blend of town and country – suburbia – later caricatured as 'bungaloid scurf' had shown its superior forerunner in the new garden city at Letchworth, 30 miles from London, and the infant motor car industry had opened an optimistic Daimler factory at Coventry. Though for years the target of *Punch* and other periodicals as a befouling menace, the embryonic motorists constituted a minute percentage of the population and some of them, such as Rudyard Kipling, were enthusiastic folk-lorists. Kipling's *Puck of Pook's Hill* (1906) – a magical evocation of the Sussex countryside which he saw under threat – was a region he explored at a spluttering 12 m.p.h. In 1903 the Motor Car Act gave the private motorist substantial freedom for the first time, and in the view of G. F. Masterman, Mr Toad was soon all over the landscape. Kenneth Grahame's wasteful character from *The Wind in the Willows* (1908) wasn't deliberately destructive, boorish and insensitive, but like a child he delighted in fortuitous noise, and he was certainly arrogant and complacent. Masterman was later in charge of British propaganda in the Great War, but from 1905 he considered the British town-dweller as Britain's most implacable enemy. He saw the urban armies out hop-picking and caricatured them as trolls, 'lured out for a season from the slums of the cities, blinking in dull wonder at the strange world of sunlight and silences'.

Kenneth Grahame, equally distressed at the mutilation of the British landscape, had set *The Wind in the Willows* in Cookham, Berkshire. Ian Jeffrey has quoted how he wrote of the Road set: 'Who is this that flieth up the reaches of the Thames in

steam-launch hired for the day? Mercury is out – some dozen or fifteen strong. The flower-gemmed banks crumble and slide down under the wash of his rampant screw; his wake is marked by a line of lobster claws, gold-necked bottles and fragments of veal pie. Resplendent in blazer, he may even be seen to embrace the slim-waisted nymph, haunter of green (room) shades, in the full blaze of the shocked and scandalized sun.'

From about 1912 onwards, right on through the 1920s, there continued a spate of landscape poetry and regional novels by the 'Georgians' – Kipling, Belloc, Rupert Brooke, A. E. Housman, Vita Sackville-West, Edward Thomas, Walter de la Mare, John Drinkwater, Mary Webb, Sheila Kaye-Smith and others – reflecting both rural concern and the upsurge in patriotism inspired by the Great War. England and her rural virtues seemed all the more precious for being threatened from outside as well as from within.

Composers too cast a lingering view over the georgic landscape last familiar to Stubbs and Constable. The outbreak of war in 1914, however, showed the English countryside to be vastly different, for British farmers were grossly ill-prepared for war. The total area under cultivation had fallen by half a million acres since 1870, while the population had risen from about 33 million to 45 million in those 40 years. While the British Grand Fleet prowled regally about the North Sea to blockade Germany into starvation and surrender, a Food Production Campaign had to be launched in 1917 to save Britain from starvation. With the belated shelving of Free Trade and financial incentives, another 3 million acres came under the plough by 1918. Meanwhile, thousands of acres of irreplaceable woodland and parkland were destroyed indiscriminately for pit and trench props, and Dutch Elm disease, due to the same war-time timber needs, advanced from Asia across Europe. It reached Britain in 1930. The Forestry Commission appeared in 1919, too late to rectify the ruination, and by the mid-1920s, when the high war-time corn prices had fallen and agriculture needed all the help it could get, the government revoked financial protection and the farmer was left to fend for himself.

The resulting distress and financial ruination put tens of thousands of acres cheaply on the market, and these were snatched up by speculators for indiscriminate building. The Council for the Preservation of Rural England came into existence in 1926 to try and stem this opportunist tide which soon went under Professor H. J. Fleure's poetic title of Ribbon Development.

Motoring hotels flourished; by 1937 over 300,000 new cars were being registered every year. With the private car came a spate of popular publications dealing with rural England, led by B. T. Batsford's *The Face of Britain*, 'designed for the intelligent rambler by car, on bicycle or foot', and 'intended to keep the reader off the more familiar and recognized tracks'. There were also *The Pilgrim's Library*, *British Heritage*, *Highways and Byways in Britain* series, and the first Shell *Guides to Britain*. Artists like John and Paul Nash and John Piper contributed to these.

Writers and artists of such series observed a landscape that increasingly had the aspect of a shop-window; a college made up of a series of different jigsaw puzzles of different styles and copyings which of course became a style in itself, almost exemplifying the 1930s, but amorphous enough for places along a road to become one long series of reflections of one another. Ian Jeffrey has noticed J. B. Priestley's diagnosis of a 'Third England' suffering from a terminal attack of: 'arterial and bypass roads, of filling stations and factories that look like exhibition buildings, of

giant cinemas and dance halls and cafés, bungalows and tiny garages, cocktail bars, Woolworths, motor coaches, wireless, hiking, factory girls looking like actresses, greyhound racing and dirt tracks, swimming pools, and everything given away for cigarette coupons.'

But the reaction of British painters to this altering landscape was very different from that of writers and musicians. To start with, except by cartoon, they couldn't reach a public through satire. In the 1820s John Martin had made himself a great deal of money and a large reputation with what many people chose to see as a condemnation of urban wealth, *Belshazzar's Feast*; he followed it with the equally successful *Fall of Babylon* the next year at the Royal Academy. Horatio McCulloch's highland landscapes had equalled the awe of urban industry with monumental purity. But Mr and Mrs Bungaloid's Morris saloon could scarcely be compared to the chariots of Sodom and Gomorrah, even if it did proportionately more damage to the environment.

Established professional artists too had to take care of their market which was the establishment – and the establishment did not wish to be criticized. Their outlets were essentially unadventurous institutions such as the Royal Academy, preserver of the *status quo*. The Royal Academy was so tame and hidebound it had refused to hang many of the finest pictures made by war artists during the Great War in case the polychromes of human decay soured the wine at the private view. They passed them to the Imperial War Museum.

Younger artists were often involved with the abstruse inter-art issues of the day (such as the role of geometry of constructivism) and were well on their way to the introspective élitism that has now all but removed Fine Art from the public eye completely. Others had dropped out of this and other pressures. But those who did drop out – and those who did not – had one thing in common; they usually went to live deep in the country.

The regions they chose to live in, either singly or in small groups, were as far as possible from the no-man's-land of ribbon development; they were generally Wales, Cornwall, East Anglia, the Cotswolds or the northern moors and fells. Ian Jeffrey has pointed out how so many of them are 'aperturists' (my phrase) or people who seem to be staring out from an enclosed space, through a window. Their pictures give a sense of alienation and separation from the landscape, the view of an outsider who is in a shell.

It would be easy, as certain critics have, to accuse these artists of the 1930s and onwards of evasion and escapism; of lacking constructiveness and of being essentially bourgeois aesthetes who made a picturesque business out of refusing to address themselves to the world beyond the cottage wall. Bearing in mind that many of them had been and were to be some of Britain's leading war artists that criticism would seem insubstantial enough; but, in any case, it misses the essential point in the attitude of escape: that escapism is by definition an act of criticism and rejection. As Tolkien said in the Merton lecture in Oxford in 1938, 'There is no more eloquent rejection of a thing than you expunge it from sight. You declare it obscene.' The landscapes portrayed by many of these painters appear to conform to that principle. They lack suburban sprawl, home of Mr and Mrs Bungaloid. They lack telegraph poles, tractors and combine-harvesters; corn is usually gathered in

OPPOSITE John Piper (1903–) *St Mary le Port, Bristol, 1940* Oil on canvas 30in × 25in (Tate Gallery, London)

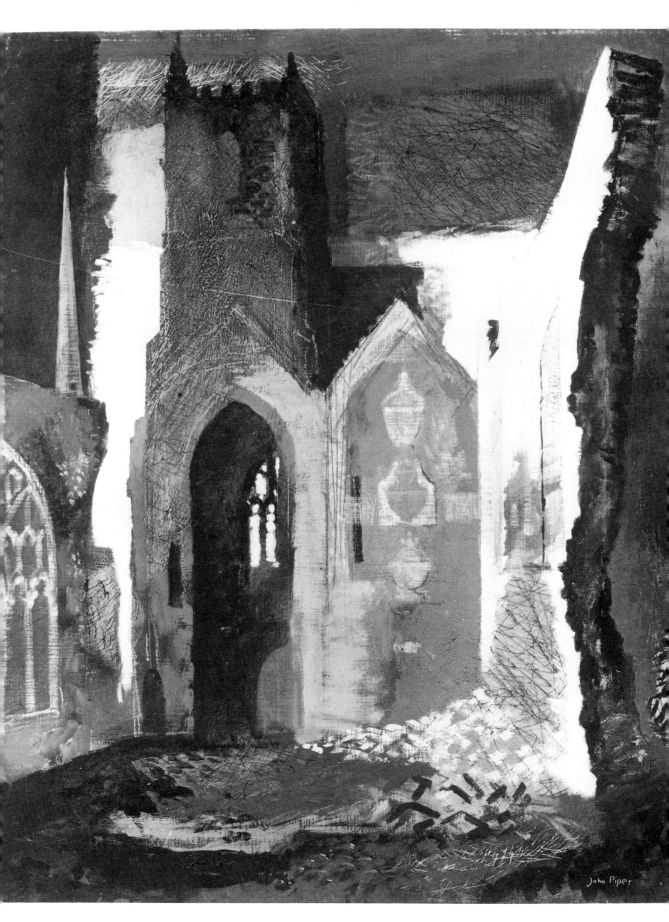

stooks and rabbits still scoot across the stubble. Although when used commercially, as in posters for railway corporations, these things could become a facile mannerism, they were also an affirmation of Britain which was under constant threat throughout the 1920s and '30s.

British landscape painters stepped aside from the mainstream of European painting in the late 1920s and did not return until well after the Second World War (although the great Belgian surrealist René Magritte considered Paul Nash one of the finest surrealists of his day) but in any case Fine Art had ceased to make any impression on the general public by then (it is over 60 years since a popular paper like the *Daily Mirror* regularly reported art exhibitions), and to demand that these artists should have followed the mainstream of contemporary painting *and* addressed themselves to the public is practically a contradiction in terms. They had to choose one or the other.

The landscape they saw, in any case, was not designed to acknowledge the concerns of the metropolitan avant-garde. Often in country areas, it was not necessary to discriminate against telegraph poles: there frequently were none. Ruinous government policies had ensured rural areas in the 1920s and '30s lacked telephones, electricity, even mains water. Gas does not exist in many such areas in the 1980s. Between 1921 and 1939 the farming community in Britain lost a quarter of its workers. Michael Rosenthal has charitably pointed out that John Nash is a rare painter for showing a tractor in a Thirties painting; he appears unaware that tractors were rarer than art students in the 1930s. Ploughing was usually horse-drawn until the end of the Second World War.

War in 1939 was the best thing that happened to British farming since the invention of the seed drill. Regardless of whether they show the desire of the town-dweller to return to the agrarian womb (as some critics predictably suggest), the corn harvest images of many landscape pictures bear witness to the great resurgence of the land which began in the later 1930s and has continued until the present day. Having learned its lesson from the Great War, government took action in subsidies and incentives to forestall food shortages as far as possible as war grew imminent. As a result, the war years were a spectacular triumph for British agriculture with over 6 million acres reclaimed for arable farming alone, and farming outstripped urban industry which was less efficient and deplorably dependent on American technology for most of the war. The war obscured this watershed in British heavy industrial decline.

As in 1814, the war increased the symbolic nature of fertile land. In Britain, it was the georgic image of small fields, small cottages, and small villages tucked into folds in the land, joined by winding leaf-verged lanes, where speeding jeeps driven by G.I.s overturned on sudden corners. The image recurs in films throughout the 1940s. It was the Hollywood idea of England beyond the archetypal metropolitan smog.

Superficially, it is the land pictured so often by John Nash, Charles Tunnicliffe and Gilbert Spencer: a land harvested by horse-drawn machinery and reaped with hand-held sickles on times, and still horse-ploughed. It is a sobering thought that mechanization came rapidly only *after* 1945. But its future prosperity was laid down in the years of rationing and shortage after the war, when urban industry basked in a glow of false confidence.

But a fundamental change had taken place in the British landscape by 1950. As though the fields were one of Beaverbrook's Spitfire assembly lines, produce had

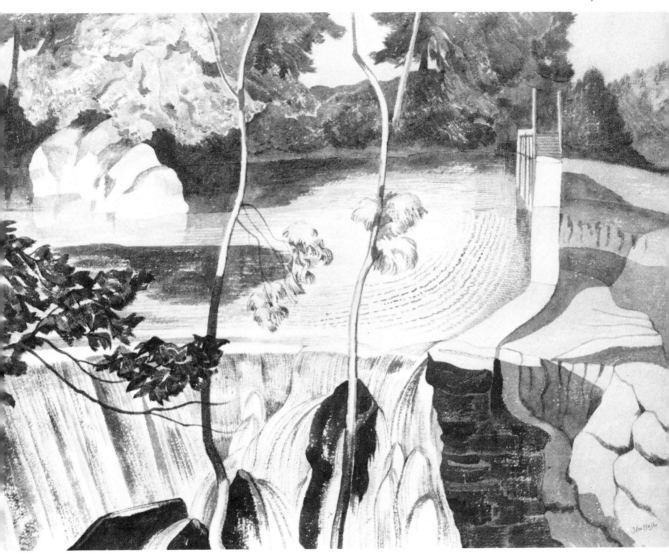

John Nash (1893–1977) *The Waterfall, Dolanog*
Watercolour 16in × 21⅛in (Leeds City Art Galleries)

been churned out, and there is another element in landscape painting apparent by the late 1940s, particularly pictures by John Nash. Unpeopled landscapes have the element of floors used with an industrial thoroughness, almost indifference. The land hasn't been raped, certainly; but it has been anaesthetized, then flayed. The British rural landscape became less and less georgic as it grew financially stronger. Myxomatosis, insecticides and mechanization with smaller and smaller numbers of people necessary to run increasing acreages rapidly made British farming among the wealthiest and certainly most efficient in Europe, but it bore no relation over great tracts of space to what urban convention still thought of as rural England. By the mid-1950s telegraph poles were modest watch-posts for hunting buzzards; seven-storey electricity girder pylons the height of war-time radar masts domi-

nated open skylines. Aesthetically, they at least possessed something of the nineteenth century's spectacular violations.

In 1949 the National Parks Commission came into being, 'to keep under review all matters relating . . . to the beauty and amenity of the countryside and the need to ensure public access . . .'. Paul Elek issued a *Vision of Britain* series; the book on *The Cotswolds* contained pictures by Humphrey Spender.

Artists, returning from war service frequently sought solace in the countryside for their displacement. But usually they found no restorative idyll: rather, a sense of unease. Much of the painting of the 1950s into the late 1960s moves almost to abstraction, as these artists lost themselves more and more in the *alien* qualities of landscape – its space and anonymity where their translation of its colour could help them achieve a stronger sense of their own individuality.

Yet the georgic remained an ideal of astonishing potency and seduction, powerful because of progressive urban decay. 'Gentrification' went on apace in rural areas from the late 1960s. Those Helen Allingham cottages were annexed by a professional middle class escaping the urban twilight either in retirement or working from commuting distance, pegging house prices higher and higher but often forming communities of close-knit cohesion among themselves in the manner of old villages. The original inhabitants, few of whom were employed on automated farms run by owners with agricultural degrees, worked in the nearest town, while on places marked white on population density charts a residue of late 1960s and early 1970s college drop-outs, still affecting a studied Pre-Raphaelite appearance, grew cabbages and children and contributed to ethnic craft fairs while they drifted into middle age. In many parts of the North and East where the land is flat the patchwork of hedges, so much a feature of the Shell Guides, was ripped up for the convenience of agricultural technology. Again there came the bald prairie Howitt saw 150 years ago, while hawks flapped from telegraph pole to pole after hedgeless voles.

But the country was more sought out than even in the days of Masterman. The work of landscape painters in urban areas was constantly undertowed with a sense of isolation – a claustrophobic sense of crowded aimlessness; the loneliness which psychologists term alienation. It was witnessed in the gulf between the crowded factory streets of L. S. Lowry and his lesser known, deserted landscapes. 'Had I not been so lonely, none of my work would have happened. I should not have done what I've done, or seen the way I saw things.' This isolation merges into the suburbia of Carel Weight: 'You pass a spot each day. You know and love every brick and tree. Suddenly, in a moment, everything is changed, and the friendly things around can't help you.'

Then in 1986 the rural balance began to sway unpredictably. The EEC drastically reduced the amount of milk farmers could sell after years of encouraging costly investment in dairy production. Many went bankrupt. British government attitudes, strongly reminiscent of the 1870s, were no help: they suggested farmers 'diversified' into tourism, when many areas had already reached tourist saturation point given the limitations imposed by the climate and ecology. And the British climate was changing. British summers in the later 1980s saw a run of cool, wet months and 'unseasonal' crop behaviour. In addition, promises of a European Market and relaxing of trade barriers in 1992 brought a threat of cheap grain production in southern Europe, and suggestions of forestry replacing open farming. A property boom and spiralling house prices in the suburban areas caused an

increase in buyers 'picking up' proportionally 'cheaper' second homes in rural areas. In rural Wales this was an excuse for a militant minority intensifying an arson campaign.

Many of the visitors to the country now appear as part-time refugees from the New Industrial Revolution. Were Joad to watch the countryside of the 1980s he might remark that Mr and Mrs Bungaloid had been replaced by their daughter, Ms New-Tech, a walking testimony to disorientation and displacement. But Joad would also observe a young woman sitting in the shade of a wall, painting the land before her with all the whirling tangled energy of Michael Ayrton or the light grace of Thomas Girtin.

It has been said that the greatest achievement of landscape art in Britain has been the assimilation of the First Industrial Revolution; but perhaps it would be more accurate of landscape painting to say that it is a testimony to the extraordinary gulf between the idea of what humane landscape should be, and what human landscape is in reality.

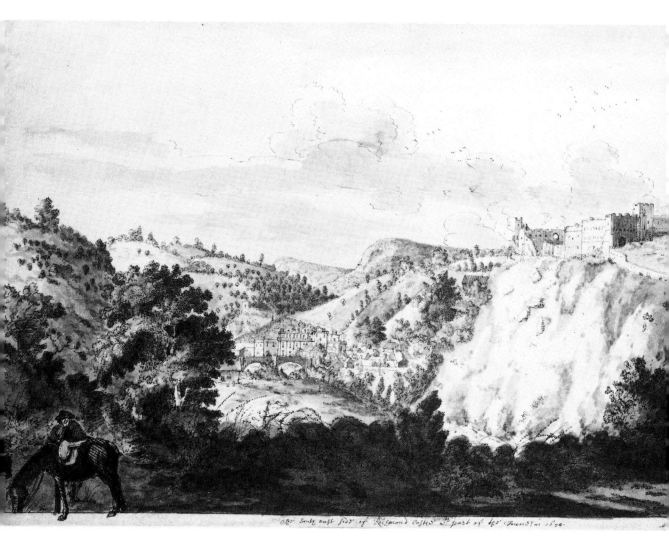

Francis Place (1647–1728) *Richmond Castle from the South East* Watercolour 11½in × 7in (British Museum)

A History

Prospects of an Ideal Land, 1635–1775

In 1636 Thomas Howard, Lord Arundel, a patron of Van Dyck and Rubens, travelled across Germany. Between Cologne and Frankfurt he found every town and village ransacked, demolished and burned, and at each halt no one left the coach except the member of his entourage whose turn it was to stand guard. He had gone to form a treaty that would end the Thirty Years' War. He failed, but brought back 'one Hollarse wth me, whoe drawes and eches printes in strong water quickely, and wth a pretty spiritte'.

Wenceslaus Hollar (1607–77) spent almost all of his subsequent life in England, and founded the English school of watercolour landscape painting. Pictured by John Aubrey in *Brief Lives*, Hollar's career illustrated what a man who was not a 'face painter' but made portraits of places might expect in England in the mid-seventeenth century. Aubrey recalls that Hollar was a printmaker from Prague, who was initially intended for the law, and whom Arundel employed to illustrate the towns and fortresses visited during his lordship's ambassadorship. On his arrival in England he made etchings from these pictures, and then 'finished' the sketches with watercolour washes. Through Arundel's influence Hollar was appointed drawing master to the Prince of Wales, later Charles II. He married one of Lady Arundel's servants, and his life and his modest art appeared secure. But the Civil War forced him to flee to Antwerp, and two years later his patron Arundel died. When he returned to Commonwealth England, he was immediately arrested on suspicion of Royalist sympathies and on release eked out a meagre living paid by the hour, engraving book illustrations for a London publisher. Before the Restoration in 1660 could benefit him, the Plague and the Great Fire of London decreased what patronage there was; he was almost destitute when Charles II appointed him 'King's scenographer or designer of Prospects' in 1666.

As such, he drew and etched the portraits of English abbeys and castles, London and the regions around. His drawings were similar to those of the Dutch, especially of the three artists Lambert Doomer, Willem Schellinks and Jacob Esselens who had toured England during the early years of the Commonwealth. They were long, low drawings, careful portraits in black or sepia ink made in pen, and sometimes filled in with a diluted ink or watercolour wash. Engravings were made from these.

Aubrey found Hollar as an elderly man in squalid lodgings, abandoned by the aristocracy and exploited by publishers, known to his landlord as 'the Frenchman limner, for they know not my name perfectly, for reason's sake. . . .' When he died, bailiffs had threatened to seize his remaining possessions.

It was an inauspicious start to landscape painting in Britain, a pathetic contrast to the prestige of the Dutch marine painters who at that time were commanding high salaries from their studios in royal premises along the Thames. But it was typical of the country and the time.

Anon *Dixon Manor – Harvesting* Oil on canvas
42in × 113½in (Cheltenham Art Gallery and Museums)

Three years before Hollar died, the Netherlander Jan Siberechts (1627–c.1700/ 05) had arrived in England. He differed from Hollar in that he was an artist who worked in oil on canvas as well as in pen and ink, and he specialized in 'Prospect' pictures. Almost all such pictures were produced by a group of Dutch artists working in England at that time. They were mostly bird's-eye views of an estate, quasi-maps of the grounds and formal gardens, with the human figures and animals of the mansion and its policies placed almost as if they were accessories on an architect's model. Some prospects employed eccentric – or naïve – twists in perspective, while others, such as those of Jacob Knyff (1639–81), have the apparent precision of a finely tinted aerial photograph.

Siberechts's pictures differed from both these types. They included, of course, the colour codes laymen of the time would recognize. The green fields and parklands, usually in sunshine around the great house, the orderly, fertile, well-regulated places of crops and therefore of wealth and comfort. Beyond were the shadowy brown woodlands or common heath, lit with a fitful light beneath cloud shadow, places not yet under the benevolent management of the estate. Figures were placed in their correct social and environmental positions: field workers gathering crops, gardeners tending formal inner grounds, house-servants on

doorsteps or in the kitchen-garden; the gentry at cultivated leisure on the lawns or at robust field-sports. But they were finely painted and seductively beautiful pictures, and their details and execution went far beyond those of a map or model-maker. Their perspective is usually lower than that employed by Siberechts's contemporaries such as Knyff or van der Hagen. It is as though the viewer is standing upon a low hill, and the grace of the surrounding land – even that beyond the estate – often reveals the care and sensitivity displayed in the sixteenth-century landscapes of Pieter Bruegel. When Siberechts made the portrait of the market river town of Henley-on-Thames (1692) he did so by showing it in a sunlit river valley with its trade and industry moving around it along the river and fields, and seen from a country lane along which farm workers move with a group of livestock. A spreading oak tree occupies about two-thirds of the picture and the town is framed beneath its boughs. This picture layout was to become a standard one during the eighteenth century, and Siberechts expanded this organizational repertoire from constant drawing in the open air to record the landscape a patron visited during a major journey. The shift in perspective from the country mansion at the centre of a painting was gradual, and it came not from the initiative of the artist but of his patron. That interest reflected a gradual expansion in the outlook of the British landowner as his power increased. That expansion was very slow until the 1730s, but so far as the medium of watercolour was concerned, it was a member of the gentry who produced the first true landscape painting in England.

Francis Place (1647–1728) was a highly accomplished artist who 'passed his time at ease'. He was a member of the York Virtuosi, a group which included physicians, merchants, craftsmen and antiquarians, similar to groups found in London and Edinburgh, which met socially to discuss and pursue topics of science and art. Although 'the ingenious Mr Francis Place' produced work for print publishers in London, this was undoubtedly for his own satisfaction after he abandoned law, and he was able to indulge his taste for drawing landscape unimpeded by the whims and finances of others.

Like some of the patrons of professional artists such as Hollar and Siberechts, Place enjoyed travel for its own sake – change and enquiry – and he explored Ireland, the Isle of Wight, the English north-east coast, the West Country, Scotland, Wales, France and the Low Countries. But this wandering around was highly unusual, and in 1678, the year that Titus Oates rigged the 'Popish Plot' to assassinate Charles II, Place was arrested and temporarily imprisoned as a spy. His travel was in all events uncomfortable and slow, and was conducted on horseback.

He recorded the variety of the land he saw in the format used by Hollar, with whom he had collaborated as a young man but whose pupil he had never been 'which was my misfortune'. But as a 'gentleman-scholar' he gave free rein to his taste and curiosity. By the time he visited Ireland in 1698 his pictures were among the first true watercolour landscapes, drawn for their own sake, not a print-maker's or travel writer's, and as they were executed in watercolour paint they possessed a far greater subtlety than the diluted washes of map-maker's ink. His pictures often contained humour, the baggily-laden traveller in grand hat and great boots astride a very small pony, and they employed devices far ahead of their time: a horse and rider looking into the picture area but placed outside it, the horse and man having their feet below the bottom framing line of the picture; something not in common design use for two more centuries.

Because he was not a professional, however, few if any of Francis Place's landscapes reached an audience beyond the large but select circle of his friends. Neither were they reproduced as etchings, and as a result his way of seeing and painting remained little known for generations.

Place was scarcely, in any case, an average sample of the English gentry. While they transformed the country around them, buying up the thousands of acres of common land, and rapidly increasing production of corn, wool and meat, they found its likeness pleasing chiefly when it reflected their business schemes, very much in the manner of late twentieth-century multi-national corporations: 'beauty' is having the biggest building on the skyline. The visual creations of the eighteenth century were rarely as banal as that, and unlike their successors they became more, not less subtle as time passed. But at the beginning of the century the gentry had small interest in recording their land in paint. Indeed, those who possessed any interest at all in visual art had been assured by the writings of Jonathan Richardson that history painting – pictures of great incidents in history – was the highest form of the painter's art; after that came portraiture – face painting. What most of the wealthy English wanted from a painter, if they wanted anything, was their portrait and, being English, Protestant, and suspicious of Continental extravagance, they wanted value for money. Cromwell may have taunted the portrait painter Lely on the subject. 'You like a King, don't you? That way you can get rich painting all his whores and bastards!' The English found that group portraits of their legitimate and illegitimate relations were far more economical than single pictures, and a

group at leisure, with their house and part of the estate in the background, suited them best of all. These 'conversation pieces' flourished early in the eighteenth century, and William Hogarth (1697–1764) excelled at them.

Hogarth was a superb social observer, painter of urban and rural scenes alike, portraitist and satirist. His widely produced prints of political and social life made him enemies with a sense of humour as caustic as his own, but the diversification and flowering of British painting from 1730 onwards was due largely to him.

The Georgic Land, 1720–60

Hogarth was acutely aware of the tendency of the British – and essentially English – aristocracy to buy art abroad. Landscape was appealing if it appreciated, and it only appreciated if it was painted by Gaspard or Poussin or Claude. From these sixteenth- and seventeenth-century continental masters it was a safe investment, and British art was not; British landscape least of all. Hogarth's contemporaries, such as John Wootton and George Lambert all produced copies of – or pastiches of – Poussin or Claude, because other buyers were happy with an English copy of a French master. This was particularly the case with rising groups of the English middle-class, who could not afford a Continental master, but could afford a copy of a painter whom Jonathan Richardson approved of; a low-price cultural rubber-stamp on their new gentility. Hogarth aimed to bring British art to these people's notice. Choosing Vauxhall Pleasure Gardens as his venue from 1732 he undertook to provide the decorative pictures which accompanied the musical entertainment there, ensuring that they would be seen by crowds all affluent enough to afford the sizeable Vauxhall entrance fee. In 1735 he reopened the defunct St Martin's Lane School (Academy) which offered painting and drawing instruction, and during the 1740s arranged for painters to donate works to the Foundling Hospital, which ensured they would be seen by affluent visitors. Hogarth's pictures were widely

George Lambert (1700–65) *View of Box Hill, Surrey* Oil on canvas 35½in × 72½in (Tate Gallery, London)

seen through engravings, and their popularity was partly the response of a society in which individual self-confidence was growing apace with an increasing sense of national importance. As a result, Hogarth and his fellow artists of the St Martin's Lane circle reflected three Britains in the landscape art which, by the 1760s, had come of age.

Over the shoulders of the genteel groups in conversation pieces the cultivated landscape often stretches away in a delicate, informal geometry, lit by a low, late afternoon sun which throws trees, hills, fields and villages into high relief. Because much of this landscape was their possession, the wealthy conversationalists – often engaged in music-making or a lawn game – began to find its units of fields and houses pleasing as a picture. Until the late 1720s, their own mansion gardens were formal 'Dutch' designs, shaped beds demanding hundreds, sometimes thousands, of bedding plants replaced two or three times during a season, the labour of numerous staff. But this fashion dwindled rapidly during the 1730s to be ousted by the 'landscape garden', the anglicized monument to Claude and Poussin, and the idyllic fantasies they had painted with classical temples standing, often in ruins, among great clouds of ethereal trees, and mirrored in lakes of still, gleaming water. This landscape was an ideal: the English countryside (let alone the Welsh and Scottish) did not much resemble it generally, but its coppices, its new asymmetrical fields, plentiful woodland and numerous medieval ruins often contained areas which did. As this changed landscape of enclosed fields lapped the edge of the grounds of the great houses, the *visual* (though certainly not the social) dividing line between them became narrower and narrower. It is a mere hedge, slope or wall in many conversation piece pictures, and the landowners concerned realized that it was not only highly attractive (in a pseudo-Poussinesque way) but more economical to make a miniature of this world within their grounds, with mown lawns in place of fields.

In the pictures of Balthasar Nebot, such as *The Gardens at Hartwell House, Buckinghamshire, with two Bastions and Men Scything* (1738), one can clearly see the transition from formal to landscape garden. As the landscape garden fashion gathered momentum, the landscape painting flowered in unison, for the designs for landscape gardens came from the pictures of Claude and Poussin, and these parkscapes led to a taste for portraits of the informal, agricultural land.

Ironically, this landscaping also provoked the first literary backlash. The poet Oliver Goldsmith, himself a subscriber to Virgil's georgic ideal, was outraged when the 1st Earl of Harcourt commissioned Lancelot Brown to design a landscaped vista for his new residence, and Brown had a village demolished in the process. Goldsmith waxed lyrical (and rhetorical) about the 'dispossessed swains' and Harcourt's greed – 'trade's unfeeling train'. This georgic sentiment was to reverberate, often with far greater substance, at intervals throughout the nineteenth and twentieth centuries against the 'ravages' of urban rather than rural industry, but the irony was that Goldsmith's complaint was more aesthetic than social. The ideal village Goldsmith mourned was largely a product of poetic fancy and, high-handed as he was, Harcourt had kept the community intact and given them better housing just two miles away. His rebuilt, nuclear village with its central green was, in fact, a model of georgic patricianism – and good management.

The village as a place of wholesome harmony was an image which Hogarth and his contemporaries portrayed with panache. They had used Dutch village scenes as models as an alternative to Claudian conventions when they had begun painting

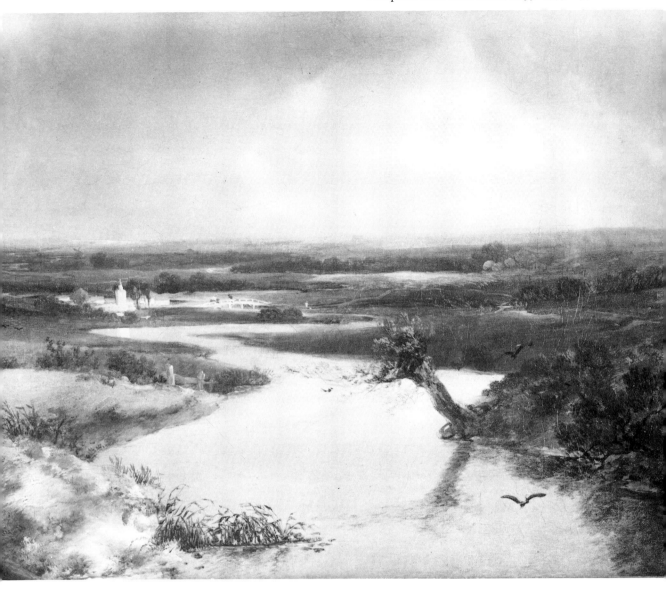

Thomas Gainsborough (1727–88) *Landscape with a View of Cornard Village* (detail) Oil 30in × 59½in (National Galleries of Scotland)

landscape pictures with the intention of selling them to the Vauxhall set, and their *nouveau riche* audience, with its taste for the new picaresque novels, enjoyed the semi-comic, mildly erotic narrative scenes in their pictures. Rural scenes were beginning to appeal to them because many more of them were now divorced from their origins and living in towns like London, Bristol, and fashionable centres like Bath. They also enjoyed the feeling of a connoisseur's superiority over the 'rustics' whose antics amused them; ones roots were amusing from a safe distance.

The pictures of this first great heyday of agricultural landscape, lasting roughly from 1730 to 1760, were not always very subtle either in composition or colouring,

but full of vigorous energy. While polite opera chose to depict a countryside people with love-sick swains in antique, semi-divine entanglements with shepherdesses, Hogarth's, Lambert's and Gainsborough's paintings of the rural population have more in common with the underside of city life in Gay's *Beggar's Opera*.

Yet frequently these pictures have a seductive grace. Their format was either a country lane – deeply rutted – with a courting couple by the roadside, a farm cart wending its way beyond them, the edge of a village tucked behind trees that might be Claudian but were more often the denser solidly painted oaks of the Dutch manner, and sloping fields pricked by a church spire fading away to the blue haze of a river valley. Above, billowing, high-lit clouds of late afternoon – often the summer-shower clouds with plume-like crests – reflected the shape of the trees. Either this, or harvest and haymaking scenes in which the field took the place of the road and among the reapers, couples tumbled energetically and lustfully amidst the stooks, or were rousted out of their horse-play with a pitchfork.

The people in these pictures really seem to belong to their surroundings. They *look* content in them and the viewer is supposed to feel contentment in that knowledge. All is right with the world. This is the great divide which separates harvest scenes and agricultural landscape pictures of that time from those of Regency and Victorian England or the twentieth century. They were never to be so light-hearted again.

Thomas Gainsborough (1727–88) excelled at these images. He knew the Suffolk countryside intimately, from the regional peculiarities of the farm implements and people's clothing to the colour and texture of the sandy soil. He was a far more sensitive colourist and a subtler observer than Hogarth, and his landscapes have a cool muted lightness and sense of airy space which typified many pictures made later by artists of the 'Norwich School'. He varied the density of his forms – like the weight and darkness of a tree's foliage – depending upon the atmosphere which he wanted to convey, rather than producing the image to a convention. In *Cornard Wood* (1748) the thick, solid trees and rutted road have all the solidity – and environmental cohesion – of nature, and the people moving through the painting resemble the trees – home-grown, weathered – and are all going about their purpose. The windy English sky is generally believable, and powerful enough to ensure that the weight of the woodland foliage does not drag the eye down to the roots at the base of the picture. Yet in a harvest scene on a hot summer day foliage may be Claudian and feathery and figures seem to be coloured ghosts on the surface of an amber haze. In all these pictures made in Suffolk between 1748 and 1759 there is an element of industry, plenty, and harmony, an existence which appears to have a purpose and a centre.

Then when Gainsborough went to Bath in 1759, these elements fell away to be replaced by a sense of mounting, fanciful unreality. The fantasy element was not necessarily a pleasant one either, not one of idyllic Arcadia-mongering. Gradually a mixture of graceful idealism in the physical landscape began to mingle with an uncomfortable social mixture of the people passing through it. They have an ostensible purpose such as going to market or home from harvest in a wagon, but they are no longer in harmony with the landscape.

On one count, it would be hard for them to belong in it. The physical land which Gainsborough painted in the 1760s was no longer a recognizable region: it was an homogenate, a 'general tranquil landscape', a well-fitted collage of pleasing parts. But across it finely dressed women, unusually handsome, often ride or consort

casually with shabby male yokels, sometimes sharing farm carts with them, as though the farm girls of previous pictures have been replaced by fashionable city women or up-market whores.

This discomforting juxtaposition is not merely an observation of the admixture of people on the roads near Bath during the second half of the century. It is almost as though the artist, well aware of the shifting structure of the society he lived in, presented the buyers of these pictures with images they could identify with, objects which they desired – fine clothes – and places they liked to believe in, and so created an image as unreal but saleable as a magazine story or a still frame from a fanciful television costume drama.

On a less cynical, more respectably scholarly level, it might be argued that Gainsborough was commenting upon the contradictions in origin and lifestyle caused by social mobility, and the general and steady distancing of increasing numbers of people from their country background in the early years of the first industrial revolution, the 1770s. By the last decade of his life Romanticism as an art movement was little more than a decade away, and his later paintings owe more to fantasy and theatre than the real world. But in that Gainsborough was a living thermometer of the artistic and cultural temperature.

Mid-century had seen the acceleration of great change in English life and most of Britain generally. Until the 1740s the gentry had lived isolated lives on their estates, towns were small, very dirty, public executions were frequent and the most popular public entertainment, and mobs were numerous and dangerous. The roads were nonetheless busy, with a constant stream of often desperately poor people seeking work. The stage coach, appearing around 1700, was one of the few horse-drawn vehicles. The poor generally walked, usually carrying their shoes and most carts were ox-drawn. Painters always had a tendency to grant a slight polish where there was none, and horses are more frequent in paintings than they were in reality. When ordinary people rode they did so on small ponies, and men and women both rode astride; only the female aristocracy rode side-saddle. Authority came usually from leadership by example, for most people did not possess the education to think otherwise. The easy-going atmosphere of the georgic landscape before 1760 came from this and the large rural population: people were numerous in the country as most people lived there, and life moved slowly.

But from mid-century England acquired rapidly increasing mercantile wealth centred in towns and ports. Abroad, between 1704 and 1776, she suffered no major military defeat of lasting significance, picking up colonies in treaty spin-offs by joining in European wars which did her no domestic damage. This global tide of success was followed assiduously in the broadsheets of the coffee houses, and the taste for exotica and foreign travel that they stimulated among the educated British, reared on Ovid and Virgil, left the not unreasonable conviction that the British were the successors to the Romans. In many circumstances they were, once they adopted the role-model. The middle classes also received a salutary broadside from Wesleyan evangelism, underpinned by much constructive philanthropy, that hard work and sobriety hurt only the idle and sottish. Hogarth echoed the sentiment in his series of paintings *The Rake's Progress*.

All this had a crucial and profound effect on landscape painting.

The Sublime and Beautiful

As the 'New Romans' the British began to see their own landscape rather

differently. Ruins were an image of Rome. They conjured up memories of power and they implied a pedigree to those who ruled. Roman ruins were known and admired in plenty, and medieval ruins were abundant and among the most dominating landmarks in Britain. The British sought out their ruins and celebrated them.

It would be a gross over-simplification to claim there was anything wholly new in the activity itself. Numerous aristocrats and gentry (such as Place) had long delighted in them, and ruins were artistically respectable. Claude and Poussin had guaranteed that, and the classical ruin and later the 'folly' was an intrinsic part of the landscape park. But this sense of time, power and spectacle which was inseparable from ruins permeated the places where they were found, and the taste for new sights and sensations agreeably discovered them from the highlands of Scotland to the inaccessible crags of north Wales. Edmund Burke's *Sublime and Beautiful* carefully examined the aesthetic criteria arising from the emotional reaction to these phenomena, for those who might be interested, but for the rest, the results of adventure by some were soon a fashion to be followed by others.

In paint, the adventure had begun from necessity. In 1746 the Duke of Cumberland routed Charles Edward Stuart's tribal Jacobite army at Culloden in the Scottish Highlands: although it was barely 20 years before the declaration of the Rights of Man and only 62 before the birth of Karl Marx, that part of northern Britain just 600 miles from London and scarcely 100 from Edinburgh, still lingered in a pre-medieval tribal clan twilight, and much of it was still unmapped. As a result of the Jacobite rising the English and lowland Scots re-garrisoned the Highlands, and in 1747 they began a detailed survey of the whole region. The young Paul Sandby (1725–1809) who had joined the Board of Ordnance Drawing Room at the Tower of London at the age of eleven, was sent north to prepare the first draft of a large map of northern Scotland.

On times Sandby accompanied the survey parties in the field, and drew the often spectacular landscape. He visited Scotland more than any other Scottish or English artist had before him, and the results delighted not only his friends, but patrons who commissioned work through them. Much of the colouring Sandby used was standard to the ordnance maps, particularly the blue-green and ochre of the sea and land, and according to Sandby's son, there were 'for many years after Mr Sandby commenced landscape drawing no (water) colours in general use except such as were peculiarly adapted for the staining of maps and plans'. Indeed, he claimed it was his father who first set John Middleton 'the colour maker' to make watercolours in small hard cakes similar to those later perfected by William Reeves. In these, the pigment no longer had to be ground by the artist but was already powdered, and then mixed with gum arabic and honey, or glycerine; they were light, fairly inexpensive and easily stored, all of which increased their popularity. They remained very variable in quality until the early 1780s, as the collector and amateur Rev. William Gilpin testified: 'They never mixed harmoniously. Some were glazed: others sank into the paper. There was no uniformity among them.' But they could easily be carried into the highlands, and other 'wild and desert lands'.

But Sandby certainly had to prepare his own colours in Scotland other than the ordnance pigments, and probably on his subsequent expeditions to north Wales during the 1770s. As these tours, often made in the company of patrons, increased, the medieval ruins of Wales and Scotland featured as frequently as the wild

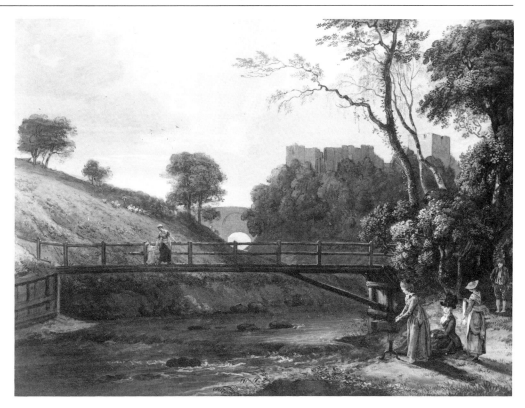

Paul Sandby (1725–1809) *Roslin Castle, Midlothian*
Watercolour and body colour on paper laid on board
18in × 24¾in (Yale Center for British Art, Paul Mellon
Collection)

landscape. Sandby often included members of these touring parties in his sketches, exploring or admiring the scenery or with one member holding a large sun umbrella over the artist or his patron to block the sun's glare from the drawing paper.

In these informal pictures Sandby managed to portray the mountain regions as both dramatic and awesome, yet approachable and worthy of the attentions of the cultivated man – or woman. His watercolour of *Roslin Castle, Midlothian* (1770), with Lady Frances Scott drawing from a *camera obscura* with Lady Elliot, also records the drawing aids employed in landscape work by amateurs and professionals alike. Sandby certainly used such instruments as a surveyor, and so did Gainsborough, Canaletto, and many others. The *camera obscura*, the earliest available of these tools, dates from the early sixteenth century, its name being the Latin for 'dark room'. The portable eighteenth-century version projected an image via the front lens on to a glass back-screen over which a thin piece of drawing paper was placed, and the image duly traced. By 1807 Dr Hyde Wollaston was to patent the *camera lucida*, which was smaller with a wider field of vision. The image was transferred in that via a prism on to the drawing surface; an eye-hole over the prism allowed the artist to see his or her hand as well as the object during drawing, and in 1811 the artist Cornelius Varley (1781–1873) patented his 'Graphic Telescope', which could magnify the image up to ×19.

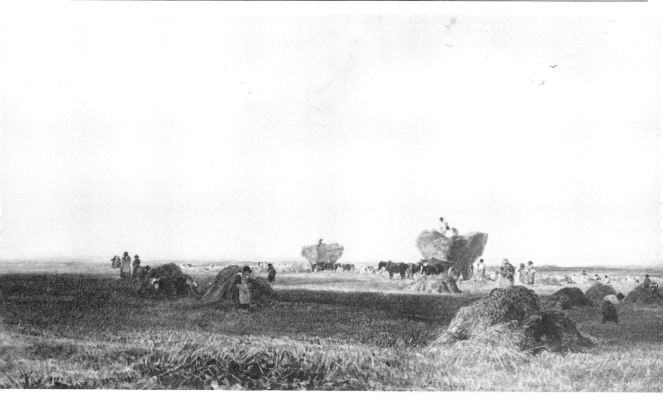

Peter de Wint (1784–1849) *Gathering the Corn*
Watercolour and surface scratching 11½in × 25¾in
(Whitworth Art Gallery, University of Manchester)

Women, like Lady Frances Scott, were to make up possibly half or more of the (largely forgotten) amateur artists in the country during the late eighteenth and nineteenth century; officers' wives often appear in Sandby's survey party sketches of the 1740s, and their letters reveal an interest in their surroundings beyond survey flags and bleak amusement at the eccentric indecency of highland clothing. This later amateurism grew out of the uncertain status of watercolour as an art form: as a medium for recreation, it was not considered a fine art by many. By the mid-nineteenth century Sandby was to be regarded as the founder of British watercolour painting, as Hollar was long forgotten and Francis Place still little known but among the founder members of the Royal Academy in 1768 he was the sole watercolourist. He was well ahead of his time, for he forthrightly referred to his work as 'Landskips: in watercolours', but many artists were still calling the medium 'tinted drawing' in 1790. It had not been helped by problems with the painting surface. It was not until 1780 that James Whatman devised a paper with a much smoother surface, and largely eradicated a 'chain-line' pattern showing through. The new surface gave artists the scope to use translucent washes of watercolour with far greater freedom.

Once the appetite was whetted, the taste for the highlands, and the nearer Lake District and north Wales was reflected in the watercolour pictures made and collected by amateurs like the Rev. William Gilpin, who enthusiastically acquired Sandby's pictures. Gilpin produced books on drawing method himself, although

he freely confessed that 'how to make reds, & greens, & greys dance into that harmony myself, I am utterly ignorant'. But his own watercolour drawings concentrated on taking the 'essence' of a landscape, that was to say the typical configurations of mountain or lakeland regions, and subtly exaggerating them into provocative variations. This was one of the foundations of later Romanticism, which held that inspired imagination could lead to higher truths beyond the deductions of reason.

Sandby's successors mingled British and continental travel and, as the vogue of the Grand Tour had become well established for a young gentleman, so it became for the artists who supplied his pictures. There was never a specific 'British school' in Rome, as has been suggested, but a constant flow of British artists who lived there for two or three years when possible, acquiring a visual vocabulary which fitted them to extract what they guessed would seduce their public most readily. Francis Towne (1739/40–1816) was able to deal seductively in watercolour with the great waterfalls of Tivoli and with the high Cumberland hills, and brought the same dramatic grace to both. So could John 'Warwick' Smith (1749–1831), John Robert Cozens (1757–97) and William Alexander (1767–1816). These painters benefited from the vast improvement in their equipment, and the appetite for antique grandeur – ruins or natural landmarks – set either in grand or gently pastoral surroundings. An artist like George Barrett the Younger (1767?–1842) could make a Claudian composition with reflecting still water, ethereal cloudy trees and a slumbering ruin from an English place, with the same visual armoury that Francis Nicholson (1753–1844) or Alexander Nasmyth (1758–1840) used to picture English hills or – in Nasmyth's case – Scottish lochs.

The method which these men used varied relatively little between them, and, as they gradually earned as much from teaching watercolour method as from selling work, their success often depended as much upon their social personality as talent. Paul Sandby Munn was described as 'rough peculiar mannered' by an upper-class pupil, while another artist, employed on the same terms to teach watercolour, was affectionately known as 'Cotty' by the whole family. Travel remained an expensive occupation for them, and they were careful to produce images which would sell as a result of this outlay. As ruins commanded a decent return they exaggerated their grandeur (or created it) by sly bends of perspective, making foreground human figures relatively large, and then deliberately shrinking figures further away so that the aisles of a ruined abbey appeared to expand hugely. These buildings were made to appear as though they had grown or sprung out of the ancient virgin rock, almost part of the historical inevitability latent in the landscape of a great nation, by blending their masonry into the cliffs on which it stood, and giving it the same overall tone and texture as the natural rock.

While Sandby had been surveying the highlands, the Italian Antonio Canaletto had been making a productive tour of Britain. Canaletto normally concentrated on the wide souvenir vista, particularly of the cities of the European Grand Tour, for which he used the *camera obscura* as a drawing aid, and which were bought as souvenirs by wealthy tourists. He was well ahead of his time in painting medieval ruins in England in the 1750s and his glossy, sharply focused oils, with their clear, somewhat Mediterranean skies of cerulean and scattered silver-white flecks of cloud, lack any real sensation of the British landscape, but the figures of strolling tourists which he dispersed around the 'noble piles' implied that these were sites worth visiting. But it was Richard Wilson who brought together for the first time

in oil the Claudian grace which so many artists imitated and patrons desired, with an observation of the real British landscape, and the grandeur of the regions which Sandby had modestly portrayed in watercolour.

Richard Wilson (1713/14–82) was a great painter: he was innovative and far-sighted, and what he did was appreciated by the artists who lived after him more than by his contemporaries and the unadventurous buyers of his own time. Turner's earliest landscapes were inspired by Wilson, and Constable confessed admiration for him all his life. He achieved neither the material nor establishment success of either of them in his lifetime, ending his career as the alcoholic librarian of the Royal Academy, a semi-charitable post given to a decrepit artist.

Wilson had studied in Italy, and by blending the British landscape with the compositional grace of Claude and Poussin he was able to reveal the splendid nature of the real places which he portrayed, leading them to be seen in a new light. In effect, he demonstrated in England that landscape did not have to be 'Italian' to be a fit subject for fine art, and that the natural landscape of England and Wales was as picturesque as anything Poussin might contrive or Claude effect. He also began to use the landscape to evoke an emotion which the artist felt: that was an underlying current of the Romantic movement, but Wilson never embraced that pattern. There always remains a coolness and classical grace in his pictures however dramatic the landscape might be. It was this and the portrayal of local people in such a style that confused his contemporaries. Unsure how to react to his pictures, they chose the safe option of ignoring them. Two of Wilson's finest pictures, *Snowdon from Llyn Nantlle* (c.1762) and *View of Wynnstay, Llangollen* (1770–1) reveal this breadth of vision. *Snowdon* shows the bleak, muted landscape of the north Welsh highlands but with a classical tranquillity and lightness of touch glimpsed in fresco, while *Wynnstay* implies an idyll suitable for an Arcadian legend. In watercolour this might have appeared less outrageous; in oil it nonplussed his viewers.

Wilson also introduced the practice of sketching outside in oil, an activity learned from the French landscapists in Rome, and a habit which seems belied in the benign grace of his finished pictures, until the speed and lightness of brushstroke reveal the fluency of the execution. This was Wilson's most immediate influence on his contemporaries, especially upon pupils like Thomas Jones, and William Hodges who sailed with Cook's expedition ships.

The apparently effortless grace of Wilson's mountain landscapes jars hard against the obvious problems other artists had with the subject in any medium. Deprived of the guiding devices of hedgerows and fields until the 1770s, many of them had to struggle against the 'formlessness' of the tumbled hill or forest. They came to terms with the problem less by looking at what they saw than by inventing formulae for evoking its 'spirit' or 'atmosphere'. The solution was given respectability in Academy circles by employing the 'wild landscapes' method of Poussin with its foliated crags, and the 'savage' Salvator Rosa mannerism, which had been celebrated in written poetry. This poetic rather than analytic solution came fruitfully to Alexander Cozens (c.1710–86).

While Canaletto was touring Britain Cozens was having to teach delineation of headlands, coasts and shipping at Christ's Hospital to boys destined for the sea. Their standards fell as Cozens became more and more frustrated and bored, and in 1756, the year after he resigned the post, he produced the *High Tor, Matlock*, an oil of 'mountain' landscape of so polished and poetic an image that it appears to be almost two decades ahead of its time. What Cozens had done was to follow the

sweeping horizon line of the high tor, make the face of the rock and the water below it the 'subject' or centre of the picture, and arrange the surrounding forms – the dark trees to the right – as a frame to form an aperture. The tor became a castle, a structure, a thing of force like an abbey or a temple. All that divided Cozens's picture from the Romantic landscapes of the next generation of painters were a rush and flow of the elements – of cloud and water. In Cozens's picture they are passive components in the manner of classical landscape, the realm where balance and proportion dominate all.

Rebellion, Romance and Realism, 1775–1830

Balance and proportion were the elements most missing from the industrial landscapes which began to expand in the North and Midlands from 1780 to 1800. They had elements of Hades and the theatre about them: in the profound silence of the eighteenth-century countryside, the 'rumour of engines labouring within the hollows of the hills' recalled the thunder machines of the opera houses to the educated and the unearthly to those who were not and who saw the flickering industrial lights in the moonglow. The traffic from theatre design into landscape art went hand in glove with the rise of industry, as the creators of new wealth, as distinct from the older gentry, travelled and acquired a taste for visual drama. To them the north and west hill country of Wales, England and Scotland became more and more easily accessible. The rise of Romantic mountain fashion was typified by an artist Cozens had anticipated: Philippe Jacques de Loutherbourg, whose experience fitted him well to the period.

De Loutherbourg (1740–1812), a Frenchman born in Strasbourg, was a member of the French Académie and a highly versatile landscape, seascape, narrative painter and theatre designer. He arrived in London in 1771 where he carried out theatre designs for Garrick and showed pictures at the Royal Academy. He delighted Gainsborough and Sir Joshua Reynolds with his *Eidophusikon*, or light box, a miniature theatre in which landscape (or seascape or battle scene) could be constructed and then illuminated to the artist's satisfaction, and a painting executed from that. Gainsborough took greatly to this, with mixed results. Indeed, as many critics have pointed out, it is difficult in Gainsborough's case not to observe coals and stones for mountains, cauliflowers for trees, mirrors for lakes and candles and gauze for sun and clouds. These were certainly the components for many of Gainsborough's mountain landscapes, and the means of their gauze-like light.

But de Loutherbourg was a man of powerful imagination – and effective lighting. A fine draughtsman and colourist of verve, he excelled in the dramatic chiaroscuro of storm light and the luminous glow of the low sun, the rugged texture of weathered surfaces, and the glitter or gleam of deep water. He was capable of telling – or implying – a story, giving his dramatic pictures a narrative content when tranquillity was in danger of making them appear too static, and could stress the depth of a chasm by clouding its heights or depths and inferring human smallness by inserting figures as shadows in the folds of rock or cloud shades. His versatility led him to tackle industrial landscape when few of his peers would do so, although he did not attempt to convey its often moonscape squalor,

Alexander Cozens (c.1717–86) from *New Method of assisting the Invention in Drawing Original Compositions of Landscape* Ink blot drawing (detail) 8⅞in × 11¾in (British Museum)

and concentrated on its spectacle: *Coalbrookdale by Night* (1801) is pure theatre, the lighting evoking a volcano or flames fit for the sack of Rome. Indeed, the picture resembles war more than industry, as this was the technical armoury with which the artist's training had equipped him.

His contemporary, Joseph Wright of Derby (1734–97) had little in common with de Loutherbourg except for his technical ingenuity and delight in – or almost pathological obsession with – light. Wright has acquired a reputation as a painter of scientific experiments and personalities of the earlier Industrial Revolution; the image of the enquiring man of science suffocating his daughter's pet cockatoo in a bell-jar to demonstrate a vacuum. But in the 1780s he made pictures of wild landscape as careful and enquiring as his scientific portraits. Compared with de Loutherbourg's, Wright's pictures are cool, and his oil of *Matlock Tor*, a study in daylight, has the clear, enquiring vision with an evenly detailed texture that one sees 60 years later in American landscape painters such as Thomas Kenset, who used photography as source material and enlarged areas for scrutiny.

Nonetheless, Wright shared a romantic method of fantasy with Alexander Cozens whose influence appears in his 'ink-blot' landscapes. In his *A New Method for Assisting the Invention of Drawing Original Compositions of Landscape* (1785) Cozens described the creation of imaginative landscapes based on accidental and deliberate ink blots on paper, which the artist could then elaborate upon. Wright employed the method with a lot of success during the late 1780s, making pictures which bore no relation to reality and were pure romantic fancy.

But basically, Wright's restraint stood out amid the exotic rhetoric of the rising Romantic movement exemplified by de Loutherbourg, who was typical of a flow

of 'cultural refugees' coming into Britain as the American War of Independence fuelled the French Revolution. The two revolutions had almost nothing in common beneath their bombast about an abstracted concept of 'freedom', but the Romantic picture was full of storm and flux, and it was basically a visual metaphor for a Europe full of revolutionary Romantics who had not yet suffered the disillusioning experience of being 'liberated' by a French army. In Britain, however, romance was tempered by unease as the century turned.

While the Duke of York's 10,000 men were wandering around the Low Countries hoping to suppress the French, 'accomplishing nothing or worse than nothing', and the young Romantic poet William Wordsworth was meditating on 10,000 daffodils, the bleak fear of French *liberty, equality and fraternity* spreading to the rural poor

Joseph Wright (1734–97) *Matlock Tor* Oil on canvas 28⅜in × 39in (Fitzwilliam Museum, University of Cambridge)

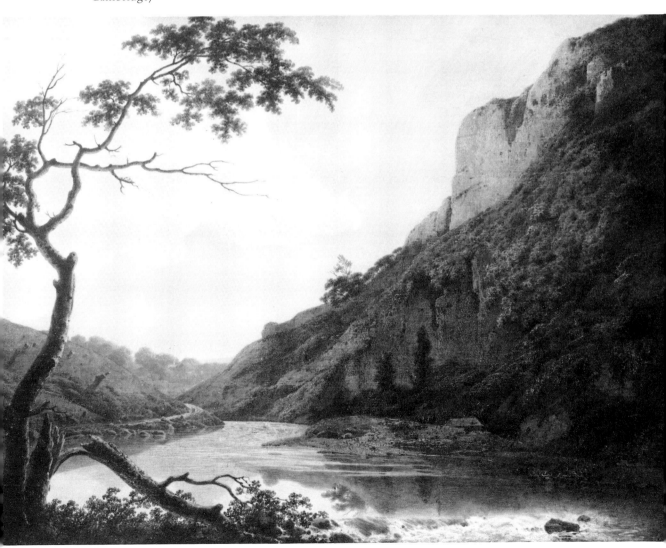

of Britain from across the Straits of Dover was descending among the wealthier members of British society. It concerned both the old patrician landowners and, to a slightly lesser degree, the growing bourgeoisie. Artists generally identified their own interests with these two groups – it was they, after all, who commissioned and bought their work – and their polite young daughters who paid their guineas per hour for tuition in the growing fashion for watercolours. Popular revolution and a 'reign of terror' in Britain was not at all unthinkable; it was much brooded upon. The smartly dressed regiments of yeoman militia who starved the regular army of recruits were more a bulwark against popular uprising than a deterrent against French invasion, and at the turn of the century artists who supplied stirring images of the highlands also began supplying again increasing numbers of consoling agrarian pictures of the old georgic *status quo*. Europe meanwhile sank into a grim perpetual motion of wars lasting for a full quarter of a century.

This second georgic cycle existed as a counterpoise to Romanticism, and lasted from approximately 1792 until 1816, almost the exact dates of the French Revolutionary and Napoleonic Wars. It petered out around 1820 with the East Anglian corn riots, although since then it has returned at least twice more.

Of course, this way of seeing the countryside had never wholly ceased. Throughout most of his career Thomas Hearne (1744–1817) was producing seductive watercolour images of leisurely haymakers: broad-limbed men in broad hats clothed with a casual smartness and shapely young women with clear complexions, not browned or reddened by the sun, in clean unfaded linen, all raking hay or dusty corn as though the hot, sweaty task was a slow dance at a midsummer fair. He had shared this pleasant fable-mongering with Joshua Cristall, Francis Nicholson, John 'Warwick' Smith, Joseph Farington, Michael Angelo Rooker, Richard Westall, Thomas Rowlandson, George Stubbs and many more.

Rowlandson did not actually idealize country life. Although his drawing was never realist in the sense that Stubbs's is minute and anatomically factual, Rowlandson's was nonetheless without a sense of morality. It was straight illustration, banal in the sense that a cup and saucer are banal, but amoral too in that the cup simply belongs with the saucer. The figures in his non-satirical rural pictures are not in any sense glamorized, as they are in Hearne's, but they do look content, like cups in saucers, as though they could not be imagined anywhere else. The harmonious view of the landscape was lastingly underpinned by Thomas Bewick.

Although not a painter Bewick was a superb illustrator, whose skill at wood engraving enabled him to produce finely detailed images. Born in 1758, one of eight children of a prosperous farmer and small mine owner, he went briefly to London which he found dirty, unfriendly and expensive, and returned to his home in Northumberland, where he lived and worked for the rest of his life. He had begun by drawing animals, birds and battles on book margins and the stones of the church porch, and his illustrator's skill recorded every aspect of rural life, from incidents like a kite caught in a man's hat to the archetypal rural images such as livestock sheltering from cold. He excelled at picturing living creatures, especially birds and cattle and his placing of them in their surroundings with understanding as well as satisfying the aesthetic demands of design made his works models of reference and harmony. Audubon, remembered primarily for his engravings of the birds of North America, described him as 'a perfect old Englishman' working in a soiled nightcap and sleeping in a blanket on the studio floor of his print shop. After his death in 1828 his legacy extended the length of the century and can still be found

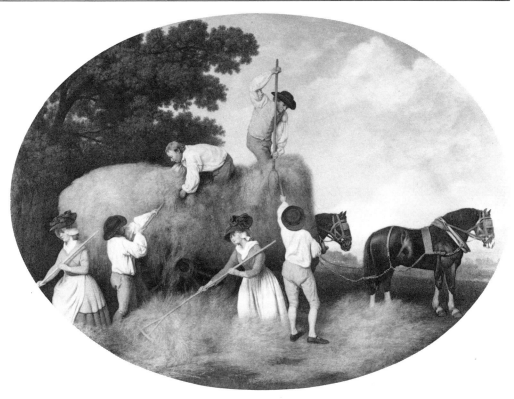

George Stubbs (1724–1806) *Haycarting* Porcelain plaque
glazed 28½in × 39½in (Walker Art Gallery, Liverpool)

in the work of another countryman, the painter and etcher of birds and landscape, Charles Tunnicliffe.

George Stubbs (1724–1806) was a brilliantly sophisticated draughtsman and observer of anatomy, who could produce an image of profound *unreality*. As Rosenthal has pointed out, Stubbs's images of haymakers, stable lads and farm workers of all kinds, pictured at work in landscape, have three things in common: while many are undoubtedly portraits of real people, they are all universally well-fed, well-clothed, and well-behaved.

Stubbs's workers are advertisements for good British management. In that there is often a military air about their work discipline, that is not unconvincing: corn harvesting was a disciplined operation, performed in lines, and the gentleman-farmer overseeing the work resembled a mounted infantry officer – he came from the same social caste. But that this is the image which Stubbs *always* produced reflects that both Stubbs and his patrons – and indeed the middle-classes who bought his smaller pictures – believed that this was how the labourers on whom they ultimately depended should behave and should look. Whether they did look like this was another matter (and not to be painted). Stubbs did have a degree of choice open to him in this. He knew perfectly well what the reality of rural life could be like. Punishments for theft, such as poaching, were more severe than those in the army: a magistrate could send a farmhand to the gallows for stealing a sheep, while a soldier who tried to pawn his officer's horse was able to get away with a severe flogging.

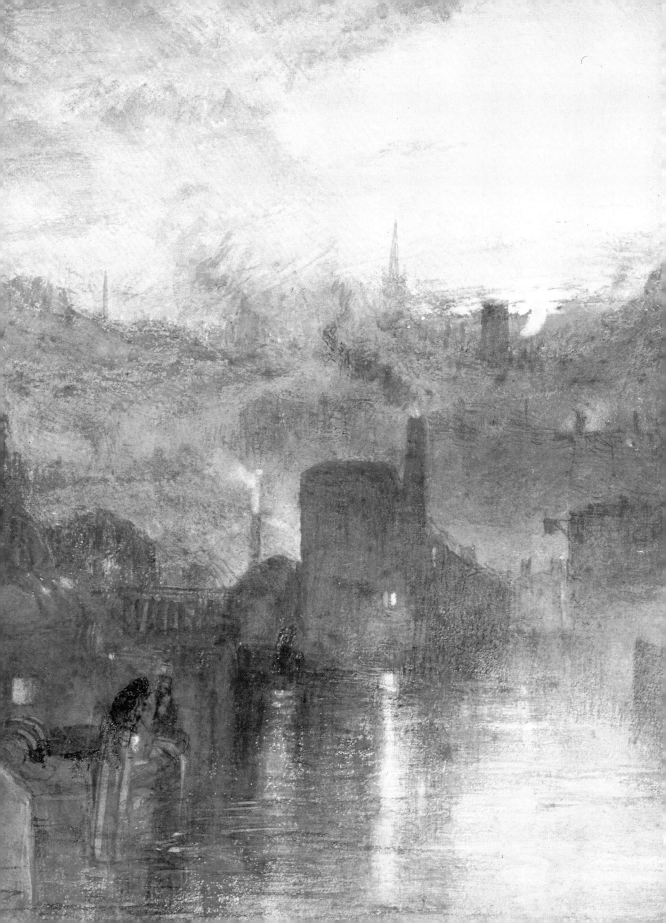

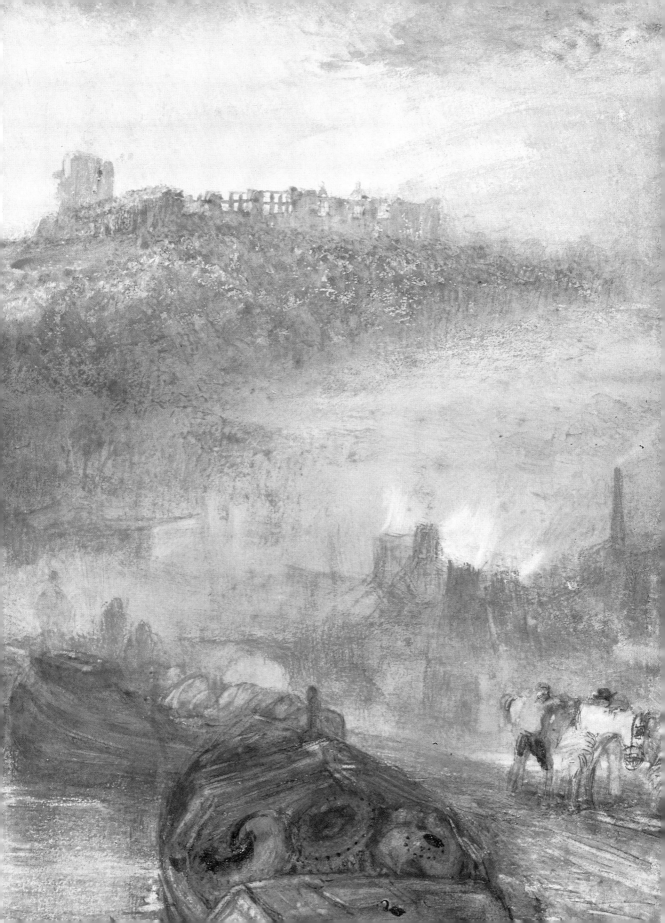

Stubbs's contemporary, the scandal-prone George Morland (1763–1804) did make pictures of this reality, and they were frequently highly embarrassing to polite members of the public. Had Morland lived 150 years later, he would probably have had a flirtation with the communist party, become one of the Paris avant-garde, and died of heroin addiction after an affair with a jazz singer. As it was he led a picaresque life, spent more on gin than on paint, and when vice got the better of his health died aged 41. But as an artist Morland had great stature. His paintings of poachers going about their furtive business, superb paintings of mellow colouring and fluid graceful brushwork when hangovers did not cause him to skimp detail with blurred scrubbing strokes, have the immediacy and disturbing, knowing intimacy of a conspirator. His images of a family facing eviction, or

ON PREVIOUS PAGE Joseph Mallord William Turner
(1775–1851) *Dudley, Worcestershire* Watercolour
11in × 16½in (Lady Lever Art Gallery)

George Morland (1762/3–1804) *Bargaining for Sheep* Oil
on canvas 55in × 78in (Leicester City Art Gallery)

farmers bargaining over sheep – sheep whose condition is less than perfect – are a harsh but finely presented packaging of the real.

By then, the 'picturesque', or 'that which was fit to be included in a picture', was also a concept sophisticated enough to become an embarrassing aesthetic. It meant that a painting could be judged on its merits for including finely observed, finely painted things which had precedent in pictures. Morland's paintings had all these qualities: hunters, livestock, trees, buildings, skies, crops, and all well-observed. But they came in a configuration which was subtly disturbing: the hunters were poachers not the gentry; the businessmen were less than honest; landowners callous and unfeeling as landlords; the poor not very clean with nothing much to be thrifty with. Hogarth had of course said as much (usually about the towns) 50 years earlier, but the political situation had been totally different when he had said it. The 'picturesque', which was not limited as a concept to wild hills and waterfalls, now enabled Morland to flout the image of the countryside which the affluent English man or woman wished to believe in. Such people were right when they held that their Regency England was not a dictatorship, that it was a democracy, that it practised no conscription (introduced to Europe by Napoleon) and that it had even abolished slavery in countries that it did not rule. But it employed the press gang to fill its ships and regiments, its democracy only represented the interests of a minute percentage of the population, millions of its town and rural people lived lives as harsh and regulated as any black American slave, and its naval ships freed slaves at sea while their own press-ganged sailors spent years in conditions worse than those on any plantation. Morland's pictures made no effort at all to conceal this, and the 'picturesque' enabled him to get away with it.

The divergence of pictorial rules which allowed Morland this latitude accelerated rapidly with the close of the eighteenth century. Reason, which had been the aspiration of gentleman-scholars like Francis Place, sick of the religious extremism and its component irrationality of the earlier seventeenth century, had been the regulator of proportion in art, and, theoretically, society. It implied that it was possible for the educated man to obtain full understanding of the world around him, by the force of his intellect and collation of information leading to knowledge. The gradual disintegration of this idea, already evident in Burke's ideas about what was 'sublime or awesome' was accompanied by a fervent belief in intuition; feeling emotion and allowing it a loose rein. This attitude often replaced analysis by contemplation, and in the pictures of first rank painters like Thomas Girtin (1775–1802), John Sell Cotman and J. M. W. Turner this concept allowed the artist to strip a subject like a building of its conventional associations and use it as an evocative object, a block of brooding or shimmering colour or just an accent in a picture, like a comma in a sentence.

For these artists an edifice like an abbey no longer necessarily had either a religious or medieval association when it occurred in a picture. It was an area of the paint or canvas which could imply threat or (through soft colour) tranquillity, decay or the long passage of time. It was a metaphor for many things other than either faith or prestige. By the time of his premature death the brilliant Thomas Girtin could use a landscape to imply an emotion through the use of watercolour paint, concentrating exclusively on the paint's translucence, delicacy and subtlety. The landscape was a mood image revealed *through* the colour. As an idea about painting that was the other side of a canyon from the pictures of Wenceslaus Hollar and Francis Place.

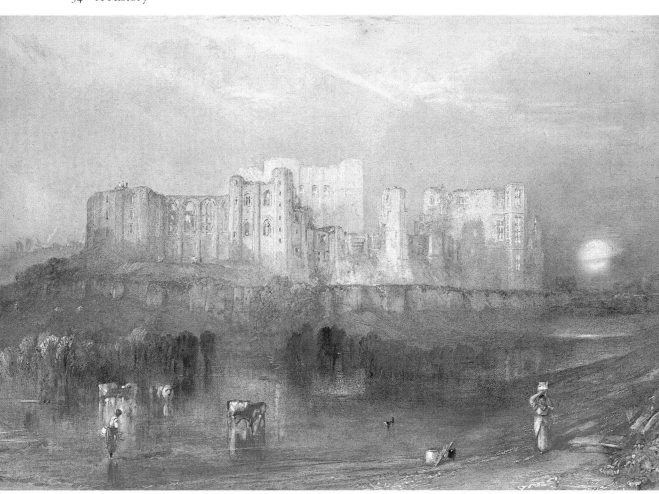

Joseph Mallord William Turner (1775–1851) *View of Kenilworth Castle*, c.1830 Watercolour and gouache on wove paper 11½in × 17⅞in (Fine Arts Museum of San Francisco, Achenbach Foundation for Graphic Arts)

Cotman and Constable built even further beyond that divide, while J. M. W. Turner was able to do that and include all that social observation which Morland, Hogarth and Gainsborough had pursued.

Turner, Constable and Bonington

Surpassing all other British painters of his own and succeeding generations, Joseph Mallord William Turner (1775–1851), son of a London barber, and sacked from an architect's office for failing to grasp the laws of perspective, possessed a technical skill so wide and subtle that its range led him into realms which other painters would not explore until half a century after his death; but unlike so many of his successors, he possessed both the intellect and humanity to make these realms accessible to laypeople in a way which eluded these later generations of artists.

Turner's working life bridged the eighteenth and nineteenth centuries. It began barely a decade after Benjamin West had scandalized the art establishment by portraying a British general of the Age of Reason dying on a battlefield in contemporary clothing, and it ended with his painting on the verge of abstraction, just as the Pre-Raphaelites were making their first pictures of minute poetic realism which would seduce the Victorian industrialists.

This range was so vast that it is easy to forget that his work contained throughout symbolism and allegory and subjects founded firmly in the eighteenth century. His work encloses the period when landscape painting rose to concern the leading painters of the age, and for some became their prime concern. It describes the era when the georgic image of England could still make some credible pretence to reality, and then, as any resemblance irrevocably faded, the georgic image became the romantic celebration by painters of the landscape itself.

A townsman whose earliest work often evoked Hogarth, Turner was a Romantic with a broad sense of humour which softened the edge of his pessimism. Although he lived through a period of social and technological revolution, he revealed little or none of the hostility to technical innovation displayed by his greatest champion and apologist, the critic John Ruskin. His was an equanimity born of a belief that, while all material things constantly changed, the basis and meaning of life did not, so that the concept of 'progress' was an illusion. As a result, he felt no threat from the changes around him, while his understanding, sympathy and amusement at the behaviour of his fellow beings gave his pictures a breadth and humanity where people of less perception, but more conviction, would have dealt in slogans.

Although Turner drew rapidly and with fluent accuracy when sketching landscape, he rarely placed human figures in these outline drawings, and his sketched studies of human appearance were executed quite separately. Yet people or the creations of people were absolutely central to Turner's landscapes in his wide series of pictures of Britain (and elsewhere). He integrated them into the structure of the finished picture to give it meaning and wider purpose. Ruskin wrote: 'He must be a painter of the strength of nature, there was no beauty elsewhere than in that; he must paint also the labour and sorrow and passing away of men: that was the great human truth visible to him. Their labour, their sorrow and their death. Mark the three. Labour: by sea and land, in field and city, at forge and furnace, helm and plough. No pastoral indolence nor classic pride shall stand between him and the troubling of the world; still less between him and the toil of his country – blind, tormented, unwearied, marvellous England. Also their sorrow; Ruin of all their

glorious work, passing away of their thoughts and their honour, mirage of pleasure, FALLACY OF HOPE . . .'

Turner used the physical appearance of his human figures as a metaphor for their mental and social state. He almost never pictured them in a precise, naturalistic way but usually as rounded, almost doll-like shapes, burdened or ebullient, gaudily dressed or dowdy with poverty or distress. As the great mass of humanity in the early nineteenth century was unsophisticated and with little or no formal education, he usually left their faces blank or 'unformed'; the superficially more sophisticated rising middle-classes he showed with a little more 'grace' but (as in picnic parties) with an air of vanity, vulgarity and frivolous flippancy. Only when he wanted to demonstrate genuine nobility in people, regardless of social position, did he draw them with a more idealized or classical proportion.

Turner's earliest displayed work at the Royal Academy, a watercolour of 1790 when he was fifteen, of the yard in front of Lambeth Palace, owed a great deal to the architectural topographer Thomas Malton, and another, of a burnt-out building in Oxford Street, where the water from hosepipes had frozen to icicles, shows his architect's (abortive) schooling together with a Hogarthian enthusiasm for milling figures. Throughout his life he professed great admiration for Claude Lorrain, longing to equal the luminous light of his pictures – which he eventually did and indeed surpassed – but there was never a 'progression' to the 'heights of Claude' in Turner's career, no progression which involved leaving behind the levels of social illustration and topography. Instead, these two concerns, of high art and illustration, merged, increasing the impact of both.

From the mid-1790s Turner painted with equal facility in both oil and watercolour, sketching and producing finished pictures in either medium, and his oil sketches frequently resemble those of his great contemporary, John Constable, apart from those of the French Impressionists of 60 years later. Unlike Constable, Turner was an inveterate traveller, but except for an extensive French visit during 1802 (when he was able to view his beloved Claude), war closed the continent to him until 1815. Between 1804 and 1809 he worked along the Thames Valley, sketching in oil with a very limited palette, often on small wooden panels, and making from these a series of large georgic paintings. These were images of agricultural land where war still guaranteed full employment, labour portrayed beneath a high and often mellow summer sky.

But this apparent state of timeless harmony collapsed under the post-war agricultural recession. Machinery and a fall in corn prices caused farmers to lay off labourers *en masse*, particularly in East Anglia, where riots broke out in 1816. They did so again in 1822. Turner was too acute an observer and as a result too great an artist to draw a georgic veil over this and, although he had to be discreet, symbols and allusions to stress in 'tormented, unwearied, marvellous England' run through his work in all media, particularly in the watercolours of England and Wales which he made during the 1820s and '30s.

These pictures show English watercolour painting and the Romantic landscape in full flower. While Turner illustrated true towns and abbeys, castles or great houses as the title subjects, exaggerating their height or form as symbols of power, vanity, waste, greed or higher aspiration, the real point of the pictures was the whole landscape which was used as an expression of the concerns or situations of the people pictured upon it, all the while exploring and revelling in the effects of light, atmosphere and forms in their own right.

As Eric Shanes has pointed out, *Ely Cathedral* (1831–32) is more than a study of a rising storm looming over a marvellously elaborate piece of architecture. The Church of England was identified with a long-entrenched, deeply reactionary political system by the time of the Reform Act of 1832, and its close ties with the aristocracy were seen to be exemplified by the Bishop of Ely, Sparke, notorious for his nepotism and abuse of church patronage. Stones had been thrown at the coaches of high-ranking clergy. The figures Turner placed across the foreground of *Ely Cathedral* imply these events in a manner both fluent and subtle. In 1831 farm workers refused to pay their tithes, and in the 'Swing' riots of that winter destroyed threshing machines. Turner spread his harvest figures along the flank of the cathedral, with their ricks beneath it, and the smoke of their cottage chimneys rising around it. In the foreground boys throwing stones play near a girl who is pointing to them and looking at the cathedral, towards a tower famous for a fall. The livid storm increases the sense of foreboding, and the poverty of the figures under the grand architecture heightens the sense of dangerous division, a complete contradiction to the 'Holy Family' group under the gable end of one of the cottages. *Blenheim, Oxfordshire* (1831) possesses a similar atmosphere, a storm rising over the great palace, while at the Woodstock Gate in the foreground (turned side-on in a compositional modification typical of Turner) figures of various social groups, largely the industrial middle class, have arrived. They are divided from the palace by members of a hunt, streaming down towards them, and a glowering figure with a shot-gun stares not at them but out of the picture to the observer, holding four hounds on the leash.

While Turner used the natural world to reflect the human condition, he often used animals in the same role, or to describe the human relationship *to* landscape. It suited his sense of humour in his picture of Battle Abbey, near Hastings. The speed of Harold Godwinson's advance from the north to that fateful battlefield had earned him the nickname 'Harold Harefoot' and led Turner to place a running hare in his preparatory drawing of the Abbey. In the otherwise tranquil *Colchester, Essex* (c.1825) the chase of a hare across the foreground reflects the random spread of the smoky town into the surrounding country, and the uneasy relations between the two worlds. He might show a huntsman shooting rabbits below a ruined castle to evoke nature's abundance and mankind's greed and empty pretensions, and the hare running at last ahead of the steam train in his great 1844 oil painting *Rain, Steam and Speed* as an emblem of speed and aggressive advance, a pursuit by an iron horse. Birds often represented the dead, nesting by falling water while unseen (faintly painted) huntsmen close in upon them, or flying into the sun over ruins.

Apart from these potent, but now often forgotten animal symbols, Ruskin praised Turner for his painting of the natural world. He considered it to be without equal, as it was in *Llanthony Abbey, Monmouthshire* (c.1834), a fading rainstorm over a deep river valley, with sunlight shining through the drifting showers.

> . . . the last drops are rattling through the glimmering hazel boughs, the white torrent, swelled by the sudden storm, flings up its hazy jets of springing spray to meet the returning light. . . . The whole surface is one of united race and mad motion. . . . The rapidity . . . of this torrent, the exquisite refinement of its colour, and the vividness of (its) foam . . . render it about the most perfect piece of painting of running water in existence.

Turner executed the billowing veils of this thinning rainstorm by plunging the whole surface of the paper into a pail of water and then 'floating' the colour on to the saturated surface and letting it 'bleed' into one area from another. This enabled him to produce 'clouds' of colour which when dry could have details added to them, and which would be built up into trees, rocks or flowing water thus appearing to shine out or fade into the rain or sunlit haze.

Turner worked at great speed, often making four or five watercolour pictures simultaneously, saturating one and quickly washing in the main colour areas, and then saturating and washing in the next in turn, until by the fourth or fifth the first was dry and he was able to apply the finishing detail to it. He did this with very small, pointed brushes, often with a stippling or hatching technique borrowed from miniaturists. By mixing watercolour pigment with gum he could make a glaze which in places he might scratch away down to the paper with a thumbnail sharpened to a point for the purpose. This gave highlights brighter than he might have gained from using white opaque paint. By the 1830s these main colour areas had become exercises in colour and harmony which bore little or no relation in their position to the main detail of the drawing, such as trees or rooftops. They crossed these things in pools of light and shade. Such pictures were often given heightened structure by patterns of shadow in long diagonals, a device which was highly effective in his wilderness landscapes.

The same preoccupation developed in his large oils, in which the Romantic impressionism grew steadily more powerful and the human figure – but not human concerns – gradually receded. In a watercolour such as *Dudley, Worcestershire* (c.1830) human figures are almost absent except by implication, and the brooding gloom of the advancing industrial town evokes a study of Hades by Bruegel (see p. 148). Yet in that year Turner produced the honey-gold Claudian idyll of *Ludlow Castle, Shropshire*, complete with stylized Claudian trees, distant reapers and tranquil water birds. Compared with the bleak, flat and frozen – almost featureless – landscape of *Frosty Morning*, an oil made 17 years earlier, it is difficult to conceive of these pictures being made by the artist. But to Turner these were equally valid facets of observation, not expressions of unalterable formulae.

Gradually light and the objects men made began to take precedence over all else. *Rain, Steam and Speed*, where the fiery bulk of a steam train whirls out of an iridescent haze which all but obliterates a shadowy plough and the traditional landscape was an expression of thrusting change racing to an unknown point and obliterating what had gone before it; it was painted in the most uncompromising modernism of its time, on the very edge of abstraction. No one in Britain attempted to cross that margin until the next century.

That Turner left no 'school' behind him is scarcely surprising. But enthusiasm for all that he did led Ruskin to embark upon his monumental *Modern Painters*, to extol his accomplishments. Among these Ruskin cited 'truth to nature'. And as Ruskin's authority increased, from this deceptively simple credo grew the highly complex and highly finished art of mid-Victorian England.

The last great flowering of the georgic ideal affected Turner's great contemporary, John Constable (1776–1837), at the time when Turner was painting his Thames Valley pictures.

ON PREVIOUS PAGE William Holman Hunt (1827–1910)
Our English Coasts, 1852 ('*Strayed Sheep*') Oil on canvas
17in × 23in (Tate Gallery, London)

Constable, who knew Turner, was a contrast to him in almost all respects. Where Turner was an intellectual, born in a city, and a great traveller, Constable was the son of a prosperous Suffolk miller, travelled only from necessity, and as little as possible, and possessed that intuitive response to the sights, colour and effects of the world around him that made him a true forerunner of the Impressionists.

Where Turner was a Romantic, who sought meaning and comment *through* the celebration of light and natural forms, and freely used symbol and allegory and visual puns, Constable believed it was enough for a painting to record the effects of light and form to make it a work of art; he was a realist who painted what was in front of him; the picture need have no wider meaning.

Constable had a greater immediate impact than Turner upon other artists – most particularly upon the French and of course in East Anglia where he lived – and indeed, an exhibition which he shared with François Louis Thomas Francia in the Paris Salon of 1824 did much to sew the seeds of Impressionism on the continent. It is one of the supreme ironies of British art history that in the 1880s young British painters would be so infatuated with French Impressionism and imagine it to be a new concept: their own predecessors Turner and Constable had left them this legacy so early they had forgotten it; they thought themselves fashionable adventurers.

Constable was already 24 when he entered the Royal Academy Schools, having initially joined his father's business, and after his spell in London, he rarely left his native Suffolk, where he painted along the Stour. He had no aptitude for such mythic spectacle as Turner's *Building of Carthage* (1803), but is famed for his superb oil sketches and pictures such as *The Haywain* (1820–21) and *Flatford Mill* (1816–17); archetypes of georgic England. So deeply have Constable's pictures of his native landscape embedded themselves in the public mind as portraits of 'the real country' they still outnumber reproductions of all other paintings on British suburban walls. They possess this power from the conviction and affection of the artist for what he saw: his knowledge of it – as a miller he was part of the rural economy – and his illustrator's love of narrative incident were wedded to a fine artist's concern with colour and form. Constable described what he saw – barges, canals and reaping in *Flatford Mill* – factually, and explained in paint the workings of the landscape he saw. He made no single 'statement' about Britain during the Napoleonic wars except to affirm the apparent harmony of its rural scene, which remained largely credible until the year he painted *Flatford Mill*.

Then it failed. As the image of harmony became less credible so Constable became more and more concerned with forms, colour and what was picturesque. For a while his interest in cloud and light became vigorous and expressionistic, and he also painted fairly large canvases in the open air at considerable speed, pictures so close to those of Monet's contemporaries of the 1870s some 50 years later that they startle with their immediacy. He had painted sizeable oils in the open air since 1816, when he had made *Wivenhoe Park*. Rosenthal has pointed out that apart from being a classic georgic celebration of the bounty of a great house in fertile land, it is also a superb *plein air* study of a summer day. But by 1828 he was making pictures like *Dedham Vale*, vigorous in its typical cloud study, seductive in its tranquillity, but highly traditional in its picturesque format.

It was Constable's *method* of painting, rather than his subjects, which made him so distinctive during his lifetime. Both he and Turner were the brightest lights in

Ford Madox Brown (1821–93) *The Dignity of Labour*
Oil on canvas 53 15/16in × 77 11/16in (Manchester City Art
Galleries)

OPPOSITE John Everett Millais (1829–96) *Autumn Leaves*
Oil on canvas 41 1/2in × 29 1/8in (Manchester City Art
Galleries)

Britain's extraordinary artistic explosion which preceded the accession of Victoria to the throne in 1837. In France, Constable's standing was reinforced by the brief life of his contemporary, Bonington.

John Parkes Bonington (1801–28) owed much to the Frenchman François Louis Thomas Francia, who in turn formed most of his style and technique during time spent in England as watercolourist to the Duchess of York. Bonington's family moved to Calais in 1817, and the greater balance of his work was made in Picardy and Normandy, where his watercolour and oil painting developed into a deceptively simple form of impressionism. In these pictures objects were formed by using blocks from a very limited colour range, and shifting form – such as cloud and water – was made from mixtures of any two colours of this range. The result was a great lightness and subtlety, with few equals until Whistler's studies of tone half a century later. Bonington's premature death cut short his career so drastically that its possible development is open to wide speculation. Had Bonington lived, Whistler's career might have appeared less significant – and certainly far less innovative.

Norfolk and Bristol
This great widening of vision was typified by the work of John Sell Cotman (1782–1842), and the artists of the Norwich School, a group 'founded' largely in 1803 by John Crome on the nucleus supplied by the Norwich Society of Artists.

Although he never achieved material success in the capital, Cotman studied in London and from 1800 exhibited at the Royal Academy. His work stands in astonishing contrast through both its colour and imagination to the stale theories so many second-rank artists taught to their dilettante pupils and were forced to pursue themselves to ensure a sale. The deceptive simplicity of Cotman's painting involved an intensity of colouring which gave simplified forms the air of near-abstraction. Picturing a rocky slope and green trees under a bright sky of cumulus cloud so many painters would reduce the trees to cauliflower bunches of olive green, divide the slope into bands of sepia and indigo shadow so that it became a dark brown mound, and tone down the sky with a light red over indigo; a cloud was scarcely ever white. Then they would evoke tufts of grass and leaves with a five-pointed brush invented by John Glover that enabled them to paint foliage five times as fast, if identical in shape.

Cotman left his sky of a midsummer day deep azure or ultramarine, and the cloud was a ragged balloon of white. His trees were deep hues and tints of emerald, Indian red and indigo, and sunlight lay in sharp patches of ocre and golden green. Often these forms had the crispness of torn paper and none of the formula detailing distracted from their strong effect. These landscapes were often bleak and deserted, and it is no surprise that Cotman enjoyed little financial success.

John Crome (1768–1821) was materially the most successful of the Norwich men. He was far less innovative but more influential than Cotman, and some of the highest quality georgic landscape had been produced by artists in East Anglia during the Napoleonic wars, especially James Stark and near Lincoln by Peter de Wint. But the general movement in subject of these and painters such as Miles Edward Cotman, Anthony Sandys, John Thirtle and John Bernay Crome (John Crome's son) towards painting their native landscape and moving away from documentary pastoral and high Romantic subject alike, reflected their altering perception of their changing country. They were the last generation of British

Samuel Jackson (1794–1869) *A Sketching Party in Leigh
Woods*, c.1850 Watercolour and body colour
17¼in × 26in (City of Bristol Museum and Art Gallery)

artists to whom the rural landscape was the usual place of work, life and death, and
as the old rural structure began to crumble around them they looked at the land
first, and only secondarily at the people on it. For this short while landscape meant
to them not an ideal description of a social state, nor a mythic fantasy. It meant the
face of Norfolk.

In Bristol, a flourishing group of painters lacked the innovation of the Norwich
artists, but the best of them, such as Francis Danby (1793–1861), the self-taught
James Barker Pyne (1800–70), and Samuel Jackson (1794–1869), responded to the
distinctive beauty of the steep hilly landscapes near Bristol. Many of these places
were almost Claudian in their crags with deep wooded glades and sloping meadows
by winding rivers, particularly the margins of the Avon and Severn. The spectacu-
lar Avon Gorge naturally resembled a romance by de Loutherbourg. Danby's *The
Avon at Clifton* (1822) involved no idealization, and indeed, so Romantic a
landscape did not encourage the Bristol artists to experiment.

The Victorian Vision, 1830–70

The faces of the poor which Turner had painted had been round and unformed; those of Stubbs were blunt-featured and expressing a fresh or ruddy health. But when, after 1810, Thomas Barker had made portraits and studies of farm labourers from life, he usually recorded them as sharp-featured, their faces fined down by wind, sun and a frugal diet. They are drawings of thin and sullenly resilient people, whose world did not generally believe it owed them a living. The same lean, weathered, somewhat hostile faces show in George Robert Lewis's masterpiece of 1815, *Hereford from Haywood's Lodge*, showing harvesters at noon. From these men came most of the recruits for Wellington's armies, and their lives were arid enough that when John Harris, a shepherd, recruited into the Rifle Regiment, was taught to read and write by an officer, he was to record in his diary the hardships of the Peninsula War as preferable to his former rural life. Memories of the rural poor like this shepherd died as their descendants were absorbed into the expanding towns. But the georgic myth did not die with them.

David Cox (1783–1859), the son of a blacksmith, had an interest in rural life and

George Robert Lewis (1782–1871) *Hereford, Dynedon and the Malvern Hills, from the Haywood Lodge. Harvest Scene, Afternoon* Oil on canvas 16⅜in × 23½in (Tate Gallery, London)

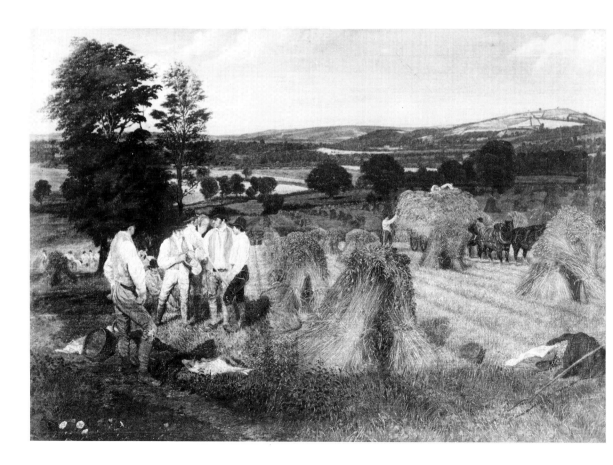

labour that went far beyond what was picturesque, and although his prime interests became the passing effects of cloud, wind, rain and light, his many scenes of harvest and the traditional rural world helped to preserve the middle-class nostalgia for the georgic land as he became one of England's leading landscape painters. Initially, Cox had worked as a colour grinder and theatrical scene-painter, after first being apprenticed to a miniaturist. He was much influenced in London by Prout, Varley, Girtin and Cotman and his *Treatise on Landscape Painting and its Effects in Watercolours*, published in 1813, was followed by *The Young Artist's Companion* in 1825. These texts reflected the great demand by amateur watercolourists in London and throughout the provinces in the 1810s–30s for lessons either personally by a tutor or by subscription. The work they produced was modelled on that of artists like Cox, and later the highly fashionable Anthony Vandyke Copley Fielding, and it preserved the compositional style of Claude and Poussin which had blended with an architectural and English pastoral genre by that date. Such teaching now took up a very sizeable part of an artist's time – especially a watercolour artist's – and constituted the major part of his income. It began to decline in the 1830s when the popularity of watercolour painting led to the opening of the Government School of Design in 1836. By the Great Exhibition of 1851 amateur watercolour painting as a fashionable pastime had been pushed into the background by various other distractions (such as cheap pianofortes), and by the steadily rising status and higher

David Cox (1783–1859) *The Challenge* Watercolour
17½in × 25½in (Victoria and Albert Museum)

and higher prices commanded by the work of such men as Turner, and other leading watercolour artists. This made emulation of their work appear (as indeed it was) far beyond the amateur. But, until the late 1830s, amateur watercolour fashionability caused much landscape painting to lie in a decorative and nostalgic doldrum. Artists tended to produce what their pupils could copy, and therefore would buy. Coupled to this came the artists' rising distaste, deepening to genuine disgust, for the industrial landscape, and the disposition of the Victorian *nouveaux riches* to escape from the urban slumscape they were creating for their employees. As a result the Arcadian images of the pastoral existence presented by the 1860s by such artists as John Linnell would have raised a sardonic laugh from an ex-shepherd like Harris had he suffered the displeasure of seeing them.

Possibly he would have felt no such hostility to the dream-like images made by Samuel Palmer (1805–81), the son-in-law of John Linnell and one of the most outstanding artists of the nineteenth century.

Thomas Creswick (1811–69) *Landscape with River – The Ferry* Oil on canvas 47½in × 72in (Sheffield City Art Gallery)

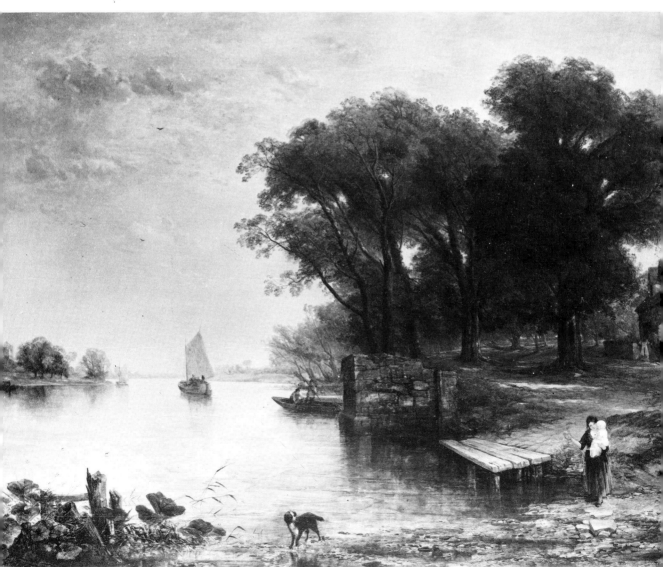

Like Turner, Palmer was a Londoner not a countryman, and first exhibited at the Royal Academy at the age of 14. A friend of the visionary William Blake, Palmer visited him in the company of friends at Shoreham in Kent, where he later settled himself, and there produced a body of painting, usually in watercolour, ink, pen, pencil and varnish, that may have owed certain forms to seeing Blake's unique woodcuts, but was basically composed from his own special vocabulary: his personal iconography which had evolved to celebrate an almost mystic sense of wonder and awe at the fruitfulness and harmony of the natural earth. Like Blake, Palmer believed in picturing a 'higher reality', concentrating on one spot on the earth where he could see this most clearly, or it was 'revealed' to him, and his pictures are an expression of this love in stylized symbolism. In the 1930s they were to have a considerable effect upon artists seeking a similar sense of belonging to what they thought of as the natural world.

Although Palmer produced some of his finest work in Shoreham in his 'Valley of Vision' he later attempted to modify and 'conventionalize' his work, largely on the not wholly well-meant advice of John Linnell, whose relations with him were strained. For many years Palmer practised his style in relative secrecy, and made many excursions abroad (especially to Italy) and to north Wales, producing much insipid and derivative work on Linnell's 'commercial' advice. Only late in life did he re-emerge from under this wasteful cloud, and create pictures of his former power.

Even so, the fact that in the 1830s Palmer was making images of the agricultural landscape which relied upon mystic stylization demonstrated how much the old rural world had changed. He could ignore Kent's rick-burning and 'Swing' riots without compromising his integrity only because he had invented an iconography which evoked 'other reality'.

Meanwhile, the opening decade of the Victorian age revealed a landscape art moving along two parallel, contrasting paths. One was the rural narrative – a country landscape with a passive or moral content – and the dramatically pictur-esque – the mountain landscapes of Scotland and Wales. In watercolour the gentle rural narrative, often pastoral with grazing flocks and strolling herdsmen, became the province of painters like Henry Bright (1814–73), Sir John Gilbert (1817–79), Daniel Alexander Williamson (1823–1903), George Price Boyce (1826–97) and George Sheffield (1839–92). They often produced these watercolours on a scale similar to middle-sized oils. They were displayed in a similar manner in heavy gilt frames and on exhibition vied with them in strength of colour, and density of finish if much bodycolour was used.

In oils, artists like Thomas Creswick (1811–69), a Birmingham man like Cox, rose to great popularity with his tranquil pastoral idylls often featuring broad expanses of still, reflecting water, their compositions as traditional as their tech-nique, and their sales as steady and predictable as their content. Creswick was a fine draughtsman, and Ruskin praised him as 'one of the few artists who *do* draw from nature, and try for nature', but Creswick continued what were basically safe formulae for the sake of a safe bank-balance. In 1869 when he died he was making pictures that could have been made in 1830 – but his popularity lasted well into the 1870s.

North Wales even more than Scotland drew the early Victorian itinerant artist seeking the picturesque and saleable scene. David Cox returned again and again there, and after his example the beautiful churchyard of Bettws-y-Coed near

Snowdonia was probably the most drawn and painted burial ground in Britain. Three things recommended it: it was real; it was a spot of dishevelled, dryad loveliness, and it evoked uplifting thoughts of moral tone and after-life which appealed to the Victorian middle class. Watercolours of this lovely place far outnumbered the regional population.

The long-lived, highly sophisticated technician Benjamin Williams Leader (1831–1923) and his friend George Vicat Cole (1833–93) performed the same service in oil. But Leader could step above the fashionable cliché, and his chilling *February Fill Dyke* of 1881 (actually painted in November) stands comparison with Turner's sere *Frosty Morning* as a sight of landscape's iron beauty that treats humanity to a cold stare.

In oil the dramatic mountainscape was at its best under the brush of Horatio McCulloch (1805–67) who managed to resist the temptation to inflate the emotional aspects of his subject – to which the Hollywood film director would later succumb. All these pictures shared one common factor: they portrayed the natural world – *not* merely a specific rural lifestyle – as a place of uplifting grandeur or uplifting tranquillity. In the immediate pre-Darwin era, the educated classes in Britain were coming under increasing intellectual pressure from scientific research into the nature of the world in which they lived, and they sought an art that did not set the natural world against them. Although environmentally they had renounced any 'natural' lifestyle, they wished to see nature as their 'natural' familiar home.

Their difficulties were summed up in the problems concerning John Ruskin as an undergraduate at Oxford in the early 1840s, who had to reconcile such discoveries as Sir Charles Lyell's about the age of the earth with the Biblical teachings of his evangelical background. Ruskin did this by affirming that the Old Testament words 'In the beginning' referred to a quite indefinite passage of time before the present state of the earth, and was therefore able to believe that nature revealed the wonder and infinite virtue of God's creation. This fuelled an art stressing faith, romance and factual integrity.

These were prime concerns of the Pre-Raphaelite Brotherhood.

The Pre-Raphaelite movement was initiated by 1848 by William Holman Hunt (1827–1910), John Everett Millais (1829–96), and Dante Gabriel Rossetti (1828–82). They were later joined by William Morris (1834–96) and a number of other artists. As students at the Royal Academy Schools, Hunt, Millais and Rossetti reacted against the conventions established there by Sir Joshua Reynolds (whom they dubbed Sir Sloshua). They also despised what they termed the graphic exaggerations which had developed from the Italian Renaissance painter Raphael. Theoretically, the 'Brotherhood', as they called themselves, wished to return to the 'natural' style of the pre-Raphael Florentine painters of the 1480s. But what they actually produced was a synthesis of the attitudes of middle-class, mid-Victorian England: high Romanticism, meticulous attention to the details of material form (which they crowded on to their canvases just as their public crowded objects into their homes), and strict 'realism' of an almost Darwinian, pseudo-scientific nature, which was laced with a frequently contradictory but high-minded morality.

Although they were initially attacked, the Brotherhood acquired the powerful support of Ruskin who by 1851 was the most influential art critic in Britain and who for thirty years directed Victorian taste. From his *Modern Painters* the Pre-Raphaelites had been inspired to their theme 'truth to nature', and in pursuit of that truth they produced one of the most formidable bodies of painting in Europe.

Pre-Raphaelite landscape is among the most extraordinary of painting, frequently allegorical with an obsession for detail which surpasses the camera or the living eye. Henry Holman Hunt, a kindly if passionate evangelical Christian, and the antithesis of his colleague, the sensuous, morbidly erotic Rossetti, used it to celebrate the meticulous abundance of God's earth by painting flora, fauna and humanity with a microscopic precision which feeds the sight to the point of visual indigestion. In Hunt's work the strengths and weakness of Pre-Raphaelitism are exemplified in the famous and oft-reproduced *Hireling Shepherd* (1851) and *Our English Coasts 1852 ('Strayed Sheep')*. The first is a complicated allegory about complacency, waste, decadence and vulnerability of the nation and the individual. Most of the significance is lost on the lay observer, and it is probably better so. It is more rewarding in revealing the beauty of the woodland, in the study of sheep, and in the textures of clothes and skin. It is also open to speculation whether such things are what really interested Holman Hunt. Given the massive power of the Royal Navy the allegory of *Our English Coasts* with its sheep wandering on a cliffside as being symbolic of a nation undefended seems as eccentric as it is obscure. It is hard to conceive of any nation better defended against marine invasion in 1850 than Britain. But as a study of animals, light and growing things it is magnificent.

Both these pictures enjoy the purity of colour gained by brushing pure (unmixed) pigment into a wet white ground. The result is the brilliance of a stained glass window, and was the original Pre-Raphaelite method. The weakness is the overpowering detail, which distracts and confuses, dispersing the forms of the picture and running the risk of depriving it of apparent meaning. There are so many seemingly unrelated things going on in so many Pre-Raphaelite pictures something had to be invented, some allegory or moral point implied, to give a focus.

The fine point of loosening this focus to achieve a greater 'truth to nature' is well shown by Ford Madox Brown (1821–93) in his georgic picture, *The Hayfield* (1855), one of the finest small landscapes of the nineteenth century. That blue-green twilight when the moon rises but the afterglow of the sun remains in the smokeless sky is superbly achieved, and that shadowless, dream-like light in which forms retain their muted colour is balanced with extraordinary skill across the picture. So is the light in the sharply focused *An English Autumn Afternoon* (1860), evoking that drowsy, mildly melancholy peace of the suburban summer landscape on the outskirts of a great city. The middle-class couple, with the feral birds near them, gazing towards Hampstead Heath, imply a layered meaning, but the acuteness of sight transcends it; it possesses that poetic claustrophobia which returned in the parkscapes of Richard Hamilton in the early 1970s; in Madox Brown's painting one can almost hear the tiny fret of whalebone under crisp summer linen and smell the forthcoming cress and bloater sandwiches.

Typically Ruskinite was the Director of the New London School of Design, William Dyce (1806–64), who was a High Churchman, and an amateur scientist. His enquiring mind composed and had published an essay on magnetism and electricity, and from 1850 close open-air observation began to affect his oil pictures. Early in his career he had painted in watercolour, then produced frescoes for the Palace of Westminster and the House of Lords, but like Hunt he turned his minute

OVERLEAF George Vicat Cole (1833–93) *Harvest Time*
Oil on canvas 37¾in × 59¾in (City of Bristol Museum
and Art Gallery)

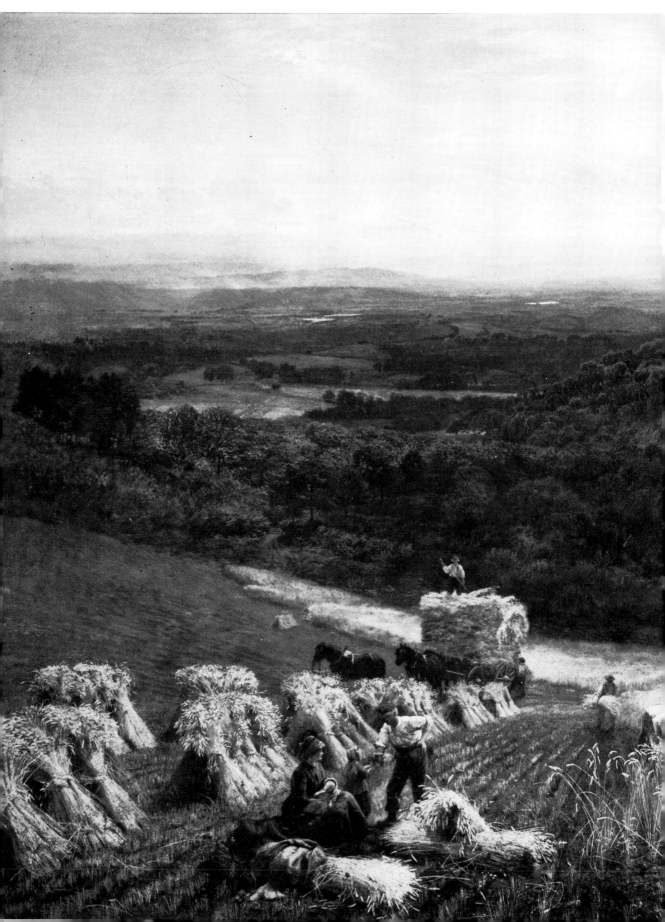

Ford Madox Brown (1821–93) *An English Autumn
Afternoon* Oil on canvas 28in × 53in (City of
Birmingham Museum and Art Gallery)

OPPOSITE William Dyce (1806–64) *Titian's First Essay in
Colour* Oil on canvas 40in × 31⅛in (Aberdeen Art
Gallery and Museums)

observation on to his native landscape to illustrate religious subjects. Although his
finest work was *Pegwell Bay, George Herbert at Bemerton* (1860) was more typical of
him, and more typical of the Pre-Raphaelite movement. What made each indi-
vidual ivy leaf, this or that finely delineated blade of grass in his pictures so
interesting to him, so important, so full of significance, was that each was God's
work, as special and separate as one human being from another.

Throughout the 1850s and '60s Pre-Raphaelitism commanded great respect on
the continent; it embraced Arthurian legend, Biblical parable and historical and
urban genre, as well as land- and coast-scape. The movement even embraced –
briefly – such painters as Henry Wallis (1830–1916), whose masterpiece of 1857,
The Stonebreaker, of a convict dead beside a road on a poignantly lovely evening, is
usually compared, in a rather facile juxtaposition, with John Brett's picture of the
same title, to illustrate Realism vis-à-vis complacency. (Brett's picture is a delight-
ful portrait of a small boy smashing stones before a delicately observed view of Box
Hill.) The chief defect of Brett's picture is that the rock looks a little like popcorn.
Ironically, it was Brett who first rebelled against Ruskin's teaching, but most
artists, of great or indifferent talent, subscribed to it. Many lesser painters could
become a minute eye, for there are many technicians who cannot grasp aesthetics.

There were exceptions. John Inchbold's 1855 picture *A Study in March* has all the casual lack of focus on detail which typifies a snapshot. Indeed, the whole content of that picture appears quite fortuitous (apart from the March lamb and the seasonal flowers) but that very casualness throws open the void which separates the snapshot from fine art: the snapshot's lack of any wider meaning. Inchbold's picture seems calculated to seem fortuitous, but so much of the detail packed into other paintings of the time was not. The trouble was in them it looked equally random and meaningless.

Ruskin, of course, was highly selective of the detail which he put into his own paintings (usually watercolour) and although his aesthetic could be considered 'naïve', that was more a comment on the simplistic way in which artists might interpret it. Alfred William Hunt (1830–96) enthusiastically embraced Ruskin's ideas, but although he received high praise from Ruskin, this was qualified by warnings about 'excessive finish'. Hunt's *Rock Study, Capel Curig – The Oak Bough* (1857) is a breathtaking *tour de force* of sunlight strained through leaves on to stone, but its very intensity takes on a peculiar two-dimensionality, where everything, seen with equal intensity, appears of equal value or importance – something which neither the eye nor the mind of an intelligent creature perceives through sight.

Hunt had originally been inspired by David Cox, but while a Fellow at Oxford he had almost certainly (like Brett) read the fourth volume of *Modern Painters* and on becoming a professional painter made sketches, in watercolour, throughout the summer and worked these into finished oils during the winter. It was a method which led to high detail building up to dominate a picture, and between 1850 and the mid-1860s it was shared by most leading British painters.

The titles which these artists chose reflect this approach, which made landscapes into outdoor still-life or monumental illustration. Many of them were, in any case, illustrators. Frederick Walker (1840–75) had trained as a wood engraver under J. W. Whymper and made his name between 1860 and 1864 contributing illustrations to *Once a Week* and *Cornhill*, then edited by Thackeray. An honorary member of the St John's Wood group 'The Clique', he avowed that his chief concern was to combine the observation of nature with 'affective sentiment'. That could have been a précis of the aspirations of most of his contemporaries. His close friend and fellow apprentice, John North (1842–1924) was more concerned with atmosphere than Walker, but their work was a microcosm of the forces pulling at British art over the decade of 1865–75. Walker's pictures were admired by Myles Birket Foster and George Mason on one hand, the hand of the narrative escapist rural idyll; on the other hand Walker shared with North a love of the natural world, a sentiment typified in Thomas Collier, who painted outside even in the snow until his brushes were frozen stiff and his palette iced over. Yet they all aspired to this 'affective sentiment', a desire to affirm and convey some moral idea.

Ultimately, this was to become British painting's flaw; it meant that as Impressionist aspirations developed alongside moral anecdotes both degenerated to the type of art produced by the Frenchman Jules Bastien-Lepage: an insipid art which Quentin Bell has described as 'an Impressionism from which the colour had been removed, and a high moral tone added'.

Such Impressionism was probably inevitable. By the late 1860s there was an undertow away from Ruskin's tight, literal interpretation of details which Millais had described as being only 'fit to judge the portraits of insects'. Walker had developed a method of adding great detail in his large watercolours and then

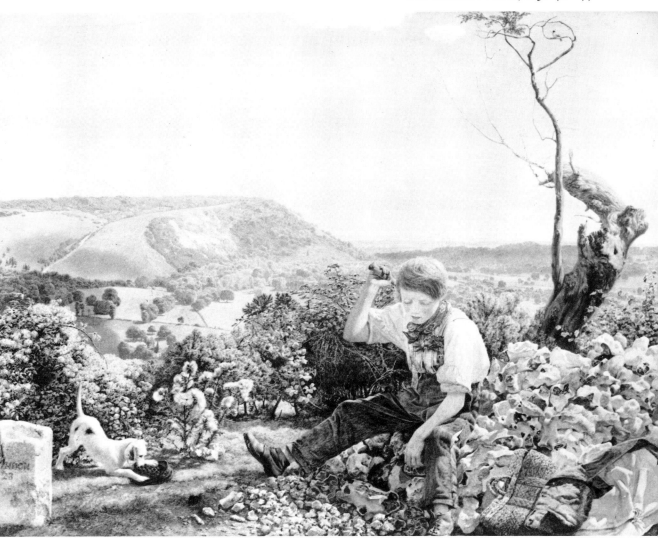

John Brett (1830–1902) *The Stonebreaker* Oil on canvas
20¼in × 27in (Walker Art Gallery, Liverpool)

carefully wearing it away in places, suggesting not emptiness but veiled complexity. This way of elaborating on forms and then erasing them inferred a degree of intelligent insight and selectivity closer to that which Ruskin had intended, and had implied in his own pictures. Martin Hardie has observed that in North's case there was a gradual tendency for the artist to 'make his drawings tingle and shimmer with light. . . . [North] painted multifarious details melting together, with spots and particles of pure colour. His method can be compared to *pointillisme*; certainly he was groping for methods of expression which the French Impressionists developed more fully.'

North's figure drawing was poor, and he persuaded Walker to add figures for him. His friend's early death forced him to concentrate on his strengths: colour and atmosphere. But, in any case, throughout the 1870s, a softer, broader vision

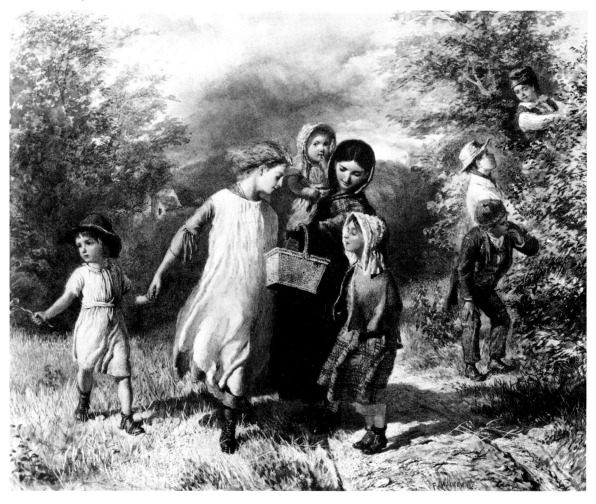

Frederick Walker (1840–75) *Blackberrying* Watercolour
13in × 16¾in (Cheltenham Art Gallery and Museums)

developed in artists who couldn't – and didn't wish to – maintain the Pre-Raphaelite intensity.

It has been suggested that the Pre-Raphaelite vision was incapable of development, and certainly it appeared to spring, fully formed, from the forehead (or brush) of a Hunt or Rossetti, leaving nothing to add. But to claim that it could not encompass atmosphere is true only insofar as many who pursued it did so literally and rather naïvely, forgetting how Ruskin had praised Turner's shimmering mists which *suggested* things unrevealed. More fundamentally, Pre-Raphaelitism, when presented as a aesthetic, was essentially a literary-based, intellectual conception with subjects taken largely from poetic myth and principles espoused (by Ruskin) through words, *about* vision, and about what was known concerning the material world. It was a philosophical treatise, and far from being naïve was a highly cerebral art form. Unfortunately the majority of painters (contrary to much historical fashion) were not and are not intellectuals.

Meanwhile, however, British landscape artists, whether or not Pre-Raphaelites

by fashion or persuasion, hardened their sight against the rising continental Impressionism, and pursued an anti-industrial celebration of the pastoral land. And they did not do this alone. To assume there was anything uniquely British in this would be facile in the extreme. French establishment painting was equally 'reactionary'; French Impressionism, although 'urban', was largely *Parisian* Impressionism, and Paris was not an industrial city. Yachts, parasols and cafés outnumbered factory chimneys by a hundred to one in their pictures. Imperial Germany produced a popular landscape art which the surrealist Max Ernst would remember as being dedicated to enumerating every pine needle around a woodcutter's cottage that was as quaint as anything painted by Birket Foster, and often perched near a Rhinish precipice. In the United States images of an untamed continent often painted with all the emotional inflation of Hollywood cinemascope, were produced to celebrate the newly invented idea of Manifest Destiny, and were the exact equivalent of MacCulloch's *Lochs*. The exquisite idylls of the Hudson River painters were no more – but no less – escapist than the pictures of Linnell or Walker. The American Winslow Homer could produce lines of fresh-faced, morally robust All-American farming folk whose children played 'Snap the Whip' like the children of Birket Foster and Helen Allingham. By 1866 urban industry had overtaken agriculture as the prime occupation in the United States, and the same rising industrial group bought pictures as did so in Britain. New York's slums were already as squalid as anything in Victorian England, so harvest scenes were popular.

In Britain, although urban genre pictures sold, urban landscape did not, and more than perhaps elsewhere painters deeply resented the steady destruction of a rural landscape which they saw as an aesthetic legacy, even if they did not share any substantial concern for its people. By the 1870s John Linnell had become one of England's most prolific and popular landscape painters, and saying that it was impossible to make progress in poetic landscape painting 'unless the whole heart and mind can be devoted to it' he did just that, settled at his estate with rolling views of the Sussex countryside and, paying no heed to the agricultural catastrophes of the 1870s, painted images of the more affluent rural past of harvests, haymaking and shepherds' reveries.

The Rural Dreamers

Linnell's rejection of the world about him was not so different from that of a secular monk. He scarcely felled a tree on the land he owned, and conserved it from a time and society of which he deeply disapproved. Like his contemporaries and many artists of the twentieth century his escapism was an act of criticism, and those people who bought his pictures were proving his point for him: they preferred his dream to the reality they were busy creating.

The same may be said for Frederick Walker (1840–75). Walker painted *The Plough* outside in bitterly cold weather so as to record the exact texture and tones of the land, yet with figures in medieval clothing. That Walker ignored the line of the railway which ran across the picture area was typical: but the archaic clothes of the labourers imply a past which had meaning and belief, in contrast to a present where meaning was negligible and belief in anything beyond gross material gain was fading.

Myles Birket Foster (1825–99) shared both Linnell's rural concern and his business sense. Foster's pictures perpetuated the decorous georgic myth and many

of his paintings were bland and facile, but their very seductiveness ensured attention and therefore opportunity for airing criticism. The poems written by Tom Taylor to augment Foster's illustrations to *Pictures of English Landscape* (1863) refer to the 'foul miasmas' of crowded cottage rooms and remarks that while the more utilitarian buildings might be shunned by sketchers, they were also shunned by fevers. Foster had been sent around the countryside while working for *The Illustrated London News*, *Punch* and other periodicals, and after 1846, when he established his own business, he produced landscape and rustic subjects which he sold to periodicals. When he gave up book illustration for watercolour painting, the sole exception was *Pictures of English Landscape*. As a member of the Old Water-colour Society from 1862, he painted scenes of the Surrey countryside which established a lasting reputation, and set a seal of rural charm which came to form the quintessential 'English landscape' of book illustration well into the 1930s. His admirer, Helen Allingham (1848–1926) reinforced his position.

Born Helen Paterson, Helen Allingham had taken up art in her family's drawing club; her mother's sister had been the first woman to gain entry to the Royal Academy Schools, which she entered herself in 1867. Returning from a visit to Italy in 1869 she gained work on *Once a Week*, *Little Folks* and the *Graphic* until 1874, contributed to *Cornhill*, and illustrated Thomas Hardy's *Far from the Madding Crowd*. In 1874 she married the editor of *Frazer's Magazine*, the Irish poet William Allingham, and so fell in with the Cheyne Walk set: Carlisle, Ruskin, Tennyson and Browning. From this vantage point her own watercolour work gained status. Her paintings of Chelsea Hospital flowerbeds inspired her to further pictures of cottage gardens, and in 1879, she began to paint cottage gardens from nature, emulating Frederick Walker and Birket Foster by moving to Surrey in 1881. There she began a long line of subtle, delicate portraits of a decaying rural architecture admirable for their technique and vulnerable for their myopic nostalgia, a seductive rose-trellis strait-jacket on perception and a future yardstick for the design of chocolate boxes.

But there was no unintentional paradox in the fact that these pictures also revealed the pathetic state of many buildings, owing to depopulation or indifferent landlords. She drew deliberate attention to this in her 1886 exhibition at the Fine Art Society. Predictably, her strongest protest was less against the quality of housing than insensitive restoration.

By the 1870s the prime concern of all these painters was the landscape – not the people who still worked upon it. That was largely the province of writers, like Thomas Hardy, and the figures artists placed on their painted hills and valleys were adjuncts which Michael Rosenthal has described as 'things which register equally with clouds or sheaves . . . typical of a summer's day, what you might see in a glimpse as you passed by on a train'. From a train was exactly how the buyers of these pictures observed the open country and adjuncts were exactly what they perceived the people to be – just part of the composition.

The scant market for industrial subjects was reflected in the work of the flourishing Manchester School, under the leadership of Joshua Hague. It perpetu-ated the northern industrial tradition of painting the highlands of north Wales and not painting Manchester. Their strong Pre-Raphaelite tendencies were typified by Henry Clarence Whaite (1828–1912), who, warned by Ruskin about excessive finish, loosened his style and came to excel in Turnerian effects in his Romantic Welsh scenes. By the late 1870s Turner was the most sought-after British painter

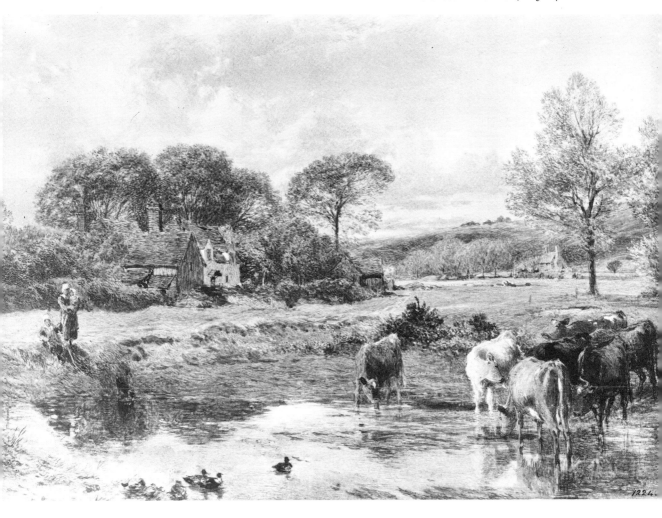

Myles Birket Foster (1825–99) *Landscape with Cattle*
Watercolour 7¼in × 10⅝in (Victoria and Albert
Museum)

among watercolour collectors, and the expedient softening employed by Whaite
was a traditionalist's precursor of the Impressionism which James Charles and
Frederick Jackson were to bring to the Manchester School as the decade closed.

Birmingham, which by 1850s had the Midlands' largest boil of industrial slums,
had already produced the naturalist David Cox and the ruralist Thomas Creswick.
It was to give rise to the Tempera Society of painters at the end of the century,
dedicated to the art techniques of Italy in the 1480s, but in the 1870s it was
dominated by artists like Henry Valter, Charles Aston, James Jelly and William
Joseph King, all of them georgic painters dedicated to painting almost anything but
Birmingham.

But that city's most notable son was the archetype of 'English dreamers',
Edward Coley Burne-Jones (1833–98), the son of a frame-maker and gilder. A
life-long friend of William Morris whom he met at Oxford, Burne-Jones studied
painting with Rossetti and was more influenced by the Italian Primitives than by

Ruskin's 'truth to nature', although he knew Ruskin personally. He adhered to G. F. Watts's view that 'painting is really a trade', and for Morris and James Powell & Co. he made stained-glass window designs. Throughout his life he kept a compilation of legend, *The Broadstone of Honour*, beside his bed; Malory's *Morte d'Arthur* impressed him infinitely more than his real surroundings: he described it as opening a vista upon a 'strange land more true than real' and his 1864 painting *The Merciful Knight* deeply impressed younger artists while spurring his own steady ascent to knighthood. His delicately and exquisitely painted foliage details owed more to Gerard's *Herbal* than to live observation, and his dreamlike, medieval-narrative paintings established his fame at a Grosvenor Gallery exhibition in 1877. But the paradoxes in his career are not untypical. He was quoted as saying that the more materialistic science became the more angels he would paint, and he took successful legal action to prevent electric lighting being introduced in Rottingdean where he lived after 1880. But he was unusual in drawing pictures of 'unsightly' telegraph poles and he was not usually hostile to the products of contemporary technology – including modern commercial pigments.

The mood of his pictures, although not the technique, was echoed by the Etruscans, notably Matthew Ridley Corbet and Sir William Blake Richmond, who also exhibited at the Grosvenor Gallery.

Corbet (1850–1902) studied at the newly opened Slade School under Davis Cooper and then the Royal Academy. At first a portrait painter influenced by G. F. Watts, he took up painting Italian landscape with Giovanni Costa after 1880, making small oil studies from nature and then finishing these on larger canvases. His dreamy, Arcadian idylls constituted nostalgia for the georgic taken to its very literary and geographical source – the Italy of Virgil – and he shared this with William Blake Richmond, whose pictures had been Pre-Raphaelite until 1866 when he was introduced to Giovanni Costa by Lord Leighton. Costa advised Richmond to simplify his style by reducing detail, and he duly did so, developing an Arcadian repertoire based on his travels in Italy and Greece. His pictures were often executed in tempera on panels, with the effect of richly coloured forms viewed through gauze. Slade Professor at Oxford, 1878–1883, and Associate of the Royal Academy from 1888, Richmond was to give crucial advice to two of the twentieth-century's leading landscape painters – Joseph Southall and Paul Nash. Nash was to express his own view of landscape as a celebration of a 'truth beyond the reality'.

As President of the Royal Academy from 1878, Frederick, Lord Leighton (1830–96) worked at increasing the status and prestige of the Academy. To do this he attracted to it painters like G. F. Watts and Burne-Jones. Before settling in London he had studied widely on the continent, particularly in Germany and Italy, and in Rome formed a strong friendship with Giovanni Costa and George Heming Mason. But the landscapes he painted were usually references for the background detail of his large, elaborate subject pictures he sent to the Academy each summer. These little studies had far greater spontaneity and life than the large finished pictures, but they also reflected the British establishment's attitude to landscape pictures by the late 1870s: if they were not merely Impressionist sketches, then they should contain the full traditionalist repertoire of rural narrative. Leighton's

OPPOSITE Lawrence Alma-Tadema (1836–1912) *94° in the Shade* Oil on canvas 13⅞in × 8½in (Fitzwilliam Museum, University of Cambridge)

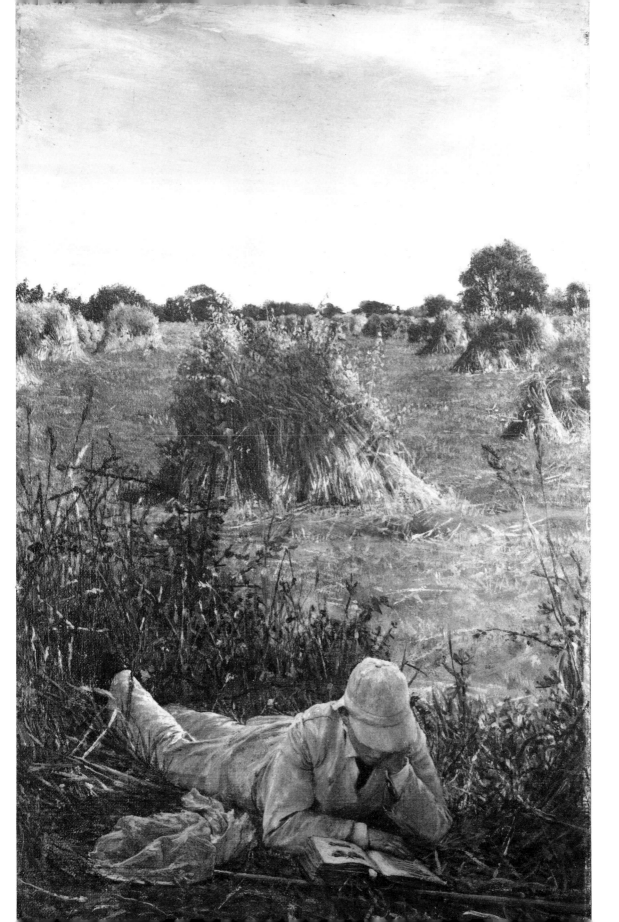

William Waterhouse (1849–1917) *The Lady of Shalott*
Oil on canvas 60¼in × 78¾in (Tate Gallery, London)

attitude entrenched itself at the the Royal Academy and, until the turn of the century, Impressionism was an entirely 'unofficial' occurrence.

94 Degrees in the Shade painted on a sweltering summer day in 1876 was one such 'unofficial occurrence' in the career of Sir Lawrence Alma-Tadema (1836–1912). A Dutchman who made a reputation with Merovingian and Egyptian subjects, his fortunes were typical of the standards of reward in establishment painting. He arrived in London in 1870 and the great technical skill he employed in his paintings of domestic incidents in Ancient Greek and Roman life – baths, banquets, and temple ceremonies – thinly veiled the sentimentality and voyeuristic eroticism of what were his basically soft-porn subjects. Carefully researched Roman ewers, cheese-cloth drapery and the vapid expressions of his girl models gained him a knighthood and Academician status. So *94 Degrees* was a rare excursion into reality for Alma-Tadema when he painted surgeon Sir Henry Thomson's son, Herbert, browsing in a wheatfield corner over his lepidoptera book and butterfly net. Yet this delightful small picture is typical of the 'realist' approach to the landscape acceptable to the Academy: a land of repose where the sun glitters on the stubble and the sheaves, and even the butterflies are filed in their proper place.

William Waterhouse (1849–1917), as accomplished a draughtsman as Alma-Tadema but an artist of far greater subtlety, gained a comparable reputation with his pictures on themes of classical and Arthurian legend, such as *Narcissus* and *The Lady of Shalott*. It was a popularity reborn in the late 1960s through the Pre-Raphaelite art-poster market, but it would be unjust to devalue his pictures by equation with Alma-Tadema's. Waterhouse's paintings are a more earthly – and more 'realist' – equivalent of Burne-Jones's, and his woodlands, river banks and pools were not Greek ideals but delicate portraits of the Surrey landscape. Pictures such as *Narcissus* often included dreamy, anonymous young women in the idyllic lagoons, but to see these female figures as comparable to Alma-Tadema's anonymous erotic models (as some critics inevitably have) would be to miss the point completely: they are anonymous archetypes – supernatural beings, spirits – and in Waterhouse's pictures they are the most ancient of associations with nature emerging from the collective unconscious, to walk and swim in the English landscape. They are manifestations of the most basic, pre-georgic nostalgia for the natural world that it was possible for a late Victorian artist to present in polished gallery form. In effect, in Burne-Jones, the Etruscans, and Waterhouse, one sees first the georgic myth removed to its geographic source – Italy – and then pursued to its root among the water sprites and fauns of tribal rite. Landscape painting could go no further in the poetic adoration of the earth.

Nocturnes and Watercolour

The widening gulf between 'establishment' pictures and the Impressionist avant-garde was highlighted by several exhibitions of French art held in London during the 1870s. It was marked by the increasing tendency of young British artists to train abroad, and by Irish artists, such as Frank O'Meara, returning to settle in their native country again. Typically when the tempestuous O'Meara returned to County Carlow after training in France under Carolus-Duran in 1873, he took with him strong elements of the work of Bastien-Lepage.

Jules Bastien-Lepage had made a great impression in England. He had done this with *The Hayfield* (1878) and his *plein-air* pictures were executed 'on location', sharing the village life and observing the daily work of the French farm people whom he painted. According to George Clausen, who was deeply impressed by him, his attitude to nature was one of: '. . . studied impartiality. . . . His people stand before you and you feel they must be true to the very life. . . . He found his ideal in the ordinary realities of his own experience.'

Although in comparison with urban French Impressionism Lepage's technique was rather staid and mannered, and his subjects appear to late twentieth-century eyes as glazed with a maudlin sentimentality, these were the very elements which established the credentials of his sincerity among younger British artists. These young men sought a freer technique than that sanctioned by the R.A., but they were afraid to lose a 'moral subject' and be seen to indulge in a painterly effect for its own sake. The pictures of Bastien-Lepage offered them a compromise.

But concerns such as a 'moral subject' were no onus upon James Abbott McNeill Whistler (1834–1903), the abrasive, exhibitionist American who was in many ways as romantic and subtle as the Etruscans and Burne-Jones, and whose attitude to landscape was more the result of selective colour memories than any *plein-air* realism. Arriving in London in 1859 from Paris, where he had enjoyed a friendship with Fantin-Latour and studied at Gleyre's studio, he produced some lucrative

Thames Set etchings and fell in with Rossetti and the poet Swinburne. His propensity for entitling his portraits 'arrangements' and his river and seascapes 'nocturnes' and 'symphonies' reflected his attitude that pictures need not have any specific 'subject' and were essentially arrangements of line and form. With Albert Moore he formed the theory of 'art for art's sake', laying the cornerstone to that monument of élitism which fine art would rapidly become as a result of this idea: an impenetrable game, played out beyond the reach – or interest – of laypeople who were no longer initiated into its language or conventions.

Whistler's effect on landscape painting was decisive, although he was not a landscape artist. When he did not paint portraits he chose tidal rivers, coasts and the sea, while living an urban life. He maintained that to create harmony an artist must discriminate and arrange, and he rejected any belief that it was the mission of the artist to copy nature. This view owed much to his enthusiasm for Chinese and Japanese painting, and it brought him into direct conflict with Ruskin who, viewing Whistler's *Nocturnes* (twilight studies of the Thames river) in 1879, accused him of 'throwing a pot of paint in the public's face'.

Whistler sued Ruskin (who was ill and unable to appear in court) for slander, and was awarded a satirical farthing's damages for a case the costs of which bankrupted him. But the publicity did more for his reputation among artists than an exhibition: Whistler had stated in public ideas which many of them had pursued privately for over a decade. But the trial had a negligible influence on the public, whose attitudes to painting were altering more as a result of photography and disturbing rumours, circulating from 1880 onwards among collectors, about the permanency of water-colour pictures.

Ruskin's theory of landscape art had maintained that there was one thing which set painting – the work of the human mind – 'above that of the daguerreotype or calotype or any other mechanical means . . . invented, Love'. Ironically, that was precisely what Whistler had sought from that most cerebral and selective of art, the Chinese and Japanese, which explored the 'harmony and essence' of a form, and its 'life' through line and tone; something which was irrevocably beyond any mechanical device which could not reflect on the meaning of life. But to the public, many collectors (and certain artists) whose naïve conception of 'truth to nature' meant transcribing Nature direct, the camera appeared to do just that – remain true to Nature. The camera was also becoming available to those dilettante sections of the middle classes who had been keen amateur watercolourists, and they used it to produce second-rate photographs where before they had produced third-rate watercolours. Meanwhile Whistler, by elegantly leading the avant-garde into 'art for art's sake', was advancing irrevocably where the camera could not follow.

The traditional techniques of landscape painting were also undermined in the early 1880s by a continuing debate over a decade on watercolour durability. This eventually reached the Lords of the Committee of Council on Education via the national press. In 1876, in a letter to *The Daily Telegraph*, Ruskin had described storage racks to protect Turner's watercolours at the Ruskin Drawing School in Oxford. He claimed that watercolours exposed to full daylight at the Manchester Art Treasures exhibition of 1857 'were virtually destroyed in that single summer. There is not one of them that is not a mere wreck of what it was.' J. C. Robinson (1824–1913), superintendent of the art collections in South Kensington in 1869, stated as much in a letter to *The Times* in 1886.

Naturally, collectors headed by Sir James Linton (1840–1916), the President of

the Royal Institute of Painters in Watercolours, asserted the contrary. Eventually, in 1888 an official *Report . . . on the Action of Light on Watercolours* by a committee under the chemist Dr Walter J. Russell and Capt. William Abney, a painter, was made public, fully vindicating Robinson's claims. They stated that light does damage certain watercolour pigments, as could varying amounts of oxygen and water, and that many artists used 'fugitive' colours which were vulnerable to light. If hung, watercolours should be displayed glazed, and out of direct daylight.

Inevitably, this badly damaged the market in watercolours. Not until the 1960s did watercolour art regain the status it had enjoyed in the later nineteenth century. Instead, with steadily improving chemistry and as a sketching tool of oil-painters and a medium of book illustrators, watercolour no longer aped oil compositions on exhibition. Artists explored it for its own sake. In the first quarter of the twentieth century its place in commercial galleries was largely filled by etchings.

These three things, Whistler's pyrrhic victory against Ruskin, photography, and the decline in popular watercolour, all freed oil painting to accelerate steadily away from 'subject' pictures down new roads. Turner and Constable had been a long way down these roads fifty years before, but the egoism and myopia so often prevalent among the avant-garde obscured that recognition.

Impression and Reaction, 1870–1910

While establishment artists tended to remain in and close to London and other large cities, during the 1880s Impressionism spread throughout the provinces in artists' colonies, which were formed in imitation of the French by younger artists returning after their continental training. In Glasgow, a group of them, including Arthur Melville, George Henry, Joseph Crawhall, John Lavery, James Guthrie, E. A. Walton, E. A. Hornel, Alexander Roche, James Paterson and William Kennedy, developed under the initial leadership of William MacGregor.

William York MacGregor (1855–1923), usually considered as the 'father' of the Glasgow School, was the son of a shipbuilder. He studied under James Docherty in Glasgow and then under Alphonse Legros at the Slade, and was influenced by the Parisian style of James Paterson. His Glasgow studio became a gathering place for younger artists, and although his style was mild and essentially conservative, its French foundation enthused his followers with the rural Impressionism of Bastien-Lepage. They imitated Lepage's lifestyle, congregating at Brig O'Turk during the summers between 1880 and 1883, and later at Cockburnspath on the Borders coast.

Arthur Melville (1855–1904) was a far more experimental painter than Mac-Gregor. Initially a grocer's apprentice, he had walked eight miles each night to attend art classes. After his *The Cabbage Garden* (1877) was hung at the Royal Academy he studied at the Académie Julian in Paris, where he saw a demonstration of watercolour sprinkled on a saturated background. From that he developed an individual impressionistic style using blurs, splashes and dabs of pure colour on thinned washes of pure colour. He never actually mixed pigments. Critics were more puzzled than hostile at this, and when the Glasgow School joined the New

English Art Club – an association formed in 1886 to spread the ideas of Impression-
ism in Britain – Melville moved to London and became involved with Whistler,
sharing an exhibition with him at Liverpool's Walker Art Gallery.

Melville's Glasgow Group colleague John Lavery (1856–1941) was brought up
on his uncle's farm in Ulster, and entered the Glasgow School of Art in 1876.
Insurance money after his studio was burnt down in 1879 enabled him to study in
London and in Paris, where he too fell under the influence of Bastien-Lepage. This
increased when he became a member of the Glasgow School. In 1887 he met
Whistler and became Vice-President of the International Society of Artists under
him. With James Guthrie (1859–1930), who had abandoned law in 1877, he
developed a 'square brush' technique which enabled forms to take on a solid tactile
appearance while not being minutely detailed, rather as if they were chipped out of
paint.

Guthrie established the Glasgow School's reputation in 1882 with his *Highland
Funeral* but the square-brush style developed after this, and his well-known *A
Hind's Daughter* (1883) is a square-brush version of Bastien-Lepage's *Pauvre Fau-
vette*, both of them 'realist' rural Impressionism by an artist living in a farming
community and painting what he saw. Both Guthrie and Lavery ultimately became
highly fashionable society portrait painters, gaining knighthoods, with work very
far removed from their *plein-air* ruralism, but their ascent was typical of the nature
of commissions: Lavery's road to social recognition began in 1888 when Glasgow
Corporation commissioned him to paint Queen Victoria's visit to the city.

Both he and Guthrie were followed into society portraiture by Glasgow friend
George Henry (1858–1943), whose best pictures were made in the late 1880s and
early 1890s, in company with those of E. A. Hornel when both of them shared
enthusiasm for the Celtic revival and Japanese painting. There was a wide gulf
between the picture of Guthrie's cabbage patch at Cockburnspath and the lucrative
London portraits which made Henry a Royal Academician, but the nocturnal
pictures of these painters showed anyway a debt to Whistler more than to
Bastien-Lepage. So did those of William Kennedy (1859–1918) and other members
of the Glasgow School.

Kennedy was elected as President when the 'Glasgow Boys' formed themselves
into a society in 1887. Like most of the Glasgow group Kennedy's nocturnal
pictures were the most muted things he did, as the first leader of the group,
MacGregor, had urged them to use bold colour. His friend James Paterson
(1854–1932) had remained different from the others in this, seeking a unity and
often delicacy of tone, a system he had learned in France under Jean-Paul Laurens.
'Absolute truth to nature is impossible,' he said, practising a softer style of painting
that evoked atmosphere rather than the starker experiments of his Glasgow friends.

In the south, the 'milk and water' Impressionism of the 1890s was often at its best
in the pictures of James Charles, Theodore Roussel and Paul Maitland.

James Charles (1851–1906), a Warrington artist, had come under the spell of the
plein-air movement at the Académie Julian in Paris and was one of the first painters
to practise continental Impressionism in England. His broken, Monet-like brush
strokes and simple, unaffected rural scenes had an easy, informal charm devoid
both of the sentimental inflation of Lepage or moral pretensions of British pictures
in the later 1880s. His pictures made a clear contrast with those of Theodore Roussel
(1847–1926), a Breton who arrived in England in 1874 and became a close associate
of Whistler. Roussel's soft, fluid paint and interest in tone bore little relationship to

the chunkiness and dense, bright dappling strokes of the French Impressionists, any more than did those of his pupil, Paul Maitland.

Maitland (1863–1909), like most 'London Impressionists', had been stirred by Whistler's praise of the 'beauty' of London, which he had perceived in its hazy tones, river mists and the asymmetry of its skyline. Maitland employed deliberate violations of the classic compositional ideas to stress this, but his pictures retained a softness and gentleness which was probably due to ill-health from a spinal curvature. That confined him to London and caused his early death.

In general, Whistler was not very sympathetic to the French Impressionists. Living in Paris after 1892, he viewed the 'screaming blues and violets and greens' of their pictures as crudities, for his own sophisticated tonal studies possessed a delicacy wholly at variance with his own abrasive personality. Not until the Post-Impressionist exhibitions organized by Roger Fry in 1910 and 1912 was this distrust of vivid colour mollified in Britain – and particularly in England.

In the meantime, the cooler influence of Whistler often mingled fluently with the subjects of Bastien-Lepage. Stanhope Forbes (1857–1947) painting in the Cornish village of Newlyn from 1884 became the leader of the Newlyn School, including Norman Garstin, Frank Bramley, Henry Scott Tuke and Thomas Cooper Gotch, whose strong interest in mood and atmosphere and whose cool, silvery tonality were their main contribution to painting. The asymmetry of Garstin's pictures was inspired by Whistler and the art of Japan, was similar to Maitland's, and sometimes evoked the Dutch – Garstin had studied under Charles Verlat in Antwerp. Even so, none of these artists achieved national recognition at speed. Garstin was reduced to fashionable portraiture and sentimental costume painting, and some of his finest work was rejected by the Royal Academy. Tuke was not made an Academician until the 1920s. In part this may have been due to his studies of male nudes bathing in landscape; had the figures been female they would have attracted no notice.

In Bushey, Hertfordshire, Hubert von Herkomer opened a school of painting in 1882, and this place grew into a thriving art centre. David Arnesby Brown, the East Anglian landscapist, studied there, as did William Nicholson, the father of Ben Nicholson, both of them among the twentieth-century's most important British painters of landscape.

In 1884 Philip Wilson Steer (1860–1942), returning from the continent, stayed a while at Walberswick, a flourishing art colony in Suffolk. A founder member of the New English Art Club, Steer had trained under Bouguereau at the Académie Julian and the Ecole des Beaux-Arts in Paris, where he was taught by Cabanel. At Walberswick he began a body of painting which owed more to Whistler than to French Impressionism, and outstripped all other British Impressionists – including the Scots – in its energy, fluency and subtlety.

Steer had paradoxically only become enthusiastic about Impressionism on his return to England, but typically his passion was for 'tone' and its values – or the weight of one colour against another – and in oil and watercolour he was able to imply the presence of a form by a few economical strokes of thin, fluid paint, instead of the heavy impastos of the Scottish or French. This very 'looseness' of his painting and drawing gave it great spontaneity, but by 1912 his free way of drawing attracted growing criticism. When he 'tightened up' his pictures they began to look empty as he 'spelled out' the outline and left less and less to the observer's interpretative imagination. Indeed, this showed that Steer was doing what Turner had done 80 years before, only without the versatility and content.

The last 20 years of the nineteenth century showed a social vitality in British art that was not paralleled by creativity. It was an era of clubs, groups and followers, and the followers were looking for someone to lead them. 1880 had seen the founding of the Royal Cambrian Academy; 1883 the founding of the Royal Institute of Painters in Oils and the Etruscan School, with the New Gallery as its venue in 1888. The Impressionist John 'Lamorna' Birch began painting in Cornwall in 1890, and Wales, like Ireland, began to attract *plein-air* Impressionists like Alfred Sisley. In 1890 the Grosvenor Gallery mounted a major exhibition of the Glasgow School, reinforcing their reputation. In 1899 the Women's International Art Society came into being, and Stanhope Forbes founded the Newlyn School of Art, which was to flourish until 1914. Yet the overriding attitude of these artists to the land and their society was one of separateness, almost insularity. Whistler had jolted those British artists who wished landscape free of having to tell a story and, in so doing, allowed landscape painters a free rein of sense-perception, and leisure to look at colour, form and atmosphere. Society cared for their pictures less as a result, and so artists sought each other's support in colonies. They looked at the landscape as city dwellers who were also separate from the urban norm. They were isolated from the town and country alike, and isolated too by their fundamental respect for atmosphere and physical appearance of the English rural landscape which was steadily crumbling around them. Representing it still mattered, and that cut them off from the art of the continental avant-garde.

As late as 1888 the Pre-Raphaelite follower Albert Goodwin could still write in his diary: 'The whole natural world, down to the smallest detail, is one great allegory, typical of the spiritual world. Our business is to study the natural world as the continued revelation of God, guiding us forever into fresh revelation of Himself'.

In France, Vincent van Gogh had shared Goodwin's deep belief, but his translation of it into paint belonged to a different era. When that paint revelation broke on British art in 1910 the Scottish Colourists showed themselves to have been ahead of the public and artists of London by well over a decade.

Ruskin, the lion of Victorian aesthetics, died in 1900 – a date of melancholy neatness. Roger Fry, the 34-year-old honorary secretary of the pro-Impressionist New English Art Club, and art critic to the magazine *Pilot* and the *Athenæum*, raised three cheers at the news with his friends at the Slade. But such a salute unwittingly credited the new century as being more post-Ruskin than Post-Impressionist. Whistler's influence in any case still held most of British painting in a tonal calm; this lasted until 1905 when the dealer Durand-Ruel brought a large French Impressionist exhibition to London. Neither painters nor public liked what they saw; little sold. In 1906 Fry left for New York, and in his wake came the newest English art movement of the new century: the Society of Painters in Tempera, who were to have nothing at all in common with Impressionism.

In 1901 Joseph Edward Southall (1861–1944), with the collaboration of Arthur Gaskin, Maxwell Armfield, Charles Gere, Bernard Sleigh and others, had founded this society, and followed it with the Birmingham Group of Artist-Craftsmen, which displayed work for the first time in 1907. Spawned in the industrial crucible of twentieth-century Birmingham, this group pursued the painting, aesthetics and techniques of the middle ages.

In 1881, Southall had seen Arundel Society prints in a shop window, including a

version of the Wilton Diptych, and these seduced him to the decorative grace of medieval art. In 1883 he had visited Italy. After reading Ruskin's *St Mark's Rest* and then seeing Carpaccio's *Life of St Ursula* on a visit to Venice, he took up tempera painting. In this he shared a pictorial mood with the Etruscans, like William Blake Richmond, but, *unlike* them, he chose to paint contemporary subjects in an antique manner, rather than antique subjects with modern materials.

There was no great paradox in this society developing in the heartland of the industrial Midlands. As Chairman of the Independent Labour Party in Birmingham in 1914, and a conscientious objector from a Quaker family during the Great War, Southall was heir to the Fabian attitudes which had inspired both Ruskin and William Morris. Their craft-based colonies had reacted against what they viewed as the squalid exploitation and degradation of people by urban industry. This attitude of the tempera painters was to resurface at subsequent intervals over the next 50 years among artists whose socialist ideas often perceived science and technology as being the insidious mask of a generally faceless capitalism. Such an outlook regarded rural landscape as a region where higher and wider truths could be seen as symbols.

Basing his approach on techniques described in Charles Eastlake's *Materials for a History of Oil Painting*, Southall gave up the use of shadow and built up his pictures with areas of bright colour which were very firmly but delicately outlined. Many of his paintings were given a base colour of raw sienna which created a golden tone throughout, as it glowed through the semi-translucent pigments placed over it. By using gesso or silk laid over wood or card, Southall also achieved a smoothness of surface and a luminosity typical of a fourteenth-century altarpiece.

This was not a regressive nostalgia as with John Linnell or Birket Foster, but a spiritual searching, as it had been with Calvert and Samuel Palmer. In particular Charles Gere (1869–1957) sought to recapture the spirit of Palmer's work in his small-scale tempera pictures and in regions Calvert and Palmer had explored, especially the Severn, the Wye and the Cotswolds. Gere had been requested by William Morris to illustrate Kelmscott books in the 1880s, and Morris's titles, such as *News from Nowhere* were almost synonymous of the quiet revelation these artists sought from landscape.

Simultaneously, a wide span lay between the cool, natural realism developing among the artists of the Staithes and Newlyn colonies and the expressive colourists in Scotland. The Staithes Group flourished until 1910, including, among others, Fred Mayor, Frederick Jackson, Gilbert Foster, James Booth, Charles Mackie and from 1894 until 1908, Harold and Laura Knight. The realism these artists practised had discarded the sentimentality of Victorian genre painting and the decorative trivia which lingered in the last wake of Pre-Raphaelitism. This was underpinned by a fascination with colour theory, the illusory effect one colour may have upon another, shown at its best in the robust paintings of Laura Knight, who with the guidance and advice of Charles Mackie responded to the tense atmosphere of the Staithes community with its stormy coast and dangerous fishing grounds.

In Scotland, William MacTaggart had pursued an Impressionism which owed little or nothing to the French of 1880–1900, but this was not the case with the younger generation of Scottish painters. Before the Great War the link between Paris and Scotland was firm. In 1943 John Duncan Fergusson (1874–1961) wrote of that time that: 'Paris is simply a place of freedom. It allowed me to be Scots as I understand it.' Fergusson had originally intended to become a naval surgeon but

took to painting with no formal training. Having acquired a studio in Edinburgh, he made regular visits to France, studied the Impressionist pictures in the Luxembourg Museum in Paris and painted with Samuel Peploe in Normandy. Like Peploe, Cadell and other members of the future Scottish Society of Eight, he mixed with the Anglo-American circle of writers and artists in Paris, and developed a taste for rich colour, and rhythmic, broadly geometric patterning inspired by the Fauvist pictures and visits to the south of France. He became editor of J. Middleton Murry's *Rhythm* magazine after painting a picture bearing that title, and when, like Peploe and Cadell, he returned to Britain on the eve of the Great War, being a Scot as he understood it, meant being a northerner who painted in the manner of Matisse and in the colours of the south.

But by the eve of Roger Fry's great London exhibition of 1910, 'Manet and the Post-Impressionists', an undertow of the newer French ideas was already flowing among the younger British painters in England and Wales. At the Slade the Australian-born Derwent Lees (1885–1931) had met the Welshman James Dickson Innes (1887–1914), whose work was influenced by Wilson Steer. He was also a friend of the swashbuckling Augustus John (1878–1961).

Innes and John had painted together in southern France in 1908. There Innes began to heighten the colour of his pictures and there he learned that he had tuberculosis. All three went painting, carousing and womanizing in north Wales and France, Lees being as successful a philanderer as Innes and John despite having a wooden leg. In Wales they all painted the landscape which their eighteenth- and nineteenth-century forebears had enthused about, but in a manner unique of themselves.

Innes, aware of his imminent death, buried a casket of love letters on the heights of his favourite mountain and with a frenetic energy painted in a mosaic of colours as intense as those of stained-glass windows, but with a lyrical, shorthand way of drawing that gave a great rhythm and flow to what he did. Although the colour was intense, it nonetheless reflected the sombre tones of the Welsh highlands, and the wild hills formed arabesque patterns to stimulate a design that reflected the painter's personal emotions. Lees imitated this way of painting. Both worked fast on a small scale, often using small dabs of colour to enliven the surface. Innes's strength rapidly failed and he died in 1914 in Morocco, his last six months spent experimenting with exotic mixtures of tobacco. Lees survived him by 27 years, but 23 of them were spent in an asylum where he was confined after 1918.

Augustus John was the type of showman who embraced landscape with a feeling of 'oneness with nature' so that nature became very largely a projection of Augustus John. Romantically, he admired the lifestyle of the Romany gypsies and his strong, glowing Post-Impressionist colour allied to his brilliant, effortless draughtsmanship made his landscapes a celebration of an attitude and feeling. As a result, places in France, Wales, Dorset or Surrey could appear interchangeable, an anonymous explosion of luminous colour celebrating intense enjoyment and a sensual revelling. And John was not alone in this. At the foundation of Post-Impressionism was the bedrock of colour and pattern explored for their own sake, and to this way of thinking landscape was one more exciting pattern to be bent to an artist's personal needs.

The artists of the Fitzroy Street Group – Richard Sickert, Robert Bevan, Spencer Gore, Charles Ginner, and William Ratcliffe, Harold Gilman and Matthew Smith – had already seized on this freedom. Harold Gilman (1876–1919), with Sickert a

Charles Ginner (1878–1952) *Hartland Point from Boscastle,*
1941 Oil on canvas 23in × 33¾in (Tate Gallery, London)

founder member of the group, had originally copied pictures by Velasquez in the
Prado, and had begun as a naturalist painter with a very skilled grasp of tone. But
Fry's 1910 exhibition altered his life and vision. He went off to Paris with Charles
Ginner to study Impressionist and Post-Impressionist pictures and in van Gogh's
manner began to use thick impasto and strong colour instead of thin paint and
restrained tone. Moving to the new garden suburb of Letchworth he let his house
there to his friend Spencer Gore, but his new lifestyle and attitudes broke up his first
marriage and cost him his job at the Westminster Institute. Becoming a Socialist as a
result of hostility, he paradoxically developed a deep dread and distrust of society
while producing urban rather than rural landscapes, and so did Spencer Gore. It was
a behavioural pattern of absurd contradictions increasingly typical of artists as the
century advanced.

His friend Spencer Gore (1878–1914) had been seduced to Neo-Impressionist
colour theory by Lucien Pissarro, reinforced by a visit to France in 1907, and after
the 1910 exhibition became inspired by Gauguin, Cézanne and Matisse. Although
he lived in London he travelled from it during the summer and autumn and his

'suburban landscapes' at Letchworth in 1912 are among the first of what was to become a great twentieth-century genre – the suburban picture. This was a blend of town and country landscape executed on a Francophile colour theory, and the bright flowers, sloping red-tiled roofs, the identical but well-spaced houses and mature trees rising among the chimneys were to become perhaps the most prevalent landscape essay among young middle-income art students well into the 1960s: it could be summed up as 'the view from my bedroom window'. But at the time, Letchworth Garden City and Gore's view of it was experimental, not the norm.

Free of older constraints as they were, Gore's pictures had other, equally firm disciplines. His idea was to group the colours found in the real or natural world into patterns, and reduce description to block-like, geometric shapes. But this was never arbitrary, and was always the result of strict and careful observation. He owed this as much to Sickert as to Cézanne and Matisse.

Walter Richard Sickert (1860–1942), son of the painter and illustrator Oswald Sickert, never painted directly from nature. Dressed sometimes like a Regency buck, sometimes as a Norfolk farmer, he wrote letters to *The Times* on the problems of kilt-wearing and the quality of fresh herrings, but his painting was as methodical and sophisticated as his persona was calculatingly eccentric. Careful preparatory drawings preceded working out a scale of tones for a particular colour scheme. He often gave his canvas a warm undercolour and then made up a patchwork of tones and tints over it, often using photographs and expanded parts of them to build up and rearrange what he saw. And what he saw and painted was often from windows, both urban and suburban. His interest in city scenery came to bear on Robert Bevan, a member of his Fitzroy Group and the later Camden Town grouping which he helped to form in 1911.

Robert Polhill Bevan (1865–1925) exemplified the British artist with a 'group and colony' lifestyle alternating between the town and country in the first two decades of the century. Influenced by Gore's Letchworth pictures, he was also encouraged by Sickert to paint London scenes, and embarked on many pictures of urban cab-yards and horse-sales while also painting with Charles Ginner and Spencer Gore in the Blackdown Hills. He abandoned making colour sketches in oil from nature and worked from squared-up drawings in his studio. Originally, he had painted in a dabbing, *pointilliste* technique, like a multi-coloured snowstorm, but his pictures gradually became more geometric, like Gore's. This change had nothing to do with the subject of the picture, urban, suburban or rural: it reflected a philosophy about painting, an exploration of style. Whether Bevan was picturing a ploughing scene on an Aberdeen farm or maples in Sussex, what mattered was the particular colour and pattern the subject offered, not its merits as a description of a way of life or any other message. Certainly Bevan greatly enjoyed painting horses, not because of their role in the world – rather because of their shape.

It would be easy to argue that this was the case with all London's Camden Town painters after 1911, and the artists of the Bloomsbury Group, such as Duncan Grant and Vanessa Bell. Certainly, their landscapes are a revelling in design, and it is hard to tell what time of day they are meant to be, whether they were made in cloud or sun, on times even what season they portray. They look disinterested as the view of a juror should be, a balancing up of what is revealed to the artist. But this deliberately objective attitude to landscape – one is tempted to describe it as a pose – is fundamentally unconvincing. To argue that landscape had become *merely* a

pattern to their objective gaze does not explain why so many of them chose to live in the country, not in the urban hinterland of their groups and clubs. Halfway and more towards geometric abstraction in their pictures by the eve of the Great War, this *ersatz* 'a-humanity' fell apart with the impact of the war as almost all these artists changed their way of seeing to a more emotional and 'realistic' view of the land after it.

Vanessa Bell (1879–1961), daughter of the literary critic Sir Leslie Stephen and sister of the writer Virginia Woolf, typified the ambivalence of the talented, avant-garde London-based socialite towards English landscape at this time. After visiting Paris she founded the Friday Club in 1904 to encourage a 'painting atmosphere' in London; she met Roger Fry in 1910 and his two great Post-Impressionist shows radically altered her own painting style, so that she produced a run of pictures where all the forms were simplified to large blocks; but she began to spend longer and longer periods in the country. Once there, she succumbed to that obsession for painting haystacks which typified so many city artists alone with something which looked conveniently like a house but was indisputably agricultural. Pictures such as *Landscape with Haystack, Asheham* (1912) with an exactly central pentagonal hayrick, are rather heavy-handed, deliberate violations of the conventional off-centre layout and, although Vanessa Bell's skill as a colourist transcends this compositional bludgeon, there is something basically pompous and ludicrous about this portentous heap of straw which borders on comedy. The antithesis of the Pre-Raphaelite obsession with tiny detail which had begged the question 'why *this* particular tuft of grass?', such pseudo-intellectual geometry still invites the query: 'why *this* hayrick?' and, if only for the shape, 'why a hayrick at all and not a pentagon, and why go all the way to Asheham to paint it?'

Vanessa Bell could scarcely be described as an '*enfant-terrible* who was yet to find her true vision' by that time. She was a highly privileged woman of 33. Fashion, rather than conviction, was obscuring her talent as a subtle, rich colourist, and she moved steadily away from it into a more naturalistic idiom; as she did so, she painted the garden landscape where she lived more and more, and although she gained a (mixed) reputation for all forms of china, fabric, book jacket and interior design, her landscape painting steadily transcended fashion for more personal interests and conviction.

So it did with Duncan Grant (1885–1978), with whom Vanessa Bell lived and worked throughout her life after she had left the critic Clive Bell in 1915. After Fry's exhibition Grant had embarked on a bonanza of experiment that culminated in a brief period of abstraction. Following the Great War he returned to a brightly coloured Impressionism where the actual shape of the brush marks formed patterns which wove the composition together, echoed by rhythmic repetitions of shapes. With Vanessa Bell his art became increasingly decorative, and the foundation of that stemmed from his time with the Omega workshops before and during the Great War.

On the eve of the war this same pull of landscape away from a hybrid flirtation with geometry was evident among all the Fitzroy Street artists, especially Charles Ginner, William Ratcliffe and Matthew Smith. But its two leading exponents did not live to see this run its course. Gore died of pneumonia in January 1914, and his Letchworth companion Harold Gilman was to die in the great 1919 influenza epidemic while a war artist painting for the Canadian Government. In 1914 Gilman and Charles Ginner had attacked the decorative tendencies already drifting into

Post-Impressionism. Ginner had written that: 'The creative power has always been realist: each age has its landscape. . . . Realism, loving life, loving its Age, interprets its Epoch by extracting from it the very essence of all it contains . . . according to the individual temperament.'

Gilman's and Ginner's geometric forms had been based on an analysis of what was really before them. But many artists following this shift of style used such schemes as little more than arbitrary decorative infilling. There was no conviction in their use of them, just a feeling it was all, literally, 'the right form'.

Insight or Creeds, 1912–80

The Cubism of the French and the machine men of the Italian Futurists circled the periphery of British art at the time of the Great War. Futurism was basically the spawn of a naïve infatuation with aggressive technology, and many of its practitioners were Fascists by the late 1920s. The English rural and suburban landscape by contrast was organic and humane and its green irregularities (all the greener and more replete with livestock after the farming specializations of the 1880s) demanded a response from a Futurist painter beyond the limited mechanical scope of his vision. He could not come to terms with it, so he ignored it and claimed it was 'irrelevant'. Ethelbert Basil White (1891–1972), a highly talented painter, dabbled typically enough in Futurism at the innocent age of 22. With the fresh young C. R. Nevinson he jointly painted the outsize *Tum-Tiddly-Um-Tum-Tum-Pom-Pom* for the Hampstead Heath Fair of 1913. But White moved steadily away to other pastures. By 1934 he was a member of the Royal Society of Painters in Watercolour.

Cubism, a far more intelligent response to the world because it attempted to increase the scope of seeing, rather than trying to submerge humanity beneath humanity's by-products, made some modest progress in Britain after the Great War. Because Cubism was concerned with exploring the space between objects, it could attract a painter who was interested in landscape. David Bomberg (1890–1957) made his reputation as one of the most original of English Cubist painters, and before and during the Great War produced angular, splintery compositions which resembled exploding or expanding forms like live concertinas. But they did not survive the war. By 1923 Bomberg had discovered he could picture not only the forms of landscape but his emotional reaction to them by broadening the type of brush stroke he used, and letting the paint swirl in a freer, or 'painterly' manner. Until the 1950s, his paintings went on developing in that way. Bomberg was anyway too emotional an artist to remain tied to the Cubist credo, and landscape is productive of emotion.

The reaction of Edward Wadsworth (1889–1949) to the world was cooler, and, trained as an engineering draughtsman, he tended to see landscape with an architect's rationale. He enjoyed imposing order on an organic thing, and his affinity for tempera paint with its crisp, clear colour and sharp outline did not sit easily with soft transitions and blending atmospheric shapes; still-life objects set in landscape attracted him. So did Cubism. Initially associated with the Rebel Art Centre of Wyndham Lewis, Wadsworth later shifted his interest to marine objects,

Albert Houthuesen (1903–) *Maes Gwyn Stackyard*,
1935 Oil on canvas 36in × 48in (Tate Gallery, London)

but his early Cubist landscapes, such as *Buxton Village* (1922), could sum up the tight, almost toy-like atmosphere of the small hills and tucked-in nuclear villages of the traditional English landscape.

This landscape, by its sheer variety, was seductive to realists, and this realism blended with Cubism in the pictures of Mark Gertler (1891–1939) during the winter of 1912–13. In 1916 it flowered into *The Merry-go-Round*, a masterpiece on the farcical and tragic wastage of the Great War. In the 1920s Gertler eased into a gentler, melancholy style of landscape picture, which partly reflected the uneasy twilight of ambitions after the war together with his own unhappiness.

He had been unfortunate enough to fall in love with the painter Dora Carrington, who had become part of a largely literary circle, and was herself hopelessly infatuated with the homosexual essayist Lytton Strachey. Gertler had also contracted tuberculosis, and from the mid-1920s his illness and useless relationship with Carrington sapped the vitality of his work; after her death, his career declined into twilight, and with the shade of another war looming, he committed suicide in 1939 at the age of 48.

Dora Carrington (1893–1932) rarely painted landscape, but when she did so achieved a naïve and poetic vision which shared elements with the decorative work of Duncan Grant and Vanessa Bell. But there was a symbolism she possessed which owed nothing to fashion or decoration: much of it stemmed from the influence of Mark Gertler and John Nash. Such a view of landscape was the antithesis of Cubist quasi-objectivity; it was a direct mirror of the emotions in such a way as to make

them accessible without being a literal narrative of event. *The Mill at Tidmarsh, Berkshire* (c.1920) with its two black swans upon the mirror of the stream, which flows under the mill house through a dark central aperture resembling pursed lips or a sexual orifice, records the place where Carrington lived with Strachey. In 1921 she married Ralph Partridge, living with him and Strachey in a three-way relationship, but was wholly dedicated to Strachey. 'How I love places,' she wrote, reviewing her pictures, '. . . my passion for a certain tree . . . the beauty of the mill at the back of the house (where) once a kingfisher dived from the roof into the stream'. Two months after Strachey's death she committed suicide, aged 38.

A founder member of Unit One in 1933, Paul Nash (1889–1946) was arguably the finest British landscape painter of the twentieth century, and the greatest war artist of his generation. He possessed a rare capacity in painting: to imply the presence of a higher or 'other' reality beyond that visibly present, and to do this by painting familiar subjects so that they are revealed as something new.

As a student, Nash suffered great difficulty with figure drawing, but was advised by Sir William Blake Richmond to concentrate upon landscape which he had drawn from an early age, especially his childhood haunts in the Berkshire Downs. These he invested with a sense of mystery, in which the clumps of trees evoked islands on the backs of Downs billowing in a state of flux like a heavy sea. This power to see 'into' landscape across a dimension beyond served him well in the Great War, when most of his contemporaries were attempting to bend their fashionable vision to encompass an experience beyond their terms of artistic reference. In pictures like *We Are Making a New World* (1917) his image of a landscape that was an enormous ocean-bed of clay swamped by a blood-red sunburst, still pregnant with a mutated life destined to rise out of the swamp, surpasses all the usual clichés of pro- or anti-war reportage.

The familiar world of his generation had indeed mutated by 1919, and he worked independently through the creative doldrums which becalmed much of the British art world during the 1920s, using the geometry of the sea and its timelessness to regain his emotional bearings. From the early 1930s onwards he began a sequence of paintings which are a celebration and study of the cycle of birth and death, a seasonal round which was mirrored in the actual geometric structure of the pictures, their titles, and their content. He used the method of 'object poems' to do this, placing an object such as a tree-stump or tennis ball in the very foreground of the picture, apparently of huge size, interposed across the main landscape. He would either draw it first and stick it temporarily to the canvas, or briefly attach a photograph of it, shifting it until the image satisfied him. Then he would actually paint the image in place, having used the manner of collage but gaining a far greater power from the increased unity formed by painting the object.

A cyclic imagery of birth, death and rebirth continued into the Second World War with pictures like the great *Totes Meer* of 1940–41: a windrow of broken aircraft evoking moths beside the sea, which would be renewed like the tides from the wreckage of its predecessors.

In the last years of his life (shortened by illness begun in the Great War) this cycle bloomed hugely in *Landscape of the Vernal Equinox* (1943), *Nocturnal Flower* (1944) and the *Eclipse of the Sunflower* (1945). As John Rothenstein has stated, these pictures were originally inspired by literary images, probably dating from the magnificent designs which Nash made to illustrate Sir Thomas Browne's 'Urne Buriall', some of the most beautiful book illustrations of the twentieth

Edward Wadsworth (1889–1949) *Buxton Village*, 1922
Oil on cardboard 25⅝in × 37½in (Bradford Art
Galleries and Museums)

century. Rothenstein quotes too Blake's lines which haunted Nash ever after:

> Ah, Sunflower! weary of time,
> Who countest the steps of the sun.

Paul Nash's talent and insight were too wide to be encompassed by any particular group or credo, while that of his younger brother John was a cooler one of concentrated insight less imaginative than his brother but more readily accessible.

John Northcote Nash (1893–1977) was best known for his book illustrations, and his preference for tilled rather than wild landscape. His early and well-known war pictures, *Over the Top* (a picture of the Artists' Rifles in battle in the snow) and *Oppy Wood*, display his power as an observer and illustrator, and such concentrated sight is continued in the geometrical power and grace of his famous *Cornfield* (1918), one of the most distinctive landscapes of the twentieth century.

Paul Nash (1889–1946) *Eclipse of the Sunflower*, 1945 Oil
on canvas 27⅞in × 36in (British Council/Paul Nash
Foundation)

John Nash's achievement, unlike his brother's, was to portray the rural land of
the twentieth century with sympathy and without sentimentality or nostalgia. He
preferred watercolour to oil paint as a medium, but his oils often possess a texture
which evokes the tactile quality of the land. Above all, he was able to see the
enormous complexity of landscape which often bewilders the observer, and extract
from it the essential elements which bring out its form and its atmosphere; many
illustrators revel in incident and diversion at the expense of the whole. In his *Frozen
Ponds* (1955) his acute vision has enabled him to reduce complexity to a simple level,
so that the picture has a feeling of grandeur.

John Nash developed this capacity early and reproduced images which mattered
to him, rather than pursued alteration or 'development' merely for its own sake.
His life was as quiet and substantial as his painting, devoid of avant-garde
histrionics and a superb study of the British landscape of the twentieth century.

The presence of the still-life object in front of a landscape, which had fascinated
Paul Nash, appeared again and again in the pictures of Ben and Winifred Nichol-
son, who had been members of the semi-Cubist, quasi-naïve Seven and Five
Society in 1919, and became founders of Unit One in 1933.

Painting in the wake of the Great War, the artists of the Seven and the Five
produced lyrical, deceptively simple landscapes which had a naïve appearance,

often with an almost toy-like charm, in which buildings could take on an air of stage-lit models. Frances Hodgkins (1870–1947) who produced some of her most vivacious paintings when she was between 60 and 70, excelled in this still-life-in-landscape mixture. Often painting the same East Anglian scenes as first pictured by Constable, she achieved a reputation in Britain only in her sixties, in contrast to her Seven and Five colleague Mary Potter (1900–81).

Initially, Mary Potter enjoyed such success in portraiture she distrusted both it and herself. She joined the Seven and Five not long after the group's formation, but left after two years, joined the London Group, married the BBC producer and author Stephen Potter, and along with the demanding social life bore him two sons. But she still went on painting, especially the Thames, and the Essex landscape, and after her marriage was dissolved in 1955 she chose to live and paint in relative isolation in Suffolk. Although never attaining the haunting vision and higher reality of Paul Nash's landscapes, her love of Chinese and Japanese ink painting, the delicacy and suggestiveness of the way she drew forms, pale colours and soft definition, gave Mary Potter's pictures a similar air of objects being symbols or façades, as if material reality was a transitory dream – of giant, fluctuating still-life.

That objects veiled higher things beyond the reach of the 'eye of the flesh' was a concept pursued by David Jones (1895–1974) in his landscape painting throughout his life. He began exhibiting with the Seven and Five in 1928, the year he started writing *In Parenthesis*, an epic poem on the Great War, through which he had fought with the Royal Welsh Fusiliers. Painting in rural and coastal Wales and suburban London, he insisted on the 'intimate creatureliness of all things', and although his earliest pictures owed a stylization to wood-cut technique, the style never obscured this central idea that landscape was alive, and to picture it was to explore its life, not merely to make patterns.

The deceptive 'wood-cut' simplicity of his early style was shared with Frances Hodgkins, Christopher Wood and Cedric Morris. Morris (1889–1981) who was later knighted, ran the small, prestigious East Anglian School of Painting, and owed something to Fernand Léger in the directness and semi-naïveté of his pictures. His crowded, almost toy-like landscapes of Brittany with their narrow, pastel-coloured houses under skies of thick, chunky paint so excited Christopher Wood that he visited the village of Tréboul and painted there on the strength of one of Morris's pictures.

Christopher Wood (1901–30) set out to recover the vision of a child in his pictures and, insofar as such a thing was possible for an adult, discovered the genuinely naïve art of the 70-year-old fisherman Alfred Wallis, whom he met while in the company of Ben and Winifred Nicholson in Cornwall in 1928. Wood was a friend of the French avant-garde, including Picasso and Jean Cocteau, in contrast to the Nicholsons who lived a non-socialite lifestyle, although he painted in the *faux-naïf* manner developed by Winifred and exhibited with the Seven and Five. Ben Nicholson (1894–1982) was deeply impressed by Wallis's asymmetrical, perspectiveless, plan-form pictures based on memories, and he formed from them a clear conception of everything perceived in nature as being a construction of the human mind, deriving its definition through the (filter of the) human understanding. This was the basis of abstract painting which he explored in his book *Unit One* (1934). From then on, Ben Nicholson pursued a path of the purest abstraction, which was partly fuelled by his relationship with the sculptress Barbara Hepworth, reducing all he did to a language of rectangles and circles. He became one of the

leading British members of the modernist movement until the Second World War. Then, as it had with painters in the Great War, abstraction and the hard edge of modernism cracked in the war years, and he returned to landscape in which the foreground was filled with serene, still-life objects which sometimes approached abstraction. For the rest of his life this pertained, the landscape sometimes so simple as to be an olive green rise in the lower third of the canvas, striated with hedge shadows, and the rest a silver-grey void whose subtle shades revealed the distant weight of hills. At other times – sometimes on a window ledge as if the 'interior' mind were reviewing the nature of objects – abstract still-life occupied about half the canvas, and seemed to be absorbed by or growing out of a realist landscape beyond, the familiar 'apparent' world the artist and others chose to see beyond.

Winifred Nicholson (1893–1981) was the granddaughter of George Howard, one of the Etruscan School painters of the 1880s. After her marriage to Ben Nicholson in 1920 she had spent her first three winters painting out-of-doors in the snow. The vivid reflected light she experienced led her to see colour as a series of veils with iridescent qualities: an idea she was to develop in her abstract pictures of the 1930s after she had abandoned the naïve, poetic style she had earlier practised throughout the 1920s with the Seven and the Five group. But with the onset of war in 1939 she resumed landscape painting, and flowers and objects of close intimacy occupied the foreground of these pictures. Like those of Paul Nash, a mysticism pervaded them, and direct light in sunbeams or filtered light on the margins of storm, such as rainbows, assumed a significance to her, which mathematics and 'the company of star galaxies and their orbits' had seemed to occupy in her abstract pictures of years before.

When Ivon Hitchens (1893–1979) moved away from the quasi-naïve style of the Seven and Five to the abstractions of the 1930s his journey, like that of so many of his colleagues, was short-lived. He returned to landscape painting in 1937, and when his London home was bombed in 1940 the Sussex countryside came to dominate his pictures. They never moved into that mystic realm entered by many of his contemporaries, but their abstraction mellowed with broad sweeps of paint, suggesting the colours and the shades and mass of the land. Reflections of pools were patches of colour one or two tones removed from the colour causing the reflection, and Hitchens left areas of canvas exposed near the edges of the main colour masses which often increased the vividness of the colour and gave a sensation of space. These semi-abstract paintings reflected the seasons and the effects of distance, not the literal appearance of the land, and the changes in them were of increasing brightness. The war years were softer and more sober; in the 1950s they grew more vivid; in the 1960s, strident.

Surrealism and the landscape of dream appeared among the artists of Unit One in the late 1930s.

In 1928 the pictures of Giorgio de' Chirico had appeared in an exhibition in London. With their long, poignant shadows, infinitely receding landscapes, serried colonnades, dreaming, anonymous manikin figures and eerie mingling of the uncanny and mundane all viewed through an exaggerated form of vanishing point

OPPOSITE ABOVE William Nicholson (1872–1949) *On the Downs* Oil on canvas 23½in × 20⅝in (Leeds City Art Galleries)
BELOW Ben Nicholson (1894–1982) *1930 (Cumberland)* Oil on board 17¾in × 21½in (Crane Kalman Gallery)

John Armstrong (1893–78) *A Farm in Wales, 1940*
Tempera on panel 25in × 20⅛in (National Museum of Wales)

perspective, these pictures were the Italian equivalent of Surrealism. They excited
the tempera painter Edward Wadsworth and showed him a way of giving a
mechanical object a sense of presence and mystery in a landscape; but Wadsworth
was more interested in the marine shore than inland. It was John Armstrong
(1893–1973), a tempera painter of great technical skill but of more imagination than
Wadsworth, who responded most vigorously to de' Chirico's poetry. He had
achieved a reputation in the 1920s as an interior decorator, designed sets for films
and theatre, and many theatrical conventions always remained in his art. In 1931 he
produced costumes and scenery for *Façade* by Edith Sitwell and William Walton
and in 1932 designed Shell posters. But his attitude to landscape was essentially

poetic, and in the late 1930s it became increasingly like a still from a filmed dream. This vision had no bearing on the British landscape *per se*, and was almost an international language explored by Surrealism; the infinite plains of Yves Tanguy and the ivy shrouds of Paul Delveaux had literal equivalents in Armstrong's pictures. But the difference lay in Armstrong's preoccupation with 'natural' or 'organic' images in Surrealism: the destruction of natural beauty, and the pervading callousness towards the natural world and landscape became his prime concern in later years, accentuated by his service first as an artilleryman and then an official artist in two major wars. During the 1950s he became a vocal opponent of nuclear weapons, seeing their long-term proliferation as involving a disastrous contempt for the world's physical as well as political well-being.

Like Stanley Spencer, famed for his Biblical parables in the Berkshire landscape, Armstrong was a method painter, beginning in the top left-hand corner of a picture and finishing each part as he progressed, while arranging the precise details of the natural world into a dream-like configuration. His fellow surrealist Thomas Lowinsky (1892–1947) shared both Armstrong's naturalist interests and illustrated many books. He helped to finance scientific expeditions to the Himalayas which brought back plants with which he experimented as subjects of his paintings. The minute observation of flora in his Surrealist landscapes reflected his own concern for the living world beyond the boundaries of art movements.

Edward Burra (1905–76), a member of Unit One in 1933 and contributor to the Surrealist exhibition of 1936, covered his landscapes with lush, tropical growth similar to the opulent, brooding forests of the French naïve Rousseau. By the late 1930s this Romanticism had gathered to menacing, sinister pictures which shared

Edward Burra (1905–76) *The Tunnel*, 1965–67
Watercolour 30½in × 51in (Mr and Mrs George Melly)

their apprehension with the dark wilderness of the German Surrealist Max Ernst. Indeed, Surrealist landscape in Britain possessed a Neo-Romantic quality which rarely included the grotesque, dream (or nightmare) machinery which Surrealist painting and construction often sported on the continent. John Tunnard (1900–71), dubbed the 'Heath Robinson of the Constructivists' in 1939, was an exception, and throughout his career he combined natural forms with technological shapes; Ceri Richards (1903–71) produced collages which evoked a blend of the work of Kandinsky and Ernst, and his Welsh landscapes of the 1940s displayed the corrugated strokes created by wiping off paint from canvas with sharp wooden or steel edges. It was a fretful effect, as though the textural nature of the world was fluctuating between water, iron, air and earth, and evoked a decomposition and recomposition of a world where the structures of the conscious mind imposed an arbitrary order.

Tristram Hillier (b. 1905), began painting with the lyrical, decorative exuberance of the Bloomsbury painters. But in 1932 economics compelled him return to England from France, and Surrealism which burgeoned into an illusionistic style of almost *trompe l'oeil* dimensions replaced his previously soft romantic decorativeness. In 1933 Frances Hodgkins dropped out of Unit One and Hillier took her place. With him British Surrealism became almost an establishment art, and he was elected a Royal Academician in 1967. It was a curious turn of events for a man who embraced an art form originally allied to continental communism.

Tristram Hillier (1905–) *January Landscape, Somerset,*
1962 Oil on canvas 20in × 24in (Harris Gallery, Preston)

Commerce and Realism

Yet beyond the currents of the Society of Eight, Fitzroy Street, Camden Town and Bloomsbury Groups, Seven and Five Society and Unit One, there remained a strong and steady current of Realist landscape painting in Britain throughout the inter-war years.

This current carried along with it artists as diverse as Sir William Nicholson and Stanley Spencer; it ferried the great etching boom, and produced a resurgence of watercolour painting. Commercially it gave illustration to the great spate of motoring guides and the poster art of the national travel networks.

Sir William Nicholson (1872–1949) had begun his career as a theatrical poster designer in the 1890s, in a duo known as 'The Beggarstaff Brothers'. His career became typical of many establishment artists. He entered book illustration, and began to exhibit oil paintings which attracted the favourable attention of Whistler, who influenced him. By the 1920s he had established himself as a successful portraitist. That earned him a knighthood. For the theatre he designed the original settings for *Peter Pan*. But his landscape art remained subtle, Whistlerian, and a celebration of space and light. His touch was impressionistic, gentle and calm, and Nicholson's taste for open downland views saw the English landscape as containing a tranquil, ordered freedom and clear, far-reaching, wind-blown intimacy.

This mixture of landscape and portraiture was fruitful for an establishment artist. As the artist Henry Watson (1871–1936) wrote: 'The landscape painter draws with more appreciation of line after he has drawn from life. Unless one perceives beauty of line throughout nature, there is a commonplace quality to the work.'

Influenced by Degas whom he had met in 1892, Sir William Rothenstein (1872–1945) painted with the quiet realism which reflected Watson's belief. One of the most distinguished painters of the Cotswold landscape, which he was always reluctant to leave, he shared with Sir William Nicholson and Sir William Orpen an experience of portraiture and a tendency to work from drawings and preliminary studies rather than painting landscape outside in the *plein-air*.

William Orpen (1878–1931) was the most successful portraitist in England in the 1920s, earning the formidable sum of £35,000 a year. He had been a superb recorder of military life in the Great War, but in landscape he found working direct from nature very hard. Many critics doubted that Sir William Russell Flint (1880–1969) worked direct from 'live' landscape at all. Formerly a medical illustrator and then designer for *The Illustrated London News*, he became a prolific etcher, book illustrator and watercolourist, and had a great reputation as a technician. In *British Watercolour Painting and Painters of Today* (1931) he explained a deceptively simple cloud or skyscape might have as many as five or six colour washes which could be taken for one. Such frank statements did nothing to allay the suspicion that Flint's work was long on technique for effect and short on sincerity of observation and feeling. But what all these artists shared was a relatively timeless view of the English landscape. They portrayed it as a man-manicured place whose natural features were enhanced by its tillage, the exhilarating downs punctuated by their neat clumps of trees that were so responsive to the shape of the brush. Like the human body in the society portrait it could be coolly erotic, and it sat comfortably for its portrait.

So too it sat for the witty and sensitive Philip Connard, Algernon Newton, Rex Whistler and Paul Fripp. In their pictures the landscapes of the eighteenth, nineteenth and twentieth centuries blended smoothly as they did for the increasing

flow of urban and suburban tourists who throughout the 1930s viewed the landscape at weekends from their family saloon, or bicycled or strolled resolutely around it with rucksack. Philip Connard (1875–1958), portraitist, illustrator, textile designer, marine war artist and muralist, brought an eighteenth-century brand of panache to his landscapes. They were decorative, vigorous with the late Impressionist brushwork of the 1890s, and full of the social narrative of costume, pose, and personality. He shared this élan with Rex John Whistler (1905–44), a brilliant illustrator and poster designer who was killed with the Welsh Guards during the Normandy landings. The landscape which Rex Whistler painted was designed to coax the urban motorist out of the city on behalf of Shell, and mirror the world described in Beverley Nichols's writings on rural life. It was the rolling farmland bounded by eighteenth-century hedgerows, English elms, coppices, sleepy spires and villages at the end of leafy lanes; often filled with incident, and bounded by a blue blade of hills on the horizon; archetypal georgic England.

Rex Whistler shared Shell's georgic task with Frederick Griggs, Roy Badmin, Rowland Hilder and numerous artists working for the railway companies during the 1920s and '30s. Stanley Roy Badmin (b. 1906), watercolourist, lithographer and engraver, concentrated on portraying the English village, its life and architecture. Shell's *Country Paintings* appeared by him in the 1940s, perpetuating the regional character of the landscape in amalgams of flora, geology and architecture, reinforcing the image of the English idyll viewed always through the eyes of the tourist, the historian, the antiquarian – but always an essentially sympathetic outsider: a picturesque collation and visual naming of parts.

This georgic imagery also seduced Algernon Newton (1880–1968) who was little concerned with advertising. In his late thirties, after the Great War, he came under the spell of the pictures of Richard Wilson and Canaletto at the National Gallery, and this led him into painting many scenes of London; these were often delicate translations of early evening light with a precision which necessitated the use of thin, semi-translucent oil paint. But in 1928 this Canalettan cityscape was ousted by the classic georgic idyll in *Dorset Landscape*, and for the next 30 years Newton maintained this vision of the English countryside executed with an eighteenth-century grace.

Artists of the Cheltenham Group often shared this vein, typified by the careful, delicate watercolours of Paul Fripp (b. 1890) whose views of the Cotswold country, if lacking any irony, were a more accurate record of an area poorly served by modern communications and technology than an urban critic's cynicism might have conceived.

The deaf–mute etcher and illustrator Leonard Russell Squirrell (1895–1979) maintained much of the discipline and method of John Sell Cotman. Squirrell worked largely in East Anglia and the Lake District, and the public knew his work mainly from railway carriage panels. Squirrell shared his style and the influence of Cotman with another railway illustrator, Charles Knight (b. 1901), who painted Lancashire scenes. The traditionalism of these two artists was significant in that they dealt primarily in advertising and used the approach of the most subtle of watercolourists.

Harry Epworth Allen (1894–1958) found his favourite subject, the Peak District, difficult of access after he lost his leg in the Great War, but his pictures of the Derbyshire landscape, mostly in tempera, belied it.

In Scotland, James McIntosh Patrick (b. 1907) achieved a wide and lasting

Algernon Newton (1880–1968) *Landscape* Oil on canvas
board 9¹⁵⁄₁₆in × 13¹⁵⁄₁₆in (City of Bristol Museum and
Art Gallery)

reputation with his minutely detailed, georgic pictures of the Angus landscape, in
which all the season's agriculture, its tasks and activities were described over wide
vistas which, although often compared to Pre-Raphaelite fineness, more often
resemble the 'seasonal' landscape pictures of Pieter Bruegel. Like Fripp and Rex
Whistler, Patrick did not deliberately have to omit tractors and telegraph poles
from these scenes before the 1950s: such regions rarely contained them; and he
practised greater realism than such seductive pictures imply, painting outside in icy
conditions with a stove to keep his paints workable. Later, when certain twentieth-
century developments intruded into the vista he asserted his right of positive
discrimination by refusing to paint them.

Similar views of the Kentish landscape made the reputation of Rowland Hilder
(b.1905) who began his career illustrating books including Mary Webb's *Precious
Bane* (1929). By 1935 he was well known for his work for Shell, particularly for his
dramatically lit watercolour pictures of rural England. His images of Kentish
oast-houses under the evocative cloud shadows and sun-pools have become
archetypes of 'home counties England'.

Hilder owed his dramatic lighting technique to the etching instruction of Alfred
Bentley and Malcolm Osborne at Goldsmiths' School of Art during the 1920s. The
etching process deeply influenced many of the notable Goldsmiths' landscape
artists, particularly Graham Sutherland, Paul Drury, William Larkins and Robin
Tanner.

The rich shadows and atmosphere of etchings by William Larkins (1901–74)
owed much to Frank Brangwyn, and in 1929 were echoed in the deep contrasts used
by the film director Eisenstein with whom Larkins worked. They were shared by
Paul Drury (b.1903) in whom F. L. M. Griggs's influence was mingled with that of
Dürer and Rembrandt. Drury's view of landscape was deeply poetic with dramatic
cross-light, but it was rarely infused with the emotional intensity of Robin Tanner

Harry Epworth Allen (1894–) *Hathersage, Derbyshire*
Tempera on board 19⅞in × 25in (Laing Art Gallery–
Tyne and Wear Museums Service)

(b.1904) who attempted to combine Griggs's technical finesse with the vision and poetry of Samuel Palmer.

Palmer's influence on Graham Sutherland (1903–80), perhaps the best known of the Goldsmiths' artists, was very great. It amalgamated with his interest in Surrealism, a blending of the 'inner world' and an older approach to a 'higher or other reality' that made a powerful impression upon the other Neo-Romantic artists who were working in Britain.

Palmer's dreamlike vision and his intensity of light and shade combined with the influence of Frank Brangwyn to make Sutherland's pictures claustrophobic and dramatic even when they portrayed wide-open space, as though the artist was being drawn into the ground or the sky and the cosmos was descending to consume him. Etching attracted him as a process because of its tonal power, but when the print market suddenly collapsed in 1930, he took up glass design, fabric design, posters and painting. In 1934 he visited Pembrokeshire for the first time. There the landscape, a potent mixture of bleak stark uplands and deep lush valleys with enclosed and secretive lanes, huge skyscapes and cliffs, and a passing spotlight effect of sun, appealed as a visual metaphor of his Neo-Romantic attitude to the natural world. Rounded geometric patterning overlaid with organic, swirling forms became more marked as he experimented with this landscape's image, an appearance of emotion with observation accentuated by his friendship with Francis Bacon. His cocooned sleeping people – reminiscent of Welsh sheep in pens – which he made in the Tube tunnels of London in 1940 are really a continuation of this 'tunnel' world, as though sheep from the hills and people are one of the same, all

entering a cavern under the mask of the visible world to a deeper, other reality.

The print market, which had largely replaced watercolour as fine art of modest price, collapsed in 1930, with the onset of the Great Depression. In the meantime, watercolour art began a resurgence spurred by artists who had gained experience in the poster and print market. This had created an exuberant, unfussy, straightforward style often using texture and patterns shared with wood-cut processes. Centred on Edward Bawden and Eric Ravilious, and linked more by their geographical proximity to one another than by any similar style, the artists of the Great Bardfield Group played a significant role in this watercolour renaissance.

Edward Bawden (b. 1903) often employed a hatching technique which gave his watercolours the look of woven fabric and their bold, elegant geometry was echoed to a more dramatic extent by Eric Ravilious (1903–42). Both had come under the influence of Paul Nash at the Royal College, but Ravilious was also very impressed by the work of the Italian Primitives. He was more interested in wood engraving than in any other medium and it affected the way he used watercolour, giving his paintings an angular, chipped appearance where forms, such as trees, boats and birds were symbols, immediately recognizable but rarely identifiable as any specific type or species; they were archetypes. Often, too, like those of Paul Nash, they were observed through an opening in something, such as a railway carriage window as in his famous *Train Landscape* (1940), made two years before he was

Eric Ravilious (1903–42) *The Wilmington Giant*
Watercolour 17⅝in × 21⅛in (Victoria and Albert
Museum)

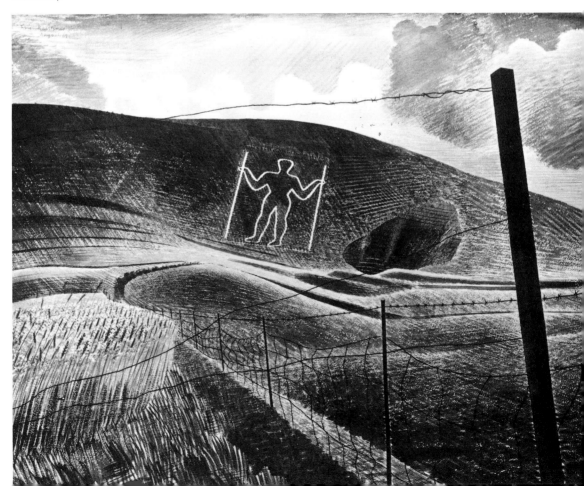

killed when flying with the R.A.F. In his 'semi-primitive' style the land and cosmos take on a toy-like appearance, or an aperture view like a dream of archetypes, with mountains like spear-points, moons and planets like golf-balls, stars like fireworks.

The posters to which the watercolour revival owed so much were a robustly georgic creation of the railway companies. By the definition of advertising, there was a completely unashamed tone to the escapism of their invitingly idyllic product – the landscape – and the artists who produced the posters were doing just what the Prospect painters of 250 years before had done. Artists like F. Gregory Brown, Frank Newbould, Fred Taylor and the ubiquitous Edward McKnight Kauffer (1890–1954) had previously set the format during the 1920s.

Formerly Brian Cook (b.1910), Brian Batsford held a similar influence. The brilliance of the colour in his work, using the Jean Berté printing process with hand-cut rubber plates and watercolour inks, became the trademark of the *Books on Britain* series. The image of Britain which he produced for his railway designs and book illustration achieved an authority precisely because of this distinctive colour and stylistic energy. His seductive ink-drawn illustrations for the *English Heritage Series* reached a wide market in the United States, and the image of Britain which it sold there was a self-perpetuating necessity for the 'landscape illustration'. It created an idea which, as later tourism discovered, needed to be maintained by those places which had been so presented.

But the Great Bardfield Group was often better acquainted with the reality of their subject than the poster artists. One of them, the poet Thomas Barclay Hennell (1903–1945), an accomplished watercolourist and illustrator, was also an expert in farm practice. His loose, light, vigorous watercolour pictures brought him a commission as a war artist in 1941, and as such he served all over Europe and the Far East, only to be killed in November 1945.

This intimate knowledge of farmed land was shared by Gilbert and Stanley Spencer and Charles Tunnicliffe. Gilbert Spencer (1892–1979) painted possibly his best-known picture *A Cotswold Farm* (1931) from this standpoint. Spencer's concern with the landscape was underpinned by a genuine rather than picturesque interest in country life, much in the manner of his brother Stanley. In 1920 he and his brother had stayed with Henry Lamb in Dorset, and he continued to return there throughout the following decades. Apart from illustrating books by the Dorset writer T. F. Powys, he was also concerned with the actual practicalities of tillage, mirrored in his work in *The Progress of Husbandry* (1963). From 1932 he was the Professor of Painting at the Royal College of Art, and his concern with working landscape guaranteed as far as possible that during the 1930s the perception of landscape as an art form was not dismissed by students as an 'irrelevant' or 'reactionary' indulgence among the urban concerns of Surrealism and much abstraction. His landscapes enjoyed wide critical praise. His portraits of named places were usually stronger than his assemblages of elements to form imaginary scenes. They are often of great beauty, such as *Garsington Village* (1924), *Stour Valley* (1927), and *Little Wilton, Burden* (1933). His style began as linear, then gradually colour became as important as outline but never supplanted it. This combination of rural understanding amalgamated with painterly strength, explaining why for him the 'real' was more potent than the imagined: 'You see *me* moving around, in search of the best viewpoint, but you don't see me moving *trees* around. My imaginary things are entirely imaginary. I couldn't *imagine* something in a real place.'

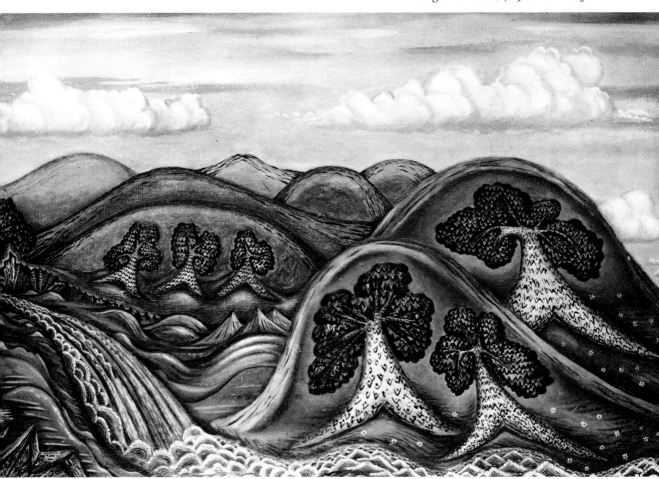

Cecil Collins *Landscape with Hills and River*, 1943 Oil on canvas 20in × 30in (Sir Michael Culne-Seymour)

OVERLEAF Evelyn Dunbar (1906–60) *A Landgirl and the Bail Bull* Oil on canvas 36in × 72in (Tate Gallery, London)

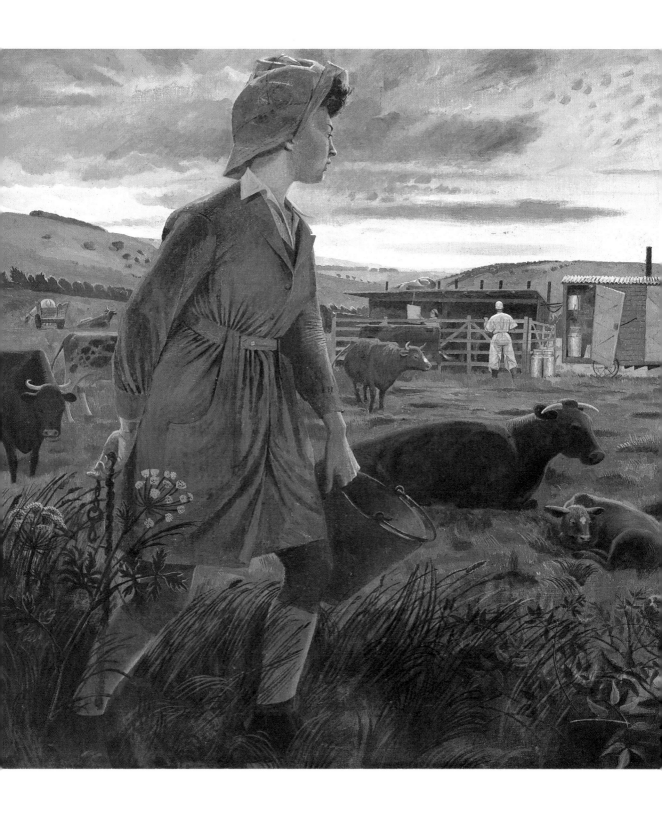

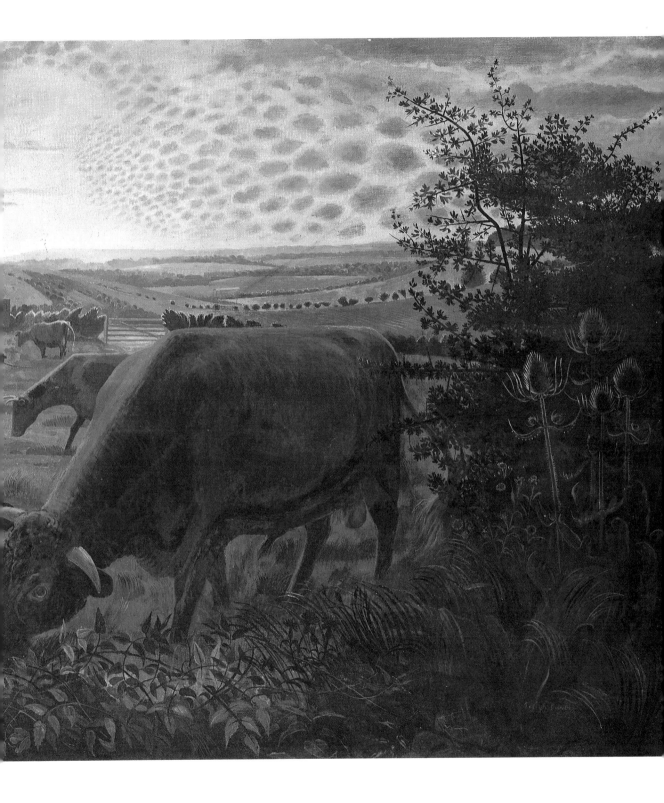

In this Gilbert Spencer was very different from his brother, for whom their original home was a stage-set for the image of another, deeply religious reality. Stanley (1891–1959) held the same mystical regard for the village of Cookham as Samuel Palmer had for his 'valley of vision' in Shoreham. He pictured the Bible stories which his father had read to him as taking place in the village and surrounding countryside, and created resurrection scenes there as well as *Swan Upping at Cookham* (1914–19); the whole picture filled with action and narrative. As an ambulance driver in Macedonia in 1915 and commissioned to paint ship-building at Port Glasgow during the Second World War, he found his ability to produce large, multi-figure compositions sharpened by both wars and his contemporary Biblical vision deepened by them; the result was that his pictures grew more claustrophobic, and the figures more rounded and cool-coloured, like medieval stone or misericord carvings. But for money, Stanley Spencer was often forced to paint open landscape. In this too he produced a unique effect, caused by isolating each element until (rather paradoxically) the mosaic of isolated parts formed a distinct whole. He was a method painter, working from upper left to lower right across the picture surface, completing each part as he went, and the intensity of this quasi-naïve technique and the quirky selectivity of his observation gave these pictures an air of intimate but oddly objective vision.

Distinct from the Thames valley mysticism of Stanley Spencer, the delighted narrative sight of Charles Tunnicliffe, the experiments of the Great Bardfield painters and the stylized paradises of the poster artists, a quiet realism had grown up among Claude Rogers, William Coldstream, Victor Pasmore and other artists of London's Euston Road Group, formed in 1937.

Yet this group held many contrasts. Claude Rogers (1907–79) was basically a Romantic. Originally, his pictures were similar to those of Cézanne and their organization was rather geometric. But in his late thirties he relaxed this into pictures like *The Harvest Moon* (1946) – significantly made during the Second World War – and by the 1950s *Burning Stubble Fields*.

By contrast, Victor Pasmore's art travelled in the opposite direction. Pasmore (b. 1908) began as a near-Romantic. He started as a clerk in the London County Council offices, painting in his spare time and studying the Impressionists, Turner, and Cotman. He had a brief flirtation with Fauvism, was elected to the London Group in 1934, received help from Kenneth Clark to pursue painting full-time, and helped found the Euston Road Group. In the 1940s his pictures resembled those of Turner and Whistler. But after the war the romance began to fade. In park scenes the geometry of trimmed trees, verges and paths hovers on the edge of abstraction. The colour in these pictures is limited to a play of greens and ambers, as though a picture was a plan for a relief sculpture catching the light with a single-coloured surface. In the often reproduced *The Park* (1947) the ghostly images of running children can dimly be seen, as if the landscape is a greater, permanent pattern and they are passing illusions.

After this, Pasmore went wholly into abstract work, became a leading member of English Constructivism, and tried to create an art which was not dependent on forms found in nature. In the 1960s this resolve slipped, and he reverted in paint to shapes evoking natural forms. William Coldstream, reserved and quietly representational, who was dispatched as a war artist to Italy in 1943, maintained his interest in natural forms. Coldstream's pupil, Lawrence Gowing (b. 1918) who was later knighted, largely continued this cool, almost reserved approach to landscape. To

Victor Pasmore (1908–) *The Snowstorm: Spiral Motif in Black and White*, 1950–51 Oil on canvas 47in × 60in (The Arts Council of Great Britain)

OVERLEAF Richard Eurich (1903–) *Men of Straw* Oil on wood 20in × 40in (Museum and Art Gallery, Nottingham)

him its natural shapes were as interesting as those which were wholly man-made, and they were a different rather than a 'better' series of colours and shapes to respond to. But by the end of the Second World War, there were elsewhere great contrasts to the work of the Euston Road painters.

These included the descendants of the Surrealists, such as Michael Ayrton, whose view of the British landscape owed nothing to the touristic georgic of posters or Constructivist abstraction. It was closer to Paul Nash's *Monster Field*, a mixture of anthropomorphism and acute observation, of seeing the landscape as a place where 'higher' or 'other' realities could be glimpsed, if not grasped, when the painting discarded all the cosy familiarity with familiar organic things.

Michael Ayrton (1921–75), novelist, art historian, critic, painter, sculptor, etcher, film director and broadcaster, had worked in de' Chirico's studio in the late 1930s, and retained a basically Romantic view of landscape from his involvement with theatre design. He shared it with Paul Nash and Graham Sutherland, and the tangled, monstrous roots and twisted, gouged hills he painted evoked Nash's pictures. Edward Middleditch (b.1923) shared with him such a realization that landscape and nature was 'miraculous and mysterious in itself' and so full of dramatic or lyrical effects that an artist did not need to impose such schemes upon it; they were already there. He had only to respond to them.

Whether the artist used this response to *reflect his own state of mind* was another matter. John Minton, Robert Colquhoun and Robert MacBryde, a trio whose

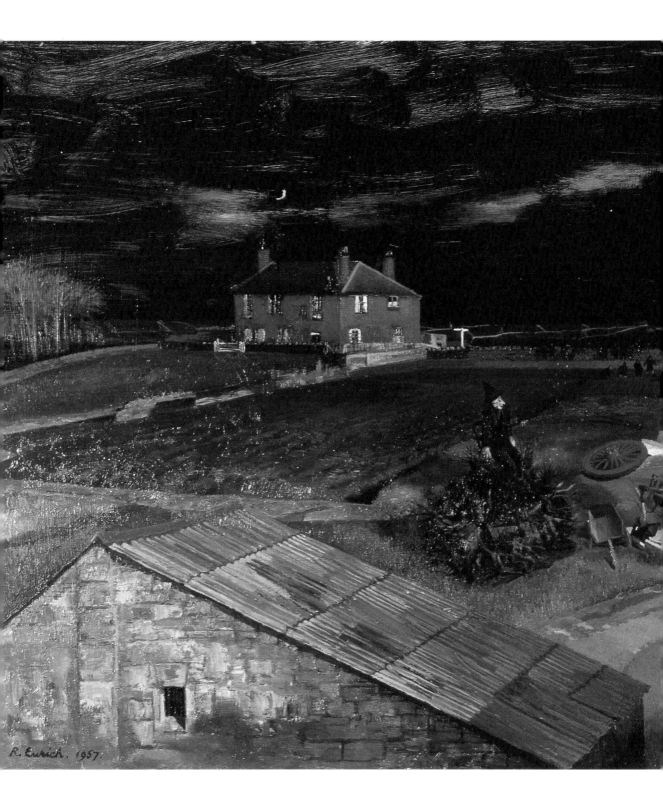
R. Eurich. 1957.

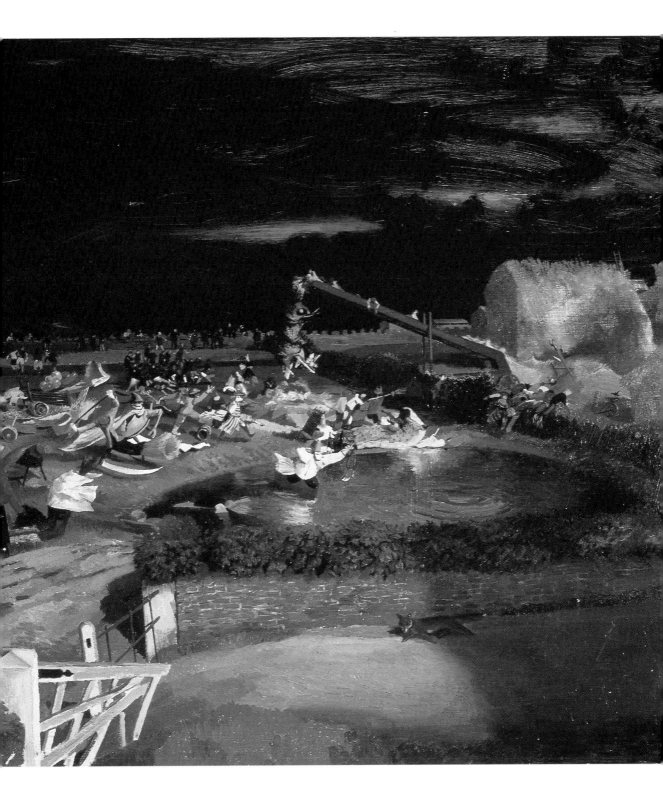

intense and unstable personalities were often quite incapable of dissociating emotion from observation, made landscape a collage of their own mental state. Colquhoun (1914–62) had initially admired the stylized incisive draughtmanship of Wyndham Lewis, and turned to the Post-Impressionists, Braque and Picasso. But mental collapse during war service in 1941, followed by driving by day and painting by night, left a deep sense of claustrophobia, anxiety and gloom in his pictures, such as *The Lock Gate* (1942). In this two semi-erotic male figures appear trapped in an entangled catacomb of gates while a great tide rises beyond. John Minton (1917–57) had originally been influenced by de' Chirico and he worked in the company of Ayrton and Middleditch. During the war he shared a studio with Colquhoun and MacBryde, and his pictures share their appearance of claustrophobia and acidic colouring – partly due to painting in false light. He also acquired various emotive devices from French Neo-Romantic pictures. Later this settled to a style that mingled the drawing of Samuel Palmer with that of Graham Sutherland. He also wandered about the London docklands, searching for some vision of urban romanticism that would no doubt have amused journalists like Joad. Both he, MacBryde and Colquhoun suffered alcohol problems; Colquhoun drank himself to death; Minton committed suicide; MacBryde was run over by a car he probably ignored deliberately.

Minton's abortive urban quest was better fulfilled by Alan Lowndes, Prunella Clough, L. S. Lowry, Carel Weight and Joan Eardley.

Alan Lowndes (1921–79), who originally trained as a decorator in Stockport, lived in St Ives after turning to full-time painting, and eventually settled in Gloucestershire; but until his death his paintings were still mostly of Stockport streets. Prunella Clough (b.1919) remained an urban painter apart from a brief three-year sojourn in East Anglia, an artist of 'signs and winking lights of the bypass, the dark débris of the industrial wasteland . . .' as was Carel Weight (b.1908). In fact, Weight shared with L. S. Lowry that bleak sense of urban loneliness which is usually one of the spurs driving artists into the country when they 'go after a landscape to paint'. It is as though the landscape existed 'out there' beyond the concrete margins, although most of their fellow beings still live within the concrete boundaries where their great great-grandfathers' generation brought them. What their pictures share is a sense of isolation from both places: of being an alien observer in the city and an alien eye in the open land. Weight's pictures of south London are a stylistic mingling of Edvard Munch and Stanley Spencer; he shares Munch's style of the neurotic face and the silent scream image with Spencer's wider religious conviction. L. S. Lowry (1887–1976) shared Weight's bleak observation, usually couched in a *faux-naïf* style of stick figures among factory chimneys. But Lowry, far from naïve with over 15 years of art school training behind him, sought the deserted landscape (as he also did the sea) and portrayed it with an almost extra-terrestrial gaze, revealing it as the surface of 'a planet', without all the arbitrary and anonymous concrete trappings which urban conditioning assumes 'reality' to be.

It is as the surface of the planet, rather than as a testament to a moral condition or touristic nostalgia that Joan Eardley, Roger Hilton, Peter Lanyon and Brian Wynter came to British landscape in the 1950s.

Joan Eardley (1921–63) spent many years painting portraits of children in the Glasgow slums, but she made her name with near-abstract images of the storms on the Scottish coast and the summer fields there. Her pictures are almost wholly

surges of colour, as the elements of water, air and earth meet and move. The personality of the artist is revealed in how she responds to that movement and translates it, and can make the atmosphere of that time and place visible to the observer. It is almost as one might suppose a gull may see: 'now the wet greyness hits the brown and there is white. The white goes thinner until there is more and more brown and then green. Above the green is more grey. That grey goes up and up into endless grey.'

Peter Lanyon (1918–64) described a similar thing in 1938. 'When I began to paint, the cliff edge and the winter storms put more pressure on me than I could absorb. My pictures became so wild, messy and dispersed that I was driven indoors. . . .' He said that he was 'immersed in landscape' and his abstract pictures of the early 1960s were a testament to this. Returning from war service with the R.A.F. he had sought out landscape as a form of constancy, literally the stable earth, and had pictured semi-abstract animal forms interlocked within it as synonymous of his marriage and children.

David Jones (1895–1974) *The Suburban Order*, 1926
Watercolour 15⅜in × 22in (Portsmouth City Museums)

Patrick Heron, Trevor Bell, Roger Hilton and Hilton's St Ives colleague, Brian Wynter (1915–75) all shared this absorption in making a 'sense of place' out of abstract paint. Wynter spoke of 'these elemental forces' entering the paintings and lending their particular qualities 'without becoming motifs'. Roger Hilton (1911–75) became a leading abstract painter of the 1950s. He explained that in his experience (although it sounded dangerously like playing with words) he moved from pictures which dealt with the illusion of space within their canvas area, to pictures which *created* space; one became aware of reality *around* the *outside* of the picture as one looked into the painting. It was a mechanism for making the observer conscious of space.

There was a variety of inherent contradictions in that, not least, in the rhetorical vacuity of giving a title *November* (1964) to a picture which is not apparently about anything other than what is outside it. The subsequently irrelevant title gets in the way and prevents understanding. But if one discards Hilton's cumbersome rhetoric, and sees his pictures as apertures from conventional, familiar 3D space and objects into a world where colours are forms, and space is in one or as many as eleven dimensions, and the essence of a season is summed up in colour, then one looks, literally, into landscape free of all the structures and divisions the rational mind imposes upon nature. One sees perhaps as an insect sees: without preconceptions.

The Poem without a Grant, 1960–80

For painters like Roger Hilton the later 1950s and early '60s fitted as a glove. Abstract painting was at a zenith, being an art of boom and affluence, and whatever preconceptions its *vision* denied, its *status* was loaded with preconceptions. It sat comfortably in boardrooms behind a director's chair because frequently it was a brand of 'visual white sound'. While remaining indisputably cultural, it could also be remarkably uncontentious if mutely toned and, with no obvious content to the layperson, easily ignored. In galleries this art commonly took its power from sheer size, and its size reflected the relative material plenty in the art world. Canvas and paint were cheap in the late '50s and throughout the '60s, and students too were plentiful: a rising birth rate and a rapidly expanding education industry eager to exploit it had altered the teaching of art – and the 'production' of artists.

The 1944 Education Act and the statutory right of students to a grant meant that for the first time thousands of people with enough ability to get into an art school – but not necessarily the ability or commitment to become artists – flooded into further and higher education. This led to an aberration probably unique in art history. Like their nineteenth-century forebears teaching watercolours, lecturers – who were generally exhibiting artists who taught two or three days per week – looked upon teaching as guaranteeing them a stable income; but their graduating students came to measure success as an artist not in producing art and exhibiting it, but in gaining an art school teaching post. To gain one, they produced hybrid work dependent wholly upon grant aid and state (or local authority) funding: as a result these mushrooming art schools took on the status of secular art monasteries, divorced from the rest of society – and the rest of art. This artificially inseminated avant-garde was of course acutely fashion-conscious within its closed world, and its pseudo-intellectual products naturally produced products like themselves, sometimes ignoring original but 'unfashionable' talent.

However, despite this nepotism and insularity, 1962 was a vintage year for

Thomas Monnington (1903–76) *Southern England 1944:*
Spitfires Attacking Flying Bombs Oil on canvas
40½in × 55½in (Imperial War Museum)

British art. A number of young painters with considerable talent and panache left the Royal College and their work began to appear in the London galleries. One of the brightest of these stars, David Hockney, a soft-spoken showman who had sported a gold lamé suit in the King's Road and whose blond-fringed baby-face behind its owl-framed glasses soon peered with benign mischief from the covers of the new Sunday colour supplements, passed during the decade from early pictures like *Procession of Dignitaries in the Semi-Egyptian Style* and *Landscape with Tired Indians* to big, sharp-focused, pastel-toned paintings such as *California Landscape* (1968) which had the same 'aperture outlook' as those of Eric Ravilious and Paul Nash 30 years before. Hockney, travelling from hotel rooms to California lounge and pool-side, constantly pictured landscape through curtains, round windows, plate-glass patio doors: the tone was of the suburban voyeur passing with only transient belonging through affluent glossy landscapes like flat-printed colour photographs, looking out from the not-always-respected privacy of a room where a sleeper lay, out on to a world enjoying the sun. By contrast, Adrian Henri reproduced the flippant urban confidence of the '60s in canvasses like *Christ's Entry into Liverpool* (1964) mingling facile social comment with a series of optimistic presumptions about the future, almost none of which would be fulfilled.

Hockney's pictures of the mid-1960s were in many aspects typical of their time. Like landscape painting as a form, they stood outside the closed, incestuous art school world which steadily and insidiously came to control so much of British art. But that bland affluence and complacency of broader society which they smoothly

reflected gave rise to a reaction among the middle-class adolescents born in the early 1950s and then entering higher education – or in the United States facing the Vietnam draft.

The art which attracted them was that which was most popular a century earlier among people who were their spiritual antithesis – they fell in love with Pre-Raphaelite painting which had attracted the Victorian industrialists. This paradox was not so wholly eccentric as labels imply. They were a generation whose parents had brought them up on the free-expression theories of the American psychologist Dr Spock; and the '50s' boom had made them probably the most materially over-privileged generation in European history – and, as they already possessed so much, one of the least motivated. Fashionable education theory ensured they were also among the least disciplined. Indignant right-wing and traditionalist left-wing writers equally described them as spoilt, decadent and naïve, an observation not wholly without substance. Their righteous indignation against this generation stemmed from its rejection – albeit typical of a generation used to material plenty – of the gross materialism embraced by both left and right factions of their society. Certainly with an almost poignant naïveté they idealized a society stripped of material greed and competitiveness, and *outside* the art school world this mannered counter-culture (comically *poseur* in buying expensively faded or 'distressed' jeans with poverty patches ready sewn on) found a visual synonym in the pictures of Lord Leighton, Rossetti and Burne-Jones. The Pre-Raphaelites, setting out to embrace nature as 'the pure untainted reality of creation', needed no élitist art-jargon to make them accessible; William Waterhouse had idealized the ancient rites of forest and pool in a Surrey landscape. The dreaming knights of Burne-Jones

John Tunnard (1900–71) *Departure, 1946* Gouache
15in × 22in (Alfred East Gallery, Kettering)

Graham Sutherland (1903–80) *Thorn Tree*, 1945–6 Oil
on canvas 50in × 40in (© Cosmopress, Geneva/DACS,
London 1988)

were in perfect accord with J. R. R. Tolkien's great campus cult success of the late
'60s, *The Lord of the Rings*, an epic adult faerie-story written largely in the 1940s.
These pictures appeared as posters on scores of thousands of bedsit walls in Britain
and America, reaching a far wider audience than they ever did in the life spans of
their creators. Their mood was imitated, on a trivial level, by photography's
latter-day answer to Alma-Tadema – the soft-focus, soft-porn photographs of
dreamy girls by David Hamilton. This air of dreamy, ethnic other-worldliness, a

Alan Reynolds (1926–) *Keeper of the Dark Copse II*
Oil on board 30in × 40in (Tate Gallery, London)

PREVIOUS PAGE David Inshaw (1943–) *She Did Not Turn*
Oil on canvas 54¼in × 72in (Private Collection)

rebirth of the craft movement throughout the provinces among middle-class
drop-outs, and the William Morris-inspired designs promoted by Laura Ashley
from 1973 onwards were a poetic equivalent to a rise in painting of a 'New Realism'
(meaning a fascination with highly detailed representational images) which in the
United States had developed into the eccentric hybrid of photo-realism, often very
large paintings made to look exactly like a photograph or copied from a photo-
graph. These took little root in Britain, but the reappraisal of Victorian painting by
young art historians like Christopher Wood rapidly displaced the dictatorial old
guard of what was starting to appear as an effete and grossly arid modernism.

The period c.1955–73, sometimes dubbed the Golden Age of British art educa-
tion, was more accurately the golden age of the grant-aided art school. It was
sensitive not so much to social critique as to financial pressure. In 1969 students in
metropolitan art schools were generally supplied with high-grade paper and other
materials free. Then, when economic recession was accelerated in 1973 by an
international oil crisis, the financial rug gradually began to slide from under these
establishments. Rapidly spiralling costs literally shrunk canvasses; paintings be-
came more 'precious' to the student because they were more expensive; students
laboured longer upon them *because* they were more expensive; the paintings became
more detailed because they laboured longer on them. Artists without subsidies
went through the same process even more rapidly. Their tone became less
confident – and less flippant. In place of *Christ's Entry* Adrian Henri began to paint

the crumbling remnants of Liverpool slums being demolished. This process accelerated rapidly through the 1970s – a decade the greater part of which became an uneasy twilight, an afterglow when the confidence of the '60s had burned itself out and many of the provincial art schools began to suffer recurrent evil dreams of bankruptcy and disillusion.

Landscape painting was less shaken by this insidious landslip in art academe primarily because – like marine art – it was not dependent upon institutions.

During the first half of the decade this changing mood of disillusion was caught in the dreamy landscapes of Richard Hamilton. These often beautiful pictures frequently sporting surreal detail possessed the melancholy atmosphere of Ford Madox Brown's *An English Autumn Afternoon*. Like Madox Brown's picture they appeared intensely material, minutely focused; others were infused with a poignant sense of passing time from which a moment was frozen. Chronologically they coincide with Adrian Henri's of a crumbling Liverpool after the euphoria, and Frank Auerbach's images of decaying London, such as *Camden Theatre* (1972), an impasto explosion of rubble and fallen beams, a ruined circus after a storm.

The 1970s' Pre-Raphaelite renaissance reached its apogee in the New Ruralist Brotherhood, spearheaded by David Inshaw, Graham and Ann Arnold, Peter Blake and Graham Ovenden, with its axis in the west of England.

Blake had initially made his reputation with paintings of rock musicians and boxers, viewed as through the eyes of a child who had idealized these people through collecting cigarette cards; but these polished, slick and abrasive images were to give way to an admiration for Millais. Ovenden, with a deep appreciation of Victorian photography, also sought to return what the Brotherhood termed 'the heart and soul' to British painting, which it believed had been lost to slick, pseudo-intellectual, quasi-internationalist fashion. Inshaw's dreamlike *She Did Not Turn* (1974) exemplifies what the group believed to be the poetic core of British landscape painting: a response to a landscape almost wholly man-made in appearance, yet inalienably the province of the natural elements, whose apparent timelessness and poetic grace holds the human condition in a perspective which it constantly seeks to deny but from which it cannot escape.

Landscape photography, which had generally pursued the poetic and romantic vision deserted by fine art painting, was used by David Hockney in the early 1980s to record hundreds of facets of landscape which he then put together as a collage. The result was so painterly that the artist returned to painting. He produced map-like pictures in vivid colours, where succeeding interior and exterior images seen on a journey were painted anti-clockwise along a long canvas so that the journey around the picture area was both a map of the landscape and that of the painter's inner view of the domestic world he inhabited.

The New Ruralists remained as a group until the mid-'80s, a time at which the sweet scent of oil paint and linseed oil returned to the studios of British art schools, after a general absence of two decades. In this pendulum swing – rather as with Joseph Southall's tempera painting in Birmingham at the beginning of the century – students felt suspicion towards the overt commercialism of the lavishly funded and increasingly 'cred', hi-tech design technology courses in which art was incidental and merely a vehicle to sell another commodity. As a commodity itself, the changing landscape may stand, as before, as a vehicle to display a political or emotional state, but the way an artist now chooses to portray it reveals above all the ecology of the artist's own mind.

A Gazetteer

Abingdon
Oxfordshire
Originally the county town of Berkshire, with abbey remains beside the Thames. Its guildhall possesses 2 paintings by THOMAS GAINSBOROUGH.

In 1871 the critic JOHN RUSKIN holidayed with the painter ALBERT GOODWIN at the Crown and Thistle Inn, an interlude which profoundly influenced Good-

win's attitude to the details of the natural world. ALEXANDER MANN visited the town between 1890 and the early 1900s, continuing to paint on the Berkshire Downs after he had finally settled in London. The Glasgow artist WILLIAM KENNEDY also visited Abingdon during his long periods of work on the Downlands before the Great War.

Aldeburgh
Suffolk
Initially a fishing village and fashionable by the early nineteenth century, when J. M. W. TURNER painted the harbour calm here. Birth-place of the poet George Crabbe, whose description of the grim lives of the fishing community in *The Borough* inspired Benjamin Britten's *Peter Grimes*.

During the late 1880s and between 1900–10, PHILIP WILSON STEER produced watercolours of the wide flatlands to the W. as along the coast, and the buildings which he treated as shades between the reflecting expanses of the sea or the wet land and the sky. DAVID MUIRHEAD BONE also visited the town while working at Walberswick. CHARLES RENNIE MACKINTOSH also painted landscape watercolours in the area. ARNESBY

BROWN, his pupil CAMPBELL A. MELLON and ALFRED MUNNINGS all visited here, Mellon painting the coast and inland, Brown the estuary lands and meadows, as did Munnings. During the late 1930s and just after the Second World War CLAUDE ROGERS worked in the coast area and along the shingle beaches here as well as inland. His pictures closely resembled those of Cézanne.

In 1951 the painter MARY POTTER and her husband Stephen moved to the Red House here. She painted the Suffolk landscape until her death in 1981. EDWARD SEAGO pictured the coast and the landscape eastward after his return to East Anglia at the end of the 1940s. He continued to work in the vicinity at intervals until his death in 1974.

Aldfield
N. Yorkshire
A village just S. of the B6265, approx. 4 miles S.W. of Ripon.

BALTHASAR NEBOT, an artist of Spanish origin, painted 7 views of the park and house at Studley Royal

(now gone) here in the 1750s, and the ruins of Fountains Abbey (q.v.) approx. 2 miles S.E. of Aldfield. WILLIAM POWELL FRITH was born here in 1819, at Druid's Farm, the son of a house steward at Studley Royal.

Amberley
W. Sussex
A village of thatched cottages, Norman church and now ruined thirteenth-century castle, situated 7 miles N. of Arundel. It overlooks Amberley Wild Brooks – 30 square miles of grazing marshes watered by the

Arun. The Rochdale-born painter EDWARD STOTT settled in Amberley in 1889, and lived here until his death in 1918. All his later rural landscape-narrative pictures were painted around the Amberley area, and although biblical subjects came to dominate his work, the setting for them was Amberley.

Arundel
Sussex
The 'Gothic' fortress of Arundel Castle dominates a

largely Victorian town beneath it, approx. 4 miles inland from Littlehampton.

MICHAEL ANGELO ROOKER pictured the castle and

valley here during the 1790s–1800s. To stress the castle's age, Rooker painted it as though growing out of the landscape like a hill. NICHOLAS POCOCK visited the area during his sketching trips along the coast, 1790–1810. Though resembling Rooker's work in subject, his has more charm. ANTHONY VANDYKE COPLEY FIELDING, while staying part of each year in Brighton (q.v.), pictured the town and castle, in his usual polished and saleable style. J. M. W. TURNER portrayed Arundel Castle a number of times, including a prospective picture for his *Rivers of England*

series, showing the pastoral life of the population in an harmonious landscape; one, of c.1830–33, shows a shepherd on crutches chatting to a young woman, a reminder that work lasted a whole lifetime.

The Pre-Raphaelites EDWARD BURNE-JONES and WILLIAM HOLMAN HUNT frequented Arundel. Burne-Jones, living near at Rottingdean (q.v.) was a frequent visitor, as were ALBERT GOODWIN and ARTHUR HUGHES, DANTE GABRIEL ROSSETTI and WILLIAM MORRIS.

Asheham
E. Sussex

A hamlet on an ungraded road approx. 3 miles S.E. of Lewes off the A27.

VANESSA BELL painted here during 1912, her work showing the influence of Roger Fry's Post-Impressionist exhibition of 1912, with objects reduced to a series of large geometric blocks.

Aylsham
Norfolk

A small market town approx. 9 miles N. of Norwich. JAMES BULWER, a wealthy cleric, lived here at Heydon Hall before becoming minister of St James's, Picca-

dilly, and befriended J. S. COTMAN in London during the 1820s. He was largely responsible for the purchase of Cotman's sepia drawings of the churches and ruins of Norfolk.

Barnard Castle
Durham

A market town approx. 23 miles S.W. of Durham.

In 1825 J. M. W. TURNER pictured the castle ruins rising against the early morning sun above the River

Tees. In the serene landscape of the sparkling river are two women fishing, while above them, the sinister silhouette of a woodcutter advances with cleaver raised, perhaps symbolic of time passing and of mortality.

Bath
Avon

The best preserved Georgian city in Britain about 12 miles S.E. of Bristol. Its hot springs were in use in Roman times.

JOHN TAYLOR OF BATH, a wealthy amateur born in Philadelphia in 1735, where 'he was baptised', settled here in the 1750s. During the 'Bath Season' he displayed his painting – which was of a high quality – and won high acclaim from both Garrick the actor/manager and Smollett the writer. Taylor died here in 1806.

THOMAS ROBINS THE ELDER settled here in 1742. Born at Charlton Kings in 1716 he achieved a reputation for 'prospect' pictures of gardens and houses. His normal medium was gouache on vellum. From the mid-1740s onwards his pictures of Rococo gardens were bordered by paintings of flowers, birds and shells.

The portrait and landscape painter THOMAS GAINSBOROUGH lived in Bath, 1760–74. He is believed to have taken rooms in the fashionable Abbey Churchyard from 1760 to 1763, and later a detached house – Lansdowne Lodge – in Lansdowne Rd. While here his

landscape painting altered radically, having relatively little to do with the Somerset landscape *per se*, but concerning itself with the structure of the society in which he lived, its relation to landscape, and the structure of composition, during the early 1760s integrating the figures in a Claudian manner, but as he felt no enthusiasm for Claude he turned toward Ruisdael and Rubens. His *Landscape with Herdsman and Cattle* (mid-1760s) is of the area. In the interests of portrait-painting he was forced, in 1765, to move to the Circus where many of the nobility stayed. In 1766 he displayed his landscape *The Harvest Wagon* in London. By the end of the 1760s he had grown accustomed to painting by candlelight, particularly when finishing portraits, and to using 'false' landscape props in his studio, owing to the lack of 'woods and waterfalls' in the city of Bath. The musician William Jackson wrote that: '. . . I have more than once sat by him of an evening, and seen him make models – or rather thoughts – for landscape scenery on the little old-fashioned folding oak table . . . and thereupon compose his designs. He would place cork or coal for his fore-grounds; make middle-grounds of clay or sand,

bushes of mosses and lichens, and set up distant woods of broccoli. . . . He made little laymen for human figures, he modelled his horses and cows . . . the limbs of trees which he collected would have made no inconsiderable wood-rick, and many an ass has been led into his painting room.'

ALEXANDER COZENS taught in Bath during the 1760s, when his teaching was fashionable, although Gainsborough never had any formal pupils while here. The Irish-born artist EDMUND GARVEY came to live here in 1769, having exhibited Italian landscape views in London in 1767 at the Free Society of Artists. He showed annually at the R.A. until 1813. In 1770 he was employed to decorate the New Assembly Rooms, and from then on painted widely in the West Country, largely prospects of great houses and estates. One of his *Views of Bath* (1778) shows the ascending terraces looking from the S. banks of the River Avon, with Beechen Cliff and the Abbey Church of Sts Peter and Paul rising above the South Parade. Today the railway station occupies the land near the river, and Kingston Square rises in front of South Parade. JOSEPH WRIGHT OF DERBY spent two unsuccessful and frustrating years in Bath, 1775–77; having formerly made a good living in portraiture in Liverpool which he hoped to repeat. He found the society uncongenial and the atmosphere pretentious and claustrophobic, and left for Derby in 1777.

The landscapist THOMAS BARKER OF BATH settled and worked here c.1800 until his death in 1847. Strongly influenced by Gainsborough, his work was nonetheless distinctive and he became a successful and wealthy man. From 1810 he lived at Doric House on Sion Hill. This house still contains his landscape mural on the ground floor. JOSEPH HORLOR was born in Bath in 1809, living there throughout his career. He worked widely in the Devon, Somerset and Dorset areas, as well as Bath and Bristol, producing a large number of coastal as well as landscape pictures, often of rustic genre and rural scenes. He died here in 1887.

Between 1916 and 1919 WALTER RICHARD SICKERT lived here, cultivating his eccentric behaviour, and continuing his theme of painting land- and townscape from window-apertures. When Sickert returned to Bath in 1937, he bought St George's Hill House at Bathampton. He particularly favoured painting Pulteney Bridge, where the river and the architecture reminded him of Venice. He died in Bath in 1942, aged 77. In 1928 the writer, poet and painter THOMAS BARCLAY HENNELL taught at Kingswood School, Bath, and at Bruton School for one day a week. A Bath student recalled that: 'He would talk with tremendous seriousness . . . he would never let his students go unless he thought the lesson had been understood. . . . The answer to an enquiry about a windmill once took him half a morning . . . he became the sails . . . he showed with his fingers the meshing of the cogs and gave lists of the hardwoods used for the different parts of the mechanism.'

In about 1930 Hennell left Kingswood to concentrate on watercolour painting and collect material for his first book, *Change on the Farm* (1934).

JOHN PIPER recorded war damage in the city in 1942: he painted *Somerset Place, Bath* and *All Saints Chapel, Bath*. He arrived 4 days after what was referred to as a 'Baedeker raid' – one particularly devised for the destruction of historic buildings – to find the ruins still smoking and bodies being dug out of the rubble. The painters and designers CLIFFORD and ROSEMARY ELLIS opened the Bath Academy at Corsham Court in 1946 for the education of art teachers, and they ran the academy until 1966. They were prolific book-jacket designers. The London-born St Ives painter BRYAN WYNTER taught at Bath Academy, 1947–1956. Like his colleagues at St Ives – Heron, Bell and Lanyon – he was primarily an abstract painter interested in the elemental idea of space. PETER LANYON worked at Corsham Court, c.1952–1957, then left to establish his art school at St Ives. The Leamington Spa artist TERRY FROST taught painting at the Academy, 1952–54, when he was made a Gregory Fellow at Leeds.

Bedford
Bedfordshire

A commercial and light industrial town approx. 30 miles N. of Watford on the A6, and straddling the River Ouse.

In 1830 J. M. W. TURNER pictured a humorous boating scene on the Ouse, with a man and two women colliding with a fisherman's boat; behind, the Swan Hotel appears at the riverside to the right, beside the 5-arched bridge and spire of St Paul's church.

The landscape and marine painter VIVIAN ALGER settled here in the mid-1880s, having come from London. He painted here as well as on the E. coast.

Bettws-y-Coed
Gwynedd

A beautiful village at the edge of Gwydyr Forest and Snowdonia National Forest Park, on the A5 in the Conwy Valley. The name means Chapel-(or Sanctuary)-in-the-Wood. In 1813 JOHN LINNELL visited the valley while on a sketching tour of Snowdonia with WILLIAM HOLMAN HUNT. The landscape made a deep impression upon Linnell who became a member of the Society of Painters in Oil and Watercolour.

Benjamin Williams Leader (1831–1923) *The Churchyard, Bettws-y-Coed* Oil on canvas 32in × 53in (Guildhall Art Gallery, London)

The village was 'discovered' by DAVID COX. In 1844, he lived here and painted a large number of watercolours and small oils, particularly of the churchyard and its imposing yew trees. His pictures were primarily responsible for the village and churchyard being 'the most painted in Britain' at mid-century. GEORGE PRICE BOYCE met Cox here in 1849, and abandoned architecture to take up painting. He became a close friend of Rossetti, painting buildings in landscape with a Pre-Raphaelite intensity. SIR JOHN GILBERT, a prolific illustrator of *The Illustrated London News* in 1850, produced watercolours of the churchyard, village and valley. Gilbert's fame rested largely on his historical subjects set in the fifteenth and sixteenth centuries. BENJAMIN WILLIAMS LEADER painted

here from 1858, in oil and watercolour. In 1863 he sold his large oil, *The Churchyard, Bettws-y-Coed*, to Mr Gladstone, later to be prime minister. He continued to paint Welsh landscape until the late 1870s.

In the late 1850s HENRY CLARENCE WHAITE began painting in the area and continued to do so throughout his career in a wide circuit of Welsh landscapes. GEORGE SHEFFIELD settled at Bettws-y-Coed 1861–1869. Under David Cox's influence, THOMAS COLLIER moved to Bettws in 1864, and painted here for 5 years, until moving to Hampstead. There suffering from consumption, he continued to work with great energy.

PHILIP WILSON STEER visited the area in 1906, during a tour of N. Wales.

Birmingham
W. Midlands

The second largest city in Britain, a conurbation with Wolverhampton extending 20 miles from N.W. to S.E.

WILLIAM ASHFORD was born here in 1746, leaving for Dublin at the age of 18, where he became one of the foremost Irish landscape artists. DAVID COX was born at Deritend, in Birmingham, in 1783, the son of a blacksmith. From c.1798 he was employed as a colour-grinder in the Birmingham Theatre, where he learned scene-painting. After 3 years in London he returned to Harbourne in 1841, where he remained until his death in 1859. From here he toured N. Wales

during the mid-1840s. The ruralist THOMAS CRESWICK was trained in Birmingham in the mid-1820s by JOHN VINCENT BARBER, leaving for London in 1828.

SIR EDWARD COLEY BURNE-JONES was born here in 1833, the son of a gilder and frame-maker. HENRY VALTER, a professional landscape artist, was born here and lived here throughout his chief working period (1854–64). Valter travelled fairly widely through the Midlands and S. England as far as Kent and Sussex; like most of his Birmingham contemporaries he did not paint Birmingham except on the very outskirts. CHARLES REGINALD ASTON, a prolific landscapist, with 247 London exhibits aside from those in the provinces, worked here throughout his career (1855–93)

while travelling generally in S.W. and S. England. HELEN ALLINGHAM studied at the Birmingham School of Design during the mid-1860s. Her family moved to Birmingham from Cheshire in 1862, when she was 14 years old. She began drawing in the family drawing clubs and left Birmingham for the R.A. in 1867. JOSEPH EDWARD SOUTHALL was articled to a firm of Birmingham architects in 1878. In 1879 he began attending evening art classes and in 1881 saw Arundel Society prints which prompted a visit to Italy. At Birmingham School of Art he met ARTHUR GASKIN who shared his interests in medieval art. In 1901 the two artists founded the Society of Painters in Tempera in Birmingham. Southall demonstrated tempera technique at the Birmingham School of Art, and gave informal lessons to ETHELBERT BASIL WHITE, MAXWELL ARMFIELD, CHARLES GERE, BERNARD SLEIGH, and others with whom he formed the Birmingham Group of Artist-Craftsmen. A prominent socialist and a conscientious objector during the Great War, Southall continued to pursue the ethics and methods of the groups he had founded until his death in 1944. CHARLES GERE trained at the Birmingham School of Art during the late 1870s and later became a member of staff, which made the school a centre of the Tempera Revival and Arts and Crafts Movement. He became closely involved with William Morris during the 1880s and 1890s remaining in Birmingham until

the early 1900s. BERNARD SLEIGH was born here in 1872, and studied at Birmingham School of Art, where he later taught from the 1890s. Sleigh painted in oil, watercolour, worked as a muralist, wood engraver and stained glass artist and illustrator. He settled in Edgbaston where he remained throughout his career, until his death in 1954. He painted particularly in the Cotswold area, and the S.W., showing work with the Royal Society of British Artists after 1898. JAMES VALENTINE JELLY painted from the mid-1880s until 1901 while a resident here, with 23 R.A. exhibits in as many years. His work has a considerable degree of narrative and atmospheric charm. WILLIAM JOSEPH KING, exhibiting from 1885 to 1943 and a member of the Royal Cambrian Academy, Royal Scottish Academy, and Royal Society of British Artists, lived and worked here throughout his career.

DAVID BOMBERG was born in Birmingham in 1890, of a Polish immigrant family. In 1895 his family moved to Whitechapel in London where he was apprenticed to a lithographer. Bomberg never returned to Birmingham, later teaching at London's Borough Polytechnic where he influenced an important group of students including Frank Auerbach. FRANCIS SEARS lived in the city from 1907 until the end of his career in 1932. An exhibitor with the Royal Society of British Artists, Sears worked in oil and watercolour in a conservative but saleable style.

Blackdown Hills
Somerset and Devon

A range of high rounded hills S. of Wellington and Taunton, extending E. to W. approx. 12 miles, dividing the hilly country of Devon from the flatlands of Sedgemoor in S.W. Somerset.

From c.1910 onwards, Harold B. Harrison, a retired rancher from Argentina who had enrolled himself in old age at the Slade School in London, invited artists whom he admired to stay at Applehayes, his

farm near Clayhidon. He had studios erected for these visitors, among them the Camden Town artists, CHARLES GINNER, FREDERICK SPENCER GORE and ROBERT POLHILL BEVAN. Bevan painted many of the landscapes around the farm, particularly the *Rosemary* canvases of c.1915–16. Inspired by the Post-Impressionist exhibition of 1912, he reduced the Blackdown Hills to geometric shapes. In 1916 Bevan took a cottage of his own in Bolham Valley.

Bolton Abbey
Yorkshire

In the 1780s, JOHN WARWICK SMITH pictured the ruined Augustinian abbey on the bank of the River Wharfe, reflected gracefully in the water. JOHN VARLEY made a watercolour of similar atmosphere here in the following decade, as did MICHAEL ANGELO ROOKER at the turn of the century. Rooker as often exaggerated the proportions of the building and the sweep of the water. J. M. W. TURNER visited the ruins c.1824/25, showing a serene scene viewed through

birches on the river bank in early morning sunlight. Ruskin wrote of this picture: 'Peace at last; no roll of cartwheel or mutter of voices in the back shop but curlew-cry in space of heaven, and welling of bell-toned streamlet in its shadowy rock. Freedom at last. Dead wall, dark railing, fenced field, gated garden, all passed away like the dream of a prisoner; and behold, far as foot or eye can race or range, the moor and cloud. Loveliness at last. It is here then, among these deserted vales!'

Bosham
W. Sussex

Situated on the middle of the 3 creeks which constitute Chichester Harbour.

The British Impressionist HERBERT LA THANGUE settled here in 1890. He specialized in rural themes, and his most famous picture, a symbolic landscape, *The Man with the Scythe* was set here, using locals as models for the figures.

Bradford

W. Yorkshire

An industrial town which grew up on the worsted trade. Its Cartwright Memorial Hall was erected in 1904 as an art gallery.

WILLIAM ROTHENSTEIN was born here in 1872, of a wealthy Jewish family involved in the wool trade. While here William met the artist ERNEST SICHEL who introduced him to the drawings of Millais and Legros. He entered the Slade in 1886, eventually becoming Director of the Royal College of Art, 1920–35, and was knighted in 1931. RICHARD ERNST EURICH was born here in 1903, the son of a bacteriologist. He attended Bradford School of Art where the emphasis was on commercial art training. His family's move to Ilkley awakened his interest in landscape, and after the Second World War he returned to Yorkshire to paint landscape.

DAVID HOCKNEY was born in Bradford in 1937, and grew up in Eccleshill. His father had a reputation for eccentric behaviour and his son was known in his schooldays as an 'almost legendary figure of fun' at Bradford Grammar. He attended Bradford School of Art, 1953–7, and the Royal College of Art, London, 1959–62. DAVID FELL, working in oil, watercolour, gouache and acrylics, and a specialist in coast and landscape and architectural subjects, attended Bradford School of Art, 1948–51. Fell held 14 one-man exhibitions, 1971–78, plus two 2-man shows and one 3-man exhibition; these covered Leeds, Huddersfield, Halifax, York, Batley, Bradford, Eccles, Oldham and Bolton. His work is now widely collected. He lives and works in Bradford.

Braintree

Essex

A handsome town which grew up on the wool trade. EDWARD BAWDEN was born here in 1903, leaving in 1922 when he won a scholarship to the Royal College of Art, after spending a year as a full-time student at Cambridge Art School. In 1930 he returned and painted extensively in the Essex countryside as a founder member of the Great Bardfield group or 'school'.

Bridge of Allan

Central Region

A town 1½ miles N. of Stirling beside Allan Water.

WILLIAM YORK MACGREGOR, the leader or founder of the Glasgow School, painted here from 1886 onwards for many years.

Brighton

E. Sussex

The premier coastal resort of S. England, notable for its Regency architecture and fantasy Pavilion.

JOHN CONSTABLE painted in Brighton and Hove when he visited the area (as he did Weymouth) for his wife's health: 'It is a marvellous place for setting people up,' he said of Brighton, but he detested the 'Brighton Set' – London and home counties socialites – and did his best to avoid them, painting along the foreshore and inland. He made oils and watercolours of the two towns, picturing Hove when it was still a distinct village and painting the old parish church in watercolour, before it was extensively damaged and rebuilt in 1832. ANTHONY VANDYKE COPLEY FIELDING lived spasmodically at Sandgate or Brighton, painting either on the coast or in the hinterland. He produced a large number of watercolours of the town itself, as did MICHAEL ANGELO ROOKER. Rooker painted in watercolour with great facility, generally showing either the coast or architecture and landscape inland. NICHOLAS POCOCK was an accomplished landscapist, and frequently worked in Brighton and Sussex, 1800–15. He produced a set of Brighton pictures for engraving and book illustration. There is a marked similarity between the work of Pocock and Rooker on this subject. RICHARD PICKERSGILL worked in Kent and Sussex, 1818–53. He produced many landscapes in the Brighton district especially on the S. Downs (as well as in the London area). WILLIAM ROBERT EARL, with 114 London exhibits, worked extensively in the county and in Kent, 1823–67. JOHN THORPE, mainly a Sussex artist, was a resident of St Leonard's near Hastings, 1855–63, and worked extensively in the Brighton region, 1834–73. Thorpe showed 172 pictures in London venues. W. W. FENN worked in Sussex regularly 1848–80, adding occasional coastal scenes to his repertoire.

R. H. NIBBS, generally associated with marine art, painted landscape widely in the area during the 1840s

and '50s, after his retirement as a professional musician. He published two books on the landscape of Sussex and its coast. DAVID COX painted the area during the 1820s and the 1840s.

JOHN WILSON CARMICHAEL, essentially a marine painter, produced accomplished landscape, and in 1848, after his book of views of the Newcastle and Carlisle Railway, he portrayed the magnificent 400-yard long London Rd Viaduct (built for the London Lewes and Hastings Railway – later known as the London Brighton and South Coast Railway) on the outskirts of Brighton. It is a fine example of the 'positive' or 'celebratory' Victorian viewpoint to material or industrial change, in contrast to GEORGE HILDITCH's near-contemporary painting of Hove. Hilditch painted in the Brighton and Hove area during the 1840s and '50s. A small oil of c. 1850 shows Hove as a village centred around the old flint-built Neo-Norman style St Andrew's Church, and the artist has deliberately deleted the gas works of 1835 with its tall chimney which adjoined the old church, Adelaide Crescent extending from Brunswicktown and the general advance of the town of Brighton itself. Hilditch was censoring the landscape as so many nineteenth-century painters did, in this case portraying what was vanishing – the identity of Hove as a village.

GEORGE ALBERT ADAMS frequently visited Brighton district although his favourite location was the Hastings hinterland. He worked well in oil and water-colour, between 1854 and 87 exhibiting some 88 pictures in London. Frequently his watercolours were higher priced than his oils, and he appears to have thought more of them. W. H. MASON visited the area, 1860–88, and was based at Arundel and Worthing, altogether exhibiting 77 of his major pictures in London during his 27-year working period. All these artists painted a relatively harmonious city and bene-volent-looking landscape, and their numerous London exhibits reflect their saleable formula. Their pictures were professionally charming. They portrayed change when it was both picturesque and praisable, or not at all.

CHARLES KNIGHT trained at Brighton School of Art at the end of the Great War, and in the early 1920s at the Royal Academy Schools where he studied under Sickert. He returned to teach in Brighton where he remained throughout the rest of his career, painting the landscape in the area of the S. Downs, in a manner influenced by J. S. Cotman. EDWARD LESLIE BADHAM lived and worked in the area between 1910 and the 1930s, picturing the landscape of S.E. Sussex. ERIC GILL, who formed the Ditchling craft and art community which flourished until the mid-1920s also painted the nearby landscape and area, as did DUNCAN GRANT and VANESSA BELL. During the 1930s REX WHISTLER produced pictures of the region. The writer and painter GEOFFREY IAN LILLEY has lived at Brighton since 1973.

Brinkburn Priory

Northumberland

An Augustinian priory of SS. Peter and Paul founded c. 1135, on a southern loop of the River Coquet 4 miles E. of Rothbury. It was restored during the nineteenth century. J. M. W. TURNER made a study of barrenness and fertility in the lush valley of Coquet Dale when he pictured the ruins of the priory here, c. 1830–31, showing the bleakness of the ruin under a threatening sky, amid luxuriant trees, and a full river sparkling with light.

Bristol

Avon

In a spectacular geographical setting beside the Avon Gorge, a cathedral, university, and major commercial city, once a thriving port. Its city museum and contemporary art galleries have extensive collections.

NICHOLAS POCOCK, better known as a marine painter, was born in Bristol in 1740, producing many watercolours of the Avon Gorge area from 1780, when he retired from the sea. Pocock was a better watercolourist than oil painter. From 1785 he painted the landscape to the N.W., especially the Blaize Castle estate (N. of the suburb of Westbury-on-Trym), Shirehampton village, and the area of Kings Weston. To the S.W., he painted in the Hotwells Spa area and made 8 aquatints of the city itself, in 1782 (published at intervals until 1801). Like most Bristol painters, he pictured the heights of St Vincent's Rocks and Durdam Down to the E. of the Avon Gorge.

The landscape and coastal painter JAMES BARKER PYNE was born here in 1800. Pyne was wholly self-taught, and painted widely in the area until 1835. He exhibited work at the British Institution and the Society of British Artists, and rarely at the R.A. Later, he was best known for his views of the Lake District and Italian views commissioned by Agnews.

The Bristol School initially focused around the Royal Academician EDWARD BIRD. When FRANCIS DANBY arrived in 1817 he joined the group's evening sketching sessions, in which they generally produced

imaginary landscapes in monochrome wash, with figures frequently added in exotic costumes and fantasy architecture. Danby, who painted some of his finest work between 1815 and the early 1830s, dominated the Bristol School after Bird's death in 1819. In the early 1820s, he worked in oil along the Gorge, painting the Leigh Woods cliffs on the E. side of the Avon, the woodlands towards the Ashton Court estate beyond, and Clifton itself from both the E. and W. side of the Avon. He also viewed the city looking N. from the river at the Cumberland Basin area (now a mass of flyovers) and the wooded valleys to the S.E. of the city and the villages towards Bath. The REV. JOHN EAGLES, a talented amateur of the group, is said to have coined the term 'Bristol School' in 1826, and with Danby sketched around Leigh Woods, Nightingale Valley and Stapleton Glen. Eagles described landscape pictures as being 'a poetical shelter from the world'. Although Danby became the dominating artist in the group, he left Bristol, heavily in debt, in 1824. His successors were SAMUEL COLMAN and SAMUEL JACKSON. Colman was a painter of limited technical ability but extraordinary imagination, and most of his work is fantasy landscape and episodic drama. Samuel Jackson, a fine watercolourist, born in the area in 1794, produced some of his best work, 1820–40. He practised a delicate, precise style which usually retained freshness, and his subjects were light and charming. Like Danby, he favoured the steep clustering woods of the Avon Gorge, especially the picnic parties that strolled there during the summer. He painted in the region until his death in 1869.

Unlike Francis Danby (an Irishman), WILLIAM JAMES MÜLLER was born in Bristol, at Hillsbridge Parade in 1812. Müller is now largely remembered as Bristol's most famous native artist along with Nicholas Pocock, but he rarely painted British landscape; he specialized in Oriental scenes. Dying at only 33, he lived in College Green and in Park Row, at what is now the White Harte pub.

The REV. JAMES BULWER, a patron of J. S. Cotman and until 1820 curate of St Mary's Redcliffe, Bristol, produced a considerable body of watercolour work here. JOHN SYER, a landscape watercolourist, lived here, 1867–78, painting here and widely in the S.W. peninsula. GEORGE WOLF, a land and coastscape painter in oil and watercolour, lived in Bristol, 1855–72.

He had 107 London exhibits. CHARLES KNIGHT was here, 1853–78. He exhibited 70 landscapes in London galleries during that time. In 1878 he moved to Tiverton in Devon. The land- and seascapist ARTHUR WILDE PARSONS lived and worked in the Bristol area all his life from the 1840s until his death in 1931. Between 1867 and 1904 was his chief working period. EDWARD GOLDSMITH, another land- and seascapist, was based in Bristol between 1877 and 1901. He painted widely all around England, but particularly in the S.W., S. and N.E. FREDERICK JOHN (BARTRAM) HILES, who lost both his arms in an accident, and thereafter held the brush in his teeth, lived in Bristol from 1908 until his death in 1927. He was both a landscape and marine painter, and his work was of a far higher standard than is usual with artists handicapped by the loss of limbs. EDWIN JOHN BOARD, born 1886, remained resident in Bristol throughout his career. He ignored oil painting and concentrated on watercolour and pastel work of subjects generally in the S.W. peninsula. During the Great War EDWARD ALEXANDER WADSWORTH lived in Bristol, essentially engaged in camouflage work for the Admiralty, but he also pictured the city.

During the late 1930s the Welsh artist JOHN ELWYN studied at the West of England College of Art (Bristol) and painted here before going to the Royal College. JOHN NORTHCOTE NASH visited Bristol during the late 1930s, and later during the Second World War.

In 1940 JOHN PIPER recorded bombing in the city, particularly the damage made by the great raid of the night of 24th November, when St Mary le Port church was razed. He found the ruins of two churches smoking when he arrived, hoses saturating the ground and mazes of rubble – all of which produced a lasting effect on his approach to what he drew.

In 1953 WALTER THOMAS MONNINGTON was commissioned to execute large ceiling paintings for the Conference Hall of the new Council House, a design unifying the music of the spheres with modern machinery. Monnington was enthusiastic about forms like radar and electricity pylons, and introduced such geometry into natural forms.

The Ruralist DAVID INSHAW lived in Bristol until 1971, when he left the city for Devizes where he was joined in 1974 by two other members of the New Ruralist Brotherhood, GRAHAM and ANN ARNOLD.

Broughton-in-Furness

Cumbria

A village approx. 8 miles S.W. of Coniston.

A Pre-Raphaelite landscapist, DANIEL ALEXANDER WILLIAMSON, lived here from 1864. Seriously ill and unable to work out-of-doors during the early 1870s, he turned to watercolour painting and became more impressionistic in his approach. He did not take up oil painting again until the early 1890s. He died in 1903, at the age of 80.

Builth Wells

Powys

A Victorian spa town surrounded by the superb scenery of the deep Wye Valley. THOMAS JONES, landscape painter and High Sheriff of Radnorshire, arrived as a 7-year-old boy in Builth Wells when his father bought Penkerrig estate in 1749, and he grew up there before going up to Oxford, and training in London as an artist under Richard Wilson. In 1787, after a career in London and Italy, he inherited Penkerrig, and returned to run the estate. In 1791 he was appointed High Sheriff of Radnor. From then his art was a pastime of great pleasure. During the 1770s he had made many small oil pictures on paper, and his work in this medium anticipated Constable's in its vigour and freshness. Jones was one of the very first *plein air* artists in Britain, and his small oil *Penkerrig* (1772), absolutely typical of the Welsh landscape in colour and form, has an astonishing modernity about it. His best known work is probably the large oil of 1774, *The Bard* (Nat. Mus. of Wales), but it is of far less significance. He died at Penkerrig in 1803.

Bungay

Suffolk

A market town on the River Waveney 13 miles inland from Lowestoft. CAMPBELL A. MELLON, the landscape and coastal painter, visited the town during the 1930s and later 1940s, painting here and along the river and the marshes. ARNESBY BROWN also visited the area, concentrating on the river flats and the natural, rather than man-made, surroundings.

Burghclere

Berkshire

One of three 'clere' settlements – Highclere to the W., Burghclere and Kingsclere to the E., approx. 12 miles N.E. of Andover.

In 1928 STANLEY SPENCER and his wife Hilda moved into a cottage built for them by the Behrends, who, having seen Spencer's drawings, had commissioned him to paint murals in a specially built chapel dedicated to the memory of Mrs Behrend's brother killed in the Great War (now known as Sandham Memorial Chapel). Spencer worked at Burghclere on this wonderful series of paintings until 1932, also making a number of landscapes here, such as *Cottages at Burghclere* (Fitzwilliam Museum).

Bushey

Hertfordshire

Now a suburb of Watford.

HUBERT VON HERKOMER, the landscapist's first visit to Bushey was in 1873. He returned in 1883 following the death of his first wife, to marry Lulu Griffiths, and opened a school of painting. Lulu died shortly after, and Herkomer built Lululaund, a huge Germanic mansion. His work, such as *Our Village* (1889–90), was in the narrative-landscape tradition although his best-known work, such as *The Last Muster*, was genre. The school lasted 15 years, and was the centre of an art colony. Herkomer recorded that 62 independent studios were set up in the vicinity by ex-students over the period. He died at Lululaund in 1914. ALGERNON TALMAGE was a student at Herkomer's school during the mid-1880s, as was ARNESBY BROWN. Brown later painted widely in E. Anglia and Essex, one of his students being Campbell Mellon. Like Nicholson, he found Herkomer's style and approach stiff, but maintained his traditional approach with greater vitality and freedom. WILLIAM NICHOLSON was a student during the late 1880s. He too found the atmosphere stiff and Herkomer rather pompous.

Caldy Island

Dyfed

An island in Carmarthen Bay, approx. ¾ mile off the Pembrokeshire Coast, and 2 miles S. of Tenby harbour; the site of a flourishing Cistercian monastery. Notable for its bird-life. DAVID JONES, while at Eric Gill's Capel-y-ffin community, visited the island and painted and drew here. Jones visited the monastery on a number of occasions during the 1920s, always seeking in his painting to reveal more than was seen with the eye, and what he called the ultimate 'creatureliness' of things.

Cambuskenneth

Central Region

A village on the outskirts of Stirling, within a loop of the River Forth. In 1888, members of the Glasgow School congregated here, as WILLIAM MACGREGOR had begun to frequent Bridge of Allan, about 2 miles

N. for his health in 1886. JAMES GUTHRIE, JOHN LAVERY, WILLIAM KENNEDY (who painted *Stirling Sta-tion* in 1888), ALEXANDER ROCHE, E. A. WALTON and JOSEPH CRAWHALL painted here.

Capel-Curig
Gwynedd

A mountain village at the foot of the Snowdon Range 6 miles W. of Bettws-y-Coed. The Pre-Raphaelite ALFRED WILLIAM HUNT painted one of his best-known oils, *Rock Study: Capel Curig – The Oak Bough*, from drawings and watercolours he made here in 1856.

Capel-y-Ffin
Powys

A hamlet in the Vale of Ewyas, about 3 miles N.W. of Llanthony and Llanthony Priory, just N. of the Gwent border. In 1924 ERIC GILL left the Ditchling Community he had organized in Sussex and moved here. He was joined by the landscape painter DAVID JONES, and later JOSEPH CRIBB, Donald Attwater, RENÉ HAGUE and PHILIP HAGREEN. Gill wrote that: '. . . we bathed naked all together in the mountain pools or under the waterfalls . . . or climbed the green mountains and smelt the smell of a world untouched by men of business.' Gill's smallholding community farmed manually the area depicted in watercolours by David Jones, who alternated living between Capel-y-ffin and London.

David Jones (1895–1974) *Afon Honddu Fach* Pencil and watercolour 9¾in × 12⅛in (Photo: Witt Library)

Carlisle
Cumbria

An industrial and agricultural city on the A6 just S. of the Scottish border. The landscape painter WILLIAM JAMES BLACKLOCK grew up in the village of Cumwhitton approx. 7 miles to the S.E. His family had moved back from London when Blacklock was aged 4 in 1820 and they lived in Cumwhitton House. His work was minutely detailed, notably for its medieval architecture and fantasy element about the landscape. He lived in London during the early 1850s but failing eyesight impeded his work and the R.A. helped him financially. In 1858 he died in Dumfries, aged only 42. The landscapist SAMUEL BOUGH was born in 1822 in a courtyard house off Abbey St. The son of a shoemaker he began to study law in Carlisle, but in the 1840s left the town and ultimately settled in Edinburgh, where he was elected to the Royal Scottish Academy. He painted widely in N. England and Scotland.

Carmarthen
Dyfed

Now the administrative centre of Dyfed, and formerly the river port and county town of Carmarthenshire on a bluff above the River Tywi. The Welsh name *Caerfyrddin* means 'Merlin's City'.

EDWARD MORLAND LEWIS painted at Carmarthen during the mid- and later 1930s while working the S.W. Wales coast, often using photographs as source material for his pictures, and changing the tonal values of the photograph to give a quite different picture while retaining the original's lay-out and composition. GRAHAM SUTHERLAND also visited the area during the 1930s while working in the Pembrokeshire area. JOHN ELWYN, a landscape painter generally associated with W. Wales, and usually the Cardiganshire (now Dyfed and Powys) coast, studied at Carmarthen Art School during the mid-1930s, before going to Bristol School of Art and the Royal College, where he was taught by Carel Weight. He illustrated the poems of Dylan Thomas. Elwyn won the National Eisteddfod Gold Medal in 1956.

Castle Acre Priory
Norfolk

In the twelfth century de Warenne founded this Cluniac priory, the jagged remains of which stand near the village of Castle Acre, built on the Old Peddars' Way. JOHN SELL COTMAN visited the priory in August 1804, writing ecstatic praise of the site, and spending 9 days sketching there.

Castle Hedingham
Essex

A small town approx. 7 miles N.E. of Braintree, once shadowed by the massive fortress of the de Veres, Earls of Oxford, c.1140. Its huge keep still stands above medieval and Georgian houses. ERIC RAVILIOUS lived here at Bank House from 1935 until 1939. From here he explored the Essex and Suffolk countryside.

Catterline
Grampian

A fishing hamlet off the A92, approx. 4 miles S. of Stonehaven: a line of cottages on a high, ragged cliff top. JOAN EARDLEY painted here from 1956, usually pictures of the storms off the North Sea, which went largely to make her reputation in the last 7 years of her life, but she also painted landscapes of the high fields to the W. of the village during the summer months. These, like her seascapes, were close to abstraction.

Charleston
E. Sussex

A farm just below Firle Beacon, a 713-foot peak 7 miles E. of Lewes. The Bloomsbury painters DUNCAN GRANT and VANESSA BELL lived here from 1916; Vanessa Bell until her death in 1961, and Duncan Grant's 17 years later. The building remains relatively unaltered, being owned by Vanessa Bell's daughter the painter ANGELICA GARNETT. It contains work by the Omega Workshop and paintings of the Bloomsbury Group. Here the large wall paintings for Berwick Church executed by Duncan Grant, Vanessa Bell, her daughter Angelica and her son Quentin were made on large sections of plasterboard later fixed to the church walls.

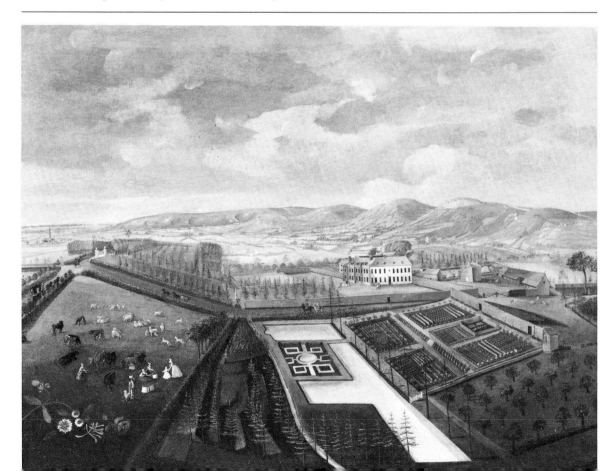

Cheltenham

Gloucestershire

A spa town on the N. edge of the Cotswold Hills, notable for its Regency houses.

THOMAS ROBINS THE ELDER was born at Charlton Kings near Cheltenham in 1716, and is now best known for his views of parks and gardens. He was apprenticed to a porcelain painter, Jacob Portat, in Cheltenham, and his only known large-scale oil to date, *A Panoramic View of Charlton Park* (c.1740) shows the house with its formal ornamental garden contrasting with the rolling Cotswold Hills stretching obliquely beyond. The artist painted all the owner's live possessions, family, dogs, cattle, milkmaids, all

OPPOSITE Thomas Robins (1716–1770) *A Panoramic View of Charlton Park*, c.1740 Oil on canvas 41in × 53in (Cheltenham Art Gallery and Museums)

gathered together in one field in the grounds, like a set of toys. The Old Bath Rd runs to the left of the house in the painting, with the spire of St Mary's Cheltenham 2 miles distant, and Lady Stapleton's Great House of 1736 (demolished c.1850) beyond.

From 1920 PAUL FRIPP, oil and watercolour landscape painter, metalworker, jeweller, cabinet-maker and photographer settled in Cheltenham, became a member of the Cheltenham Group painted extensively in the Cotswolds and the surrounding area of the upper Severn Valley.

JOHN PIPER painted and drew buildings in Cheltenham during the Second World War, part of his general shying away from abstraction as his interest in architecture and the disappearance of many buildings he deemed deserving of record caused him concern. He contributed paintings to various published regional guides and painted *Italian Cheltenham* in 1939.

Chepstow

Gwent

Historically, a fortress town built on limestone terraces at the crossing of the River Wye nearest to the Severn Estuary, Chepstow is still dominated by its massive Norman castle.

JOHN INIGO RICHARDS painted on the lower Wye during the 1750s, his image of Chepstow Castle of 1757 probably inspiring Richard Wilson's painting of Pembroke Castle nearly 20 years later. Richards employed familiar devices to frame the view of the castle across the water, such as trees on both sides of the picture, and denoted the castle's antiquity by blending the colour of its walls into the rock from which it rises, as though it had 'grown' from the ancient land – something which Chepstow Castle does not appear to do. RICHARD WILSON visited the Wye Valley during his career, but produced more innovative pictures further N. as at Holt on the Dee.

PAUL SANDBY worked at Chepstow and the Wye valley during the summer of 1773, on a tour made with Sir Joseph Banks around South Wales: '. . . and this journey he ever afterward remembered with the fondest delight, having experienced from Sir Jos. Banks an attention and kindness, which called forth in him the highest feeling of respect and affection. . . .' During 1770 the ubiquitous REV. WILLIAM GILPIN, amateur watercolourist and travel writer, explored the Wye from Gloucester to Chepstow. During 1790–1810 JOHN VARLEY, JULIUS CAESAR IBBETSON, JOHN 'WARWICK' SMITH and JOSEPH FARINGTON and NICHOLAS POCOCK all painted in the area. J. M. W. TURNER pictured Chepstow Castle from beyond the stone and wooden bridge below the old fortress, while the castle itself enjoyed a gently Rhenish appearance in his watercolour of 1794. JOHN LINNELL and DAVID COX

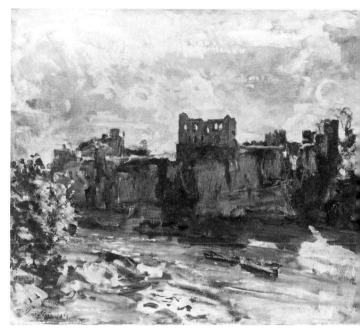

Philip Wilson Steer (1860–1941) *Chepstow Castle* Oil on canvas 30⅛in × 36⅛in (Tate Gallery, London)

worked here during the next decades, their images influencing the work of THOMAS CRESWICK. In the last quarter of the nineteenth century Chepstow and the lower Wye again attracted painters such as JAMES CHARLES and PHILIP WILSON STEER. Steer gained official recognition in 1909 when Mary Hoadley Dodge presented his *Chepstow Castle* to the Tate Gallery. FRED BROWN and HENRY TONKS, their work a great contrast to Steer's, painted here, 1900–10. The tem-

pera painters CHARLES GERE and RICHARD SOUTHALL worked here after the Great War, and WALTER RICHARD SICKERT before and after that conflict. In 1937–40 ALAN SORRELL made archaeological recon- structions of sites here for the National Museum of Wales. In the 1940s KEITH VAUGHAN, road-building in the Wye Valley with the Pioneer Corps, drew and painted here.

Chichester
West Sussex

A cathedral city with a fine natural yacht harbour divided into three main channels.

The brothers GEORGE SMITH and JOHN SMITH OF CHICHESTER were born and brought up in the town. George, born 1714, had marginally the greater talent and with his brother specialized in producing very professional, decorative but highly repetitive pastoral landscapes. These were frequently portrayed under snow, and their image has lasted throughout the landscape tradition from the Dutch essays in that genre as the popular winter landscape format. Both artists lived their full careers in the town, George dying there in 1776. Their elder brother WILLIAM SMITH – born in Guildford in 1707 – whose work was frequently indistinguishable from theirs worked most of his life in Chichester and died here in 1764. ABRA- HAM PETHER was born here in 1756. A pupil of George Smith, Pether was a specialist in moonlit landscape – a genre in which he was followed by his sons – and painted such subjects widely in the S. of England, in London, and along the coasts. He died in South- ampton in 1812. JAMES LAMBERT SR, born in Willing- don, Sussex, trained with the Smiths of Chichester. He worked in the county much of his life, dying in Lewes in 1788. The lesser known JOHN PARKER studied under the Smith brothers during 1765; his work, like Lambert's, shows their influence.

Coalbrookdale
Salop

During the 1760s Coalbrookdale was the centre of the British iron industry; now an industrial tourist attrac- tion and part of the general development known as Telford. Ironbridge in Coalbrookdale still sports Abraham Darby's iron bridge of 1779 spanning the Severn, the first iron bridge in the world.

WILLIAM WILLIAMS, born in Norwich in 1740, and generally described as an itinerant artist, painted Coal- brookdale in the mid-1770s. A pair of oils dated 1776, *A Morning View of Coalbrookdale* and *An Afternoon View of Coalbrookdale*, shows contrasting geographi- cal viewpoints as well as different times of day. The first looks down into the valley from the N., with the River Severn in the middle distance, while white smoke rises from the furnace buildings and contrast- ing black-mauve from the Ironmaster's House. To the l. foreground a coal wagon descends by the Welling- ton Rd. In the second picture the view is from the S., from what is now the Rotunda. These two pictures contrast in their restraint with the dramatic theatre of PHILIPPE JACQUES DE LOUTHERBOURG's in 1801 which portrayed *Coalbrookdale by Night*, using his talents as a theatrical scene painter: a celebration of the iron indus- try as vigorous as it was rare. PAUL SANDBY MUNN did likewise with his smoke-shrouded watercolour of open-cast ore-mining, *Bedlam Furnace* (1803).

Cockburnspath
Borders

A village which reminds one of Cornwall, near the deep valley of the Douglas Burn, marking the boun- dary between Borders and Lothian.

The Scottish painters known as 'The Glasgow Boys' began to congregate here in the summer of 1883. The initial leader of the group, WILLIAM YORK MACGREGOR, and JAMES GUTHRIE, ARTHUR MELVILLE, E. A. WALTON, E. A. HORNEL, GEORGE HENRY, ALEX- ANDER ROCHE, JOSEPH CRAWHALL and JOHN LAVERY all worked here from 1883, and Lavery remained here for a further 3 years. While staying here, he painted *A Hind's Daughter*, closely inspired by Bastien-Lepage's sentimental *Pauvre Fauvette*, but more robust. George Henry met E. A. Hornel here in 1885, and Hornel presented him with a watercolour of Guthrie's cab- bage garden; they became close friends, making a trip to Japan together in 1893–94.

Conway or Conwy
Gwynedd

A town still dominated by Edward I's massive castle with a plan-form of a Welsh harp and ½ mile of 15-foot-thick walls, 8 drum- and 23 semi-circular towers. Thomas Telford's superb railway bridge over the Conway was built to match it in style; Robert Stephenson's tubular bridge on one side of it was built

in 1822 and the road bridge on the other in 1958. Bodnant Gardens, 3½ miles S.E. are among the most beautiful in Britain. The castle was the prime subject of every painter of note who worked here during the eighteenth and nineteenth centuries.

PAUL SANDBY visited the town during 1772 and later, during his tours of N. Wales. In 1776 he made an oft-reproduced water- and body-colour picture, *Conway Castle*, showing a typical touring party – a visitor sketching with his servant holding an umbrella to shield the light from the drawing, a companion leaning casually against the horses, while a lady and small child admire the general scene. The castle is bathed in a golden west light; although for the period a 'dramatic' landscape, the picture has a gentle, dreamlike atmosphere. JOHN SELL COTMAN and THOMAS GIRTIN (rivals but without the same acrimony as between Crome

and Cotman) are both said to have arrived to paint Conway at the same time in 1800. Girtin chose to paint the great hall, its succeeding arches overgrown and resembling a canyon or gorge through which the turrets rise as if from another place. NICHOLAS POCOCK and JOHN VARLEY painted the town and castle in the 1790s, Pocock concentrating on the boats under the castle walls and putting his charming, slightly naïve figures busy in the foreground. Varley was more architectural in his approach. J. M. W. TURNER portrayed the castle from across the water and vessels too beneath its walls. Later BENJAMIN WILLIAMS LEADER, DAVID COX, and HENRY WHAITE, as a leader of the Manchester School, painted here. After 1890 the Liverpool artist GEORGE COCKRAM settled here, as did DONALD MCINTYRE during the 1950s.

Cookham
Berkshire

A village of red-brick cottages arranged around a central green, with an ironwork bridge spanning the River Thames above the 50-acre Formosa Island, largest in the river.

STANLEY SPENCER was born at Fernlea, Cookham in

Stanley Spencer (1891–1959) *The Resurrection, Cookham* Oil on canvas 108in × 216in (Tate Gallery, London)

1891, the seventh child of William and Annie Spencer. He attended the Slade, 1908–12. He was known by his fellow students as 'Cookham' and went and sat on Paddington station for the next train back as soon as his last class finished. In 1915 he left Cookham for the Royal Army Medical Corps, an experience he was to turn into a series of murals for Burghclere Chapel in Hampshire. He returned to Britain in 1919, when he completed his landscape *Swan Upping*. His huge religious pictures absorbed him, but he also produced

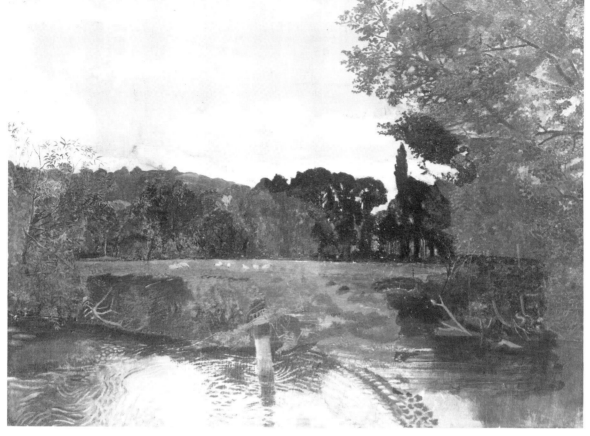

Gilbert Spencer (1892–1979) *Sashes Meadow, Cookham*
Oil on canvas 18¼in × 24¼in (Tate Gallery, London)

direct, retinal or 'straight' landscapes for sale, such as
May Tree, Cookham (1932) and *View of Cookham
Bridge* (1936). During 1940–45 he painted at Port
Glasgow as a War Artist, but returned to Cookham
where he painted until his death at Taplow, 2 miles S.
of Cookham in 1959.

GILBERT SPENCER, his brother, was born at Fernlea,
Cookham in 1892, the youngest of the Spencer chil-
dren. Stanley was not content to let his younger
brother play with toys only and insisted he explore
paints. In 1909–11 Gilbert went to Ruskin School in
Maidenhead, and in 1912 to Camberwell School of
Art. He attended the Slade, 1913–15 but, unable to
afford more than 3 days a week there, painted on his
own at Cookham. He won the Slade's Summer Com-
position Prize in 1914 (shared with T. T. Baxter) with
Summer, painted at Cookham. His picture of 1913,
The Seven Ages of Man, set at Cookham, was bought
by Lady Ottoline Morrell for the Contemporary Arts
Society. He left Cookham in 1915 for the army.

Corfe Castle
Dorset

This grey stone village, almost exactly in the centre of
the Isle of Purbeck, is still dominated by its ruined
castle which looms starkly high above on a steep hill.
FRANCES HODGKINS lived at Corfe Castle, 1939–47.
The most important New Zealand-born artist of the
twentieth century, she had been a member of Unit
One during the earlier 1930s, and had lived much of
her time in France where she was much influenced by
Matisse. She was 70 when she settled at Corfe, living
as a recluse, in dire poverty, but producing some of
her best work until 1947 when she began to suffer
appalling hallucinations. She was certified as insane
and died a few weeks later.

Coventry
W. Midlands

A large cathedral city, a commercial and industrial
centre formerly in Warwickshire.

J. M. W. TURNER produced a watercolour of
Coventry in c.1832 for his *England and Wales* series,
which showed a sharp division between town and
country, with grazing livestock in sunlit fields to the l.
of the picture while the advancing town glimmers in
squally storms which fall in shadowy veils edged with

sharp diagonals; the aggressive confusion of the town seems mirrored in the storm but it advances nonetheless, like the stagecoach speeding out from it along the road.

JOHN PIPER drew the bombed ruins of Coventry Cathedral in 1940, as part of his job as a War Artist in the Ministry of Information; the image of the wrecked cathedral was one of the most memorable pictures he had made up to that time. The *Interior of Coventry Cathedral* showed freer, bolder strokes than he had previously used, and a sweeping vigour and vitality grew out of his war pictures which vastly enriched his work.

Cuckfield

W. Sussex

A village of Sussex-style houses with a winding main street set on a gentle slope, about 14 miles N. of Brighton. The Camden Town Group painter ROBERT

POLHILL BEVAN was born and grew up here until c.1883 when he attended Westminster Art School. He returned to paint in the area at intervals before the Great War.

Dale

Pembrokeshire Coast, Dyfed

A village which overlooks Milford Haven from the S. headland of St Bride's Bay. To the W. lies the bird reserve of Skomer Island. GRAHAM SUTHERLAND visited this headland during his exploration of W. Pembrokeshire in 1934, and continued to visit the region until the Second World War. He wrote to a friend of the place: 'At first I attempted to make pictures on the spot. But I soon gave up. It became my habit to walk through, and soak myself in the country. I would make small sketches of ideas on the backs of envelopes, and in a small sketch-book, or I would make drawings from nature of forms . . . which I might otherwise forget. . . . I would lie on the warm shore until my eye, becoming rivetted to some sea-eroded rocks, would notice that they were precisely reproducing, in miniature, the forms of the inland hills.'

Dedham

Suffolk

A large smart village which has benefited from its associations with JOHN CONSTABLE whose father owned the watermill at Dedham and previously with the wool trade.

John Constable painted the village many times, its two most famous images being *The Cornfield*, looking towards the village in the vale beyond the sloping corn and high trees of the middle ground, and *Dedham Vale* of 1828, looking eastwards down the valley of the Stour from high on the S. bank, with a light on the rim of the sky telling of the Stour Estuary, and with the sixteenth-century church tower rising in what appears to be a loop of the river.

SIR ALFRED MUNNINGS settled here after the Great War. Previously he had painted rural life in general, particularly fairs, landscape, donkeys, people and cattle, as did ARNESBY BROWN, who stored his belongings in a cottage near his 'painting ground', and stretched canvases there on wet days, making enlarged versions of small work in ground colours upon them. From 1920 he became increasingly known for his equestrian pictures. Castle House still contains many of his paintings. In c.1930 SIR CEDRIC MORRIS and his friend and colleague LETT HAINES opened a small but what was to become under their direction a highly acclaimed and influential East Anglian School of Painting and Drawing at Dedham.

Derby

Derbyshire

Derby initially grew wealthy from its silk mills begun in 1717. In the nineteenth century it became the centre of a great railway locomotive and coach works, and in 1908 was the founding place of the Rolls-Royce motor company. It is now an industrial and commercial town.

The portraitist and landscape painter JOSEPH WRIGHT was born in Derby in 1734. Wright became well-known for his lantern-lit portraits of men of science and industrialists, but from the 1770s he painted widely along the Derwent and the dales of Derbyshire. His landscapes reflect his interest in natural phenomena, particularly rainbows, and the fall of contrasting light. THOMAS SMITH, one of the earliest English painters of landscape views and country houses, was born in Derby c.1745, and worked in the area where he painted a number of the gentry's great houses at the end of the 1750s and during the following decade. He died in Bristol in 1767, aged only 22.

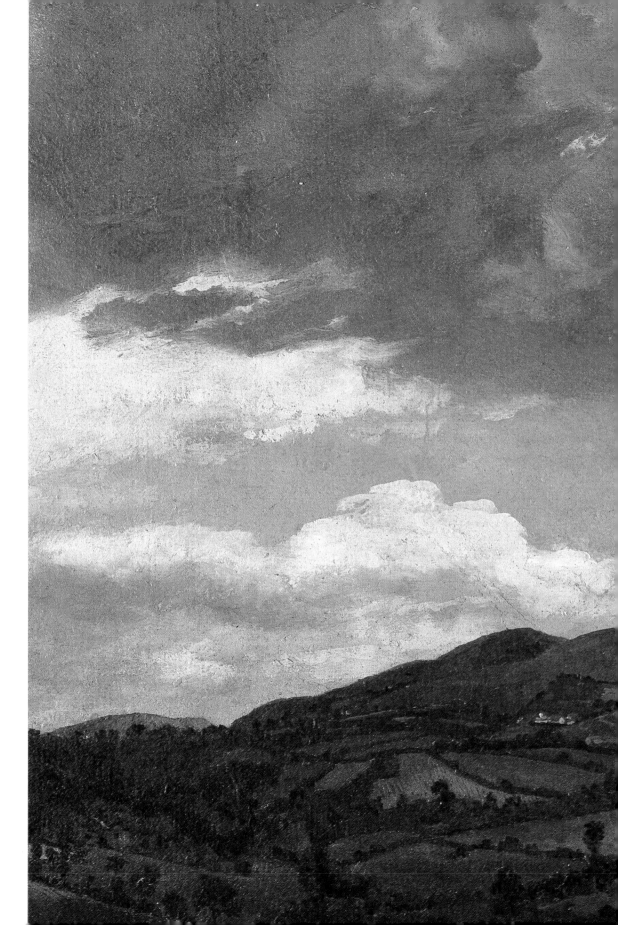

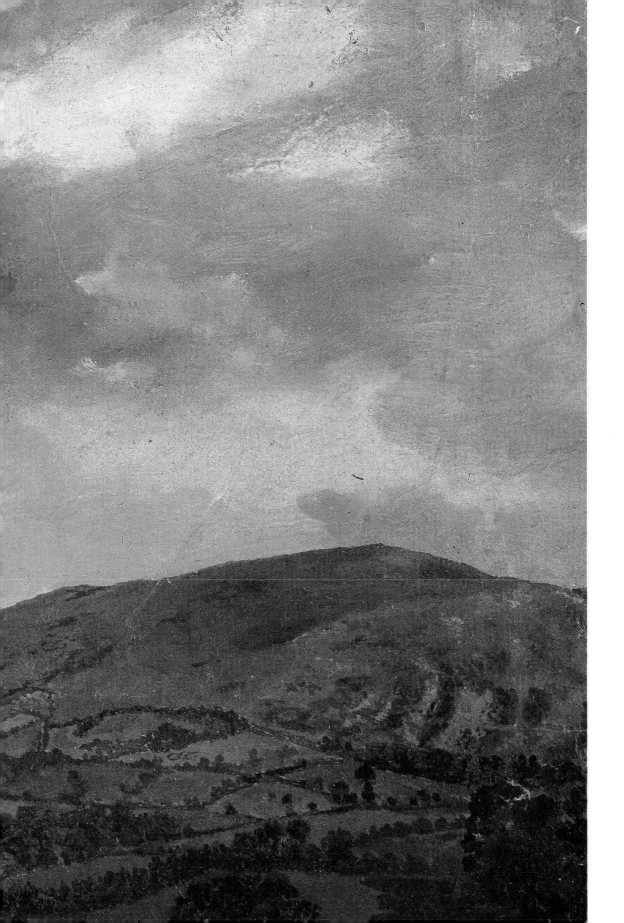

Devizes

Wiltshire

An attractive market town with a number of fine Georgian buildings and a nineteenth-century castle on the Kennet and Avon Canal.

The Ruralist DAVID INSHAW arrived here from Bristol in 1971. Much of Inshaw's painting had responded to the Wiltshire landscape, the intent of the Brother-hood of Ruralists being to restore the poetic landscape tradition in British painting to pre-eminence. Inshaw's oil *She Did Not Turn* with its stark rain-washed light evokes the landscape of dream. In 1974 GRAHAM ARNOLD and ANN ARNOLD moved to Devizes, the three Ruralist painters then living in next-door houses in Lansdowne Terrace.

Ditchling

E. Sussex

A village approx. 2½ miles N. of Ditchling Beacon, one of the highest points on the South Downs.

In 1912 ERIC GILL formed a community of 'artist-craftsmen' here which lasted until 1920.

FRANK BRANGWYN, the Bruges-born, Anglo-Welsh artist, lived at Ditchling from c.1914, having, like Gill, moved from Hammersmith. When Brangwyn's wife died during the 1920s, he finally settled here permanently.

Dudley

W. Midlands

Now part of the conurbation of Birmingham and Wolverhampton. Around 1830 in his 'Birmingham' sketchbook J. M. W. TURNER made drawings of Dudley, and also painted a sombre watercolour of the spreading industrial town in 1831. He used the ruined Cluniac priory and old castle dim on the skyline as last ghosts of the old England vanishing under the morass of the industrial towns. The image is archetypal, bursts of fire and smoke in the gloom evoking Hades, the name of the town given only on the bow of a barge moving on the artificial current created by a steam-pumping engine on a canal.

Dumbarton

Strathclyde

A ship-building town until the early years of the twentieth century, under a high dramatic crag and castle on the N. bank of the Clyde. The etcher and landscape painter DAVID STRANG was born here in 1887, the son of the etcher William Strang. From 1902 he studied in Glasgow. After the Great War he settled in London, and painted southern English and Midlands landscape.

Dundee

Tayside

Originally a whaling port which expanded industrially with the jute trade. JAMES MCINTOSH PATRICK was born in Dundee in 1907, and remained in the city throughout his career, picturing the surrounding landscape of Angus – now Tayside – from the 1930s until the 1970s. He was absent from the area only during his period as a student in Glasgow, between 1924 and 1928, and the Second World War, when he served in North Africa and Italy.

Dunmow, Great and Little

Essex

Great Dunmow – a market town with picturesque thatched buildings, 8 miles E. of Bishop's Stortford, Little Dunmow – a village with a priory church, 1½ miles E. After the Second World War JOHN ARM-STRONG settled in the area and lived here till his death in 1973. During this time, he completed mural paintings in Bristol, painted more works on the Icarus theme and remained active in the Labour Party and C.N.D. In 1962 he began to suffer from Parkinson's Disease, but continued to paint until about 1970.

Dunvant

W. Glamorgan

A mining village approx. 4 miles W. of Swansea. CERI RICHARDS was born here in June 1903. His father, a rollerman at the tinplate works nearby, was a passion-

ON PREVIOUS PAGE Thomas Jones (1743–1803) *Penkerrig* Oil on paper 9in × 12in (Birmingham City Museum and Art Gallery)

ate poetry reader and producer of a number of Welsh and English plays, his son becoming the chapel organist and pianist at concerts. He drew with ease but associated the activity only with engineering through watching engineering draughtsmen, and entered Swansea School of Art in 1920 when his parents and friends, rather than he, deduced that visual art might be his greatest talent. He studied there until 1924, when he left for the Royal College of Art in London.

Durham

Durham

A cathedral and university city. Durham cathedral is positioned dramatically on a high crag surrounded on 3 sides by a wide loop of the River Wear.

Between 1820–30 J. M. W. TURNER made drawings at Durham, of the cathedral and castle, one of the finest, 1834–35, viewing the cathedral from across the river so that it towers up in the early afternoon sunlight. Ruskin considered his depiction of the trees overhanging the river among the finest in European art. In the late 1950s and early 1960s VICTOR PASMORE taught a Basic Form course at King's College, Durham University, with RICHARD HAMILTON. By the mid-1950s Pasmore had become a leading figure in English Constructivism although by the mid-1960s he returned to painting and later still to forms which evoked nature.

Eastbourne

E. Sussex

A sedate resort notable for its excellent Victorian coastal architecture, blue-tiled band-stand, parks, art school, Martello towers, and beaches stretching N.E. to Hastings. The Tower Art Gallery has an extensive collection. ERIC RAVILIOUS was brought up here when his father abandoned his unsuccessful draper's shop in London. Eric Ravilious went to a church school at Willingdon and Eastbourne Grammar, 1914–19. During 1919 he attended life classes at Brighton. He studied at Eastbourne College and was awarded the yearly scholarship to the Royal College of Art when the winning contestant announced she wished to become a missionary instead. He left in 1922, but returned to the Sussex area many times during the later 1920s and 1930s where he painted the landscape.

East Bergholt

Suffolk

A large, finely-kept village 8 miles S.W. of Ipswich. Its name derives from the Anglo-Saxon for 'Wooded Hill', and it spreads along the winding ridge above the Stour valley with its Elizabethan plastered cottages. JOHN CONSTABLE was born here in 1776. His father owned 2 windmills here and watermills at Flatford and Dedham. Constable at first followed his father into the milling business, and thus went late to London to the Royal Academy Schools, a little before the turn of the century. He returned regularly to the village where he maintained business interests, saying 'I associate my careless boyhood with all that lies on the banks of the Stour; those scenes made me a painter'. During the 1820s he painted an increasingly picturesque view of the area as the social strains after the Napoleonic wars undermined the harmonious georgic view of the English landscape.

East Linton

Lothian

A large village on the A1 approx. 17 miles E. of Edinburgh. The Scottish colourist ARTHUR MELVILLE lived here as a boy. First apprenticed to a grocer and later working as a shop bookkeeper, he attended evening art classes, walking half the distance to Edinburgh and back each day until his work was accepted by the Royal Scottish Academy. In 1879 he went to study at the Académie Julian in Paris. In 1898 his *The Cabbage Patch* was exhibited at the R.A. in London.

East Pennard

Somerset

A small village approx. 5 miles S. of Shepton Mallet. The painter TRISTRAM HILLIER lived here from 1946 until his death in 1983. His wife's attachment to Somerset prevented him returning to Spain, his 'visual' home, as he delighted in the crisp, clear-cut light and vivid outlines, but his landscapes of the misty 'soft' Somerset countryside offset his passion for Spain which he viewed with greater vitality as a result. In spite of this, he produced landscapes in Somerset which reflected his 'sharp' taste, such as *January Landscape, Somerset* (1962).

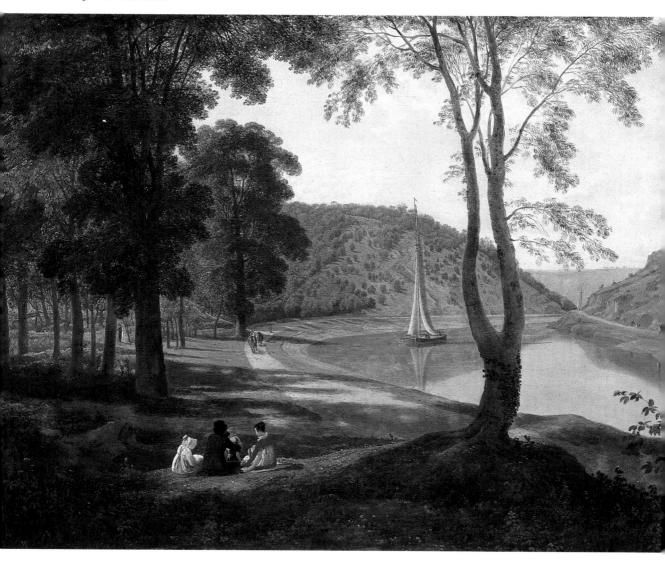

Francis Danby (1793–1861) *The Avon Gorge, Bristol*,
1822 Oil on panel 13⅝in × 18⅞in (City of Bristol
Museum and Art Gallery)

Edinburgh

Lothian

The Scottish capital notable for its superb Georgian architecture and dramatic position on the Firth of Forth. Initially a squalid city short of water, with greater political than financial power, it expanded rapidly after the Act of Union in 1707. Edinburgh's National Gallery of Scotland contains a wide range of work, including many Scottish artists, and the Scottish National Gallery of Modern Art has an excellent collection of twentieth-century painting.

In 1747 the topographical draughtsman and watercolourist PAUL SANDBY arrived here to make a survey of the Highlands. Sandby used the city as a staging post for his surveys, and later in the 1750s as part of a tour.

HORATIO MCCULLOCH settled at Edinburgh in the late 1820s, having been educated in Glasgow under John Knox, but acquired a taste for Highland subjects under the influence of JOHN THOMPSON of Duddingston and the Romantic fiction of Walter Scott. MacCulloch's dramatic pictures of the Highlands and the lochs of the (now) Strathclyde region show a certain Dutch influence. But by the 1840s they led to his being hailed as the national painter of Scotland, appearing to exemplify the Scottish *idea* of the Scots landscape as Constable did that of England for the English. In 1830 WILLIAM DYCE settled in Edinburgh where he lived and worked until 1837. Dyce had been advised to paint by Sir Thomas Lawrence during a brief visit to London, and painted mostly portraits in Edinburgh. He did not take up landscape with any conviction beyond a small number of watercolours until 1850.

WILLIAM MCTAGGART attended Edinburgh School of Art in 1852. McTaggart had been born on a croft at Aros, in Laggan of Kintyre, and apprenticed to a Campbeltown apothecary who saw his talents and encouraged him to attend Edinburgh. McTaggart was influenced here by the colourist, ROBERT SCOTT LAUDER, and in 1860 left briefly for Paris; he was only gone two weeks. Thereafter he painted farming, landscape and coastal subjects in the Midlothian area, in Fife and Tayside and on the W. coast. JOHN MACWHIRTER arrived in Edinburgh at the same time as McTaggart, whom he knew as a fellow-student, and a contemporary of PETER GRAHAM. He achieved early success in Scotland, leaving Edinburgh for London in 1869, although he returned to paint landscape in Scotland in the Lothian and W. coast area. ARTHUR MELVILLE attended art classes in Edinburgh from 1870, walking much of the way from East Linton (see entry). In 1883 he became a member of the Glasgow School.

WILLIAM RUSSELL FLINT was born in Edinburgh in 1880. In 1894 he was apprenticed as a lithographic artist and completed this training in 1900. He left Edinburgh that year for London. Flint returned to the Lothian area frequently and his reputation was largely established by his etchings and watercolours of the Scottish and Northern English landscapes, aside from the exotic – and erotic – subjects he also portrayed. SIR DAVID YOUNG CAMERON studied in Edinburgh in the early 1880s, after leaving Glasgow, and became one of Britain's most prolific etchers and landscapists. He worked most frequently in what is now the Central, Tayside and Highlands regions.

SAMUEL JOHN PEPLOE was born here in 1871. He studied at the Edinburgh School of Art from 1885, and then in Paris, returning during the mid-1890s before going to paint in the Hebrides. He came back to Edinburgh at intervals between 1902 and 1910, after which he remained on the Continent until the outbreak of the Great War. He was declared unfit for military service, as was his friend FRANCIS CADELL, who was found to have 'smoker's heart' when he volunteered for the army, but who later became an officer in the Argyll and Sutherland Highlanders. Cadell was born in Edinburgh in 1883. At 15 his work impressed Arthur Melville enough for him to advise Cadell's parents to send him to the Académie Julian in Paris, where he studied, 1899–1903. From 1920 he spent every summer painting in Iona, with winters in Glasgow and Edinburgh. JOHN DUNCAN FERGUSSON, who initially intended to become a naval surgeon, took up painting in Edinburgh where he rented a studio in 1894, making regular visits to France from 1897. He left in 1907 and lived in Paris until the Great War, after which he settled in England, although he did make a tour of the Scottish Highlands in 1922. EDWARD ALEXANDER WADSWORTH was educated at Fettes College, Edinburgh c.1906, and then Munich to perfect his German, with his family's intention that he should go into the worsted business. While in Edinburgh he decided to become a painter.

ANNE REDPATH, the daughter of a Galashiels tweed designer, entered Edinburgh College of Art in 1913, qualifying as an art teacher in 1917. She left Edinburgh but returned to Scotland in 1934, where she painted chiefly on Skye and the Borders. The Selkirk-educated WILLIAM JOHNSTONE entered Edinburgh College of Art in 1919, encouraged by TOM SCOTT, and studied there until 1925. SIR WILLIAM GILLIES, born near Edinburgh at Haddington, drew and painted in the area until he entered Edinburgh College of Art in 1914, leaving in 1916 to join the army. After the Great War he returned to study here until 1924 when he won a travelling scholarship to Italy and Paris. In 1925 he returned to a teaching post in Inverness, and from 1928 he taught at Edinburgh College of Art where he eventually became Principal. In 1932 he became a member of the Scottish Society of Eight. He painted in the Edinburgh area throughout his life, working in the College of Art itself and the surrounding country-

side at all times of the week and season, and in all weathers. DOUGLAS PERCY BLISS was educated at Edinburgh University, where he took a degree in rhetoric and English literature and won a medal for fine art between 1918–21. In the early 1920s he attended the Royal College of Art, London, along with Ravilious , Tunnicliffe, Henry Moore and Barbara Hepworth.

Ely
Cambridgeshire

A cathedral and town on the River Ouse and Bedford Level, approx. 12 miles N.N.E. of Cambridge. The cathedral, begun in 1083 and completed c.1130, was drawn on a number of occasions by J. M. W. TURNER, who made exceedingly careful outline studies of it, c.1802, which were the source of work in the 1820s and 1830s. During the winter of 1831–32 he produced an image of the cathedral as the symbol of establishment intolerance and reactionary hypocrisy (see main text). J. S. COTMAN visited the area in the 1800s and 1810s. His extensive collection of ecclesiastical ruins and buildings ranged widely across East Anglia, and up to the Lincolnshire border, although with less vigour than his Yorkshire subjects. EDWARD DAYES was typical of watercolourists producing pleasing images of church architecture during the 1790s, with none of the later irony of Turner, his portrayal of Ely being a gently picturesque image with people in the local Cambridgeshire costume passing by with the peaceful rural deliberation of distant figures in Claude or Poussin. MICHAEL ANGELO ROOKER, 'WARWICK' SMITH, JOHN COZENS, and during the 1840s WILLIAM CALLOW worked in the area.

Epsom
Surrey

Best-known for its racecourse to the S.E., site of the Derby since 1780, Epsom was originally a spa around a medicinal spring. Now a residential area S. of Greater London.

GEORGE STUBBS painted numerous landscapes with the racehorses of his day on the wide downlands stretching to Box Hill. As at Newmarket, he used the small rectangular buildings with their cupolas to give an anchor to the composition. In 1858 WILLIAM POWELL FRITH produced what is probably one of the best-known panoramas of Victorian society at leisure – *Derby Day*. Frith's painting showed an apparently infinite sea of figures, minutely detailed, stretching to the horizon which was broken only by the great temple-like grandstand, while in the foreground acrobats, the racing fraternity, and all strata of society are massed around carriages and booths. Only in the distant background does one glimpse horses and jockeys. Between 1914 and 1919 between the ages of 11 and 15, GRAHAM SUTHERLAND attended Epsom College. During the early and mid-1930s LAURA KNIGHT made a striking figure of herself by painting at Epsom during the races with her easel inside or on top of a hired Rolls-Royce.

The painter JOHN PIPER was brought up in Epsom, where he was born at Alresford. Here he became an articled clerk in his father's firm until his father's death in 1928, when he attended Richmond and Kingston School of Art.

Ewell
Surrey

Now a residential suburb of Greater London. In 1851 the Pre-Raphaelites JOHN EVERETT MILLAIS, his brother WILLIAM HENRY MILLAIS and WILLIAM HOLMAN HUNT, stayed at Worcester Park Farm, John having 'bullied' his brother 'into doing nothing all summer but paint in the fields' two years before. Substantial parts of two of their best-known exhibition paintings, Hunt's *The Hireling Shepherd* (1851–2) and Millais' *Ophelia* of the same date, depict the area. Hunt modelled the *Hireling* landscape on the meadows around; Millais painted the willow-lined river bank of *Ophelia* on the River Hogsmill where it now flows near Worcester Park Rd. He was plagued by swarms of midges, and attacked by nesting mute swans.

Eynsford
Kent

A very attractive village of medieval and half-timbered houses beside the River Darent, spanned by a fifteenth-century bridge.

The painter GRAHAM SUTHERLAND and his wife Kathleen moved here in 1931. During this time Sutherland was very much under the influence of SAMUEL PALMER's Kent pictures, and also designed posters for Shell-Mex, the Post Office and the London Transport Board, many concerning the English landscape.

Exeter

Devon

A cathedral city and former port on the River Exe. The landscape watercolourist FRANCIS TOWNE was born here in 1739/40. He lived almost his entire career in the city, moving to London only in 1807, 9 years before his death. He painted widely in the Lake District during the 1780s, otherwise producing work in Wales and Devon. FRANCIS HAYMAN was born and brought up there, before going to London where he collaborated with Hogarth, producing the decorative paintings at Vauxhall Gardens. He spent almost all the rest of his life in the capital, in contrast to two other well-known landscape artists, Towne and Abbott, born in the city shortly after him. JOHN WHITE ABBOTT, a pupil of Towne, was born here in 1763. A highly successful and talented amateur, White painted in the S.W. across Devon, Cornwall and Dorset, inland and along the coast. A surgeon by profession, Abbott showed work widely in London, including the R.A., his work being a very polished imitation of Towne's, although never a slavish imitation. He lived all his long life in Exeter, and died there in 1851.

Between 1825–29 J. M. W. TURNER pictured the town and its river port for the *England and Wales* series of watercolours and engravings, showing the cathedral partly obscured by the houses of Colleton Crescent and the general lack of focus ecclesiastical buildings by then enjoyed in a rising commercial and industrial town. JAMES FRANCIS DANBY moved to Exmouth in 1847, and lived for a time in Shell House (now gone), facing the Maer estuary, where he died.

Farningham

Kent

A very attractive village with many eighteenth-century houses approx. 5 miles S. of Dartford. GRAHAM SUTHERLAND and his wife Kathleen Barry took a house here in 1927, where they remained until 1931.

Far Oakridge

Gloucestershire

Near Oakridge and Oakridge Lynch, 5 miles E. of Stroud. In 1912 SIR WILLIAM ROTHENSTEIN bought Iles Farm here, and painted in the area throughout the rest of his life until his death in 1945.

Felpham

West Sussex

Formerly a village and now absorbed into Bognor Regis and Middleton-on-Sea. WILLIAM BLAKE lived in a cottage at Felpham, 1800–3, and while here illustrated some of William Hayley's writings with landscape studies, and made his visionary drawings to accompany his own poetry, and the book *Milton*.

Fifield

Oxfordshire

A small village 6 miles S. of Stow-on-the-Wold. ALGERNON TALMAGE, the landscape and animal painter, and colleague of Sir Alfred Munnings, was born here in 1871, the son of a clergyman.

Flatford Mill,

Suffolk

Now within the National Trust area comprising Valley Farm, approx. ½ mile S. of East Bergholt, on the N. bank of the Stour. The Constable family owned Flatford Mill during the late eighteenth and early nineteenth century, and it was the subject for one of JOHN CONSTABLE's most famous paintings, *Flatford Mill* (1816) (see main text). The region has an air of unreality as scarcely any area of England is deliberately preserved to look like a two-dimensional painting. During the late 1930s the New Zealand-born painter FRANCES HODGKINS, formerly a member of the Seven and Five, painted extensively along the Stour valley, and pictured Flatford Mill on a number of occasions.

Ford

Northumberland

A village approx. 8 miles E. of Coldstream on the Northumberland border. During the 1860s and 70s LOUISA, MARCHIONESS OF WATERFORD, a highly talented amateur painter, recorded the landscape around the village in a series of murals in the schoolhouse there depicting Bible stories dealing with childhood. Whereas the portrait of the village was idealized, the figures were based on the actual people and the Northumbrian landscape.

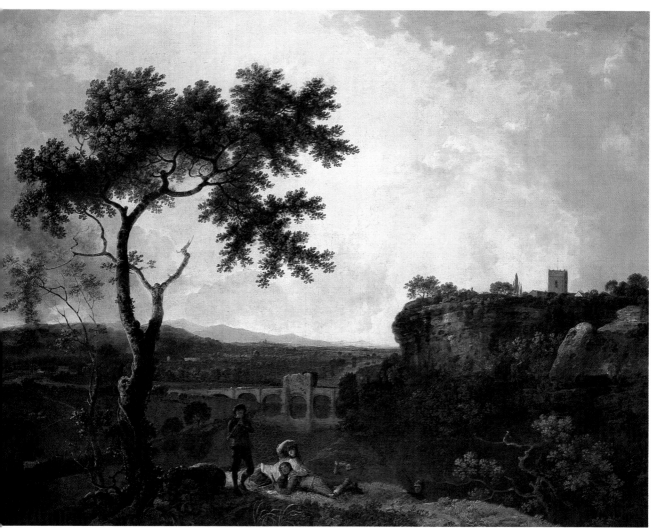

Richard Wilson (1713/14–82) *Holt Bridge on the River Dee* Oil on canvas 58½in × 76in (National Gallery, London)

OPPOSITE Samuel Palmer (1805–81) *Coming from Evening Church* (Shoreham) Tempera on paper 11⅞in × 7⅞in (Tate Gallery, London)

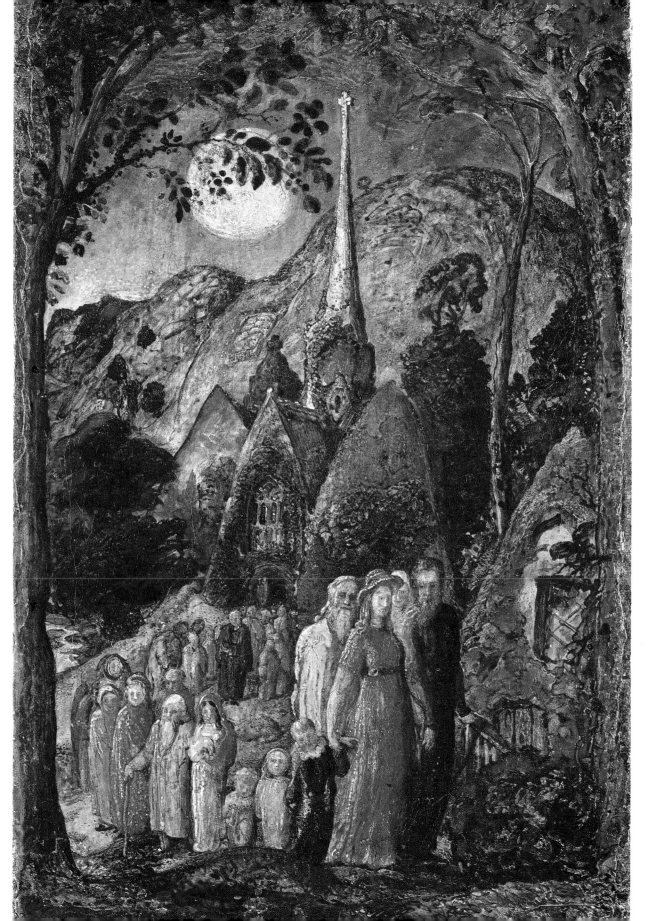

Fordingbridge
Hampshire
A market town approx. 10 miles S. of Salisbury. In 1927 AUGUSTUS JOHN settled at Fryern Court here, and lived here until his death in 1961. He was elected to the Royal Academy soon after his arrival. Here while working he fell into a melancholia precipitated by alcohol and other personal problems. The formal garden ran wild and began to invade the house, which also fell into disrepair.

Framlingham
Suffolk
A market town dominated by its 12th and 13th century castle. SIR ALFRED MUNNINGS attended school at Framlingham College from late 1880s, where he came into contact with the sons of the Newmarket racing fraternity, which by fanning his equestrian enthusiasm deeply influenced his landscape painting. Best known for his hunting scenes he painted in the region throughout his career. During the Great War he was attached to the Canadian Cavalry Brigade and executed 45 war pictures for the Canadian government.

Freshwater
Isle of Wight
A small affluent residential and tourist town on the Freshwater Peninsula below Tennyson Down. From 1874 to '78, GEORGE FREDERICK WATTS lived on Moon's Hill, near Farringford, home of his friend Tennyson.

Gerrards Cross
Buckinghamshire
Now a commuter town 5 miles N.W. of Uxbridge. The book designer, politician and landscape painter BRIAN COOK, better known since 1947 as BRIAN BATSFORD, was born at Gerrards Cross in 1910, leaving c.1926 to study at Repton, Derby, under Arthur Norris. In the autumn of 1919 JOHN NASH settled here, spending most of the summer at Whiteleaf, Princes Risborough, drawing the landscape in watercolour. He had been engaged in painting oils of his war experiences for the War Office previously, but disliked working in oil and did so less as he returned to civilian life.

Glasgow
Strathclyde
A cathedral, university and industrial city on the Clyde estuary, known for its ship-building yards since the mid-nineteenth century. Glasgow expanded at a prodigious pace during the Industrial Revolution, much of its burgeoning population occupying areas – such as the Gorbals – which were arguably the worst slums in the British Isles. On the city's margins lie some of the loveliest areas of Britain: the Campsie Fells, the Kilpatrick Hills, and a little further the Kyles of Bute, Loch Lomond and The Trossachs. The Art Gallery at Kelvingrove Park has a wide range of paintings including many from the Scottish schools.

JAMES PATERSON, later closely associated with the Glasgow School, was born here in 1854, studying at the Glasgow School of Art, 1871–74. After two visits to France, he returned to Glasgow in 1883, going to the winter classes held at the studio of WILLIAM YORK MACGREGOR, whom he had known since his schooldays. He was strongly influenced by MacGregor, who advised him to reject narrative genre subjects, then very popular, and concentrate on bolder colour and freer technique. William York MacGregor was born the son of a ship-builder at the Clydeside yards in 1854. Having attended the Glasgow School of Art he was responsive to James Paterson's Parisian approach to painting while also influencing Paterson's subject matter. In the late 1870s he set up a studio in Bath St, which became a gathering place for younger artists. JOHN LAVERY (later SIR), while a boy of 12, ran away to Glasgow from the Ayrshire farm where he had been sent by his uncle who had brought him up in Ulster after he was orphaned at 3 years of age. He was sent back to Ayrshire but returned to Glasgow in 1876, to study at the College of Art. A beneficial fire in his studio in 1879 gave him enough insurance money to study at Heatherley's School in London, then in Paris. He returned to Glasgow in 1885 and became a member of the group gathered around MacGregor. Making the acquaintance of Whistler in 1887 he helped form and then became vice-president of the International Society under Whistler. In 1888 Glasgow Corporation commissioned him to paint Queen Victoria's state visit to the city.

GEORGE HENRY arrived in Glasgow in 1873, and on leaving the Art School became attached to MacGregor's studio circle. He became closely allied to E. A. HORNEL with whom he painted and travelled, and visited the Bath St studio. In the mid-1890s he

moved to London. JAMES GUTHRIE (later SIR) came to study law at Glasgow University in 1877, but abandoned it to paint in London. In 1881 on a Glasgow visit he appears to have viewed Bastien-Lepage's pictures at the Glasgow Institute, and joined the Bath St circle c.1883. He painted widely with them until the late 1880s, becoming president of the Glasgow Art Club at the turn of the century. EDWARD ARTHUR WALTON became a member of the Bath St group during the early 1880s, painting with them on the coasts, before leaving Glasgow for Edinburgh in the later 1890s. ARTHUR MELVILLE became associated with the Glasgow School group in 1881 when he returned from a visit to Egypt, and painted with the circle until the Glasgow School joined the New English Art Club in 1889, when he moved to London. From 1885, JOHN QUINTON PRINGLE attended evening classes in Glasgow Art School on an evening school bursary, which he continued until 1896. At the turn of the century he painted the back streets of Glasgow, a subject which had engaged DAVID YOUNG CAMERON. Cameron was born in Glasgow in 1865, studying here and in Edinburgh. A fine draughtsman, he achieved a reputation as an etcher, arguably the best known of all in that medium, and a powerful painter of landscape, frequently of highland areas. He sketched the streets of Glasgow and made etchings and paintings of the subject as a grim contrast to the open land. In 1924, he became part of the Fine Arts Commission – its only painter – and was knighted that year, later becoming a Trustee of the Tate Gallery. The architect and painter CHARLES RENNIE MACKINTOSH was born in Glasgow in 1868. After his apprenticeship he entered the firm of Honeyman & Kepple, where he met HERBERT MAC-NAIR with whom he attended evening classes at Glasgow Art School. There MARGARET and FRANCES MACDONALD with whom he and MacNair formed 'The Four', produced watercolours, book illustration, posters and metalwork and furniture. Mackintosh produced landscape watercolours during this time and throughout his career. In 1914, after vigorous criticism – not wholly baseless – he resigned from Honeyman & Kepple and left Glasgow, to which he never returned. In London he practically abandoned architecture and produced landscape watercolours in increasing number, particularly in France 1923–27, before returning to England where he died in 1928.

DAVID MUIRHEAD BONE was born in Glasgow in 1876. He was one of 8 children of a journalist. He intended to become an architect, but studying at Glasgow School of Art became a draughtsman. In 1901 he illustrated the industry and street-life of Glasgow in James Hamilton Muir's *Glasgow in 1901*. He had taken up etching in 1898, leaving Glasgow for London in 1901. In 1932 ROBERT COLQUHOUN began his studies at Glasgow, the same year as his inseparable friend ROBERT MACBRYDE who had worked for 5 years in a factory before getting a scholarship there. They came under the teaching of IAN FLEMING, who rapidly recognized their talents and inseparability, which he reflected in a painting of them, MacBryde strongly in focus and seated, Colquhoun more softly painted and standing, appearing to support Mac-Bryde. Both Roberts, or 'The Two Roberts' as they were later known in London, studied at Glasgow for 5 years, Colquhoun winning an extra year's scholarship. They left Glasgow in 1938, painting first in Ayrshire and from the end of 1941 in London, Colquhoun having been discharged from war service with a cardiac condition; MacBryde was tubercular.

Two Poles, JANKEL ADLER and JOSEF HERMAN settled in Glasgow in 1940. Herman had helped found a group known as 'The Phrygian Cap' who drew their subjects from the proletariat in Warsaw in 1935, and they continued this theme in their work and ideas in Glasgow. Herman remained in Glasgow until 1943, when he left for London. He had a considerable effect on young JOAN EARDLEY whom he befriended. Joan Eardley was born into an affluent middle-class family in Sussex, her family moving to Scotland on her father's death. During the early 1940s she studied at Glasgow School of Art and at the Patrick Allan-Fraser Summer School of Fine Art. After a scholarship to Italy where she made scores of paintings and drawings of peasants she settled in Glasgow in the slum areas until 1956, painting the children there. In 1956 she left for Catterline on the N.E. coast of Scotland. She died prematurely, aged 42, in 1963.

Glossop
Derbyshire

An industrial town on the edge of the Peak District, about 5 miles E. of Hyde in Greater Manchester. The consumptive landscape painter THOMAS COLLIER was born here in 1840. Excelling at skyscape effects, he is primarily remembered for his pictures of the East Anglian landscape and coast.

Godstone
Surrey

A village approx. 1½ miles S. of Caterham. SIR LAWRENCE ALMA-TADEMA painted one of his rare contemporary landscapes here, *94° in the Shade*, in 1876.

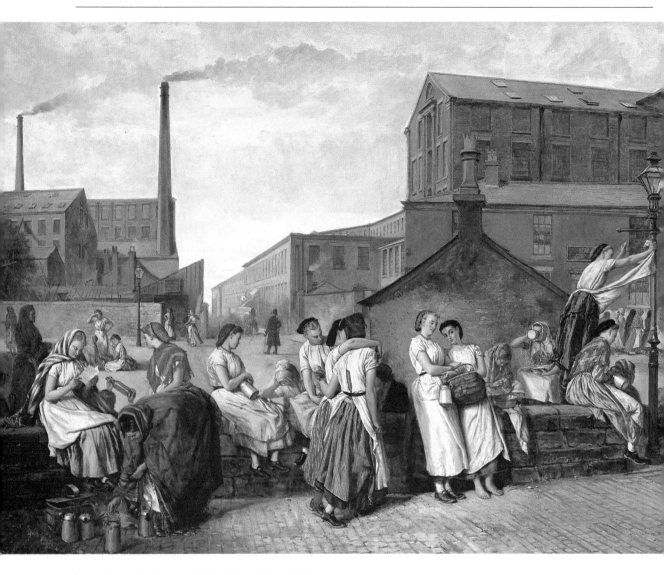

Eyre Crowe (1824–1910) *The Dinner Hour, Wigan*, 1878
Oil on canvas 30¹⁄₁₆ × 42½in (Manchester City Art
Gallery)

OPPOSITE John Sell Cotman (1782–1842) *Devil's Elbow,
Rokeby Park*, c.1806–7 Pencil and watercolour
17¾in × 13¾in (Norfolk Museums Service–Norwich
Castle Museum)

Gomshall

Surrey
A village approx. 5 miles E. of Guildford and 5 miles

W. of Dorking. BENJAMIN WILLIAMS LEADER lived and painted here from 1890 until his death in 1923.

Goodwood

West Sussex
Approx. 1¾ miles N. of Chichester, Goodwood House, home of the Duke of Richmond and Gordon, built of Sussex flintwork in 1780–1800, stands in parkland below the ridge of the S. Downs and Goodwood race course. In 1760–61, GEORGE STUBBS stayed at Goodwood and portrayed the estate's parkland stretching away toward the coast, with the Duke's racehorses being exercised. This was one of Stubbs's earliest attempts at landscape painting and was very

successful, although lacking the lightness and breadth of colour across the middle ground and receding planes that came later. It is famous for the repeated motif of three jockeys in yellow coats on three rocking-horse-like racehorses in matching yellow horsecloths arranged across the l. of the picture. The picture looks S.E. towards Chichester. Stubbs made other pictures for the Duke, these showing stable lads with the horses of the estate, more accomplished but less memorable.

Great Bardfield

Essex
A village – once a market town – approx. 7 miles N.W. of Braintree, near the River Pant. Its High St retains medieval and Georgian houses, a museum of Essex farming, not far from a restored windmill.

EDWARD BAWDEN took Brick House here in 1930, which he initially shared with ERIC RAVILIOUS, forming the nucleus of the Great Bardfield School which helped to revive the art and popularity of watercolour painting during the 1930s.

Green Tye

Hertfordshire
A village about 2½ miles S.W. of Bishop's Stortford. In 1939 EDWARD MORLAND LEWIS bought a house

here and painted the landscape of the area until 1940, while teaching at Chelsea Art School, London. He was later commissioned as a camouflage officer and was killed in N. Africa in 1943.

Greta Bridge

Durham
A slender, single-arched, eighteenth-century bridge spanning the River Greta, 2 miles S. of Barnard Castle and about 10 miles N.W. of Richmond. The valley of the Greta extends S.W. along such beauty spots as the Devil's Elbow and Scotchman's Stone. In August 1805 JOHN SELL COTMAN visited the Greta Bridge area as part of a tour of what was then N. Riding, prompted by his patrons. They recommended him highly as a drawing master to their friend John Morritt of

Rokeby Hall, whose father had designed Greta Bridge. Cotman visited Morritt for a few days, and stayed three weeks at the inn beside the Bridge. There he produced a set of watercolours among the finest in British art, their subjects taken along the Greta river from approx. 2 miles above the Bridge at Brignall Banks down to the grounds of Rokeby Hall. *The Devil's Elbow* picture has an extraordinary economy of tone and form, while its atmosphere is that of Claude. (Most of this set is in the British Museum.)

Guildford

Surrey
A commercial and residential town. The Preston-born artist ANTHONY DEVIS, a landscape and topographical watercolourist, and the younger half-brother of ARTHUR DEVIS, retired to Albury village, near here, in 1780. Anthony Devis had lived in London since c.1743, exhibiting with the Free Society of Artists and after 1768 at the R.A. From 1308 until 1914 an annual 5-day fair was held on Drake or St Catherine's Hill, about ¾ mile S. of Guildford. J. M. W.

TURNER portrayed it in watercolours, 1830–31: a packed scene showing stalls of home-brewed beer, a 'back-sword' or short single-stick fight, and the booth of a well-known London showman, Richardson. On the r. of the picture the shadowy mass of the Portsmouth coach approaches up a strangely dark cutting, as if from a passage to or from the underworld.

The artist and critic ROGER FRY lived at Durbins (now Quince House), 37 Chantrey Rd, S. of Guildford, from 1909 until his death in 1934. The stairway is decorated by Fry, VANESSA BELL and DUNCAN GRANT.

Haddington

Lothian

A town 12 miles E. of Edinburgh, and approx. 6 miles inland from the Firth of Forth. SIR WILLIAM GILLIES was born here in 1898, and as a boy was taken sketching in the district by the painter WILLIAM RYLE SMITH, his uncle. Later he was to become a member of the Scottish Society of Eight and Principal of Edinburgh College of Art.

Haddiscoe

Norfolk

A village 5 miles inland from Lowestoft. ARNESBY BROWN, the Nottingham-born landscape painter lived here from c.1920. Brown lived and worked in East Anglia throughout the rest of his life until 1955, during the last 10 years of which he was blind. He gave lessons here to to CAMPBELL MELLON, the marine and landscape painter.

Hadleigh

Essex

Hadleigh, directly to the W. of Leigh on Sea, itself part of the long development of Southend-on-Sea, overlooks Canvey Island and the mouth of the Thames Estuary. JOHN CONSTABLE made sketches in 1814 of the landscape and foreshore, the ruined castle and the Kent hills to the S. On the death of his wife Maria in 1828 he returned to the pictures, making an oil painting of Hadleigh Castle under a windy, cloud-racked sky, which seems to reflect his sense of loss.

Hagbourne (East and West)

Oxfordshire

Two small villages approx. ⅔ mile S. of Didcot. The Glasgow painter, ALEXANDER MANN, settled here in the mid-1880s. Many of his landscapes were made on the Berkshire Downs and he continued to paint the area after he had moved to Streatham in the mid-1890s.

Halifax

W. Yorkshire

An industrial town which expanded with the clothing trade.

THEODORE NATHANIEL FIELDING was born here at Sowerby Bridge, now a suburb of Halifax, in 1747, beginning his career as a portraitist, but turning to landscape with a considerable degree of success. He had four sons, THEODORE, ANTHONY VANDYKE COPLEY, THALES and NEWTON, all of whom became painters. His second son, Anthony Vandyke Copley, born here in 1787, became by far the best-known. In 1788 Theodore Nathaniel moved to London, and then in 1803 to the Lake District, for the benefit of his sons' art work, so that they might 'imbibe the landscape'. Theodore Fielding, his first son, later worked in London (see Camden). Much of Anthony Vandyke Copley Fielding's prodigious output is associated with the Lake District.

The painter MATTHEW SMITH was born in Halifax in 1879. His father owned a factory in the area. He was a contradictory parent with a very strict puritanical outlook who discouraged his son's artistic leanings while having a deep enthusiasm for poetry and music himself. After working in a Bradford wool mill Matthew managed to persuade his parents to let him attend art school when the family moved to Manchester. After studying there and at the Slade, Matthew Smith never returned to Yorkshire or ever painted there.

Harlech

Gwynedd

Once the capital of the county of Merioneth, and the site of Edward I's superb castle on a high spur overlooking the Irish Sea at Tremadoc Bay.

JOHN VARLEY and NICHOLAS POCOCK visited Harlech during their tour of the Welsh coasts. Pocock portrayed Harlech with his characteristic charm, Varley with grace. Neither explored the darker atmosphere of the old fortress high above the flats that were formerly covered by tides which came to the foot of the crag where the castle stood. MICHAEL ANGELO ROOKER pictured the ruins standing as though they were part of the hills, under a windy sky. He exaggerated the heights in the same way that the Manchester painter HENRY CLARENCE WHAITE would 50 years later.

J. M. W. TURNER produced one of his most poignant watercolours here. In 1798 he made drawings at Harlech, which he saw as a symbol of lost causes and human endeavour: Owen Glendower captured it in 1404 when its tiny garrison succumbed to a ruse; it

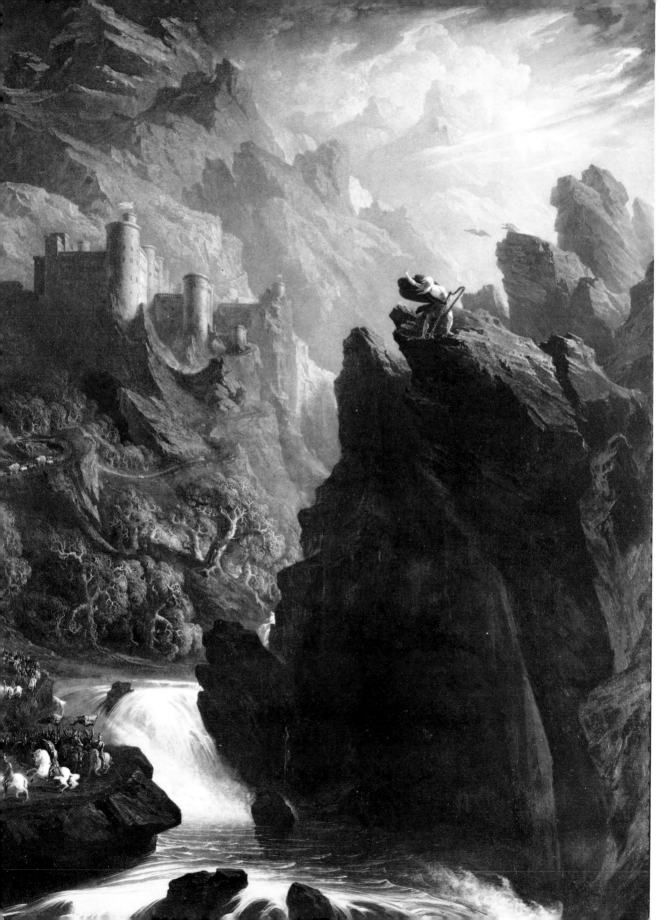

was the last castle in Wales to resist Parliamentary forces two centuries on. In 1834 Turner portrayed its ruins towering above the pathetic hovels of the Welsh village which had clustered about it, with an old woman toiling up the steep hill toward the viewer, helped by a child carrying a dead bird; in the foreground a girl in ragged clothes has just climbed the long hill to a spring. Beyond the ruined castle and the threadbare village the huge natural grandeur of the landscape throws the human condition into sharp relief.
relief.

JOHN MARTIN incorporated Harlech into his large dramatic oil, *The Bard* (1817), seen through a gorge in a fantasy mountain setting, on a theme of Thomas Gray's poem (1757). Martin chose Harlech because it was so great a landmark and it was English-built: a symbol of 'subjugation'.

HENRY CLARENCE WHAITE painted large oils of Harlech during the later 1860s and '70s, in a vigorous, Romantic Turneresque style which could have come from Turner's *England and Wales* watercolour series except that it was without Turner's irony.

Hartwell House
Buckinghamshire
Approx. 1 mile S.W. of Aylesbury are the landscaped grounds of Hartwell House. They contain the church of St Mary the Virgin, built in 1753–55, after BALTHASAR NEBOT carried out the paintings of Hartwell grounds during the late 1730s, showing the transition from the formal gardens which had preceded them to the 'landscape' garden of the mid- and late eighteenth century. One picture shows the lawns being scythed and two 'bastions' or recessed areas in clipped hedges which contain standing sculpture, with trees grouped informally around them, and another picture the great formal terraces leading on either side of a central 'axial' canal, toward Gibbs's Temple at the far end. In this second picture cattle and sheep wander right up to the raised terrace where the gentry stroll.

Hastings
Kent
An important fishing and trading port since before the Norman conquest and one of the medieval Cinque Ports, Hastings is divided in half by steep cliffs which separate Old Hastings from its nineteenth- and twentieth-century developments.

The watercolourist SAMUEL PROUT lived here, 1836–40. WILLIAM HOLMAN HUNT visited Hastings in the summer of 1852, painting his oil *Strayed Sheep* on the cliffs at Fairlight. He was introduced to the area by EDWARD LEAR, a friend of Marianne North the flower painter. In 1854 DANTE GABRIEL ROSSETTI brought his future wife Elizabeth Siddal to Hastings for her health, and married her here in 1860 at St Clement's Church. The landscape painter HERCULES BRABAZON BRABAZON lived at Sedlescombe, Hastings, for the greater part of his career, painting inland and along the coast. Chiefly a watercolourist, Brabazon died here in 1906, at the age of 85.

The landscape painter, muralist, theatrical and film designer JOHN ARMSTRONG was born here, the son of a parson, in 1893.

Hathersage
Derbyshire
A village 2 miles N.W. of Longshaw Park, a National Trust estate, on the high moors. HARRY EPWORTH ALLEN painted here during the late 1940s, showing a landscape which he divided up into formal units. His loss of mobility after losing a limb caused him to concentrate on a wealth of illustrative detail.

Haverford West (Hwlffordd)
Dyfed
Originally the county and market town of Pembrokeshire, on the West Cleddau.

GRAHAM SUTHERLAND visited this area during the 1930s and 1950s, while exploring the hinterland of coastal Pembrokeshire. The paintings of green tunnel-like lanes which are sometimes held typical of his pictures of this period were conceived from the small roadways in the vicinity. JOHN ELWYN has worked in the region, having originally studied at Carmarthen, and worked around the Dyfed landscape since the Second World War. JOHN ROGERS and JOHN KNAPP-FISHER have painted in the area during the 1970s and '80s.

OPPOSITE John Martin (1789–1854) *The Bard: 'Ruin seize thee, ruthless King'* Oil on canvas 85in × 61¾in (Laing Art Gallery–Tyne and Wear Museums Service)

Haydon Bridge
Northumberland

A village where the road crosses the South Tyne 6 miles W. of Hexham. JOHN MARTIN, the painter of spectacular and apocalyptic landscapes and dramas, was born in a single-roomed cottage at East Lands-ends Farm, Haydon Bridge, in 1789. During his first 14 years here he probably developed his taste for dramatic landscapes, such as the nearby Allendale Gorge, and in those years decided to become a painter.

Hemingford Abbots and Hemingford Grey
Cambridgeshire

Two linked villages, Hemingford Abbots by two meres and Hemingford Grey with thatched and tim-bered cottages, by the banks of the Ouse or Old West River, about 3 miles E. of Huntingdon. WILLIAM FRASER GARDEN, the landscape watercolourist, was born at Hemingford Grey Manor House in 1856. Two of his brothers also painted. Until 1898 he lived at Hemingford Abbots, then moved to Holywell, approx. 3 miles further E., where he lived until his death in 1921.

Henley-on-Thames
Oxfordshire

The site of the first river regatta in the world, held in 1839, now a very elegant residential town.

In 1935 JOHN PIPER and Myfanwy Evans, his second wife, moved to Fawley Bottom Farm House here, where a little previously she had published *Axis*, the provocative quarterly review of abstract painting and Constructivist sculpture. John Piper has remained based here throughout his career. ARTHUR MELVILLE painted here in 1891, picturing the regatta in his personal style of using pure colour blobs and letting the soaked paper bleed the watercolour effects to-gether.

Holmbury Hill
Surrey

Approx. ¾ mile S. of Holmbury St Mary village and 7 miles S.W. of Dorking. The landscapist GEORGE VICAT COLE, close friend of Benjamin Leader, lived here from 1863 to '67, having achieved a reputation with such pictures as *Harvest Time*.

Holt
Clwyd

A village on the W. bank of the River Dee, 4 miles E. of Wrexham. In 1762 RICHARD WILSON produced a superbly classical picture of the 7-arched bridge over the river here, seen from rocky crags on the far bank; it is a Claudian image designed to show that the ordi-nary British landscape was as worthy of appreciation as any Italian one.

Horsham
W. Sussex

A market town on the A24, extensively developed by London commuters and light, low-profile industry. It lies on the borders of the 12,000-acre St Leonard's Forest, one of the wildest woodland areas in England. The painter KEITH VAUGHAN attended Horsham School during the early 1920s, and was deeply affected by the surrounding landscape, its colour and forms.

Hughenden Valley
Buckinghamshire

Approx. 1¾ miles N. of High Wycombe. Hughenden Manor (a National Trust property) with its extensive grounds was the home of Disraeli 1847–81. GILBERT SPENCER painted landscape here, showing a wide variety of flora.

Ilkley
W. Yorkshire

A spa town on the River Wharfe. To the S.W. Ilkley Moor rises with crags and ghylls to superb scenery. In the early 1920s RICHARD EURICH lived here while still a student at Bradford Art School. He recalled that his first winter here 'opened his eyes to the great beauty of landscape under weather conditions which in town

were only a signal for putting on extra clothing'. After the Second World War, in 1949 he went to live on the S. coast, but returned to paint Yorkshire landscape and continued to do so until the later 1960s, often picturing huge expanses of moorland with intricate farmland or narrative detail.

Ipswich
Suffolk

A port on the river Orwell for centuries the county town of E. Suffolk. Christchurch Mansion contains an art gallery with work by Gainsborough and Constable.

THOMAS GAINSBOROUGH lived in Ipswich from 1752 until 1759. He took a house on Foundation St, facing the Shire Hall. Gainsborough painted chiefly portraits for a living, extending landscape behind them. Initially he charged 5, then 8 guineas for a 'Head', and 15 guineas for a half-length, but produced landscapes in their own right although they were very difficult to sell. They were bought as overmantels, and after 1755 the Duke of Bedford bought two of his paintings for ground-floor rooms at Woburn: *A Woodcutter Courting a Milkmaid* and *Peasant with two Horses: Hay Cart behind*, set in composites of the landscape around Ipswich. Gainsborough made large numbers of drawings of the landscape around Ipswich, which later, when he moved to Bath, circulated among the community: 'To be sold . . . All the HOUSEHOLD GOODS of MR THOMAS GAINSBOROUGH, with some PICTURES and original DRAWINGS in the Landskip way by his own hand, which as he is desirous of leaving them amongst his friends, will have the lowest price set upon them. . . .'

J. S. COTMAN and MILES EDMUND COTMAN exhibited here, the former at intervals from 1800 until his final return to London in the later 1820s. Miles Edmund and JOHN JOSEPH COTMAN, painting extensively in East Anglia, showed work here between the late 1830s until the late 1850s and 1870s respectively. JOHN MOORE of Ipswich was born here in 1820 and painted throughout his career in East Anglia, and along its coasts. Between 1875 and 1901 he showed 332 pictures at the annual exhibitions of the Ipswich Art Society, but never exhibited his excellent work at London galleries or the R.A. His landscape painting owed a great deal to Thomas Gainsborough, whom he greatly admired, and a certain amount – particularly skyscape – to JOHN CONSTABLE.

The deaf–mute artist LEONARD RUSSELL SQUIRRELL was born in here in 1895; he studied at Ipswich School of Art before going to the Slade. Squirrell achieved a reputation for the carriage-panel designs he made for the major rail companies, and in a style not dissimilar to J. S. Cotman's, painted extensively throughout East Anglia.

Irvine
Strathclyde

Once the main port of Glasgow, and now a resort at the mouth of Annick Water. GEORGE HENRY of the Glasgow School was born here in 1858, the son of a brewer.

Iver Heath
Buckinghamshire

A residential suburb 1 mile W. of Uxbridge. PAUL and JOHN NASH lived here from 1901 when their family moved from London. Paul Nash left for the Slade in 1910. John joined a local newspaper until he asked for money to buy a bicycle and was dismissed. He became involved with the London art world – briefly – in 1910 when invited to participate in the London Group, but lived at Iver Heath until 1914 when he joined the 28th London Regiment (The Artists' Rifles) after serving in the Ministry of Munitions.

Kelmscot and Kelmscott Manor
Oxfordshire

Kelmscot village lies on the N. bank of the River Thames. The Pre-Raphaelite WILLIAM MORRIS is buried in the churchyard. Kelmscott Manor, S. of the village on the river, dates from the late sixteenth century.

In 1871 the Pre-Raphaelites William Morris and DANTE GABRIEL ROSSETTI settled here. Morris lived and worked at Kelmscot until his death in 1896, producing craft-work and illuminated books. Rossetti, already ill, and deeply and morbidly infatuated with Jane Morris, produced a number of claustrophobically erotic portraits of her filling the sky above twilight landscapes and lagoons. In the mid-1870s he returned to London where he died. Morris's studio and workshop included a large number of students. He was also visited here by BURNE-JONES, WILLIAM HOLMAN HUNT, FORD MADOX BROWN and ALBERT GOODWIN. In 1877 Morris founded the Society for the Protection of Ancient Buildings here.

Kidwelly

Dyfed

A small town under the fine (now ruined) castle built by Edward I which still dominates it, approx. 9 miles S. of Carmarthen, a mile from the Gwendraeth Estuary. During his 1795 tour of S. Wales J. M. W. TURNER drew Kidwelly Castle and the town. In c.1832 he used these drawings as a basis for finished watercolour work, producing a radiant picture of rain-washed sunlight in which the – in reality grey – castle basks as a blue-gold edifice like an apparition, while in the foreground on the N. bank of the Gwendraeth-Fach river two couples walk at the head of a line of loaded wagons. The picture has an air of fruitful affection and fertility; the figures are graceful, indicative of Turner's sympathy.

Kilmarnock

Strathclyde

A town on the River Irvine, approx. 20 miles S.W. of Glasgow.

The painter ROBERT COLQUHOUN was born here in 1914, the eldest of two sons of an engineering fitter. In 1927 he entered Kilmarnock Academy where he specialized in art from 1929 to 1932, when he had to leave in order to help support his family during the Depression. His art teacher, James Lyle, persuaded a local patron of the arts, Sir Alexander Walker and the Rev. James Hamilton to support his studies, and in 1932 Colquhoun won a scholarship to Glasgow School of Art. There he met Robert MacBryde, from whom he was to become inseparable. He never returned to Kilmarnock during his lifetime. A Colquhoun Memorial Gallery was opened here in 1972.

Kilgarren (Cilgerran)

Pembrokeshire, Dyfed

A village and ruined castle approx. 3 miles S.E. of Cardigan, on the S. bank of the River Teifi.

During the 1770s RICHARD WILSON produced an oil colour of the castle above the steep wooded gorge here, a dark, brooding composition which was in certain degree as stark as his portrayal of Pembroke Castle, although not so austere. J. M. W. TURNER was apparently influenced by this image when he produced the first of 4 oil paintings of the castle in 1801. In the 1790s he had painted a pair of watercolours, somewhat dark and sinister, showing the ruins above the deeply cloven wooded river valley at sunrise. c.1820–30 he produced another watercolour variant, of the same dawn, but suffused with an airy, Claudian light, wholly different in atmosphere. Figures similar to Gainsborough's appeared on the slopes, with a hoop which was one of Turner's symbols of harmony.

Kirkcudbright

Dumfries and Galloway

A harbour town with an art colony at the mouth of the River Dee, which from 1883 became a centre for the Glasgow School painters, particularly E. A. HORNEL and GEORGE HENRY – who shared a studio here, c.1886–89. ALEXANDER ROCHE and JOSEPH CRAWHALL also worked here, 1883–87, as did E. A. WALTON.

Knaresborough

N. Yorkshire

A market town approx. 3 miles E. of Harrogate. In 1815–16 J. M. W. TURNER made drawings here and, c.1825, watercolours showing the town on the banks of the River Nidd basking in a romantic glow with castle ruins at the central anchor, and cattle winding down from the heights.

Knowsley

Merseyside

A village approx. 3 miles N.E. of Liverpool.

The animal-painter, portraitist and landscapist GEORGE STUBBS was apprenticed to the portrait painter Hamlet Winstanley here for approx. a month at the age of 15 in 1739. Stubbs quarrelled with Winstanley and left to set up on his own in Liverpool.

EDWARD LEAR had an intimate relationship with the family of the 13th Earl of Derby at Knowsley Hall, 1832–37. The Earl had a magnificent collection of birds and Lear, better known later as an exotic landscapist and fantasy poet, was working as a zoological draughtsman. CHRISTOPHER WOOD was born in Knowsley in 1901, the son of the doctor of the 17th Earl. At 14 he suffered an attack of polio which left him helpless for three-and-a-half years. He studied at Malvern College where he was allowed to work lying on a couch. After an abortive time at Liverpool university, he left for London in 1920.

The Lake District
Cumbria

An area approx. 25 miles across, consisting of 16 major lakes among the Cumbrian Mountains, including Derwentwater, Coniston, and Windermere (see below) under 4 major mountains, of which Scafell Pike, at 3,210 feet is England's highest peak. They are separated by the highest passes in England, including Sticks Pass, Nan Bield Pass, and Esk Hause, all above 2,000 feet. It includes the towns of Ambleside at the N. end of Lake Windermere and Kendal.

The travel writer, watercolourist and collector, the REV. WILLIAM GILPIN, arrived here in 1772, although his *Observations on the Lakes of Cumberland and Westmoreland* were not published until 1786.

THOMAS HEARNE toured the Lakes region during the later 1770s; he reduced the scenery, such as that of Derwentwater from the top of Skiddaw, to a series of closely related, delicate tones and shades, devoid of human life and almost deserted, stretching away into haze and cloud. These watercolours set out to convey loneliness and desolation by emptiness and cool tones; no clouds or lightning; just quietude and hills.

A painter and diarist, JOSEPH FARINGTON made an extensive tour of the area during the mid-1780s, with the purpose of publishing a set of *Views of the Lakes in Cumberland and Westmoreland* which were duly engraved and published in 1789. THOMAS GIRTIN travelled the Lakes in the 1800s, painting Derwentwater, Windermere, Keswick and the high passes. He pictured the Falls of Lodore, Derwentwater, probably in the spring of 1801, about a year before his early death.

JOHN GLOVER, a watercolourist, set out in about 1805 and made such a comprehensive tour of the district that it brought near-sarcasm from art reviewers. Glover was typical of the fashionable watercolourist of the first 20 years of the nineteenth century, and JAMES PRINCEP, contributing to the Haldimand collection in 1828, produced a watercolour of a pillar with engraved names, *A Monument to Perpetuate the Fame of British Artists*, of which Glover's name appeared on the foundation of the pillar. Glover's views of the lakes were as lightweight as his hold on posterity. CORNELIUS VARLEY toured the area to better effect, 1800–10, as did EDWARD DAYES, 1795–1800. At the turn of the nineteenth century PHILIPPE DE LOUTHERBOURG produced highly atmospheric oils of the lakes and Cumberland, as finely attuned to the market as his views of the Wye Valley, a blend of mountain and wind-ruffled reflecting water, with a small splash of colour supplied by people in local costume or the scarlet coat of a highland soldier resting by the roadside near a young woman. De Loutherbourg's *Lakes* were rather more placid than his views of the Peak District. J. C. IBBETSON painted

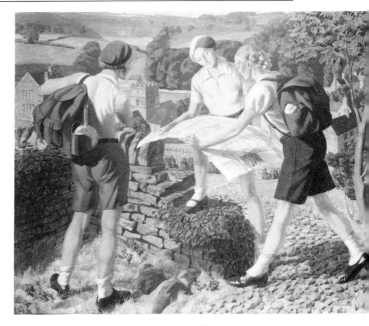

James Tucker (exh. 1928–40) *Hiking* Tempera on board 20⅛in × 23¾in (Laing Art Gallery–Tyne and Wear Museums Service)

in the area during the 1790s and 1810s, as did JOHN 'WARWICK' SMITH and JOSHUA CRISTALL, whose scenes of rural or rustic life included a high peak in the background of the 'cottage door' scene instead of a rolling woodland, and a lake rather than a stream.

Gilpin's book on the lakes was later satirized by THOMAS ROWLANDSON in his illustrations to the *Tour of Dr Syntax in search of the Picturesque* (1812) but it had a considerable effect on many artists, as well as the public.

J. M. W. TURNER toured here in 1797, sketching Ullswater, after visiting Derwentwater and Windermere.

Some time in 1833–34 he made watercolours of all three major lakes for engraving as part of the *England and Wales* series, all notable for their airy tranquil atmosphere and sense of great distance and limpid light. Ruskin thought the foreground rocks in the Ullswater watercolour the finest example in the world of drawings of rocks which had 'been subjected to violent aqueous action'. He also made drawings of 'Keswick Lake' (Derwentwater) which he used as a basis for his oils of c.1800–08, many of which possess a brooding quality, with shadows and mists which give a sense of distance and mystery, but not the limpidness of the region's light. In the mid-1830s he made 'colour beginnings and a finish view' of 'Winandermere' where the hills bore no relation to reality at all but mirrored the patterns produced by boats over

the water. In the later 1830s he produced further watercolours of the area for engraving for the *England and Wales* series, and pictured 'Keswick Lake' suffused with light, figures who have been drenched by a passing shower hurriedly disembarking from a boat, while Lodore Falls and a rainbow act as counterpoints of light against the rain haze.

In 1848 the Bristol artist JAMES BARKER PYNE was commissioned by Agnews of Manchester to paint 24 views of scenery in the English Lakes area. In c.1849–50 he pictured Derwentwater, Windermere and Ullswater, views lithographed in 1853 and chromolithographed in 1859. During the 1840s and 1850s HENRY BRIGHT came here. He used tinted paper to make drawings and watercolour washes. Bright was an influential teacher and had studied under J. S. Cotman and Alfred Stannard, although much of his later work is sometimes described as 'overaccomplished'. In 1868 ATKINSON GRIMSHAW, another Norfolk artist, toured the Lakes with considerable success, becoming known for his moonlit studies of landscape. HENRY CLARENCE WHAITE, whose forte was to become his paintings of the scenery of N. Wales, visited the area during the 1860s and 1870s. DANIEL ALEXANDER WILLIAMSON settled in the region and painted extensively there from the early 1870s, except for a period when illness prevented his travelling or leaving his home.

From 1871 JOHN RUSKIN lived at Brantwood, on the E. shore of Coniston Water until his death in 1900. He suffered increasingly from intermittent bouts of madness, interspersed with great creativity. The village museum at Coniston houses some of his drawings.

ALFRED WILLIAM HUNT, who visited Ruskin at Coniston, painted in the area during the 1870s. Artists of the 'Manchester School', dominated by JOSHUA ANDERSON HAGUE who worked largely in N. Wales came here for the mountainous scenery and lakes. JAMES CHARLES and FREDERICK WILLIAM JACKSON, deeply influenced by French Impressionism, painted

here during the late 1870s and 1880s.

SYDNEY CARLINE painted in Westmorland and the lakes area in 1914. In 1920 the painters BEN NICHOLSON and WINIFRED ROBERTS painted in the Cumberland and lakeland region, developing a *faux-naïf* style for the landscape and its sparse occupants. In the later 1920s they were joined by the brilliant and highly impressionable CHRISTOPHER WOOD, who embraced a similar way of looking as the Nicholsons. From the early 1930s onwards the born-deaf artist, LEONARD RUSSELL SQUIRRELL, painted in the Lake District, producing carriage panels for railway companies and landscapes in their own right. His style was similar to that of J. S. Cotman whom he much admired; Squirrell painted the region well into the 1950s. At the onset of the Second World War WINIFRED NICHOLSON, who had lived in Paris after her divorce from Ben Nicholson and his marriage to Barbara Hepworth, returned to Cumberland. She painted here using a method which expanded small close things such as flowers until they dominated the painting area. By the early 1950s she was painting semi-mystic views of nature.

The German Dadaist KURT SCHWITTERS settled in Ambleside in 1945, after being forced to leave Germany because of Nazi antipathy to his 'degenerate' art. He lived here until his death in 1958. Schwitters painted landscape quite extensively for money, in a highly naturalistic style which is usually ignored by historians more interested in his Dadaist period, and *Merz* collages (a deliberately meaningless term he coined himself) and 3D assemblages called *Merzbau*, one of which he constructed in a barn at Ambleside (University of Newcastle-upon-Tyne). He was buried at Ambleside, but his body was later reinterred in Germany. Only the stone remains.

During the latter part of his career, L. S. LOWRY painted Lakeland landscape, usually wholly deserted, the lake and hillscape reduced almost to abstraction, the water hard, an iron reflection of the grey sky.

Lamorna Cove
Cornwall

A wooded valley sloping down to a cove opening into Mount's Bay, approx. 3½ miles S.W. of Penzance.

JOHN 'LAMORNA' BIRCH settled permanently here in 1902, in Flagstaff Cottage, an old harbourmaster's house overlooking Lamorna Bay. In 1910 Harold and LAURA KNIGHT came to Cornwall, and settled first at Newlyn, then at Lamorna. Here she painted a series of female nudes in landscape, among the best of which

was *Daughters of the Sun* (1910–11). ALFRED MUNNINGS, sporting a vivid check suit and spats, was frequently a guest of the Knights. JOHN ARMSTRONG worked in Lamorna from 1947 till 1955. JOHN TUNNARD settled in Lamorna Valley, at Trethinnick, in 1952. He had lived in Cornwall since the early 1940s, first in a caravan, and then in an old tinminer's cottage at Morvah Hill. At Trethinnick he produced some of his most powerful near-abstract canvases.

Lancaster
Lancashire

Formerly a port of greater importance than Liverpool, and now a commercial town on the River Lune,

dominated by a massive castle and priory on high ground.

In 1825 J. M. W. TURNER painted watercolours from the Aqueduct Bridge, showing the town in a shimmering haze with figures working in the fields below. The canal system was at its height by the early nineteenth century, and was essential to Turner's image of an expanding industrial town. REGINALD ASPINWALL lived and worked in Lancaster throughout his main career, 1883–92, painting in Lancashire and along the N.E. coasts. An Associate of the Royal Cambrian Academy he exhibited chiefly in the N. PHILIP GILCHRIST, a landscape and marine artist, a member of the Royal Society of British Artists, painted while working in the city, and travelling in the N. He exhibited in Manchester and Liverpool as well as London from the 1890s onwards. He died in 1956.

Langbank
Strathclyde

A small estuary-side town directly opposite the dramatic Dumbarton castle heights across the Firth of Clyde. JOHN QUINTON PRINGLE was born here in 1864, the son of a station-master on the Glasgow–Greenock line. He trained as an optician, and attended evening classes at Glasgow School of Art. Initially influenced by the Pre-Raphaelites, he became a Realist in the late 1880s into the early 1890s, and, at the turn of the century, was painting the back streets of Glasgow.

Lavington Common
W. Sussex

An extensive tract of woodland and open land, S. of the River Rother approx. 2½ miles S.W. of Petworth. In 1940 the landscape painter IVON HITCHENS abandoned his bombed London house and bought an area of woodland here. On it he built a house and constructed a large pond, which became a subject of his paintings, using the reflections and general areas of colour as guides. His pictures were always twice as wide as they were tall.

Leamington Spa
Warwickshire

Often sporting the prefix 'Royal', this watering-place with its graceful terraces and riverside walks is now merged with Warwick.

The painter TERRY FROST was born here in 1915, and from the age of 15 until he was 24, worked in a cycle repair shop, a radio factory, aircraft factory and radio components firm. He joined the Territorial Army in 1939, served in the Mediterranean area, was captured, and sent to a prison camp in Bavaria where he met the artist Adrian Heath and took up painting.

Leatherhead
Surrey

Near the woodlands of Bookham and Banks Common, a smart town retaining its central narrow streets and many gabled houses despite commuter development. Between 1795–1805 the collector and entrepreneur Dr Thomas Monro rented Feltham Cottage here, and was regularly visited by PAUL SANDBY MUNN, GEORGE SHEPHERD, THOMAS UNDERWOOD and FRANÇOIS LOUIS THOMAS FRANCIA. JOHN SELL COTMAN attended meetings there in 1799. In 1800 JOHN and CORNELIUS VARLEY came and between 1802–05 so did JOHN LINNELL, PETER DE WINT and WILLIAM HENRY HUNT. At the turn of the century J. M. W. TURNER and THOMAS GIRTIN also stayed there.

Leeds
W. Yorkshire

A major industrial and university city. The Cistercian monks of Fountains Abbey founded Kirkstall Abbey on the banks of the River Aire, approx. 3 miles N.W. of the city centre, in the twelfth century. The city initially expanded through the thriving woollen trade, and later through engineering, chemical, canning, furniture and ferro-concrete industries. The art gallery has an international reputation.

THOMAS GIRTIN produced a memorable picture of Kirkstall Abbey looking across the open landscape and a windy, clouded sky during a visit of 1800. He showed the ruins alone under a low wooded hill and the River Aire meandering W. of it through open pastureland. JOHN ATKINSON GRIMSHAW was born in Leeds in 1836, and having gone to live in Norwich worked for 9 years on the Great Northern Railway. He became a professional artist only at 25. After amassing a considerable amount of money and building an exotic castellated mansion at Scarborough Grimshaw suffered a financial disaster and returned to Leeds. He died here in 1893, having produced many Whistlerian pictures in the N. during the 1880s,

mainly townscapes, in contrast to the Pre-Raphaelite landscapes with which he had initially made his name. The poster-designer HAROLD SANDYS WILLIAMSON was born here in 1892, and from 1911 until 1914 attended Leeds School of Art, leaving for the Royal Academy Schools where in 1915 he won the Turner Gold Medal.

During the 1930s JOHN NASH was commissioned to produce a series of murals for Leeds Town Hall concerning the history of the city. He made a number of preparatory drawings for these, although the project never came to fruition. RAYMOND COXON was a student at Leeds, 1919–21.

Letchworth

Hertfordshire

Britain's first Garden City, planned in 1903, the prototype of the villa-and-garden suburban developments of the 1920s and 1930s; 24 miles N. of Greater London. The Post-Impressionist HAROLD GILMAN lived here in 1912, letting his house while he visited Sweden that year to his friend FREDERICK SPENCER GORE of the Camden Town Group, who painted some of his most 'radical' landscapes here, organizing his pictures into block-like shapes and the colour into systematic patterns reflected in the surroundings. Gilman painted here and in London, using a thick impasto technique which he acquired from the work of van Gogh.

Lincoln

Lincolnshire

Lincoln is dominated by its tall, triple-spired, honey-coloured cathedral, whose stone appears to change colour in the varying light. The flat country stretching toward East Anglia and N. is still marked by the airfields of the 1940s, with crumbling runways among wheat and barley, which recede level to the horizon.

PETER DE WINT lived here for part of each year after 1814, and painted from drawings of the Lincolnshire landscape until his death in 1849. De Wint painted widely in Lincolnshire, W. towards the Trent but particularly the wide flat wheatfields to the N. and E., more occasionally to the fenlands S.E. In oil and watercolour he perfected a picture with a sky occupying two-thirds of the canvas, the curving ground of the harvest fields, and the flatlands beyond stretching to the horizon. A sense of infinite space, plenty and peace is achieved through the intimate grouping of figures rather than straggling stark lines against the sky. De Wint also painted Lincoln and the cathedral in watercolour and oil in the 1810s, but thereafter concentrated on open landscape.

Liverpool

Merseyside

A major port, industrial, cathedral and university city at the mouth of the Mersey. It expanded rapidly in the late seventeenth and early eighteenth centuries on the slave trade and sugar, but the steamships of the 1840s caused its 7 miles of dockland development, much of it is now redeveloped, with trade at the western, Seaforth container area. The Walker Art Gallery has an extensive collection of British and European painting, particularly Pre-Raphaelite.

GEORGE STUBBS was born here in 1724, where his father was employed in the tanning trade. At the age of 19, he left Liverpool, returning briefly to paint portraits c.1775. His animal paintings influenced a number of animal painters in Liverpool (to his distaste) such as Charles Towne and later Richard Ansdell, who became a rival of Landseer, and William Huggins. DANIEL ALEXANDER WILLIAMSON was born here in 1823, and apprenticed as a draughtsman to a cabinet-maker, but turned increasingly to painting. In 1849 he left Liverpool for London, where he attended life-classes at Newman St. Initially he became a portrait painter, but in the mid-1850s took up landscape. He returned to the N. in 1861. The genre and landscape painter JAMES CAMPBELL was born here in 1828. He worked for an insurance company until the late 1840s when he studied painting at the R.A. Schools in London. On returning to Liverpool he came under strong Pre-Raphaelite influence until c.1860 when his style loosened. In 1862 he moved to London but had little success there, and with failing eyesight and consequently deteriorating work, he returned N., to Birkenhead, where he lived on a pension of £50 p.a. from the R.A. In 1830 the Pre-Raphaelite ALFRED WILLIAM HUNT was born here, leaving for Oxford in 1848, where he won the Newdigate Prize for English verse. After marrying in 1861 he lived in London, but exhibited regularly at the Liverpool Academy. JOHN WRIGHT OAKES was born in Liverpool c.1827, exhibiting over 155 pictures in London between 1847–88. He painted widely in Britain and abroad, but remained based in Liverpool throughout his career.

HARRY WILLIAMS was born here c.1834, where he struggled to find recognition for his delicate-toned and highly detailed pictures. He left for London dur-

ing the 1860s, and died there poor and almost unknown. During the early 1850s the Pre-Raphaelites WILLIAM HOLMAN HUNT and JOHN EVERETT MILLAIS, WILLIAM MORRIS and FORD MADOX BROWN exhibited at the Liverpool Academy. In 1851 Hunt was awarded the annual £50 prize for a non-local artist. The house of John Miller a tobacco merchant in Crosshall St became a focus for local Pre-Raphaelite artists, notably WILLIAM WINDUS, the landscape and figure painter, James Campbell the figurativist, WILLIAM DAVIS and W. J. J. C. BOND.

WILLIAM JOSEPH J. C. BOND, dubbed 'Alphabet Bond' after his jumble of initials, a highly accomplished landscape and marine artist, came to live in Liverpool during the late 1840s, where he was apprenticed to a framemaker and gilder. Initially influenced by the Pre-Raphaelite movement, then by Turner, Bond's painting later became far freer and impressionistic. He painted extensively in the N. – The Wirral – Midlands and S.E., as well as in the Netherlands. He died in Liverpool at the age of 90 in 1926. His reputation in the N. was substantial. The favoured landscape painting ground for Bond, Davis and Windus was the Wirral.

JAMES ABBOTT MCNEILL WHISTLER was a regular visitor to Speke Hall, 1869–77, when its tenant was his patron Frederick Leyland. His later disciple, PHILIP WILSON STEER, was born in Birkenhead in 1860, where he lived until aged 4, when his family moved to Whitchurch in Herefordshire. JOSIAH CLINTON JONES studied in Liverpool during the 1860s. Thereafter he worked largely in Wales, exhibiting work in Manchester and Liverpool, the Royal Academy and other London galleries. He died in Wales in 1936. The landscapist TERRICK WILLIAMS was born in Liverpool

in 1860. He studied in Antwerp and Paris, and painted widely in Britain and abroad, particularly in the W., where he evolved a highly coloured, strong Impressionist style. He became the President of the Royal Institute and Vice-President of the Royal Institute of Oil Painters. He spent most of his career based in London (see Blackheath) and died in Plymouth in 1936. GEORGE COCKRAM began his career in Liverpool in the early 1880s and worked there until 1890, when he moved to Conway. JOHN MCDOUGAL began painting in Liverpool in 1877, and worked there for 20 years before going to live in Anglesey. Between 1877–1903 he exhibited some 45 pictures at major London venues, as well as others in the provinces.

FREDERICK WILLIAM HAYES began his painting career in Liverpool c. 1872 before going to London in 1880. His style of painting was similar to that of John Brett, a marine artist, and one initially strongly influenced by Pre-Raphaelitism. From about 1885 Hayes turned to painting coastal subjects although he remained essentially a landscape artist.

In 1901 AUGUSTUS JOHN arrived to teach for 2 years at the School of Applied Art, University College, where he managed to offend practically everyone, but sowed the seed of student rebellion which caused the founding of the Sandon Studios Society in 1905. There he strongly influenced James Hay and Gordon Lightfoot. The painter ADRIAN HENRI – jazz musician, poet and playwright – worked extensively in Liverpool during the 1960s, when it was basking in its self-consciousness as a centre focused on pop culture, and some of his semi-flippant pictures reflected it. Later he became more concerned with depicting the city's demolition sites which recorded urban decay in the wake of 60s' optimism.

Llanelli
Dyfed

Once a major industrial town and port, and now undergoing piecemeal redevelopment, Llanelli remains a main trading and marketing centre of W. Wales. JAMES DIXON INNES was born here in 1887, at Greenfield Villas, Murray St, of Franco-Scottish parentage. He went to school here, and then to Christ College, Brecon. In 1904 he attended Carmarthen Art School, where in 1906 he produced a series of views of Carmarthen and Llanelli, Llanelli being viewed from Furnace Quarry. He continued his studies at the Slade where he met Augustus John.

Llanferres
Clwyd

A village approx. 5 miles S.W. of Mold.

RICHARD WILSON, who with Thomas Gainsborough was the leading British landscape painter of the eighteenth century, died, a penniless alcoholic, at Colomendy Hall, Llanferres, in 1782. During his last year in London he had fled from address to address to avoid landlords and other debt collectors. Traditionally, the Loggerheads Inn has a sign painted by him in part-payment for his drink-debts. It is preserved in a glass case.

Llangefni
Anglesey

The administrative centre of Anglesey, approx. 5 miles N.W. of Bangor.

The painter KYFFIN WILLIAMS was born here in 1918. From the age of 18, in 1936, he worked as a land agent in Pwllheli, a job in which he gained a wide knowledge of topography. On being discharged early from the army because of his poor health, he took up painting and attended the Slade School, 1941–44. Although he painted in N. London while teaching with Alan Gwyn-Jones at Highgate School, he returned to the area and central N. Wales. Williams is the first native Welsh artist to have painted Snowdonia – an astonishing situation reflecting John Rothenstein's observation that the Welsh attitude to painting is far less culturally local than the source of its literature. Williams's paintings of lonely Caernarvonshire cottages became very popular, as did those of local people, who bought his work and in whose houses his pictures hang.

DAVID BOMBERG painted in Anglesey in the late summer of 1944, having finally saved enough money from his depressing teaching posts at the Clapham L.C.C. Institute and Evening Institute, and the Katherine Low Settlement in Battersea, to take his family. He made some vigorous pictures here with very free brushwork, which attempted, but failed, to rival the quality of pictures he had made in Spain in the late 1930s.

Kyffin Williams (1918–) *Gwastadnant*, 1971 Oil 48in × 48in (Private collection)

Llanthony Abbey

Gwent

A ruined Augustinian priory in the valley of the River Honddu, approx. 5½ miles N. of Abergavenny.

In the mid-1830s J. M. W. TURNER painted the priory viewed dimly through a rainstorm. Ruskin praised the picture for its depiction of rushing water, falling rain and the effects of such crepuscular light (see p. 57).

London

Bexley, *Greater London*

A large affluent residential district; the most easterly of the Greater London boroughs, immediately S. of the Thames. In 1859 the newly married WILLIAM MORRIS built the Red House in what became Red House Lane and lived here until 1865.

Bromley, *Greater London*

A big suburban borough extending from Crystal Palace to the W. and Chislehurst in the N., as far S. as Biggin Hill. GERTRUDE HERMES, the painter, muralist, sculptor and engraver studied at Beckenham Art School, 1919–20. MARY ATTENBOROUGH, later MARY POTTER, was born in Beckenham in 1900, and studied at the local art school under A. K. Browning, before going to the Slade in 1920.

Camden, *Inner London*

Now the London Borough of Camden, lying N. of the Euston Rd and Pentonville Rd, including the areas of *King's Cross*, *St Pancras*, *Kentish Town* and *Holloway* to the N., *Pentonville* to the E., *Bloomsbury* and *Holborn* to the S. of the Pentonville Road, and *Hampstead* to the N.W., as well as *Camden* itself.

RICHARD WILSON lived at various addresses in Charlotte St, c.1750–75. BENJAMIN WEST, the American-born painter who launched the 'contemporary-history event' – removing historic moments from classical costume and portraying them in the clothes of their own time – which affected the Romantic movement, lived at 14 Newman St, 1775–1820. FRANCIS WHEATLEY, best known for his superb *Cries of London* prints and his rural landscape scenes lived at 90 Charlotte St, 1789–94. The painter and writer JOSEPH FARINGTON lived at 35 Upper Charlotte St (now gone)

from 1780 until his death in 1821. JOHN CONSTABLE, a friend of Farington's, later leased the house as his London residence until his own death in 1837. EDWIN LANDSEER was born in 1802 in Foley St, near the house of Henry Fuseli (no. 37).

From 1819 to 1826 John Constable rented a cottage on Hampstead Heath for the summer with his family. During the summers of 1821 and 1822 he painted most of his famous cloud studies at 2 Lower Terrace. He stayed at Langham Place on Downshire Hill (now Nos. 25–6) in 1826 and in 1827, finally leased 40 Well Walk which he kept until his death in 1837. His most favoured places on the Heath included Branch Hill Pond (now gone) which was where West Heath Rd joined Branch Hill, and the Admiral's House (then known as The Grove) on Admiral's Walk. Constable was not a great art socialiser, and he did not much enjoy the presence of other artists in the vicinity, particularly as JOHN LINNELL, whom he did not much like, was the centre of their circle. From 1823–29 Linnell lived with his family near North End Way, at what is now Old Wylde's – where he was on close terms with WILLIAM BLAKE and SAMUEL PALMER, the genre painter William Mulready, and Mulready's brother-in-law, JOHN VARLEY, Linnell's former teacher. Blake loathed Hampstead but liked the other artists.

DANTE GABRIEL ROSSETTI was born at 38 Charlotte St (also gone; now Rossetti House in Hallam St, with plaque). Rossetti lived there from 1828–52.

ABRAHAM PETHER (1765–1812) worked in the Camden area, a specialist like his son (see below) in moonlit landscape scenes. The accomplished landscapist ALFRED VICKERS SR moved with his son, ALFRED GOMERSAL VICKERS, also a landscapist, to 20 Cumming St, Pentonville in 1837, from Westminster (see below). Although he died at Cumming St that year, aged 27, A. G. Vickers showed 104 pictures in London between 1827–37. In 1833 he visited Russia on a drawing commission, and made oils of Russian subjects. WILLIAM CRAMBROOK lived at High Holborn when he moved from the Strand in the 1840s. Formerly resident in Deal, Kent, from the outset of his career in 1824, Crambrook was a highly accomplished landscapist, with approx. a quarter of his work marine. He had 92 exhibits in the Suffolk St shows and 6 in the British Institution. CHARLES STEEDMAN, a landscape painter with 122 London exhibits lived and worked at various addresses in Hampstead Rd throughout his career, 1828–58. WILLIAM ARCHIBALD WALL took a studio and house in Kentish Town during the late 1850s. Formerly he had lived at Liverpool St and Windmill St, Soho; in the early 1860s he left for Woking, Surrey, then Norbiton. Wall was born in New York, and is frequently claimed as an American artist, but spent most of his career in Bri-

Fred Taylor (1875–1963) *London Memories – Hampstead*, 1918 Poster 40in × 25in (London Transport Museum)

tain. His father, WILLIAM GUY WALL (c. 1792–1863), an Irish landscapist who exhibited in Dublin and London, 1840–53, lived in the Kentish Town area during his visits. The moonlit landscape (and seascape) specialist HENRY PETHER, although he claimed to live in Greenwich, had addresses in Camden Town (which he left deliberately vague) from 1828 until the late 1840s, before going S. to Clapham, where he ended his days in 1865. LIONEL BLOFIELD, a landscapist who flourished briefly from 1849–51 and

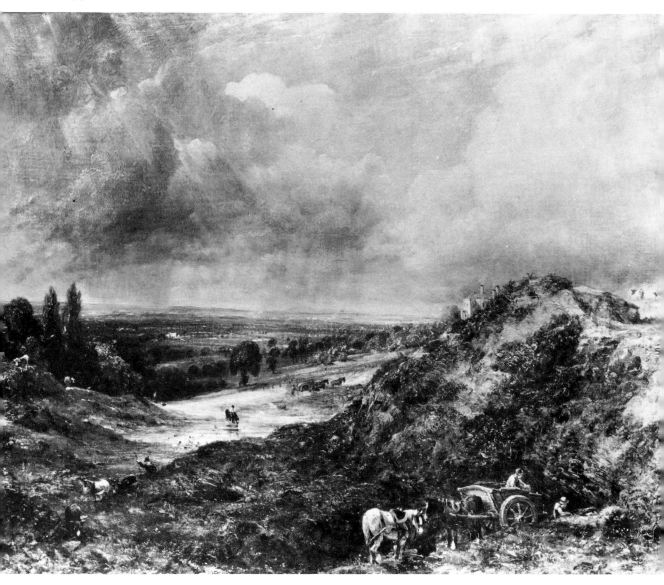

John Constable (1776–1837) *Hampstead Heath, Branch Hill* Oil on canvas 23½in × 30½in (Victoria and Albert Museum)

painted largely in Kent, lived at Holborn at this time, near Red Lion Square, where the Pre-Raphaelites WILLIAM MORRIS, DANTE GABRIEL ROSSETTI and later EDWARD BURNE-JONES kept a studio from the 1860s. A cartoon by Max Beerbohm shows a squat, broad Morris with wiry, up-brushed hair, and known to his friends as 'Topsy', with a sere, tall, drooping Burne-Jones side by side on a settle 'plotting the poetic moment' over a loaf of bread and a bottle of porter.

JOHN EVERETT MILLAIS lived at 83 (now 7) Gower St, where his parents had settled, from 1841 until 1854. The early meetings of the Pre-Raphaelite Brotherhood were held here as a result of Millais' invitation. The marine (and to a far lesser degree landscape) painter CLARKSON STANFIELD lived at Green Hill, now called Stanfield House, at the corner of the High St and Prince Arthur Rd, Hampstead, 1847–65. FORD MADOX BROWN the Pre-Raphaelite, permanently very short of money, moved all around Hampstead, Hendon and Kentish Town addresses as various cash-flow crises pursued him. His most famous picture, *Work (The Dignity of Human Labour)* which occupied him intermittently, 1852–65, was set at The Mount, a crescent rise on Heath St, Hampstead. He moved to Manchester in 1881. WILLIAM

POWELL FRITH occupied a studio at 15 Fitzroy St during the 1870s.

JACK BUTLER YEATS, painter brother of the poet W. B. Yeats, was born at 22 Fitzroy Rd, Primrose Hill, in 1871. Yeats painted many coastal and landscape subjects in the W., along the Irish Sea coast and in Ireland itself as well as in Scotland. In 1880 Primrose Hill Studios were built off Fitzroy Rd, and became a centre of the late Victorian artists working in the Fitzroy Rd/St John's Wood area. JOHN WILLIAM WATERHOUSE occupied studio 6 there, later used by the great illustrator ARTHUR RACKHAM. In 1872 THOMAS COLLIER built himself a large house in Hampstead where, suffering from consumption, he worked constantly. He painted on the Heath and in Surrey and Sussex and the Suffolk coast, in all weathers, until in the mid-1880s he was too frail to work out of doors. He died at Hampstead in 1891. OWEN DALZIEL, a landscapist who exhibited at the R.A. and Suffolk St between 1878 and 1904 painted at Primrose Hill until 1893, from where he went to Dover and then Herne Bay. From 1869 to the mid-1870s F. W. MEYER lived off Albany St, before going to Regent's Park. He travelled widely throughout the country which he pictured by day and moonlight, inland and along the coast. HECTOR CAFFIERI, a prolific landscapist with 203 London exhibits between 1869 and 1901 lived in Hampstead Rd throughout the 1880s before moving to Great Russell St where he remained until 1901. ALGERNON NEWTON was born in Hampstead in 1880, and educated at Farnborough School and Clare College Cambridge. He returned to Hampstead while studying at the Slade School and London School, went to Cornwall in 1916, but returned to London in 1918, where he produced London landscapes until 1928. After that he became more interested in rural and agricultural subjects. CHARLES SIM MOTTRAM, member of the Royal Society of British Artists, who exhibited 68 pictures at their Suffolk St shows lived at Hampstead addresses from the early 1880s until 1901.

In the mid-1890s WALTER RICHARD SICKERT moved his studios to 13 Robert St (now gone), S. of Mornington Crescent, due largely to Chelsea becoming too 'fashionable'. Sickert liked to cultivate a 'working class' environment and he remained here until 1899 when his marriage broke up and he went to live in Dieppe. He returned to London probably due to a visit by Frederick Spencer Gore in 1905, took rented rooms at 6 Mornington Crescent and after at 15 Granby Terrace (now gone), 1909–13. In company with Madeleine Knox he opened a private art school at 208 Hampstead Rd (gone) in 1910 and then the larger Rowlandson House School at 140 Hampstead Rd (also gone). This closed in 1914 and Sickert left the area soon after, later going to Bath. Sickert's colleague and former Slade student, FREDERICK SPENCER GORE –

who was much influenced by him – occupied rooms at 31 Mornington Crescent in 1909, later sharing Sickert's studio at Granby Terrace.

GEORGE CLAUSEN occupied 4 The Mall, Hampstead, from 1878–84. C. R. W. NEVINSON, the landscapist, essayist and war artist, was born at John St, now renamed Keats Grove, Hampstead, in 1889. In the late 1920s and 30s, Nevinson held massive publicity-seeking parties at Steel's Studios, Haverstock Hill, a magnet despite or because of Nevinson's gross vulgarity and journalistic provocativeness spurred by his neurotic persecution complex and feeling of rejection by the art establishment. During the late 1880s VIVIAN ALGER lived and worked in Albany St which he left in 1889 for Bedford. FREDERICK J. SANG, generally claimed as a French landscapist on the continent, where he exhibited numbers of 6 × 15 foot canvasses at the Paris Salon 1877–91, lived for much of the time 1877–1908 at addresses in Kentish Town, painting in the southern counties as well as along the coast. The prolific ARTHUR RACKHAM, lived in Chalcot Gardens from 1903–20. Rackham's work blended narrative landscape and figures with delicate panache.

WILLIAM ROTHENSTEIN moved in to 26 Church Row, Hampstead, in 1902. Rothenstein found it exhilarating to live 'so near the country', seeing Turner and Constable vistas everywhere. He grew tired of the house, not the Heath, and in 1906 moved to another house in Hampstead: 11 Oak Hill Park. MICHAEL ROTHENSTEIN, his younger son, was born there in 1908, studied at Chelsea School of Art in 1923, and Central School in 1924. In 1939 he began painting landscapes, staying in the Cotswolds with Gilbert Spencer.

In 1907 AUGUSTUS JOHN occupied a studio at 8 Fitzroy St formerly used by WHISTLER. Another studio at No. 8 was used by WALTER RICHARD SICKERT in 1907 for holding 'At Homes' for the Fitzroy St Group. MATTHEW SMITH occupied a studio at 2 Fitzroy St 1913–19; during that period he had little to do with landscape art, sharing a model with Sickert to create his famous 'Fitzroy Street Nudes' c.1916. Sickert's associate HAROLD GILMAN lived at 47 Maple St, c.1910–20.

In 1913 ROGER FRY opened the Omega Workshop at 33 Fitzroy Square. In 1914 another member of the Bloomsbury Group, DUNCAN GRANT, occupied a studio at 22 Fitzroy St. From 1920–40 Grant had another at 8 Fitzroy St, which VANESSA BELL shared with him from 1928. EDWARD WADSWORTH took a flat over a furniture shop at 2 Gloucester Walk, Camden Hill, in 1912, after his marriage to the violinist Fanny Eveleigh. From there he worked at the Omega Workshops, being employed to repair the Mantegna cartoons at Hampton Court, before becoming involved with the Vorticists and Wyndham Lewis. The

Camden Town group of 1911 was centred on the studios rented at Camden Hill. It grew around Sickert, who worked there intermittently during the next four years, ROBERT POLHILL BEVAN, who joined in the same year, and Gilman, who joined under the influence of Sickert. CHARLES GINNER became a member in 1911/12, being friendly with Gilman with whom he had gone to Paris in 1910. Frederick Spencer Gore, who painted a large number of urban scenes from Sickert's example, belonged for 2 years, but died of pneumonia in March 1914.

Gilman took a studio at 33 Parliament Hill, the same year as his friend, Charles Ginner, took 51 High St. Gilman died there in March 1919 of influenza. Ginner remained at his High St address until 1938, producing a large number of paintings there, mostly looking out on to Flask Walk. Bevan lived for his last 25 years – 1900–25 – at 14 Adamson Rd, where the landscape painter ALFRED EAST had once lived. WILLIAM RATCLIFFE and AUGUSTUS JOHN became involved with the group, which drifted apart under the impact of the Great War. From 1912 until the early 1920s William Ratcliffe lived in Hampstead Garden Suburb. His pictures resembled Ginner's and Gilman's but were softer, with a charm and warmth theirs do not possess. WILLIAM NICHOLSON worked in Hampstead before the Great War, frequently painting on Hampstead Heath, which appealed to him in the same manner as the Wiltshire Downs. In 1913 ETHELBERT BASIL WHITE, MARK GERTLER and Nevinson painted and exhibited a large Futurist canvas *Tum-Tiddly-Um-Tum-Tum-Pom-Pom* on Hampstead Heath during the Allied Artists' Exhibition. White later abandoned – or outgrew – Futurism, but he retained a studio in Hampstead Grove until the 1960s.

In 1913/14 George Carline, the father of RICHARD and SYDNEY CARLINE, bought 47 Downshire Hill, Hampstead. His five children, Anne, Hilda, Nancy, Richard and Sidney all took up painting. Here they were visited by Henry Lamb, who in 1919 introduced Hilda to STANLEY SPENCER, whom she married in the mid-1920s. Spencer acquired Lamb's studio in Hampstead in 1924; this was above The Vale Hotel (now gone) the site of a block of flats called Spencer House. In this studio Spencer painted *The Cookham Resurrection* and a number of Heath landscapes.

Gertler took solace in the lively atmosphere of Hampstead Heath. As his work and mental health declined he came to rely much upon it, as it had inspired his painting *The Merry-Go-Round*, prompted by a fairground scene in the Vale of Health on the eve of the Great War. Initially in 1916 he occupied a studio in Rudall Crescent, which he kept until 1932. After his lover, Dora Carrington's suicide he moved to Well Road, then to Haverstock Hill before going to Grove Terrace, Highgate. There, his wretched mental state

was given the *coup de grâce* in 1939 when he heard of Hitler's massacre of his fellow Jews, and he committed suicide.

BEN NICHOLSON attended Haddon Court, a prep school in Hampstead, at the turn of the century, and then Gresham's School. During the 1930s he returned to Hampstead, where he remained in close contact with Herbert Read, HENRY MOORE, and the refugee artists NAUM GABO, MOHOLY-NAGY and WALTER GROPIUS, which experience reinforced his position as a modernist. In 1936 PAUL NASH took a house at 3 Eldon Rd, Hampstead, in which he lived and worked primarily until 1939. There, Rothenstein has noted, he paid '. . . the same attention to oddities, to the remoteness and *minutiae* of vegetable objects, the same entireness of subject . . . quincunxes in earth below, and quincunxes in the water beneath the earth; quincunxes in deity, quincunxes in the mind of man, quincunxes in the optic nerves, in roots of trees, in leaves, in petals, in everything.'

The presence of these continental refugees caused a greater influence of abstraction and Constructivism on the Hampstead artists, and later Surrealism. Nicholson, Hepworth and Gabo helped to produce the *Circle*, the Constructivist manifesto in 1937. In 1938 this group centred on the Dutch painter Piet Mondrian who stayed for a while at 60 Parkhill Rd. The Surrealist exhibition at the New Burlington Galleries in 1936 was organized by the critic and painter ROLAND PENROSE, who lived at 21 Downshire Hill 1936–39. This exhibition attracted the surrealist writers Paul Eluard and André Breton to Penrose's Hampstead address. In 1936 when the Carlines vacated 47 Downshire Hill the German painter Fred Uhlman formed the Artists' Refugee Committee there.

In 1937 VICTOR PASMORE, Nicholson, JOHN PIPER, BARBARA HEPWORTH, WILLIAM COLDSTREAM and CLAUDE ROGERS established a school of drawing and painting at 12 Fitzroy St, and in 1938 moved it to 316 Euston Rd, where they were joined by GRAHAM BELL. In the Depression of the 1930s the 'élitism' of geometric and abstract painting had come to concern them, and they sought to develop the tradition of painting apparent between David and Cézanne in France which, it appeared, succeeding generations had failed to develop. This group collapsed with the outbreak of the Second World War which dispersed its members.

In 1941 ROBERT COLQUHOUN and ROBERT MAC-BRYDE shared a studio at 77 Bedford Gardens, Camden Hill, where they were joined for a time by JOHN MINTON. This became a meeting place for the painters MICHAEL AYRTON, KEITH VAUGHAN, PRUNELLA CLOUGH and JOHN CRAXTON, and the poet Dylan Thomas. In 1943 the Polish painter JANKEL ADLER took a studio above in the same building. The painter

ROBERT FRAME, the poets Ian Hamilton Finlay and W. S. Graham, and Helen Biggar the stage designer and sculptor, and later in 1943 the poet George Baker visited these studios. This meeting place broke up in 1947 when Colquhoun and MacBryde were ejected by the landlord for holding 'drunken orgies' after dark. From 1948 to 1953 the luckless and self-destructive DAVID BOMBERG rented a house in Hampstead.

City of London

Traditionally, the square mile on the N. bank of the Thames enclosing two hills, Ludgate Hill and Cornhill.

WILLIAM HOGARTH was born in 1697 in Bartholomew Close, just off Smithfield Market. In c.1701 his father conceived the absurd idea of running a Latin-speaking coffee-house. As a result he was steeped in debt by 1708 and from then until 1711 the Hogarth family lived in the Fleet Prison (the site of Caroone House, 95–7 Farringdon St). There are 2 murals by Hogarth in St Bartholomew's Hospital (on view by appointment).

The Pre-Raphaelite WILLIAM HOLMAN HUNT was born in Cheapside in 1827. He attended drawing classes at the Mechanics' Institute where he received encouragement and advice from JOHN VARLEY, and later took painting lessons from the portraitist Henry Rogers. He continued to study art in his spare time while working as a clerk and making textile designs. In 1844 he met JOHN EVERETT MILLAIS and entered the Royal Academy Schools, sharing a studio with Millais from 1848. With Millais he helped found the Pre-Raphaelite Brotherhood. DANTE GABRIEL ROSSETTI occupied a set of rooms in 14 Chatham Place (now gone; near Blackfriars Bridge) 1852–62, living for 8 years with his beautiful red-haired model 'Lizzie' Siddall whom he married in 1860. She committed suicide in 1862, an event which permanently affected Rossetti's mental stability. He moved to Chelsea soon after and never visited the place again.

The son of Jewish immigrants, MARK GERTLER was born and brought up in extreme poverty at 16 Gun St, Spitalfields (now gone) in 1891. After studying at the Slade, 1908–12, he moved into a studio in Elder St until 1915 when he went to live in Hampstead. DAVID BOMBERG arrived from Birmingham as a 5-year-old with his family to live in Tenter Buildings, Whitechapel (now gone) in 1895. He began his first Vorticist pictures there while studying at the Slade, 1911–13.

Chiswick and Hammersmith, *Greater London*

JACOB KNYFF painted along the Thames here, 1675–80, depicting the Old Corney House (now gone) and the osier beds in the river which are now the tree-

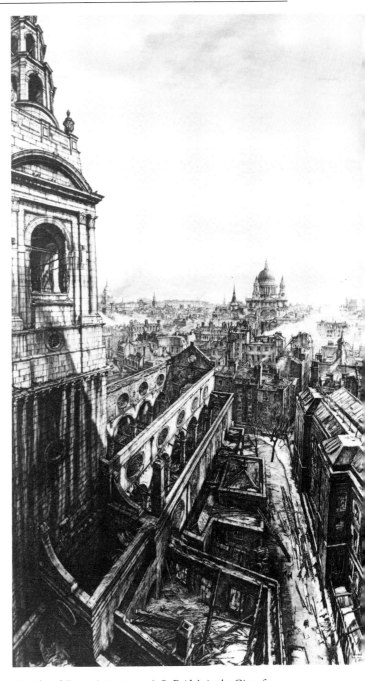

Muirhead Bone (1876–1953) *St Bride's in the City after the Fire, 29th Dec 1940* Chalk and pen 77⅞in × 44⅛in (Imperial War Museum)

grown Chiswick Eyot. Knyff was born in Haarlem, studied under his father, and came to work in England by 1673. His younger brother LEONARD KNYFF worked in London, his prospect paintings being en-

graved for the *Britannia Illustrata* by Kip. PIETER
ANDREAS RYSBRACK THE YOUNGER painted in Chis-
wick and along the upper and lower reaches of the
Thames from the mid-1720s, being commissioned to
paint a series of views of Chiswick House grounds by
Lord Burlington, c.1729. It has been suggested his
pictures influenced SAMUEL SCOTT, rather than those
of the Italian, ANTONIO CANALETTO.

WILLIAM HOGARTH kept a summer residence here
near the grounds of Chiswick House for 15 years until
shortly before his death in 1764. In 1775 THOMAS
GAINSBOROUGH was robbed by highwaymen of a
watch and 2 guineas on the Great Western Rd, Ham-
mersmith. They also robbed J. C. Bach the composer,
who was riding in the carriage ahead.

PHILIPPE JACQUES DE LOUTHERBOURG lived at 8
Hammersmith Terrace from the 1780s until his death
in 1812. From 1806–11 J. M. W. TURNER occupied a
cottage near him at Upper Mall (now gone) while
keeping his other addresses in central London. Turner
produced much work along the river during these
years, much of it highly impressionistic and on a small
scale. He spent much of his childhood at his uncle's
house (now 22 Market Place), in Brentford. Later he
rented Sion Ferry House – now Ferry House, Park Rd
opposite Isleworth Church – between 1804–6 and
1811–13.

During the 1830s JOHN VARLEY painted along the
river here, in watercolour. EDWARD CHARLES WIL-
LIAMS, a landscapist with 136 London exhibits, lived in
Hammersmith during the closing 11 years of his
career, 1854–65. His brother, GEORGE AUGUSTUS
WILLIAMS, lived at Castlenau Villas (Barnes) from the
mid-1860s until the mid-1880s. F. W. MEYER lived
along the same Hammersmith Rd during the late
1870s before moving to Fulham. The Dawson family
of landscape and coastal painters lived in the Chertsey
and Chiswick area, at various addresses. HENRY DAW-
SON, a productive artist from Nottingham, moved to
Chiswick c.1860 from Croydon, Surrey. A member
of the Society of British Artists, his work is often
confused with that of his sons, especially HENRY
THOMAS DAWSON, largely a marine painter although
all 28 of his Royal Academy exhibits were landscapes.
Between 1838–78 Henry Dawson Senior exhibited 85
paintings at major London galleries. His son, Henry
Thomas Dawson, was also a member of the Society of
British Artists, as was his other son, J. C. DAWSON,
also largely a marine artist who executed landscapes.
His third son, ALFRED DAWSON, was wholly a land-
scapist, who lived at the same Chiswick addresses and
Chertsey with his father until the late 1870s.

From 1878 WILLIAM MORRIS lived at Kelmscott

Walter Greaves (1846–1930) *Chelsea Regatta* Oil on
canvas 36⅛in × 75½in (Manchester City Art Gallery)

House, 26 Upper Mall, until his death here in 1896.
This is now the premises of the William Morris
Society. LUCIEN PISSARRO, son of the French Impress-
ionist, occupied Portland House, 62 Bath Rd in Bed-
ford Park, 1897–1901, and subsequently The Brook
on Stamford Brook Rd, 1901–44. During the 1890s
MUIRHEAD BONE settled in Chiswick, where he lived
until the Great War. His son, STEPHEN BONE, was
born here in 1904. GEORGE DOWNS began painting in
the Chiswick area during the 1920s, and remained
there until aged 80, when he left to live in Cheshire.
Downs painted three days a week, as he worked as a
salesman selling for factories on commission. He was
'discovered' here by Julian Trevelyan in 1937. During
the Second World War he served on the Central
Committee of the Artists' International Association.
RAYMOND COXON, a Stoke-on-Trent artist, lived and
worked in the area from 1925, teaching at the Rich-
mond School of Art and becoming a member of the
Chiswick Group. The S. London artist CAREL WEIGHT

studied at Hammersmith School of Art during the later 1920s, and VICTOR PASMORE lived here, at Brook Green, from 1927, when he was 19, until 1938. During that period he worked as a clerk in the L.C.C.'s Department of Health at County Hall, attending evening art classes at the L.C.C.'s Central School of Arts and Crafts, 1927–31. In the 1940s he moved to 2 Riverside, Chiswick Mall, and after that to 16 Hammersmith Terrace. His series of Thames landscapes of this period shows the strong influence of Whistler. During the 1930s the painter MARY POTTER lived in Chiswick where she painted the area and the river until she left for Aldeburgh in 1951. The painter JOHN TUNNARD settled in Chiswick during the early 1920s, but worked as a designer of textiles and as a semi-professional jazz drummer and did not begin painting until 1929. After his first one-man show at the Redfern Gallery in 1933, he and his wife left to live in a caravan at the Lizard in Cornwall. RODNEY BURN, marine and landscape Impressionist, has lived at Chis-

wick for much of his career, while teaching at the Royal College of Art, 1929–31, and from the 1950s onwards. He was elected to the R.A. in 1962.

Greenwich, *Greater London*

Now the London Borough of *Greenwich* extending to include *Blackheath Common, Charlton* and *Woolwich* E. along the Thames as far as Thamesmead, and S. as far as Eltham. Greenwich and Blackheath offer spectacular views over most of central and N.E. London, as far as Epping Forest on the N. horizon, from high ground S. of the Thames.

Some of the earliest views of the city were painted from here, and visiting French and Netherlands artists were responsible for these pictures. It has been suggested that WENCESLAUS HOLLAR or CLAUDE DE JONGH made the earliest picture extant, *A Prospect of London from Above Greenwich Park* (c.1620–30). However, as Hollar did not paint on a large scale in oils, and de Jongh's dates are wrong, it was almost certainly exe-

cuted by a Frenchman or Fleming, who painted the foreground figures wearing Continental-style clothing.

JOHN FEARY, who painted widely around London and its environs, worked spasmodically at Greenwich between 1766 and 1788. Feary is best known for his finely painted and attractive conversation pieces in landscape, the style of which owed something to RICHARD WILSON, under whom he may have studied. His two best-known pictures of this area, *Conversation Piece with a View of Greenwich* (1775) and *View of One Tree Hill, Greenwich* (1779) are typical of his style at its best. Both show the wide spread of London and the loop of Greenwich Reach with fashionable figures in the foreground. A London-born landscapist GEORGE SAMUEL painted in the Greenwich area, 1785–1823. His *Greenwich Landscape* (1816) shows the wide sweep of the Thames and Greenwich, still a quite distinct entity, separated from the advancing city by the open lands between Deptford and Southwark. JOHN VARLEY painted here in watercolour during the 1820s, along the river and on the high ground toward Blackheath.

GEORGE BROWN, a prolific landscapist, lived on Blackheath Hill from the mid-1840s until 1853, and then in Greenwich until the late 1880s. He exhibited 139 pictures in London, 1836–85. The illustrator ERNEST SHEPARD, who produced many landscape oils in the Surrey area, and is largely remembered for Winnie The Pooh, took a small cottage on Blackheath Hill from the 1890s until the Great War, when he joined the Royal Artillery. The Impressionist TERRICK WILLIAMS moved from Lewisham Park in the 1890s and lived in Blackheath until his death in 1936. CLAUGHTON PELLEW-HARVEY was born in Blackheath in 1890. A contemporary of John Nash at the Slade School, 1911–12, Pellew-Harvey's landscapes of the 1920s often reflected the Sussex and Surrey landscape with a sense one sees in Nash's pictures of the Berkshire Downs. The painter and illustrator ROWLAND HILDER became a resident of Blackheath in 1935, and remained here for the rest of his career. From this base he produced the pictures of the Kent landscape which made his reputation, and set up the Heron Press. In the Fifties he worked on 2 *Shell Guides* – to Flowers and Kent. He devoted himself primarily to painting after 1960, producing many pictures of the Thames valley and estuary with a period flavour as well as areas of S. and E. Kent. MAUREEN BLACK, painter of coastal, landscape and river subjects, and founder member of the Greenwich Printmakers Association lives in Blackheath, with work in the National Museum of Wales and Greenwich Print Collection. GRENVILLE COTTINGHAM, a widely shown landscapist is resident in Blackheath, as is ANTHONY FLEMING, like Maureen Black a graduate of Goldsmiths' College and a marine

and landscape painter. DAVID GENTLEMAN, notable for his landscape and stamp designs, also lives in the area.

Hackney, *Greater London*
Originally a small market town N. of London, and now a large urban borough bordered to the N. and E. by the Hackney Marshes along the River Lea. JOHN VARLEY was born at the Old Blue Post Tavern, Hackney, in 1778. In the early 1790s he attended the drawing school at 12 Furnival's Inn Court, Holborn, and lived in London throughout his career, painting along the River Thames as well as many London city landmarks, and widely in the provinces, particularly Wales and the Lakes.

Harrow, *Greater London*
A borough to the N.W. of London occupying ground high above the surrounding plain. The Impressionist RODNEY BURN attended Harrow School c.1911, after which he went to the Slade. Burn later taught at the Royal College of Art 1929–31, and in 1931–34 was Director of Drawing and Painting at the Museum of Fine Art, Boston. He became an R.A. in 1962. VICTOR PASMORE was a pupil at Harrow, 1922–26, where he won drawing prizes and it was assumed he would go on to art school. But as a result of his father's premature death his family moved to Hammersmith and in 1938 he became a clerk in the L.C.C.'s Health Department at County Hall. The urban and rural landscapist DAVID JONES settled in Harrow in 1947, after his second nervous breakdown. He painted the area at intervals during the last 25 years of his life, for much of his time living in a residential hotel. He died there in 1974.

Hillingdon, *Greater London*
A borough on the W. Greater London boundary, stretching N. from Heathrow Airport.

The leading abstract painter ROGER HILTON was born at Northwood in 1911.

Kensington and Chelsea, *Inner London*
Known as the Royal Borough of Kensington and Chelsea this area extends from the 630 acres of Hyde Park and Kensington Gardens to the N.E., along Kensington High St, includes *North Kensington* and *Notting Hill* to the N.W., *Earl's Court, Kensington, South Kensington* (home of the V. & A. Museum) and *Holland Park* to the W., and *Chelsea* extending S. to the Thames.

The watercolourist ROBERT MARRIS died in Chelsea in 1827. He was born in the London area in 1750, and became a pupil of ARTHUR DEVIS, whose light touch can be seen in his work. He married one of Devis's daughters. A contemporary and companion of Hogarth, the landscapist JOHN WOOTTON died in the

area in 1764. Originally from Warwickshire he had become the leading horse painter of his era, and his fine landscapes had begun as a vehicle for his equestrian subjects. SAMUEL BUCK, a well-known topographical draughtsman and engraver, died here at the age of 83, in 1779. He had worked widely in Britain, particularly in the N. (see Ripon). Marine painter and landscapist C. J. SARTORIUS lived at 155 Old Church St, Chelsea, 1807–12. PHILIP REINAGLE, renowned for his sporting and landscape pictures, lived in Chelsea during the latter years of his life, dying there in 1833. His daughters, CHARLOTTE REINAGLE, fl. 1798–1808, and FANNY REINAGLE, fl. 1799–1820, both lived in the area. FRANCIS TOWNE, the Exeter landscapist, moved here in 1807, and died here in 1816, having lived in London before only when studying at Shipley's School during the 1750s.

J. M. W. Turner resided at 119 Cheyne Walk, from 1839 until his death in 1851. Here, and at North Side, Campden Hill Square he painted most of his later works, including *Rain, Steam and Speed*. Strongly influenced by Turner, JOHN MARTIN lived at 4 Lindsey Row – now 98 Cheyne Walk – from 1848 until his death in 1854. Martin had made himself a reputation and a fine bank balance with his (melo) dramatic historic spectacles and Romantic landscape, the finesse of which he owed to Turner. WILLIAM HOLMAN HUNT lived at 5 Prospect Place, Chelsea (now gone), 1850–54, during the formation of the Pre-Raphaelite Brotherhood. SAMUEL PALMER lived at 6 Douro Place, 1851–61, during one of his most depressed and unproductive periods.

In 1851 the painter GEORGE FREDERICK WATTS came to visit Sara Princep and her husband, Thorby, at Little Holland House, Kensington, 'for three weeks and stayed thirty years!' as Sara said. Watts actually stayed 23 years there; the house was demolished in 1875 to make way for Melbury Rd, so he had to leave. The Pre-Raphaelites D. G. ROSSETTI, WILLIAM HOLMAN HUNT and EDWARD BURNE-JONES were regular guests there. In 1874 Watts built himself a new house backing on to FREDERICK LEIGHTON's at 6 Melbury Rd, and Watts kept this as his London address until his death. In 1866 Frederick Leighton had built himself Leighton House, Holland Park, to his own design. It contains the Arab Hall, decorated with oriental tiles and elaborate stained-glass windows, now open to the public. Leighton became president of the Royal Academy in 1878. William Holman Hunt lived to the E. of the Holland Park Estate, occupying 1 Tor Villa – now 1 Tor Gardens – from 1857–66. He was abroad much after that, but returned in 1872 to Draycott Lodge (now gone) in West Kensington, near the North End Rd. In 1902 he moved to 18 Melbury Rd, where he died in 1910. His friend Edward Burne-Jones bought The Grange near Draycott Lodge in

1867, in North End Crescent (now gone). JOHN EVERETT MILLAIS lived at 7 Cromwell Place in 1861, but as he grew wealthier he built 2 Palace Gate in the 1870s. He died there in 1896. Rossetti occupied 16 Cheyne Walk, 'Tudor House', from 1862, following the suicide of his wife, Elizabeth Siddal. Throughout his time there Rossetti's mental and physical health steadily declined. He spent more and more time in the company of WILLIAM MORRIS, developing a morbid passion for his wife Jane. Tudor House was crammed with pets, alive and stuffed, including kangaroos, lizards, a racoon, parrots, wombats and a Brahmin bull. A semi-paralysed recluse in his closing years (unable to hold a brush because of drugs) Rossetti died there in 1882.

From 1860 JAMES ABBOTT MCNEILL WHISTLER lived in what is now part of Cheyne Walk, where he became closely involved with Rossetti and the poet Swinburne. In 1866 Whistler moved again to what is now 96 Cheyne Walk, where he remained until 1878. Here he produced most of his *Nocturnes* of the Thames, rowed out on the water by the Greaves brothers (whose father had ferried Turner); the lights in these pictures are frequently those of the Cremorne Pleasure Gardens (now gone) on the S. Bank. From 1878 until the early 1890s he lived in Tite St. The cost of this property bankrupted him, and he afterwards left London for Paris.

PAUL MAITLAND was born in Chelsea in 1863. When a small child his nanny dropped him and the injury caused a permanent curvature of the spine. He studied at the R.A. under THEODORE ROUSSEL. Unable to travel far, he lived all his life in Chelsea, painting the area, where he died in 1909. JOHN DUJARDIN SR, with 97 London exhibits, lived at Westbourne Place and then in Chelsea. His son, JOHN DUJARDIN JR, who painted in Kent, Essex and Sussex, lived in Chelsea with his father until 1858. In 1874 HELEN ALLINGHAM married the Irish poet and editor William Allingham, and became one of the 'Cheyne Walk Set', including Carlisle, RUSKIN, Browning and Tennyson. She painted along the Chelsea Embankment and the gardens there and in Chelsea Hospital, leaving London in 1881 for Surrey. WALTER GREAVES, the former Thames boatman who came under the influence – and unpaid exploitation – of WHISTLER during the 1870s, and who painted London and riverscape pictures in unsuccessful imitation of him, lived until bankruptcy at 104 Cheyne Walk. During the 1920s Greaves haunted the bookshops of Chelsea, Soho and the Charing Cross Rd, dressed as Whistler, trying to exchange his pictures for books which he hoped to re-sell. He died in a poor house in 1933. In 1890 WALTER RICHARD SICKERT had a studio at 10 Glebe Place, and in 1891 53 Glebe Place. In the mid-1890s he occupied 1 The Vale, a house previously belonging to

William de Morgan the decorative artist. WILLIAM ROTHENSTEIN took Sickert's old studio at 53 Glebe Place, 1894–1901. (1 The Vale was later occupied by Henry Tonks the crusty and reactionary draughtsman who later exasperated Richard Eurich at the Slade.)

PAUL NASH was born in Earl's Court, in 1889. Between 1904 and 1906 he attended St Paul's School, which he described along with the rest of his schooldays as a 'long and complicated purgatory', and in 1908 took elementary illustrative training at the London County Technical School at Bolt Court in Fleet St, before going to the Slade, where he and Henry Tonks regarded each other with mutual lack of enthusiasm. Nash had little feeling for London, although he lived for periods in Hampstead and Camden (see above). His brother, JOHN NORTHCOTE NASH, was also born in Earl's Court in 1893. In 1901 his family moved to Buckinghamshire. In 1914, as a result of joining the New English Art Club, he briefly associated with the Cumberland Market Group in Fitzroy St (see Camden).

In the early 1890s CHARLES CONDER lived in Cheyne Walk, associating with the circle who created the *Yellow Book* and other periodicals. He attempted to give Chelsea a Parisian atmosphere, and died the same year as his acquaintance in poor health, Paul Maitland. Conder was an Australian-trained artist, and at his studio, 44 Glebe Place, he is reputed to have gathered as many as 30 Australian painters at one time – probably all there were in S.E. England. The two great illustrators CHARLES RICKETTS and CHARLES SHANNON who founded the celebrated Vale Press, occupied 2 The Vale in 1888. Sickert's pupil ETHEL SANDS owned 15 The Vale, and ETHEL WALKER 127 Cheyne Walk from c.1910 until she died in 1951, aged 90. WALTER CRANE occupied The Old House, 13 Holland St, from 1892.

THEODORE ROUSSEL lived and taught at the Bolton Studios, Earl's Court, from the early 1880s until 1891, when he moved to Parson's Green. A teacher at the Slade School until the later 1930s, the Impressionist PHILIP WILSON STEER resided at 109 Cheyne Walk from the 1890s, from where he painted along the Thames and in the provinces. JOHN LAVERY, formerly one of the landscapists among the 'Glasgow Boys' of the 1880s and by the turn of the century a successful society portrait painter, settled at 5 Cromwell Place in 1899. As a war artist during the Great War, he painted a number of marine and landscape pictures of moderate success but never returned with any commitment to landscape painting thereafter. He died in Cromwell Place in 1940. EDWARD JOHN BURRA was born in 1905 at 31 Elvaston Place, South Kensington, his grandmother's house. He was sent to school at Northlaw Place, Potters Bar, was withdrawn through ill-health, and grew up in Rye. He returned in 1921 to study at

Chelsea Polytechnic for two years before going to the Royal College in 1923. The rural landscapist CHARLES TUNNICLIFFE, a fellow student of Burra's, occupied a bedsit in Earl's Court while at the Royal College, 1921–24.

From 1916 until 1923 CHARLES RENNIE MACKINTOSH lived in Chelsea, where he designed textiles and made landscape watercolours, moving to France in 1923. During the 1920s the sculptor HENRY MOORE worked from a studio in Park Walk. During the later 1930s his interest in drawing sheep and landscape overlapped into his celebrated 'Sleepers' pictures executed in the London Underground during the blitz of 1940–41, where the long lines of wrapped sleeping forms evoked flocks of penned sheep. PHILIP CONNARD had studied in South Kensington during the 1890s, and lived in the area after the Great War, while teaching at the Lambeth School of Art. MATTHEW SMITH settled in Kensington in 1914, while keeping a studio in Fitzroy St, Camden. During the 1920s he alternated between Cornwall and London, and during the 1930s London and Provence. From 1938–39 PRUNELLA CLOUGH studied at Chelsea Art School, where she later taught throughout the 1950s. With the exception of an East Anglian sortie during 1946–49, she has remained an urban painter. VIVIAN PITCHFORTH taught at Chelsea School of Art during the early 1960s. DAVID HOCKNEY lived at Kempsford Gardens, Earl's Court, during the early 1960s, when he lived a publicity-seeking exhibitionist lifestyle; he maintained a studio at Powis Terrace, Notting Hill.

Lambeth and Southwark, *Inner London*
The borough of *Lambeth* includes *Kennington*; *Southwark* also includes *Rotherhithe*, *Camberwell*, *Peckham* and extends to Crystal Palace.

The landscapist WILLIAM MARLOW was born in Southwark in 1740. He became apprenticed to SAMUEL SCOTT, producing a variety of London and southern landscapes, and painting along the Thames. He studied at the St Martin's Lane Academy, and worked with facility in oil and watercolour. A companion of Hogarth, he later took up residence in Twickenham, where he died in 1813. EBENEZER TULL, an early prospect painter taught for 10 years, 1752–62, at St Olaf's School, Southwark, dying at about 30 years of age. The mystic, poet and painter WILLIAM BLAKE, who so influenced the landscapes of SAMUEL PALMER and later the work of the Goldsmiths' landscapists, lived at 13 Hercules Buildings (now gone; the site is Blake House in Hercules Road) from 1790–1800.

SAMUEL PALMER was born in Walworth in 1805, when the area was still a village separated from Southwark, Bermondsey and Lambeth by open fields. It is now a large residential and commercial area S.E. of

the Elephant and Castle. The watercolourist DAVID COX lived in Kennington, 1827–41. He had taught previously in Hereford, and still travelled widely in Yorkshire (1830) and Derbyshire during the ensuing decade.

The great Victorian critic and painter JOHN RUSKIN lived on Herne Hill, Camberwell, from 1823 when his parents moved there and he was aged 4, until 1844, when the family moved to a larger property on Denmark Hill. Later Ruskin returned to occupy another house at Herne Hill next door to his old childhood home. Here he spent the last two years of his unconsummated marriage to Effie who later left him for the young Pre-Raphaelite Millais. Bethlem Hospital which was rebuilt in 1815, and is now the site of the Imperial War Museum, on Lambeth Rd housed RICHARD DADD, the faerie and landscape painter, who was committed here for 20 years after he murdered his father in 1844.

In 1873 the Dutch painter VINCENT VAN GOGH arrived in London as an employee of Goupil's, the art dealers, and lived until 1874 at 87 Hackford Rd, Lambeth. There he fell in love with his landlady's daughter, Ursula Loyer, only to discover that she was already engaged to the previous lodger; he returned home in a state of deep depression, which his parents attributed to the insidious effects of the London fog.

The Glasgow painter ALEXANDER MANN lived at Streatham, now a residential and commercial area on the A23 S.W. of Dulwich, from the mid-1890s, keeping a studio in Chelsea, until his death in 1908. During this time he continued to paint on the Berkshire Downs, Walberswick and Suffolk, and the S.W. Peninsula.

Lewisham, *Greater London*
Initially a small village in Kent Lewisham expanded rapidly in the later nineteenth century. It now includes *Brockley*, *Catford*, and *Hither Green* to the S., and *New Cross* and *Deptford* to the N.

The landscape painter DAVID JONES was born in Brockley in 1895, attending Camberwell School of Arts and Crafts in 1910. During the 1920s he alternated his work between S.W. Wales and the landscape of Brockley, which he painted from his parents' home. From the early 1930s he lived in Devon, returned to London in 1939 and lived there throughout the Second World War. He suffered a nervous breakdown in 1947, and moved to Harrow, where he remained for the rest of his life.

ROWLAND HILDER, born in the United States in 1905, arrived in New Cross with his parents in c.1912, having crossed on the *Lusitania*, and in the early 1920s studied at Goldsmiths' College (the School of Art was located at Lewisham Way, New Cross, until 1978).

There he was a contemporary of the landscapists PAUL DRURY, ROBIN TANNER, GRAHAM SUTHERLAND and WILLIAM LARKINS, all of whom were influenced by FRANK BRANGWYN who taught there. Hilder later settled at Blackheath (see above) while making his reputation in book illustration (see main text). These artists were strongly influenced by Dürer, Rembrandt and Samuel Palmer; unlike Brangwyn, they portrayed a rural rather than urban landscape, as did Hilder; when it was urban (or industrial riverside) it was generally retrospective, but dramatic and powerful.

EVELYN DUNBAR painted murals at the County School, Brockley, during the later 1920s, portraying the area at the time.

Norwood, *Greater London*
A commercial and residential borough S. of the Thames beyond Lambeth and including Crystal Palace Park.

CAMILLE PISSARRO, half-Creole, half Portuguese-Jewish Impressionist painter, visited London in 1870, taking refuge from the Franco–Prussian war. He stayed at 2 Chatham Terrace (now 65 Palace Rd), Norwood, returning to France in the summer of 1871. He painted a number of local views, including that of Crystal Palace.

Richmond and Twickenham, *Greater London*
PIETER ANDREAS RYSBRACK THE YOUNGER, a Fleming, worked in the district during the 1740s. An oil of that date, *A View of Richmond Ferry from the Town Wharf* has a slightly misleading title as it depicts the ferry docking at Town Wharf in the foreground when it actually moored at Ferry Hill – now Bridge St – shown away in the middle distance of the picture. The bridge was erected, 1774–77. RICHARD WILSON painted in the Richmond area during the 1760s, including *The Thames Near Marble Hill, Twickenham* (c.1762). Wilson painted 4 versions of the river banks at Marble Hill. They are not 'naturalistic' with river traffic in the manner of Samuel Scott, but depict it as an Italian water idyll, leaving out buildings along the bank and Twickenham village in the distance. Wilson was typically ahead of his time in painting the view from river level, rather than a 'prospect' from high ground up on Richmond Hill. The topographical artist THOMAS DANIEL was born in Chertsey in 1749. Later well-known for his views of India, he also produced many vistas in Yorkshire during the 1780s. He died in London in 1840, having out-lived his nephew, WILLIAM DANIEL (1769–1837) who is best remembered for his series *A Voyage Around Britain*. THOMAS HOFLAND painted extensively along the Thames c.1800–30. Early in his career he had been commissioned by George III to execute botanical

John Piper (1903–) *House of Commons, Aye Lobby* Oil 48in × 35in (Imperial War Museum)

drawings, but turned with much success to landscape, frequently river bank essays.

From 1813 J. M. W. TURNER stayed at intervals at Sandycombe Lodge, at first called Solus – Lonely – Lodge, which was owned by his father. Turner Sr sold it in 1826 when declining health decreased his use and interest in the property. The Dutch painter VINCENT VAN GOGH worked as a teacher in Hulme Court, Twickenham Rd and as a lay preacher at the local Congregational church in 1876. When sacked as a preacher, he returned to Holland and decided to become a professional painter.

Waltham Forest, *Greater London*
A borough on the borders of Epping Forest, which includes the former parks and villages of *Wanstead, Walthamstow, Woodford* and *Chingford.* c.1760 CHARLES CATTON THE ELDER (of Norwich) painted at Wanstead Park for Richard Child, the 2nd (and last) Earl Tylney, making 3 large views for the Wanstead Park Estate. The pictures portray the park after the formal French gardens had been augmented with winding canals cut from the River Roding, a Roman ruin, and curving 'serpentine' walks leading to landscaped glades (now a golf course). WILLIAM MORRIS lived during his boyhood at Water House, in Lloyd Park, Forest Rd, Walthamstow.

Wandsworth, *Greater London*
Once a picturesque village S. of the Thames beside a large open common; built up during the nineteenth century.

ALAN SORRELL, best known for his architectural reconstructions of British archaeological sites, was born in Tooting, in 1904.

Westminster, *Inner London*
Extending N. of the Thames Embankment and the Palace of Westminster, this area includes *St James's, Mayfair,* Hyde Park and Kensington Gardens to the W., *Soho, Aldwych, Covent Garden* and *Lincoln's Inn* as far N. as High Holborn to the E. To the N. of Mayfair it extends through *Paddington, Bayswater, Marylebone,* and most of *Regent's Park* as far as *St John's Wood.*

ANTONIO CANALETTO stayed at 41 Beak St, Soho, during his lengthy and partially successful visits to London in the mid-eighteenth century. He painted Westminster and along the Thames, giving the area a colourful but essentially too Mediterranean an air. The sharpness of the image under a clear sky was accentuated by using a *camera obscura.* Canaletto also painted numerous views from Lord Carlisle's house at Whitehall – now the site of the Scottish Office.

WILLIAM TOMPKINS was born in the area in c.1732, his landscape style owing much to GEORGE LAMBERT. He lived throughout his career in London, his pupils including CHARLES TOMPKINS, born 1752, whose landscape and genre resembled William's, and Charles's brother, the engraver PETRO WILLIAM TOMPKINS. MICHAEL ANGELO ROOKER lived at Great Queen St – at the time a thoroughfare connecting Drury Lane to Lincoln's Inn Fields – during the 1760s. He remained there until 1789, when he lived for 4 years in Long Acre. In 1793 he finally moved to Dean St, Soho, where he remained until his death. Throughout his career Rooker travelled widely in Britain, inland and along the coast, but particularly in N. Wales, S. Wales – the Wye Valley – the Midlands and the S.E. coast. His watercolours were emulated by a large number of lesser artists. THOMAS NICHOLAS DALL, notable for his paintings of large country estates

in Yorkshire, settled in Covent Garden during the 1750s. Of Scandinavian origin, Dall became a scene painter at Covent Garden in 1756 but continued to travel in the provinces. He died here in 1776.

From 1733 until his death in 1764, WILLIAM HOGARTH occupied a house known as The Golden Head on Leicester Fields, now Leicester Square. The name came from a bust of van Dyck which decorated the doorway. WILLIAM BLAKE, the son of a hosier, was born at 28 Broad St in 1757. (The site on the corner of Broadwick St and Marshall St is now occupied by William Blake House.) When he married at 25, he moved to what is now Irving St. In 1784 his father died, leaving him money sufficient to start a print shop next door to his birthplace; but at the end of 1785 he moved again, this time to 28 Poland St. He and his wife lived there until 1790.

GEORGE STUBBS, the animal and landscape painter, lived in Somerset St, Marylebone, from 1763 until his death in 1806 (now Selfridges).

THOMAS GAINSBOROUGH took Schomberg House (82 Pall Mall) owned by the painter JOHN ASTLEY, in 1774. When Gainsborough quarrelled with the R.A. in 1784 he used the glass-roofed hall of the house as an exhibition gallery. He died here of cancer in 1788. PAUL SANDBY bought a Bayswater house, 4 St George's Row, in 1772, where he maintained a studio surrounded by trees and a walled garden, and lived in comfortable style until his death in 1809. The cartoonist, satirist and landscapist THOMAS ROWLANDSON lived at 16 John Adam St (off The Strand), c.1800–1810.

J. M. W. TURNER was born in Maiden Lane above his father's barber shop in 1775, later moving to another house in the same street. He lived at these Covent Garden addresses with periodic visits to Brentford until he was 24. After leaving the Royal Academy Schools he worked with THOMAS GIRTIN, 1794–7, for Dr Thomas Monro, copying watercolours. The churchyard of St Paul's, Covent Garden, has a tablet Turner carved for his parents' grave.

In 1803 WILLIAM BLAKE moved to 17 South Molton St where he took lodgings on the first floor. He remained here until 1821, when he moved to Fountain Court (now the site of Savoy Buildings). Here he produced his unfinished watercolour illustrations to Dante, while existing in a state of severe poverty. Between 1811 and 1827, Bayswater was a favoured painting ground of the young JOHN LINNELL, especially around the Kensington Gravel Pits, where his friend William Mulready kept a house at which he often stayed. In 1829 Linnell built 38 Porchester Terrace where he lived until 1851. W. P. FRITH lived in Bayswater, 1854–88, at the corner of Pembridge Villas and Pembridge Place (now a garage). JOHN MARTIN lived at 30 Allsop Terrace (now gone) near the

S.W. corner of Regent's Park, 1818–48. While here he augmented his spectacular paintings by designing plans for magnificent public monuments and grand designs for new urban sewage systems. EDWIN LANDSEER, Queen Victoria's favourite painter, lived and worked at 13 Mansfield St (off Portland Place) until 1826. Although he began his career as a first-rate painter of animals he soon discovered that anthropomorphism massively increased his sales. In 1824 he visited Scotland, and many of his animal subjects, such as his famous *Stag at Bay*, were thereafter set in the Scottish Highlands, although he lived and worked in London (see Camden). The distinguished landscapist ALFRED VICKERS SR whose work is distinctive for its light, delicate touch, and who painted in Sussex, Hampshire and Kent as well as the Midlands, lived at 8 Barton St, Westminster, 1827–36. He showed 61 paintings at the Royal Academy during his career, 125 in the British Institution, and 81 at the Suffolk St Galleries, between 1814 and 1868. His short-lived son, ALFRED GOMERSAL VICKERS (see Camden) shared his address until 1837. THOMAS DEARMER exhibited 60 paintings in London between 1840 and 1867 and lived in Soho during the early 1840s before moving to the Haymarket in the next decade, then up to Kilburn. JOHN SELL COTMAN taught, 1835–42, at King's College, where he was Professor of Drawing. DANTE GABRIEL ROSSETTI was one of his pupils. WILLIAM CALLOW, a watercolourist of great distinction famed for his architectural and landscape pictures, was employed during the early 1820s to colour prints for THEODORE FIELDING, a brother of ANTHONY VANDYKE COPLEY FIELDING, at 26 Newman St. In the 1850s he lived at 20 Charlotte St, producing over 1,200 London exhibits in his long career, 1,152 of them at the Old Watercolour Society venues. He shared this address with his younger brother JOHN CALLOW, a very talented landscape painter and a marine painter of less distinction, who showed over 369 pictures in London, 1844–78.

Two landscape artists also bearing the name Callow, GEORGE D. CALLOW and JAMES W. CALLOW, apparently no relation to John and William, lived and worked at 82 Newman St during the 1850s and '60s. Watercolours by George D. Callow are at times attributed to John Callow, although *Graves Dictionary* lists George D. with 40 London exhibits. JAMES BARNICLE, a prolific landscapist, with 123 London exhibits, 1821–45, lived at 50 Park St, Grosvenor Square, until c.1845. CHARLES MINS, showing landscapes at the Royal Academy, British Institution and Suffolk St lived in St Martins Lane and Brewer St, Soho, 1833–40, and THOMAS CHAMBERS, landscape and marine painter, at 47 Dorset St, Portman Square, until returning to Scarborough in the late 1840s. WILLIAM A. WALL (see Camden) lived and worked in Windmill St,

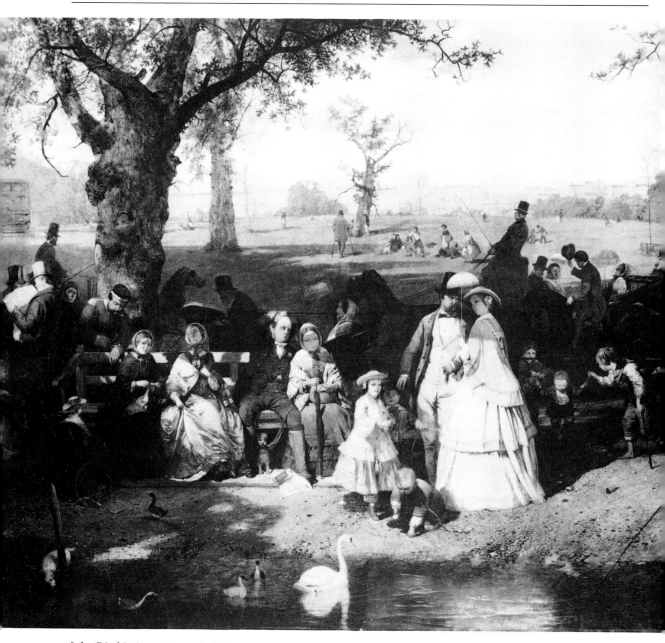

John Ritchie (act. 1855–75) *A Summer Day in Hyde Park,*
1858 Oil on canvas 30in × 51in (Museum of London)

Soho, during the later 1840s and early '50s. JAMES
BURRELL, who painted frequently in Yorkshire and
Cumberland, lived and worked in Covent Garden
between 1859 and 1868, showing work at the Suffolk
St Galleries. The landscapist JOHN EWBANK, who has
been confused with the famous Scottish marine artist
John Wilson Ewbank, worked from 8 Abingdon St,
Westminster, during the 1850s and '60s. RICHARD
DADD, whose minutely detailed fantasy and faerie
scenes formed a brand of still-life-in-landscape with
miniature figures superimposed, lived at 15 Suffolk
St, Westminster. He travelled in the Middle East,
completing a number of dramatically composed
watercolours and moonscapes. Always mentally un-
stable, he murdered his father in 1844, and being
judged of unsound mind was sent first to Bethlem,
then Broadmoor. The Pre-Raphaelite DANTE GABRIEL
ROSSETTI resided at 110 Hallam St (off Great Portland

frequently that of the Mediterranean as well as England and Holland. JOHN RITCHIE painted subjects in the central London area during the 1850s and '60s, generally inspired by Frith's social genre panoramas like *Derby Day*. The most notable of Ritchie's pictures in this genre are *A Summer Day in Hyde Park 1858* showing a closely observed crowd by the Serpentine, and a pendant picture, *A Winter Day in St James's Park*. He also worked on Hampstead Heath showing a similar social vista.

EDWARD LEAR, known primarily to posterity for his fantasy poetry, but in his lifetime as much for his large oils of the Middle East and Mediterranean (which rarely sold) and later, small, vigorous watercolours of the same regions (which did sell), was born in Highgate in 1812, but lived in Seymour St, near Marble Arch. There, during evening entertainments he paced up and down in front of his large pictures proclaiming at intervals in conversation 'I've *no* money! I've *no* money!' He finally left to settle in San Remo. From 1826 EDWIN LANDSEER lived at 1 St John's Wood Rd (now gone). Fully aware of the gradual degeneration of his work in proportion to his rising success he became an alcoholic. In 1869 he was removed from the house hopelessly insane, and died in a mental hospital four years later, in 1873.

WILLIAM BLAKE RICHMOND was born in Portman Square in 1842, the son of the portrait painter George Richmond. He studied at the Royal Academy Schools, where he was awarded silver medals, travelled in Italy, and in 1866 under the influence of Giovanni Costa became involved in the Etruscan School in Britain. He was made Slade Professor at Oxford in 1878, an R.A. in 1895, and knighted in 1897. WILLIAM POWELL FRITH, best known for his *tours de force* of Victorian social and sartorial fashion lived throughout most of his long career from the mid-1840s at 114 Clifton Hill, between Maida Vale and St John's Wood, where he died, in his 90th year, in 1909. During the mid-1860s the illustrator and landscapist FREDERICK WALKER lived and worked in St John's Wood, becoming an honorary member of 'The Clique' – a group of artists based here. While here, he visited Italy, and died of consumption here in 1875. During the early 1870s LAWRENCE ALMA-TADEMA, whose historico-pornographic pictures enjoyed great popularity, built himself a large villa here, where he regularly entertained. Elected an R.A. and knighted, his popular garden settings were his general involvement with landscape and gave his pictures much of the 'respectability' which his finely observed figures painted in his studio lacked. In 1871 he took Townshend Hotel (now gone), Park Road, where he remained until 1882, after which he moved to 17 Grove End Rd – where the French immigrant painter James Tissot had lived 1873–82 – enlarged it, and trans-

St) during the early and middle parts of his career, after which he spent more time with William Morris at Kelmscott. That was a period when landscape became more incidental to his brooding portraits of sultry eroticism, whereas previously it had been a poetic stage-set.

After he became established as a successful artist, the great marine and landscape artist CLARKSON STANFIELD lived in Buckingham St until his death in 1851. Better known for his robust, superbly drawn marine subjects, Stanfield also excelled at broad landscape,

formed it into a magnificent Pompeian palace.

During the later 1870s JOHN MACWHIRTER built a 'Renaissance palace' in the area. Unlike Alma-Tadema he painted widely, in Scotland and England, and subscribed all his life to Ruskin's theories of landscape painting, enjoying unbroken success. He died here in 1911. WILLIAM WATERHOUSE lived throughout his career in St John's Wood. He was not a great 'art socializer' but lived quietly with his wife and daughters, painting either in his extensive garden or in Surrey where he made sketching trips with his family. His pictures enjoyed great success. He died in 1910. GEORGE CLAUSEN lived in St John's Wood from the mid-1880s, having become known for landscape and country life subjects which were exhibited at the Royal Academy during the 1870s. Gradually Clausen turned from being a naturalist into an atmospheric painter. During the 1920s he designed posters for the London Midland and Scottish Railway, although he generally painted in Essex, and despite having 'Modernist' sympathies his images of the rural landscape tend to be emotionally drawn to the past, like those of Walker, Alma-Tadema and Waterhouse, of the St John's Wood area.

LAURA KNIGHT settled in St John's Wood in 1918, spending her summers at Lamorna. She became increasingly interested in back-stage life at the ballet and circus while in London. She was elected an Associate of the Royal Academy in 1927, and created a Dame in 1929. The Café Royal in Regent St was early this century a great meeting place for artists and writers; in the 1920s it was extensively remodelled but its famous Domino Room was preserved due to the intervention of the painter C. R. W. NEVINSON, whose importance had been increased socially by his powerful landscape images of the Great War. During that war an alternative Soho café, The Cave of the Golden Calf, had attracted large polyglots of artists which AUGUSTUS JOHN aptly described as 'Cubists, Voodooists, Futurists and other Boomists'. Another was the Eiffel Tower Restaurant in Percy St.

WILLIAM NICHOLSON kept a London studio at 11 Apple Tree Yard (now gone) between 1917–40, using it as the setting for many of his interior pictures, including a large top hat in which he kept his brushes. Between 1911 and 1912 ETHELBERT BASIL WHITE studied at St John's Wood Art School, as did IVON HITCHENS between 1912 and 1914. Hitchens then became involved with the landscape painting of the Seven and Five, then non-figurative pictures until the late 1930s, when, after his London home was bombed in 1940, he left for Sussex. CATHERINE DEAN, a painter who became principal of St Gabriel's College, Camberwell, lived and worked at 20 Abbey Gardens, Maida Vale, during the early 1930s.

Long Eaton
Derbyshire

An industrial town which grew up on the lace industry, approx. 6 miles W. of Nottingham, and about a mile N. of picturesque loops of the River Trent. Laura Johnson, later DAME LAURA KNIGHT, was brought up in her grandmother's house here after the death of her father, while her mother taught art in Nottingham. When her mother's health failed, Laura took over her teaching, at the age of 14. She then studied at Nottingham Art School, where she met Harold Knight whom she married in 1903.

Louth
Lincolnshire

Market town approx. 25 miles N.E. of Lincoln.

Between 1825–27 J. M. W. TURNER produced a picture of a horse fair here which Ruskin – who owned the picture – thought a facile piece of genre produced to humour the publishers of Turner's engraver. During the late 1820s the Yorkshire artist and journalist WILLIAM BROWN settled here, where he lived until his death in 1859. Apart from working on the local paper Brown painted extensively in the area, and in the 1850s he became absorbed in painting a panorama of the town viewed from the lightning-damaged spire of St James Church. Initially he completed this astonishingly comprehensive 360-degree bird's eye view of the town by July 1847, although he continued to add buildings – the railway station in 1848, the Corn Exchange of 1853, and the Town Hall of 1854–5 – as they were erected. These big pictures now hang in the Council Chamber of Louth Town Hall, an extraordinary time-capsule of an expanding, early mid-Victorian town surrounded by rolling farmland; a town in which coaches are still being built, haystacks still exist in essentially urban gardens, laden barges move along canals, a water-carrier fills his cart from the river, a workhouse lies on the outskirts of the town, and the railway is visible in the middle distance. In the far distance Spurn Head Lighthouse can be seen.

Ludlow
Salop

A still-mellow, picturesque town on the River Teme, on the A49, approx. 22 miles N. of Hereford, dominated by its massive red-sandstone castle, cathedral-like St Laurence's church (burial place of the poet

A. E. Housman), and medieval, Tudor, Stuart and Georgian buildings.

Turner painted the castle in 1830 (see p.000). PHILIP WILSON STEER painted here in 1899, his oil *Ludlow Walks* being one of the best examples of Impressionism beyond the 'milk and water' level that was prevalent in England at the end of the nineteenth century. Steer painted along the river and in the surrounding countryside, generally in watercolour. The Manchester Impressionist JAMES CHARLES visited the area, as did HENRY TONKS and FRED BROWN at the turn of the century. The Tempera Painters CHARLES GERE and EDWARD SOUTHALL worked in the region during the 1920s, and ALAN SORRELL made historial reconstructions here.

Macclesfield
Cheshire

Traditionally a silk-manufacturing town with steep streets and eighteenth- and nineteenth-century mills. Macclesfield Forest, 4 miles E., on the edge of the Peak District, embraces moorland rising to 1,600 ft and gives clear views 30 miles across Cheshire into North Wales.

CHARLES TUNNICLIFFE was born here into a farming background, his work strongly influenced by Thomas Bewick's. Tunnicliffe worked in oil, watercolour, etching and line drawing, becoming well known for his pictures of birds and intimate images of the traditional work of agriculture, which he portrayed with great finesse. In 1947 he moved to Maltraeth, Anglesey (see below), where he remained until his death in 1979.

The London artist GEORGE DOWNS retired to Macclesfield in 1982, having spent his entire career based in London in the Chiswick area.

Maesteg
Mid-Glamorgan

A small town on the A4063, approx. 6 miles inland from Port Talbot.

The Celtic-revivalist painter CHRISTOPHER WILLIAMS was born in Maesteg in 1873, the son of a shopkeeper in the High St. He spent his entire career in London, where he lived after attending the Royal College of Art, 1893–96, and being considerably influenced by Frederic Leighton and George Frederick Watts. He 're-discovered' Wales on a visit to Bangor in 1905, when he wrote that he felt a National revival taking place there and that he felt 'steeped in Celtic ideals'. Although much of his work is conventional in the Victorian mode, he began painting Welsh landscape in 1917 with the panache of the younger Welsh generation who had been at the Slade during the first decade of the century, and these often small landscapes are by far his finest work. He presented a group of pieces to Maesteg Town Council in 1934, the year of his death.

Maidenhead
Berkshire

Situated on the Thames, now a smart dormitory town for London. STANLEY SPENCER trained at Maidenhead Technical Institute from 1907 until 1910. His brother GILBERT SPENCER attended the Ruskin Drawing School here in 1909, before going to the Camberwell School in London in 1911.

Maidstone
Kent

An affluent market town on the banks of the River Medway. The son of a builder and local preacher, the Pre-Raphaelite painter ALBERT GOODWIN was born here in 1845. He was apprenticed to the drapery trade but met William Holman Hunt, himself a devout Christian like Goodwin, who introduced him to Arthur Hughes and Ford Madox Brown. He studied with Hughes.

Malham
N. Yorkshire

A village on the Pennine Way approx. 1½ miles W. of Gordale Scar and 3 miles S. of Malham Tarn. The landscape painter WILLIAM SHACKLETON of Bradford settled here in 1918 and produced many dream-like images of the surrounding landscape. Notable for bovine idylls or Rubensian rural scenes, J. J. CHALON painted a striking landscape of *Gordale Scar* in 1808, portraying the huge rock fault – part of the North Craven Fault – as great sweeping walls like curtains thrown into sharp relief by vivid sunlight and deep shade, dwarfing two human figures and their animals.

Malmesbury
Wiltshire
A small market town with the remains of a Benedictine abbey. J. M. W. TURNER visited here in 1791, and included drawings of the town and landscape in his 'Bristol and Malmesbury' sketchbook during that time. He made a watercolour painting in 1792, and a further one in 1825–28. The last shows the ruined abbey silhouetted against the evening sky while a young milkmaid cold-shoulders the attentions of an aged 'swain', to the amusement of two onlookers.

Maltraeth
Anglesey
A harbour on the N.E. tip of Maltraeth Bay. CHARLES TUNNICLIFFE, the bird and landscape painter, settled here in 1947, and remained here until his death in 1979. Tunnicliffe scarcely left Anglesey during these 32 years, remarking that he preferred the birds of Anglesey to the birds of Piccadilly.

Manchester
Greater Manchester
Now the centre of the Greater Manchester conurbation comprising *Stockport, Ashton-under-Lyne, Oldham, Rochdale, Bolton, Eccles* and *Altrincham*. Initially a large market town which expanded rapidly during the early nineteenth century, largely on the textile industry fuelled by the nearby coalfields which fed its steam-powered mills. Heavily bombed during the 1940s, its levelled areas were rebuilt during the 1960s. The City Art Gallery specializes in the English school of painting.

JOHN RATHBONE, who later was given the comically inappropriate label 'The Wright of Manchester' as though his pictures compared with JOSEPH WRIGHT of Derby's was born in Manchester c.1750. He had a very modest talent but produced large numbers of highly derivative Wright and Wilsonesque landscapes which enjoyed considerable popularity. Not so much a bad painter as a misguided one, he tended to paint subjects beyond his capacities. Most of his work in the area was done in the 1770s. He died in 1808. EDWARD HAYTLEY, known for his small portrait-in-landscape pictures, worked in the area during the 1740s. In 1746 he painted Sir Roger and Lady Bradshaigh in the grounds of Haigh Hall. The picture shows the gardens of the Hall modernized to the latest fashion of the period, with terraces and a Gothic folly ruin under a rainbow.

During the 1820s and 1830s watercolour painting was exhibited increasingly at Manchester. The first exhibition solely of watercolour was held in 1827, at Daniel Jackson's Gallery in Market St. DAVID COX exhibited here. JOHN GLOVER showed paintings of the area here as did JOHN VARLEY and ANTHONY VANDYKE COPLEY FIELDING.

HENRY CLARENCE WHAITE was born in Manchester in 1828. He worked successfully in oil and watercolour, gaining acclaim in 1862 with his picture *The Rainbow*, a highly popular treatment of a panoramic landscape, painted with a minute, Pre-Raphaelite intensity and with a sentimental figurative interest, in the manner which would later typify the work of Myles Birket Foster. Whaite became a member of the Manchester Academy and the Royal Cambrian Academy, and was one of the most respected and sought-after painters in the N. and Midlands. Ruskin approved of his work although advising him to beware of excessive detail. Whaite never achieved success in London, but became a central figure in Manchester, chiefly exhibiting N. Wales subjects popular with businessmen. GEORGE SHEFFIELD was apprenticed to a pattern designer in Manchester during the mid-1850s, where he was taught to paint by the genre and reportage painter Sir Luke Fildes. He took up landscape painting in the late 1850s, rapidly realizing that the most saleable subjects in the industrial Midlands were narrative genre or rural idylls. He worked first in N. Cheshire and S. Lancashire, moving to Bettws-y-Coed, N. Wales, in 1861. He finally returned to Manchester in the mid-1880s, and died here in 1892. The landscape watercolourist THOMAS COLLIER arrived in Manchester in 1855 to study at the School of Art. Influenced by DAVID COX, he left Manchester for N. Wales in 1864.

In 1881 the Pre-Raphaelite FORD MADOX BROWN carried out a series of murals in Manchester Town Hall recording the city's history. He had begun work on it in 1879, and died before completing it in 1893. The Norfolk-born painter WILLIAM RATCLIFFE studied at the Manchester School of Art from 1885, under WALTER CRANE, becoming a wallpaper designer for 20 years during which he painted landscape abortively. In 1906 he moved to Letchworth where Harold Gilman was to encourage him to resume painting seriously. The French-born ADOLPHE VALETTE arrived in Manchester in 1876 and unlike his Mancunian counterparts or predecessors, he pictured the industrial city itself in a series of sophisticated and sometimes powerful Impressionist images. He retired to France in 1928. He tutored for a time at the Municipal Art School, one of his students being L. S. LOWRY.

FREDERICK WILLIAM JACKSON lived and worked in Manchester throughout his career, c.1880–1904. He

painted widely in Yorkshire and Lancashire, and as a member of the Royal Society of British Artists showed over 50 paintings in London. The highly talented and luckless WILLIAM WEBB lived and painted in Manchester where he produced Impressionist work which owed a strong debt to Turner. He painted widely throughout Britain, especially in the S.W. peninsula, and in Northumberland, Boston in Lincolnshire, Churchdown in Gloucestershire, Guernsey and S. Wales. He exhibited much in Manchester, at Liverpool's Walker Art Gallery, and at the R.A., all between 1890 and 1904. Run down physically, domestically and financially Webb committed suicide in 1903 (his last exhibits were posthumous). The Halifax-born landscapist MATTHEW SMITH entered Manchester School of Art c.1902, having worked for 6 years in industry. He studied here until 1905 when he left for the Slade School, London.

The industrial landscape and marine painter LAURENCE STEPHEN LOWRY was born in Manchester in 1887. At about the age of 15 he received private painting classes with William Fitz, and from 1905 at the age of 18, until 1915 he studied at the Manchester Municipal College of Art, while working as a clerk for a firm of chartered accountants. In 1909 he moved from Rusholme in Manchester to Salford. From 1910 until 1952 he worked for the Pall Mall Property Company, rising from rent collector to chief cashier. He portrayed Salford and Greater Manchester scenes from about 1918, when studying at Salford School of Art, and began exhibiting in London from 1932. In 1931 he had illustrated *A Cotswold Book* by Harold Timberley but other than this, his pictures were urban. During the later 25 years of his life he painted deserted landscape in the lakelands area and marine scenes on the N.W. coast. The New Zealand-born artist FRANCES HODGKINS, known chiefly in England for her paintings of S. Suffolk and her involvement with the Seven and Five Society worked as a textile designer in Manchester in the late 1930s and painted in the area.

Marlow
Buckinghamshire

A riverside town approx. 5 miles N. of Maidenhead, upstream from Cookham (see above) notable for its graceful suspension bridge of 1836 and its riverside walks to Marlow Lock. Shelley wrote *The Revolt of Islam* here, and his wife *Frankenstein*. The painter WILLIAM DELAMOTTE worked here during the early 1800s, his oil *The Thames Valley Between Marlow and Bisham* (notable for its abbey) being a marvellously free exercise in Constable-like *plein air* painting, a green landscape under a soft grey sky along the winding Thames valley under wooded hills. It is extraordinarily similar to the looser landscapes of the area of GILBERT SPENCER 150 years later.

Masham
N. Yorkshire

A small town on the W. bank of the Ure 9 miles N.W. of Ripon. JULIUS CAESAR IBBETSON, the landscape and genre artist, lived here from 1805 until his death in 1817. He is buried in the churchyard. Ibbetson had a need of honest criticism and found that he received it from children who criticize pictures guilelessly.

Meadle
Buckinghamshire

A village 1 mile N. of Princes Risborough. JOHN NASH settled here in 1921 and remained until 1941. Here, for the first time, he possessed a garden at his cottage, and his love of plants was given full rein in his pictures. Some of his finest were *The Moat, Grange Farm, Kimble* (1922) and *The Deserted Sheep Pen* (1938). He also illustrated *The Curious Garden* (1933) by Jason Hill and R. Gathorne-Hardy's *Wild Flowers in Britain* (1938). Watercolour landscape painting became his primary concern.

Mendham
Suffolk

A village on the River Waveney, approx. 7 miles S.W. of Bungay where ALFRED MUNNINGS was born in 1887, and spent his youth. The main art work he saw was in *The Graphic* magazine and *The Illustrated London News*. From here he attended Framlingham College before becoming apprenticed to a lithographer in Norwich, c.1893.

Merthyr Tydfil
Mid-Glamorgan

An industrial town formed largely in the early nineteenth century around the ironworks and coal-

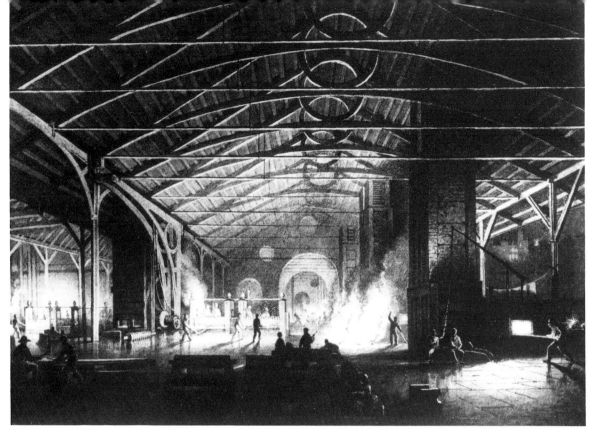

Penry Williams *Cyfarthfa Works Furnace*, 1825
Watercolour (Cyfarthfa Castle Art Gallery)

mines owned by the Crawshay family. The son of a house-painter, PENRY WILLIAMS was born in Merthyr Tydfil c.1800. He was patronized by the Crawshays who owned the great Cyfarthfa ironworks and pro-

duced some impressive views of the industrial landscape of Merthyr, sometimes with a glaring red sky worthy of theatre painters like de Loutherbourg. Williams was probably the most accomplished professional Welsh-born artist of the century, but most of his later career was spent in Rome.

Mold
Clwyd
Formerly the county town of Flintshire in the foothills

of the Clwydian Range. RICHARD WILSON was buried in Mold churchyard in 1782, having died of 'alcoholism, grief and old age'.

Moniaive
Dumfries and Galloway
A village by Cairn Water, approx. 16 miles N.W. of Dumfries, where the Glasgow painter, JAMES PATER-

SON, settled after his marriage in 1884. He painted the local landscape with a tonal method which he had learned in France: softer and more redolent of atmosphere than his colleagues of the Glasgow School.

Mottram-in-Longdendale
Greater Manchester
A village formerly in Cheshire. The industrial landscape painter LAURENCE STEPHEN LOWRY lived here from 1948, retiring from his position as a cashier in

1952. During the 1950s he painted a large number of deserted landscapes in the rural and moorland areas at the edge of the Peak District, as well as marine subjects.

Murthly
Tayside
A village near the River Tay approx. 9 miles N. of

Perth. SIR JOHN EVERETT MILLAIS painted landscapes here, 1887–96. By that time he had greatly loosened his style and enjoyed great popular success.

Naworth Castle

Cumbria

A fourteenth-century castle with courtyard, oratory and great hall, set in Naworth Park, approx. 10 miles E. of Carlisle. This was the home of GEORGE HOWARD, 9th EARL OF CARLISLE, a landscape painter, and grandfather of WINIFRED NICHOLSON. In 1888 Howard entertained the Italian painter GIOVANNI COSTA here, who influenced the British 'Etruscan' painters during the 1880s. Many examples of Costa's work entered Howard's collection, and both men painted widely in the area. George Howard had studied figure painting under the guidance of Burne-Jones but was a better landscapist. In turn he gave lessons to his granddaughter Winifred Roberts, later Winifred Nicholson. During the 1920s BEN NICHOLSON visited Brampton and Bankshead, a farm over the River Irthing from Brampton, with Winifred. From 1932 Winifred Nicholson made Bankshead her permanent home, until her death in 1981.

Newbury

Berkshire

A large, prosperous town associated with horse racing which grew wealthy on cloth manufacture and once serviced by the Kennet and Avon Canal. JOHN LINNELL painted here, 1800–10, picturing the canal, its bridges and the town, often making excellent *plein air* oil sketches and finished pictures which held far more vitality than his later paintings. Many are similar in mood and style to Constable's at the same period.

John Linnell (1792–1882) *The River Kennet, near Newbury* Oil on canvas 17⅞in × 26½in (Fitzwilliam Museum, University of Cambridge)

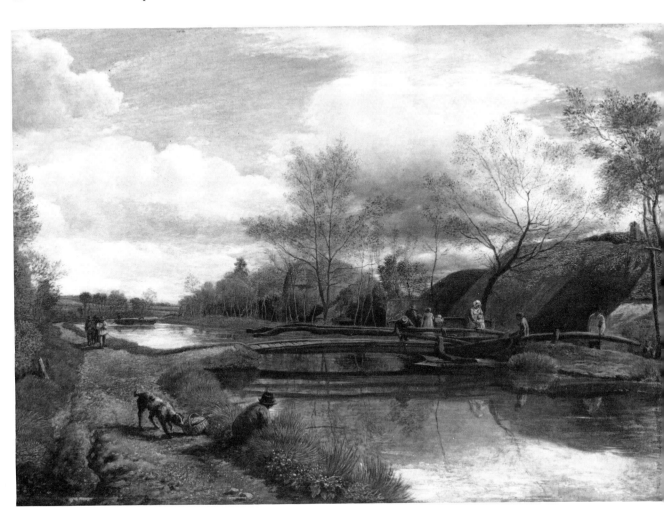

Newcastle-upon-Tyne
Tyne and Wear

Now a massive conurbation stretching approx. 14 miles to the mouth of the Tyne, incorporating *Bladon*, *Gateshead*, *Wallsend* (literally the end of Hadrian's Wall), *Jarrow*, *North Shields*, *South Shields*, *Tynemouth* and *Whitley Bay*. Newcastle has the fine Laing Art Gallery.

The wood-engraver THOMAS BEWICK served his engraver's apprenticeship in Newcastle, and after his brief visit to 'dirty, expensive, unfriendly London' kept his workshop near St Nicholas's Church – now Newcastle Cathedral – with a house across the river in Gateshead. He died at Gateshead, and was buried at his birthplace, Ovingham. The oil and watercolour landscapist ROBERT POLLARD was born in Newcastle in 1755. In mid-career he settled in the London area, having been formerly a pupil of Richard Wilson, whose landscapes his work tended to resemble. Pollard was the last surviving member of the Society of British Artists, the papers of which he gave to the R.A. in 1836, two years before his death.

JOHN MARTIN lived in Newcastle. Originally he apprenticed himself to a coachbuilder painting heraldic arms in order to become a painter. This was a very limited training, and after a year he became a pupil of an Italian, who, in true eighteenth-century manner, taught fencing, perspective and enamel painting as a lucrative mixture of attainments. In 1806 his teacher took himself off to London and Martin went with him, to remain there for the rest of his life. The Glasgow School painter JOSEPH CRAWHALL was born in Morpeth and later lived in Newcastle. ARTHUR HESLOP, the etcher, oil and watercolourist, was born and lived most of his career in Newcastle.

Newlyn
Cornwall

Still a working fishing port just S. of Penzance, facing on to Mount's Bay.

STANHOPE FORBES settled here in 1884, taken with its similarity to Brittany, and founded a model of a Breton art colony here. His cottage on Paul Hill became the centre of the art community. During the later 1880s the Forbes were joined by the painters NORMAN GARSTIN and Frank Bramley and Thomas Cooper Gotch, not significantly landscape artists. Bramley is best known for his sentimental but still telling domestic scene *A Hopeless Dawn* (1888), of a fisherman's young wife weeping at the loss of her husband – a picture which much impressed LAURA KNIGHT when she saw it in a Nottingham exhibition. Garstin painted some magnificent coastal, land- and townscapes before lack of funds forced him into costume piece pictures. In 1899 the Forbes founded an art school, quickly gaining an international reputation. The Newlyn School continued until 1939 when Stanhope Forbes' health failed. He died here in 1947. Harold and Laura Knight were part of the art community at Newlyn, 1910–12. TERRY FROST moved to Newlyn in 1974 after his time at Reading.

Newmarket
Suffolk

Since the seventeenth century the centre of British horse racing. In the High St are the headquarters of the Jockey Club and studs and stables, many with cupolas, speckle the skyline on the open land.

During the last 30 years of the eighteenth century, GEORGE STUBBS produced numerous paintings set on Newmarket Heath.

The painter ALAN REYNOLDS was born in Newmarket in 1926, the son of a stableman, leaving school at 14 to become a fitter in the R.E.M.E. He took up painting in the afternoons while an education sergeant in Germany in 1945, studied full-time at Woolwich Polytechnic, 1948–52, and exhibited in 1952 at the Redfern Gallery, London. ALFRED MUNNINGS also painted here.

Newport (Trefdraeth)
Dyfed

Of Norman origin, this small town was once a busy port with a quay on the Nyfer Estuary; it is now a centre for artists and tourists in the Pembrokeshire Coast National Park. The bluestone slabs of Stonehenge in Wiltshire came from Carn Ingli mountain nearby.

For 28 years the painter FREDERICK KÖNEKAMP lived and worked as a semi-recluse in the highest house on Carn Ingli, the most western peak of the Preseli mountains above Newport; his home could be reached only on foot or by Land Rover. Könekamp was born in Germany in 1897, and had lectured in philosophy and mathematics. When the Nazis came to power in 1933, he went into exile in Switzerland where he took up painting. In 1949 he settled in Pembrokeshire, where he painted the landscape in a vigorous expressionist manner until his death in 1979. JOHN KNAPP-FISHER has painted in

the area regularly for over a decade, his dark-skied watercolours with low white buildings typifying the upland landscape of the Pembrokeshire peninsula.

Northampton
Northamptonshire

A commercial and industrial town. During the winter of 1830–31 J. M. W. TURNER portrayed an election campaign here, heralding the passing of the Great Reform Bill of 1832. In his finished watercolour he turned the church of All Saints through 90 degrees and moved its cupola into a new place, to help the composition.

Norwich
Norfolk

A cathedral, university and industrial city, port, and administrative centre of Norfolk, on the River Yare. The massive Norman keep of Norwich Castle houses the Art Gallery which has a good collection of the Norwich School painters.

WILLIAM WILLIAMS was born here in 1740. Generally remembered as an itinerant artist – producing portraiture, theatrical scenery, and sentimental genre – he also produced an attractive body of landscape pictures, which were shown at the R.A., 1770–92. He also travelled widely around the British Isles. CHARLES CATTON THE ELDER, one of a family of 36 children, was born here in 1760, and apprenticed to a London coachpainter. His work was of a very high quality, and he became coachpainter to George III. He was also an accomplished landscapist; his work was exhibited at the R.A.

JOHN CROME, JOHN SELL COTMAN's great rival, was born here in 1768, and spent his entire career here. Son of a weaver and publican who kept The Griffin alehouse in King St. Crome painted inn signs and liked pubs; he was a great drinker. In 1785 he was apprenticed to a coach- and sign-painter. He began working as an artist only at 22, in 1790. In contrast to Cotman, Crome was an astute businessman (which was one of Cotman's greatest resentments toward him) giving drawing lessons – at Miss Heazel's Seminary in Norwich, and later at Norwich Grammar School. On his death in 1821 Crome's large family suffered great financial hardship, at which Cotman was spitefully delighted. John Sell Cotman was born in the city in 1782. He was a far greater painter than Crome – *great* while Crome was very talented – but he was an inveterate snob and highly ambitious, disliking the provincial atmosphere of Norwich and the Norwich School. He resented Crome's financial success more keenly because he realized his rival had far less talent, but his own vaulting ambition was compounded by the bane of many artists – financial ineptitude. He found teaching difficult because there were so many artists engaged at it, left for London and travelled extensively in Yorkshire while working in London, 1798–1807. He moved to Great Yarmouth on his patron's advice in 1812, where he remained until 1823, returning to Norwich to live once again beyond his means. In 1831 he became Vice-President of the Norwich Society, and President in 1835.

JOHN THIRTLE exhibited here with the School after 1805, and continued to do so until the late 1830s. JOSEPH STANNARD exhibited work at Norwich between 1811 and 1820, generally still-life and landscape of the East Anglian area, turning to the coastal regions during the last 10 years of his life.

JOHN BERNAY CROME, John Crome's son – known as 'Moonlight Crome' – worked in the region from c.1814 until his death in 1842. Many of his pictures were set along the river estuaries in N. Norfolk, by moonlight, although he also painted views of Norwich and the towns of East Anglia with the same nocturnal effect. JAMES STARK painted in the area during 1810 and 1830. He produced unsentimental pictures of great charm in the 1820s, particularly those of sheep farming – penning flocks, sheep-dipping in the rivers – and those of the Norfolk landscape itself, his shabby, toy-like figures blending with it as easily as the sheep. From the late 1840s Alfred Stannard's eldest son GEORGE ALFRED STANNARD worked here and exhibited oil and watercolour at Norwich; his subjects were generally rural, with a few sallies into coastal views. Throughout the 1830s John Crome's pupil GEORGE VINCENT exhibited and painted in Norwich, like most of the East Anglian painters, concentrating on landscape while making forays into coastal scenes. MILES EDMUND COTMAN, a marine and landscape painter, exhibited and worked here from c.1830 until his death in 1858. His younger brother, JOHN JOSEPH COTMAN, exhibited here from c.1834 until the early 1870s and painted widely in Norfolk and the Midlands and N.

The landscape, urban and coastal painter ATKINSON GRIMSHAW lived here from 1842, from the age of 6, until the mid-1860s. From 1852 he worked as a clerk on the Great Northern Railway until 1861 when he became a professional painter. He had started to paint in 1859 highly detailed still-life of rural subjects such as dead birds, rocks and ferns, for which there was a good market. He moved to Yorkshire in the later 1860s, made a success of his landscape painting, which

became even greater after his tour of the Lake District in 1868. THOMAS COLLIER visited this area many times, the greater part of his work being done in Suffolk and along the East Anglian coast. Collier painted the landscape around Norwich during the 1870s in oil and watercolour, excelling at the big sky areas typical of pictures of the region.

RICHARD LEITCH, son of WILLIAM LEIGHTON LEITCH, worked near the end of his career in the Norwich area where he portrayed architecture in landscape as he had at Castle Acre Priory in 1862. THOMAS LOUD, a member of the Norwich School, worked for 11 years here. Chiefly a watercolourist, he rarely signed his work. He was a highly accomplished conveyor of atmosphere and perspective. The painter and etcher CHARLES WATSON was born in Norwich in c.1852, and his wide range of subjects accounted for 137 London painting exhibits, 64 of them at the Royal Academy. Watson lived in London during his career, but returned to Norwich where he died in 1927. EDMUND BLAIR LEIGHTON, who achieved a reputation for historical and narrative subjects, painted in Norfolk and visited the town during the 1880s and 1890s. ARNESBY BROWN settled in Norfolk after his marriage in the 1890s, and lived at Haddiscoe, near Great Yarmouth. He painted widely in the county. The Castle Museum at Norwich has examples of his work, and he painted the environs of the town until the early 1940s. Represented in the British Section of the Venice Biennale of 1934, Brown was blind for the last 10 years of his life. The Suffolk landscape and equestrian painter ALFRED MUNNINGS was apprenticed to the lithographers Page Bros and Co. in Norwich during the late 1890s. He studied at the Norwich School of Art, leaving for the Académie Julian in Paris

in 1903. During his years as a lithographer he lost the sight of an eye. He settled near Dedham in Suffolk, but painted extensively all over East Anglia. The Castle Museum has work by Munnings.

The landscape and marine painter EDWARD BRIAN SEAGO was born here in 1910, and studied under the naturalist painter BERNARD PRIESTMAN. By the age of 19 he was exhibiting and selling equestrian pictures in Bond St. He met Munnings in 1930 during a Munnings exhibition in Norwich and was advised by him to concentrate seriously on painting and observation and less on intuitive 'genius'. Seago travelled with a circus company around Britain, 1930–33, and another on the Continent; he published three books on circus life. He returned to East Anglia where he stayed until his death in 1974, painting especially the fen and dyke lands S. of Cromer and around Norwich. His work is well represented at the Castle Museum.

The poster designer HAROLD SANDYS WILLIAMSON lived in Norwich throughout his career after the Great War. He became headmaster of Chelsea Polytechnic from 1930 to '58, and painted in East Anglia and designed posters for the Empire Marketing Board. By the early 1930s his full-sized posters appeared in 450 of the largest British towns. In 1945 he worked for the Council for the Encouragement of Music and the Arts. The landscapes in Williamson's posters were always full of detail, usually local, and the figures and transport in them form a curious mixture of past and present, a familiar device employed by artists working for the railway companies between the wars. A member of the Norfolk and Norwich Art Circle for over 30 years, the watercolourist ANTHONY BENTALL, born in 1916, has lived in Norwich throughout most of his career.

Nottingham
Nottinghamshire
A large commercial and industrial town.

The Antwerp-born artist JAN SIBERECHTS appears to have worked here during the 1690s. In 1697 he painted the Elizabethan mansion, Wollaton Hall, for Sir Thomas Willoughby. Another view, probably commissioned by the 1st Duke of Newcastle, looks to the E. of the city from Colwick Hill past the village of Sneinton towards the parish church of St Mary's and Nottingham Castle, built by the 1st Duke in 1679. The Baroque details of the castle are rendered minutely, showing features such as the equestrian statue of the Duke which, according to John Harris, could not have been seen from Colwick Hill. The surrounding flatlands and the meandering River Trent are slightly exaggerated, the river appearing closer to Nottingham than in reality, and the hills in the l. distance are made higher. The Castle is now the City

Museum and Art Gallery which, incidentally, houses this picture.

In 1795 J. M. W. TURNER produced a drawing and engraving of Nottingham from the Trent with barges and bargemen in the foreground with Nottingham Castle behind them. During the autumn of 1832 he made another watercolour of this scene, this time altering the details of the boats, but shifting the castle across the background and placing figures burning stubble under its walls: the Duke of Newcastle, opponent of the Reform Bill, had evicted dozens of his tenants who had voted to support it, and caused so much hatred for himself that the castle was fired by a mob when the Lords blocked the Bill. Turner shared the Nottingham people's contempt for Newcastle, but had to be subtle in his allusion to the subject to protect his own patronage. The water meadows area where the picture is set were actually a large slum by the time Turner made the 1832 watercolour.

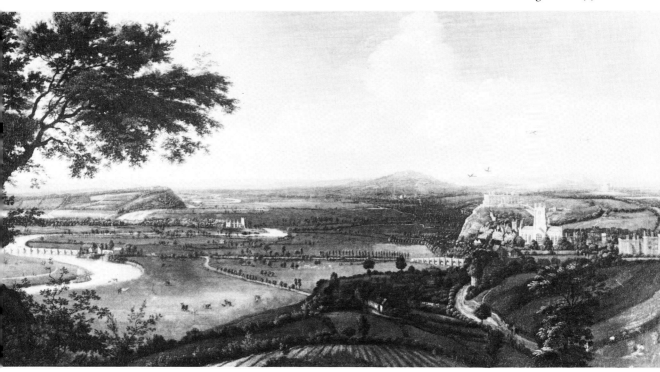

Attr. Jan Siberechts (1627–1702) *Nottingham from the East*, c.1700 Oil on canvas 23in × 48in (Nottingham Castle Museum and Art Gallery)

HENRY DAWSON, a prolific landscapist, born in 1818, living here until 1850. Between 1838–75 Dawson had 85 London exhibits: all 28 of his R.A. pictures were landscapes, although he occasionally produced a seapiece. His sons HENRY THOMAS DAWSON, ALFRED DAWSON and J. C. DAWSON all became painters (see Chiswick, London). The tempera-revivalist JOSEPH EDWARD SOUTHALL was born in Nottingham in 1861, and grew up there until being articled at the age of 17

to a firm of Birmingham architects. ARNESBY BROWN was born in the town in 1866. He was educated here and attended Nottingham Art School before going to the Herkomer School of Art in Bushey at the end of the 1880s. The landscape and coastal painter CAMPBELL A. MELLON, born in Sandhurst, spent his early years in Nottingham. He went into business in the area, retiring after the Great War, when he was just over 40, and moved to East Anglia, where he studied under Arnesby Brown. LAURA KNIGHT took over her mother's art-teaching job in Nottingham in 1891 at the age of 14, when her widowed mother became ill. She later studied at Nottingham School of Art, where she met Harold Knight whom she married in 1903.

Oldham
Greater Manchester
An industrial town, now part of the conurbation of Greater Manchester.

WILLIAM STOTT, generally referred to as 'Stott of Oldham', to distinguish him from the painter Edward Stott, was born here in 1857. He studied at Manchester School of Art, and enjoyed great success in the Paris Salon of 1882. A member of the Royal Society of British Artists, he was a close friend of Whistler until

he painted Whistler's mistress as *Venus Born of the Sea Foam*, which finished their relationship. Oldham Art Gallery has a number of works by Stott, including the offending *Venus*. Stott painted many landscapes, some of great perception, but he never managed to amalgamate imagination satisfactorily with other concerns, such as colour and form. He was drowned in the Irish Sea on the Belfast packet, and Whistler commented acerbically that his drowning was apt as he was always at sea as an artist.

Oxford
Oxfordshire

A medieval university, industrial and commercial city on the A40/M40, approx. 40 miles N.W. of London.

One of the first popular drawing masters, the watercolourist JOHN MALCHAIR taught watercolour drawing and music here, 1760–92, to undergraduates and 'amateurs of polite society'. In the 1790s J. M. W. TURNER produced a large number of drawings and watercolours of the Oxford colleges, particularly Christ Church and Merton. Forty years later he explored a series of witty portrayals of Christ Church while building work was in progress there, using his vocabulary of bickering dogs beside 2 dons and youths flying a kite, to denote high spirits to be quelled by academic discipline or lofty (or idle) exploratory theories going on beside the construction of education. He used the same images in his scene of Merton in 1837. WILLIAM TURNER OF OXFORD came to live here on his marriage in 1824. Born at Brampton in 1789, he was known as William Turner *of Oxford* to distinguish him from his great contemporary. He was a pupil of JOHN VARLEY who had a high opinion of his talent and he became a member of the Old Watercolour Society with which he exhibited 450 works during his career, apart from those shown at the R.A., the British Institution and the Society of British Artists. He continued to travel widely in Britain after he settled in Oxford, especially in the Lake District, N. Wales and the West Country, but his work never attained the heights promised by his youthful talent, so that critics usually consider his earlier pictures the best. He died in Oxford in 1862.

In the early 1840s the art critic and political thinker John Ruskin was educated at Christ Church, where he formed many of the guiding theories which underlay his aesthetic attitude. He founded the Ruskin School of Drawing at Oxford. The Pre-Raphaelite ALFRED WILLIAM HUNT studied at Oxford, winning the Newdigate Prize for English verse and remaining a Fellow at Oxford from 1853 until his marriage in 1861, after which he devoted himself to painting. His early work was inspired by David Cox, a friend of his father. His sketchbooks are now in the Ashmolean Museum, Oxford. EDWARD COLEY BURNE-JONES studied at Exeter College, where he met WILLIAM MORRIS in 1854, becoming a life-long friend. While here he read *The Broadstone of Honour*, keeping a copy by his bed for the rest of his life, and Malory's *Morte d'Arthur*. On leaving Oxford he studied painting with Dante Gabriel Rossetti. WILLIAM BLAKE RICHMOND, the 'Etruscan School' painter, was Slade Professor at Oxford 1878–83. HAROLD GILMAN spent a year as a non-collegiate student at Oxford in 1895, leaving as a result of poor health. Between 1909 and 1912 THOMAS LOWINSKY studied at Trinity College before going to the Slade. JOHN ARMSTRONG studied law at St John's College 1912–13, but having little interest in the subject, visited the Ashmolean Museum to study the paintings and drawings there instead. In 1922 SYDNEY CARLINE was appointed Ruskin Master of Drawing at Oxford, where he was later joined by RICHARD CARLINE, JOHN NASH and GILBERT SPENCER. Sydney Carline died in 1929 – from pneumonia after visiting John Nash on a bitterly cold evening.

Gilbert Spencer executed wall paintings for Holywell Manor, an annexe of Balliol, 1934–36. They illustrate the legend of the foundation of Balliol College, and show amongst other things the journey of the scholars from the Border lands through the Oxfordshire countryside, the landscape based upon Spencer's own experience. PAUL NASH lived principally at 106 Banbury Rd from 1939 until his death in 1946. There he made a collection of *objets trouvés* of all kinds and took a great many photographs which he used directly in his landscapes of the Berkshire and Oxfordshire countryside.

From 1950 until her premature death in 1960 at the age of 54, EVELYN DUNBAR was a visiting teacher at the Ruskin School.

Painswick

Gloucestershire
In origin a wool-town, still with grey-stone buildings and its churchyard with 100 (officially 99) clipped yew trees, about 3 miles N. of Stroud.

The tempera painter CHARLES GERE settled here in 1904, painting in the Wye Valley and mountains of S. Wales. He also worked extensively in the Vale of Gloucester and on Painswick itself, often on a small scale, attempting to achieve the spirit of the work of Calvert and Samuel Palmer.

Peak District

Yorkshire and Derbyshire
An area some 33 miles long from Ashbourne in the S., to Saddleworth Moor, between Oldham and Huddersfield in the N., and 23 miles wide in the High Peaks region between Stockport in the W., and Sheffield to the E. The area includes *Buxton* and *Dovedale*.

During the 1750s ALEXANDER COZENS travelled and painted here, producing in 1756 an impressive oil, *Matlock Tor*, anticipating the pictures of de Loutherbourg by almost 30 years. In the early 1770s JOSEPH WRIGHT of Derby painted along the Derwent, his pictures often as concerned with the quality of false light or conflicting light sources, such as his *Earth-Stopper on the Derwent*, showing a man stopping up

foxholes before the following day's hunting to prevent the quarry going to ground. The real content of the picture, as Michael Rosenthal has pointed out, is the conflicting light of his lantern and the chill light of the moon on a chill calculating activity. But Wright also painted the area in its own right, in the early 1780s: Matlock Tor, a scene of tranquil wilderness with the great crag reflected in the glassy Derwent water. In 1784 PHILIPPE JACQUES DE LOUTHERBOURG explored the Peaks area, painting the sinister and storm-lashed *Dovedale in Derbyshire*, a *tour de force* of stage-scenery in which clouds swirl over the high rocks and a torrent streams in the gorge while sheltering figures almost vanish into the shadows of the rocks. De Loutherbourg painted in the Peaks during the 1790s and early 1800s, usually to dramatic effect.

JOHN and CORNELIUS VARLEY painted in the area, 1800–10, as did JOHN 'WARWICK' SMITH, MICHAEL ANGELO ROOKER and J. C. IBBETSON. In 1830 DAVID COX paid the first of his many visits throughout the 1830s. The landscapes Cox painted varied from the high open lands and sloping fields to lowland valleys. HENRY BRIGHT worked here during the 1840s and 1850s, and THOMAS COLLIER and ATKINSON GRIMSHAW during the 1860s. The young WALTER CRANE scored a great success for himself in 1863 when his scenes along the Derwent were bought by Sheffield businessmen who came to fish here. Crane painted in the area at intervals until the 1880s. In 1908 STANLEY ROYLE initially explored the region, to which he was to return after the Great War.

EDWARD WADSWORTH visited here during his tour of the Black Country, 1919–21, and painted Buxton in 1922. The resulting image is a good example of English Cubism in polished form, a satisfying composition in its own right, conveying almost nothing of Buxton or the Peak District. HARRY EPWORTH ALLEN, having lost a leg in the Great War, took buses into the Derbyshire countryside to paint, and pictured Buxton and the White Peak area near the town during the later 1920s and 1930s. Painting mostly in tempera, Allen organized his landscapes into formal units, but never removed their identity and essence, as Wadsworth did.

LEONARD RUSSELL SQUIRRELL painted the district at intervals from the 1920s onwards. Squirrell's style of work resembled J. S. Cotman's, whom he much admired and pictures of Dovedale might well have been done by Cotman. He produced advertisements for the region for railway companies too. MCKNIGHT KAUFFER, the American-born poster designer, also made advertisements of the region and JAMES TUCKER, the tempera painter, portrayed hikers there. CHARLES GERE of the Tempera Society visited the region.

In 1931 DAVID BOMBERG was commissioned by Shell-Mex and the Empire Marketing Board to design an advertising poster on the Dales of Derbyshire. Bomberg and his second wife, Lilian Holt, camped for three weeks in constant rain and cold above Millers Dale: 'Then one morning the sun glimmered . . . we gathered all the equipment . . . and started off . . . a sixteen mile tramp with canvas and painting equipment . . . The Cavedale rocks appeared. Then it happened: a grand flood of sunlight shafting through, throwing great forms into the shadow depth. A great excitement was on. Everything was flung down in haste. The easel flew into position, paint streamed over the . . . palette. All the happiness, the grandeur of the moment at that vista must be captured . . . While David worked feverishly I set about gathering wood and heaping it on the fire, warming myself quietly in the tense stillness . . . and when I felt the moment of fulfillment nearing, on went the kettle . . . "Come over Lilian . . . What do you think?" "Lovely. It's lovely, all there" . . . We were too tired, to seek warmth with the fire; just able to get the canvas into cover and then drift into slumber. That was *Cavedale*. Lovely, but too subtle to reproduce said Shell-Mex . . . they gave it back to David.'

In the 1940s STANLEY ROYLE revisited the region as part of his travels around Derbyshire and painted the area during the 1950s and early 1960s, motorcyling around the country. During the Second World War GILBERT SPENCER painted and drew this landscape, as an escape from the time and a change from more familiar places. JOHN PIPER visited the region, making pictures which shared a method and atmosphere with those he made in Wales. During the 1960s ARTHUR PERCY BLISS, retired to Derbyshire, has painted the landscape.

Pembroke
Dyfed

A small market town, originally surrounded on three sides by two small rivers, and overshadowed by the impressive castle.

RICHARD WILSON painted Pembroke Castle and the town beyond in 1773, a remarkably stark and open picture for the time, unframed by trees in the conventional manner, the hard ramparts in deep shadow running out of the picture area to the R. against the bright sky so that the painting borders on abstraction. It is a vivid image of the place, and far too unconventional for Wilson to have had any real hope of its acceptance. J. M. W. TURNER portrayed the castle three times, although these pictures were essentially coastscapes with a dramatic, exaggerated sea, none of which were really successful.

During the 1930s GRAHAM SUTHERLAND and ED-

WARD MORLAND LEWIS painted in Pembroke. Lewis worked along many of the S. Wales coastal towns using a method of photographing the area and altering the form of the picture when painting by changing the colour values and weight from those in the photograph. Sutherland, exploring inland from St Bride's Bay, found the forms of the land so wholly different from those of Kent where he lived that after he had gone to live in the S. of France in the later 1950s he returned constantly to this area. The convolutions of the rocks, the twisted trees, the deep inland lanes, wooded valleys and bare-topped hills also attracted MICHAEL AYRTON who was in contact with Sutherland here during the 1940s. AYRTON had been deeply influenced by de' Chirico (the Italian Metaphysicist) when he had worked in his studio in Paris in 1938, and he found the forms of the land redolent of Surrealism, and the pictures he made in Pembrokeshire in 1945–46 also have much in common with Paul Nash's pictures such as *Monster Field*. JOHN ELWYN, a Cardiganshire-born painter, painted widely along the W. coast of Wales and worked in this area during the 1930s and after the Second World War, although he generally worked further north. JOHN KNAPP-FISHER, who also works in W. Wales, has pictured the district, generally with a deep, crepuscular light in which forms merge and pale low buildings stand out like dominoes.

Penegoes
Powys

A village in the Dovey Valley, 2 miles E. of Machynlleth, on the S. edge of the Snowdonia National Park. RICHARD WILSON, one of the most forward-looking and influential British landscapists of the eighteenth century, was born here in 1713. He is deservedly better known than any other Welsh artist, his Classical landscapes pressing uncompromisingly at their time the outrageous notion that British landscape was worthy of being painted as high art in its own right. When Wilson was 15 he was sent to London to train as an artist. Wilson's father was rector of Penegoes.

Petworth
W. Sussex

A village recorded in the Domesday Book, adjacent to Petworth House. J. M. W. TURNER visited Petworth House on numerous occasions in the late 1820s and 1830s. He was given a studio there on the death of his father in 1829, and on the invitation of his friend and patron Lord Egremont executed interior scenes for the house and a number of landscape paintings, particularly of the surrounding parkland. One of the finest is *The Lake, Petworth: Sunset, Fighting Bucks*.

Picton (Picton Ferry)
Dyfed

The twelfth-century Picton Castle stands in parklands on the banks of the Eastern Cleddau 3 miles E. of Haverford West. In the rear of the castle the GRAHAM SUTHERLAND Gallery, opened in 1976, is open most days in summer. It contains a wide collection of Sutherland's work produced in W. Wales from the 1930s until early 1970s, while he was living abroad. The area of the Cleddau was a much favoured region for Sutherland, the shores and roads containing the curled and gnarled trees which he imbued with anthropomorphic qualities and the steeply rounded hills possessing the same animal quality. After the mid-1950s he visited this area more than Trottiscliffe in Kent, where he retained a house.

Preston
Lancashire

An industrial town on the Ribble. ARTHUR DEVIS (see Guildford) was born here in 1729, the son of a joiner. During his early career he enjoyed the patronage of the de Hoghtons of Hoghton Tower, before moving to London c. 1743.

Prudhoe Castle
Northumberland

Approx. 8 miles W. of Newcastle-upon-Tyne. In his sketchbooks of 1817 J. M. W. TURNER made various drawings of Prudhoe worked up into watercolour in 1825. In the watercolour he raised the low hill by the Tyne topped by the castle to a Rhenish precipice higher than the high moors to the S., behind the castle.

Reading
Berkshire

An industrial town on the junction of the Thames and Kennet. Quite aptly dubbed 'Ugly Reading' by Jerome K. Jerome. The painter EVELYN DUNBAR was born here in 1906. She later left to study at Rochester School of Art, Chelsea, and the Royal College of Art from 1929 to 1933. In 1940 JOHN PIPER painted in Reading, recording the suburban and Edwardian villas there, his style a transition from abstraction and geometry to representation. *Reading Villa* is halfway between these two polarities.

Redenhall
Norfolk

A village close by the River Waveney, 5 miles S.W. of Bungay. In 1963 JOHN PIPER produced some of his finest East Anglian church pictures here, at a period when light and atmosphere had become his interest, augmented by his love of architecture. Robert Melville said of these pictures that: 'The colour is formed by mild moist English air. The line defines while confiding a diffident lyricism, like a song nearly lost as the singer turns away.'

Redhill
Surrey

With *Reigate*, a residential town to the S. of Greater London. From 1851 until his death in 1882, JOHN LINNELL lived in Redstone Wood, with (once) fine views across the escarpment of the N. Downs with the Pilgrims' Way running along their base. Here he recovered the mystical involvement with nature which he had enjoyed with Blake and Samuel Palmer, and during his 31 years here became the most successful (and prolific) landscape painter in Britain. His son-in-law SAMUEL PALMER moved to Redhill for the last 20 years of his life, where he died in 1881. Here Palmer regained his vision which he had suppressed in London during the 1850s, was elected to the Old Etching Club, and worked on plates for illustrations of his own translation of *The Eclogues of Virgil*. HENRY BRIGHT, the Suffolk landscapist, lived at Redhill from 1860. By then he had become an influential teacher, also publishing *Bright's Drawing Book* and *Bright's Graduated Tint Studies*. He died here in 1873.

Rhyd-y-Fen
Gwynedd

An inn 2 miles W. of Llyn Celin (lake), about midway between Bala and Ffestiniog. In 1910 AUGUSTUS JOHN and JAMES DICKSON INNES discovered the inn, from whose windows Innes saw the mountain of Arennig Fawr when he awoke. In 1912 John, Innes and DERWENT LEES took a cottage near here, and painted here until 1913. Innes painted Arennig Fawr many times, and buried a sealed casket of love letters on its summit.

Richmond
N. Yorkshire

A handsome market town 12 miles S.W. of Darlington.

In 1674 FRANCIS PLACE drew and made wash and ink drawings of Richmond Castle from the S.E. Place used a gentle and hesitant colouring of water-based paint, the transition between coloured drawing and painting. J. M. W. TURNER worked here on a number of occasions, delighting in this part of Yorkshire. In 1825 for his *Picturesque Views of England and Wales* he pictured the castle and the town based on drawings of 1816. The whole town and fortifications rise out of an enveloping glow, while a milkmaid with two dogs at heel passes on her way. The same figure and her

James Dickson Innes (1887–1914) *Bala Lake* Oil on panel 12⅞in × 16½in (Manchester City Art Gallery)

dog(s) appear in Turner's three other views of Richmond, two in the drawings for engravings in Whitaker's *History of Richmondshire*. The second *England and Wales* view of the town was from Swaledale looking S.E., with the landscape spread out in a wide panorama with slanting rain falling away beyond the town. The solitary seated girl playing with her dog enhances the sense of scale and distance.

Ridley
Kent

A small village, 1 mile S. of Meopham Green where the poet, writer and landscape watercolourist THOMAS BARCLAY HENNELL was born in 1903 and brought up at the rectory, leaving in 1921 to attend Regent St Polytechnic. Later he became affiliated with the Great Bardfield group in Essex, but moved back to Ridley in 1936 where he wrote and painted until being commissioned as a War Artist in 1941, having worked on the *Recording Britain* project of 1940.

Rievaulx
N. Yorkshire

Village 2 miles N.W. of Helmsey. The Cistercian Abbey in the wooded vale below Rydale was the subject of two watercolours and subsequent engravings by J. M. W. TURNER, c. 1825, and c. 1835. Turner portrayed the early morning mists swirling around the abbey ruins, fishermen playing the River Rye below, and high on the R. of the picture, the Classical temple built in 1758 by Thomas Dunscombe.

Rothesay
Island of Bute, Strathclyde

The largest Clydeside resort, built largely during the nineteenth century under the shadow of its castle, on a low island surrounded by highlands. LESLIE HUNTER, a Glasgow painter, was born here in 1879. His family moved to California, where Hunter attempted to farm. He gave this up and, after a visit to Paris in 1903, took up art, only to have his opening show destroyed in the San Francisco earthquake and fire of 1906. In 1910 his family returned to Rothesay, and Hunter rejoined them. He became well known in Glasgow art circles. In 1923 he exhibited work in London with Peploe and Francis Cadell, and painted in Fife and Loch Lomond, until leaving the area in 1927. He died in Nice in 1931, after a mental breakdown.

Rottingdean
E. Sussex

A picturesque village 2 miles E. of Brighton. SIR EDWARD COLEY BURNE-JONES lived at North End House here 1880–98. He took legal action to prevent unsightly violation of the area, such as electricity posts, and was visited here by WILLIAM MORRIS, HOLMAN HUNT and other members of the Pre-Raphaelite movement. In 1909 WILLIAM NICHOLSON visited Rottingdean to paint Rudyard Kipling as part of a commission. He leased an empty vicarage here, until the outbreak of the Great War. Soon after his second marriage in 1919/20, he occupied Burne-Jones's old house, where he restored the frescoes.

Rye
Kent

Once an important port and now a major tourist attraction, with its narrow cobbled streets, and eighteenth-century Lamb House.

 The invalid EDWARD BURRA lived almost his entire life at Rye, except for short spells in London – at school and at Chelsea Polytechnic – and travels in France and Spain. Burra actually detested Rye and its people, finding the place nosy, narrow-minded and claustrophobic – the vices of most very small towns. He died there in 1976. PAUL NASH, a great friend of Burra's, also lived in Rye, 1930–33, in a house looking out over the Romney Marshes. He took many photographs at Burra's home, Springfield, as motifs for paintings.

St Benet's Abbey
Norfolk

An early Benedictine monastery on the banks of the River Bure in the Norfolk Broads, midway between Norwich and Great Yarmouth.

 JOHN SELL COTMAN made watercolours, drawings and etchings of St Benet's, 1812–13. His image of it is of dark cloud rolling in from the N.E. off the sea,

while the light strikes upon the abbey and the River Bure beyond; the sails of the windmill adjoining the abbey ruins give the stonework height against the stormy sky. The same dramatic chiaroscuro was employed in the first half of the nineteenth century by JOHN CROME, JOHN THIRTLE, ROBERT LADBROOKE, HENRY NINHAM, GEORGE VINCENT, JOSEPH STANNARD and HENRY BRIGHT. *St Benet's Abbey* (1847) by Henry Bright is one of the last pictures by a Norwich School artist in the obviously Dutch landscape style to be made of the ruins. It is probably Bright's most often reproduced picture, with the windmill sails still standing high against the N.E. storm, cattle in the shadowed foreground, and light bathing the ruins. In the twentieth century the remains are even more decayed. The windmill sails had disintegrated by the mid-nineteenth century, and only a stump-tower remains. EDWARD SEAGO painted the place in the late 1940s. His picture evokes those of predecessors, his Impressionist style augmented by the Romantic device of two rainbows slanting diagonally above the ruins, and the points of sails on the river beyond.

St Columb Major

Cornwall

A village approx. 6 miles inland from Newquay. In the autumn of 1920 MATTHEW SMITH moved to St Columb Major where he remained until the spring of 1921. Here he produced some of the most distinctive landscapes in British twentieth-century painting: the dark granite of the houses evoking Brittany to him while the paintings owed much to his feeling for Gauguin. Typical of these St Columb pictures is *Cornish Church* (1920) (Tate Gallery).

St David's

Pembrokeshire Coast, Dyfed

The smallest cathedral city in Britain. Built in the twelfth century the cathedral lies in a hollow valley below the small town, beside the impressive ruins of the Bishop's Palace. To the S. are high cliffs and bays of considerable beauty, including St Non's Bay. GRAHAM SUTHERLAND visited this area in 1934, and continued to do so each summer until the Second World War. Inland, he explored bare bleak uplands and outcrops of gnarled rock resembling ruins or massive sleeping animals. The painter JOHN KNAPP-FISHER has worked in this region since the 1960s and produced distinctive work; the low white scattered buildings almost absorbed into a dark land and windy sky which blend and appear inseparable. JOHN ROGERS has also worked here for a corresponding time, dividing his time between London and W. Wales.

St Ives

Cornwall

Originally a fishing village. Its harbour, sheltered by the breakwater wall built by John Smeaton in 1770, became a focal point for artists during the late nineteenth century, and has continued so.

In 1926 BEN and WINIFRED NICHOLSON painted extensively in Cornwall in the company of CHRISTOPHER WOOD, and in 1928 met the 'primitive' painter ALFRED WALLIS at St Ives by whose work they were deeply influenced. Ben Nicholson continued to work in the area in the early 1930s, marrying the sculptor Barbara Hepworth in 1934. PETER LANYON was born here in 1918, took lessons from BORLASE SMART and attended Penzance Art School in 1936. He returned to Cornwall in 1945 after studying in London and France, and after war service with the R.A.F. in North Africa. He founded an art school at St Ives with WILLIAM REDGRAVE and TERRY FROST, 1957–60. In 1964 he died in a gliding accident, aged 46. In the early 1950s the Stockport artist ALAN LOWNDES painted here, although he remained primarily attached to the industrial landscape of the N. Midlands. BRYAN WYNTER, living at Zennor near St Ives, painted in the area

Bryan Wynter (1915–75) *Landscape* (Victoria and Albert Museum)

during the 1950s and early 1960s; at St Ives he associated with Lanyon, PATRICK HERON and TREVOR BELL. ROGER HILTON, who had emerged as a leading abstract painter by the middle 1950s, worked in Cornwall from 1957.

Salford
Greater Manchester
A district of the industrial city of Manchester. From 1909 LAURENCE STEPHEN LOWRY lived at Pendleton in Salford, where he began work as a rent collector in 1910. From 1915 to '20 he studied at Salford Art School when he began painting his famous urban subjects. He first exhibited at the R.A. in 1932, and from 1939 with the Lefevre Gallery, usually painting at night in his Salford house.

Salisbury
Wiltshire
A commercial and cathedral city.

JOHN CONSTABLE first visited Salisbury in 1811, as guest of the Bishop. Constable was also a close friend of Archdeacon John Fisher, the Bishop's nephew. Constable frequently visited his house in Cathedral Close, and painted a number of pictures there. The best known however was painted for the Bishop, *Salisbury Cathedral from the Bishop's Grounds* (1823). The Bishop is seen strolling along a path with his wife on his arm, indicating an aspect of the cathedral to her with his raised cane. J. M. W. TURNER exaggerated the height of Salisbury Cathedral in his picture of 1828–29, based on drawings made on a visit c.1795. The two great British religions, Druidism and Christianity, seemed most apparent to him on the Salisbury plains, where 'Druidic' monuments (Stonehenge) and church spires were starkly visible. In the city pictures the sky and the spire are in harmony, rain and wind being the benevolent breath of God, and flocks in the foreground and children flourish because of it. This is a great contrast to the Stonehenge pictures.

In 1930 the painter CHRISTOPHER WOOD died under a moving train at Salisbury railway station. Wood's death has frequently been described as mysterious; certainly it was tragic, as the 29-year-old artist had just returned from France where he had produced what John Rothenstein has described as some of the most important British painting of the twentieth century. Wood appears to have suffered a mental breakdown after months of feverish activity leading up to a major exhibition of his work. He was buried in Broad Chalke churchyard; the grave has a headstone carved by Eric Gill.

WILLIAM NICHOLSON painted in the region before the Great War and during the 1920s and '30s, picturing the open downlands and views of landscape under snow. GILBERT SPENCER also visited the area during the 1930s. During the Second World War KEITH VAUGHAN worked here and on Salisbury Plain, constructing roads with the Pioneer Corps. The work he produced here was bought by the War Artists' Advisory Committee.

Sandleford Priory
Berkshire
A former Augustinian priory approx. 1 mile S. of Newbury, with gardens landscaped by Capability Brown. In 1744 EDWARD HAYTLEY portrayed the residents of Sandleford Priory on their grassy lawns, having tired of bowls, relaxing while behind them the vista of countryside, with villages around Newbury, and haymakers scything grass recede in tranquil order. The picture is a transition of the group-portrait into georgic landscape, beautifully observed, with everything in the world 'in its place'.

Sapperton
Gloucestershire
A beautiful village overlooking Golden Valley beside the River Frome, approx. 5 miles W. of Cirencester. JOHN NASH lived here 1920–21, the period at which he became *The London Mercury*'s first art critic.

Saxmundham
Suffolk
A small well-kept town 7 miles inland from Aldeburgh. HENRY BRIGHT the landscapist was born here in 1814, the son of a jeweller, and was later indentured to the oil painter ALFRED STANNARD. Later he was instructed by JOHN CROME and J. S. COTMAN. He left East Anglia in 1836, but returned to Saxmundham 1860–62, before moving to Surrey.

Scarborough
Yorkshire

A large resort and port.

The pioneer watercolourist FRANCIS PLACE drew and painted here during the 1680s, picturing the town and headland in line-and-wash but using a wider range of technique and portrayal than was typical of 'watercolour draughtsmen' for almost a further century.

FREDERIC, LORD LEIGHTON was born here in 1830, and remained here until 1840, when his family left for the Continent for the benefit of his mother's health. Much of his adolescence was spent on the Continent, where he visited art galleries and filled many notebooks with sketches. In the later 1840s he studied at the Academy in Berlin and Accademia di Belle Arti in Florence. He finally returned to Britain in 1859 and settled in London. JOHN ATKINSON GRIMSHAW lived in Scarborough for part of each year from 1860s onwards. He built an exotic, battlemented 'villa' not far from Scarborough Castle. He painted landscape and coastal pictures here and in the Yorkshire Dales until a major financial disaster when he moved back to Leeds in 1876. HARRY WATSON, the landscape and figure painter, was born in Scarborough in 1871. He studied at Scarborough School of Art, 1884–88, then at the Royal College of Art, and then went to Rome on a scholarship. He taught in London thereafter and painted widely in England.

Selkirk
Borders

A former tweed-manufacturing town, now a centre for exploring the lovely Ettrick and Jarrow Valleys. The painter WILLIAM JOHNSTONE was born here in 1897. TOM SCOTT of the Royal Scottish Academy inclined him towards painting which he studied in Edinburgh from 1919. He travelled in France and America but returned to Britain in 1929, becoming the Principal of Camberwell School of Arts and Crafts 1947–60. During the 1930s he painted extensively in the Borders area, and in 1960 retired to take up farming near the Eildon Hills (to the N. of Selkirk), whose triple peaks rising to 1,387 feet he had pictured many times.

Sheffield
S. Yorkshire

An industrial and cathedral city.

The ruralist THOMAS CRESWICK was born here in 1811, leaving c.1825 to train under John Vincent Barber in Birmingham. GODFREY SYKES, best-known for his decorative work at the V. & A. Museum, London, worked here in the 1850s. He had studied under the portraitist Alfred Stevens during that painter's brief visit to Sheffield in 1850–51, and during the 1850s produced some of the finest and most interesting industrial cityscapes in the nineteenth century. WALTER BELL was born here in 1904, and attended Sheffield College of Art. Initially he had no material success in painting, and not until 1937 did he gain any recognition outside Sheffield, where he belonged to the Sheffield Society of Artists and exhibited in the local galleries.

Shere
Surrey

A village 5 miles E. of Guildford, near the gardens of Albury Park. HELEN ALLINGHAM the watercolourist and illustrator began her long series of rural domestic pictures here in the summer of 1879, painting cottage gardens from nature. In 1939 KEITH VAUGHAN lived for a year here, making paintings from photographs of the coast and people on the seashore, and painting the surrounding landscape from sight. During the 1930s, while he had worked for Unilever, he had been affected by the writings of Clive Bell and Roger Fry and been influenced by Ben Nicholson and Matisse, but the qualities of the landscape were those which had affected him at Horsham, where he had spent his boyhood.

Shoreham
Kent

A village in the valley of the Darent 3 miles N. of Sevenoaks. In 1825 SAMUEL PALMER, BLAKE, Richmond and Calvert spent many weeks at Shoreham, where they were known locally as 'The Extollagers' from their habit of wandering through the landscape at night with lanterns reciting spontaneous poetry and eulogizing on their surroundings. Palmer settled here until 1835, being visited here in 1827 by the dying Blake in a wagon pulled by 18 horses and hung with lamps. Palmer regarded the area as his 'Valley of Vision' and before 1835 produced his most outstanding work here.

Sidmouth

Devon

A resort and harbour surrounded by tall red cliffs. DAVID JONES came here to paint and live after a nervous collapse in 1932, and lived here from 1935 to 1939. Here he continued, but never finished, his monumental poem, *In Parenthesis*.

Snowdon

Gwynedd

At 3,560 feet the highest peak in England and Wales, 10 miles S.E. of Caernarvon.

RICHARD WILSON travelled and painted here in the early 1760s. He produced a memorable – and for its time remarkable – oil picture of Snowdon from Llyn Nantlle, a composition of sweeping curves which not only recorded and responded to the N. Welsh landscape, but found an aesthetic to accommodate it. In the early 1770s Wilson returned to the area, working along the valleys around Llangollen, of which he made another memorable oil, *View of Wynnstay, Llangollen* (1770–71). The Irish painter GEORGE BARRET painted extensively in the area in the 1760s, his favourite site being Llanberis Lake. His pictures frequently echo those of Richard Wilson, partly through their subject matter and partly through Irish landscape provoking similar developments in style.

In 1771 PAUL SANDBY set out with his patron, Sir Watkin Williams-Wynn of Wynnstay, for a tour of the N. Wales mountains and the Snowdon range, a route which was the pattern for most of the major British landscape artists to take through the area for the next 100 years. The course followed by the party was to Llangollen and Llantysilio, Corwen, Rûg, Bala beside its long lake, down to Dolgellau and to Barmouth by the Irish Sea. Then up along the coast to Harlech, inland to Ffestiniog under the Snowdon Range, then back to the sea at Portmadoc, then N. via Pont Aberglaslyn to Caernarvon, aside inland to Llanberis, then on up the coast going N.E. to Bangor and Beaumaris, then Conway on the N. Wales coast inland up the Conway Valley to Llanrwst and finally E. to St Asaph and Holywell, before turning back S.E. towards Wrexham, Ruabon, the English border and Wynnstay. SANDBY's aquatints from the sketches and watercolours he made on this tour, partly published in *Views in North Wales, being part of a tour through that fertile and romantic country* (1776), became famous.

Aberglaslyn Pass was visited by FRANCIS TOWNE during his tour of 1777, where he painted its salmon leap just above Pont Aberglaslyn, an important tourist area of the late eighteenth century. In the early 1790s JULIUS CAESAR IBBETSON crossed the pass in a thunderstorm while touring with his patron, and produced one of his best-known works, *A Phaeton in a Thunderstorm* (1798), an oil showing the horses of a phaeton rearing wildly at the lightning above a foaming torrent in a gorge, while his patron attempts to control them from the driving seat and Ibbetson fetches rocks to prevent the vehicle rolling backwards. This was a perfect subject for Edmund Burke's aesthetic of the 'sublimely awesome'.

THOMAS GIRTIN paid his first visit to N. Wales in 1798, passing the edge of the Snowdon range, and as much concerned by money as the scenery, having to borrow £25 from a fellow traveller to make ends meet. In 1802 CORNELIUS VARLEY visited the region, making a mass of watercolour sketches and later finished work, and returned in 1805. On his second tour he made a series of muted, grey-green and steel-blue watercolours where the highlands and the sky appear to interweave, the shifting cloud and changeable light of the area, without the melodrama given by Ibbetson, but more atmospheric and specific to N. Wales, rather than 'a mountainous region'. JOHN LINNELL made a tour of the valleys around Snowdon during 1813, painting a large number of watercolours which deeply affected all his subsequent work. He went to Llanberis, Capel Curig, and the lakes of Llyn Padarn, Llyn Peris and the Nantygwyryd valley towards Bettws-y-Coed.

During his N. Wales tour of 1798, J. M. W. TURNER passed through Llanberis, sketching Snowdon, Llanberis Lake, Dolbardan Castle and Llyn Peris. He exhibited an oil of Dolbarden Castle at the R.A. in 1800, a rather dark brooding image. His other paintings (oil and watercolour) of the region until the late 1820s retained a similar dark mysterious quality. After 1830 however his watercolours of Snowdon had achieved a highly Romantic misty airiness which captured the atmosphere of the area. In 1833 he painted Llanberis Lake and Snowdon, with Dolbarden Castle as a gold-patched outcrop in the centre of the picture, full of windy movement, with diagonal sunbeams weaving together the curves of a landscape given scale by the tiny figures of two fishermen and a woman and child.

SAMUEL PALMER made his first Welsh tour in 1835, on the advice of Charles Linnell. Palmer, like Girtin 37 years earlier, was reduced to borrowing to get through the journey, which he lamented was as costly as setting out for N. America.

During the 1840s DAVID COX, while staying at Bettws-y-Coed at the foot of the Snowdon range made frequent painting trips in the region, usually using the mountains as a discreet back-drop to the wooded valleys he preferred. SIR JOHN GILBERT drew

here in the mid-1850s, and BENJAMIN WILLIAMS LEADER towards 1860. During the 1860s GEORGE SHEFFIELD and THOMAS COLLIER made oil and water-colour studies of the lower land of Snowdonia. HENRY CLARENCE WHAITE worked here with increasing frequency from the 1860s onwards, and well into the 1870s he produced dramatic, Romantic, Turnerian images in watercolour and large-scale oils.

In 1945 and 1946 JOHN PIPER drew and painted extensively in N. Wales and the Snowdon range, with a style of drawing changed fundamentally by his experience during the Second World War. He was to come back to the area for the next 30 years. In the late 1940s and '50s the structures of mountains well-suited Piper's deep response to architecture, and showed well in his portrayal of rocky outcrops and escarpments. KYFFIN WILLIAMS worked in the region, drawing and painting both the landscape and the local people and their houses and life-style. As such, he was the first native-born Welshman to do so. Williams frequently uses a long, wide canvas for a panorama of isolated buildings and sweep of landscape, a palette-knife technique, and the closely-related colour tones of the landscape.

Solva
Pembrokeshire Coast, Dyfed

A small fishing village perched above a winding inlet. GRAHAM SUTHERLAND came here in 1934, exploring the land around St Brides Bay, between St David's and Milford Haven and Haverfordwest. He wrote to his patron and friend Colin Anderson: 'I wish I could give you some idea of the exultant strangeness of this place . . . [the W. Pembrokeshire landscape] . . . the impenetrable damp green gloom of the woods, which run down on the edge of . . . moss-covered cliffs – it is all dark save where the mossy lanes . . . admit the sun, hinged, as it were, on the tops of the trees . . . precipitating new colours, turn the red cliffs . . . to tones of fire . . . Cattle crouch among the dark gorse. The mind wanders from the contemplation of the living to their dead ghosts. It is no uncommon sight to see a horse's skull or horns of cattle lying bleached on the sand. . . .'

Southampton
Hampshire

Britain's major passenger port, with 6 miles of docks along Southampton Water. SIR JOHN EVERETT MILLAIS was born in Southampton in 1829, and lived here until the age of 10, when he travelled to London with an introduction to Sir Martin Arthur Shee, President of the R.A. The landscape and marine painter RICHARD EURICH settled at Dibden Purlieu, on the outskirts of Southampton, in 1947, where he has lived and worked since, painting along this coastline, as well on the Yorkshire moors.

Southport
Merseyside

A resort with a wealth of Victorian and Edwardian watering-place architecture on the Lancashire coast. The witty and versatile landscape painter, illustrator, miniaturist and marine painter PHILIP CONNARD was born here in 1873.

Stalybridge
Greater Manchester

Now an industrial and residential suburb of Greater Manchester. The Impressionist STANLEY ROYLE was born here in 1888, the son of the station master. In 1904 he left to study art in Sheffield, becoming a member of the Sheffield Society of Artists and Royal Society of British Artists. In 1938 he settled in Worksop, where he became known for his pictures of the Derbyshire landscape.

Stamford
Lincolnshire

One of the finest stone-built towns in W. Europe, with much seventeenth- and eighteenth-century building. J. M. W. TURNER drew here in 1797 during his tour of N. England (Northern Notebook) and worked up finished watercolours between 1825–28, showing the impressive church architecture (St Martin's church) rising above a busy stage coach scene, with laden, irate passengers disembarking and quarrelling dogs.

Stockport
Greater Manchester

A manufacturing town, now part of the Greater Manchester conurbation. The landscape and urban painter

ALAN LOWNDES was born here in 1921. The fifth child of a railway clerk, he was apprenticed to a decorator at the age of 14, attending evening classes at Stockport Technical School. There he was instructed in the decorative crafts of graining and lettering, and the structure of paint. At the end of the Second World War he was attached to an army mapping unit, enabling him to see paintings in Italy. Returning to Stockport in the late 1940s, he worked as a decorator then textile designer, and attended evening classes at Stockport Art School. He began to paint full-time in the early 1950s. Although he left the region for St Ives and Gloucestershire, he continued to paint the Greater Manchester area; Stockport, Oldham, Huddersfield and Rochdale, until his death in 1979.

Stoke-on-Trent

Staffordshire

One of the five famous pottery towns. RAYMOND COXON, a founder of the short-lived British Independent Society of 1927, was born in Hanley, a N.-central district of Stoke, in 1896, leaving in 1914 to join the cavalry. He returned from Palestine in 1919, and went to study art at Leeds.

Stone

Staffordshire

A small market town 6 miles S. of Stoke-on-Trent. PETER DE WINT, a leading British watercolourist of 1800–50, was born here in 1784. De Wint was educated here and left the town c.1800, settling first in London where he exhibited and taught, and later in Lincoln, where he painted extensively until his death. He is primarily associated with his watercolour pictures of level harvest fields, although he travelled extensively during the first 20 years of the nineteenth century, including in his work the vistas of the Wrekin and Clent Hills.

Stonehenge

Wiltshire

A bluestone monument begun c.1900 B.C. and completed c.1400 B.C., 2 miles W. of Amesbury.

The Dutchman JAN KIPP produced some of the earliest images of Stonehenge at the very end of the seventeenth century, showing the monument in what was then thought to have been its complete form, its vertical slabs with cap-stones in place and a low earth wall surrounding the perimeter.

Stonehenge was almost an archetype of Edmund Burke's definition of the 'sublime'. The dramatic history-painter JAMES BARRY used it as a model for his landscape background to his *King Lear Weeping over the Dead Cordelia*. Barry, a friend and protégé of Burke, used landscape as an extension of the dramatic moment, and Stonehenge was portrayed in this way by practically every artist who visited it from the late eighteenth until late nineteenth century.

During his Salisbury visit of 1795 J. M. W. TURNER made drawings of this monument, and a second group of drawings in 1811–15, in which he made several variations of a scene of violent storm with a shepherd lying dead, struck by lightning. In a major watercolour c.1825–28 he altered the exact disposition of the standing stones and made a long, liquid hook of lightning falling away within the stone ring, while the course of the lightning is revealed by a ragged line of dead sheep and a dead shepherd, a picture taken to show the fate of a dead religion and a belief that ultimately the human race would end in extinction. JOHN CONSTABLE visited Stonehenge on numerous occasions while at Salisbury, but did not make major pictures of it until late in his career. He showed the great standing stones under a dark squall with two rainbows curving down to them in a watercolour of 1836.

JOHN VARLEY pictured the monument as did JULIUS CAESAR IBBETSON and MICHAEL ANGELO ROOKER, all interpreting in a Romantic, dramatic vein, Rooker exaggerating the height and ragged 'disorder' of the stones, and none of them bothering to depict the correct number. WILLIAM NESTFIELD who portrayed a number of other Neolithic monuments in Britain, made Romantic drawings of the stones, 1830–40, much in the manner of Turner. In the latter half of the nineteenth century the site became *passé* for artists, returning to fashion again in the early twentieth century.

During the late 1920s and early 1930s the monument was used as a tourist attraction by the railway and oil companies. EDWARD MCKNIGHT KAUFFER in particular excelled at this type of subject, producing an image of apparently luminous stones rising against a black, starlit sky, and adding 'See Britain First on Shell!' in dark letters which seem to grow out of the ground at the base of the poster.

In 1937 Barbara Hepworth wrote of the monument's abstract qualities in the avant-garde *Circle* in a collaboration with HENRY MOORE, who produced a set of prints entitled *The Stonehenge Suite*, 1971–73, from a large number of source drawings and photographs. In 1963 KEITH GRANT visited it as part of his work for the *Shell Guides*.

Stoney Middleton

Derbyshire

A village on the E. edge of the Peak District, approx. 10 miles S.W. of Sheffield. The painter WALTER BELL worked here as a hairdresser during the late 1920s and 1930s, a member of the Sheffield Society of Artists and showing work in local galleries. In 1937 his painting of the local landscape, *Derbyshire Quarry*, won him some recognition at the R.A. He moved to Cornwall where he relied on sales to tourists for his livelihood.

Southend-on-Sea

Essex

A coastal resort at the mouth of the Thames Estuary. ALAN SORRELL, the historical landscape painter, was brought up at Southend from c.1909, the son of a master jeweller and watchmaker. In 1919 he went to Southend Municipal School of Art, before becoming a commercial designer in the City of London. He went late to the Royal College of Art in 1924, won the Prix de Rome in painting, spent two years in Rome, and returned in 1931. He executed murals at Southend Municipal Library, 1933–36.

Stourpaine

Dorset

A village on the A350 approx. 4 miles N. of Blandford Forum, on the S.W. edge of the West Wiltshire Downs. From 1920 STANLEY and GILBERT SPENCER came here to stay with their friend Henry Lamb. Gilbert Spencer painted the area frequently during the 1920s and 1930s, the images sometimes being 'composites', or mixtures of various separate details put together in an harmonious collage which typified the region.

Strumble Head

Dyfed

A jutting headland with dramatic rock-folding approx. 15 miles N.E. of St David's, and 4 miles W. of Fishguard, on the Pembrokeshire Coast.

In 1963 JOHN PIPER and his wife Myfanwy took a cottage on the wind-swept peninsula, which they have retained ever since. Piper spends part of each year here, a large body of his later work exploring the landscape and the architecture of Wales – particularly that of the nineteenth-century nonconformist chapels – hitherto almost a taboo amongst conservationists and architectural students – about which he published a book and which feature in many of his pictures.

Sudbury

Suffolk

An affluent market town on the Stour, which marks the Suffolk/Essex border. The landscape and portrait painter THOMAS GAINSBOROUGH was born here in 1727, at the Tudor house in Sepulchre St. His father, formerly an affluent clothier, went bankrupt in 1733 and was given the job of postmaster by the Sudbury authorities. Thomas attended the local grammar school at Sudbury, when he began to draw the surrounding landscape: '. . . a great many sketches of Trees, Rocks, Shepherds, Ploughmen, and pastoral scenes, drawn on slips of paper or old dirty letters, which he called his *riding School*.' An obituary stated that after painting several landscapes 'from the age of ten to twelve, he quitted Sudbury in his 13th year'. In 1740 he left for London, to study. He came back to stay in Sudbury, 1748–52, during which time he painted *Hadleigh Church* and *Cornard Wood* and his famous landscape portrait of Mr and Mrs Andrews. This picture is set at Auberies, midway between Sudbury and Bulmer. Behind the figures is the valley of the Stour with purple hills rising in the distance beyond Mr Andrews's gleaming stooked hayfield. Other pictures of this period include *River Scene with Figures and Dogs Barking*, *Sandy Lane Through Woods with Cottage and Donkey*, which has many rococo swirls of composition, and *Wooded Slope with Cattle and Felled Timber*, forming a Claudian pattern and using the Stour landscape with church steeples and fallen trees in place of Classical architecture. By c.1751 his pictures of local people, like *Old Peasant with Ass and Dog outside Hut*, formed an approach to landscape he practised until he moved to Bath.

Swanage

Dorset

A quiet holiday resort and once a Saxon port. In 1933 PAUL NASH visited Swanage, where he later conceived the oil painting *Event on the Downs* (1933) which looks out over Ballard Down to the sea. Between 1934 and '36, while compiling the *Shell Guide* to Dorset which was his favourite county he lived in Swanage, first at

Whitecliff Farm near the town and later at 2 The Parade. In the *Architectural Review* (April 1936) Nash wrote of *Swanage, or Seaside Surrealism* and contrasted the magnificence of the landscape with the gross 'Purbeck-Wesleyan-Gothic' buildings of the town, which he thought revolting.

Temple
Lothian

A village on the banks of the South Esk, 8 miles S. of Edinburgh, beneath the Moorfoot Hills. WILLIAM GILLIES lived here from 1939, painting the landscape in the area in oil and watercolour.

Tenby
Dyfed

A coastal resort and harbour 11 miles E. of Pembroke, notable for its excellent Georgian and Regency building. AUGUSTUS JOHN was born here in 1878.

Tidmarsh
Berkshire

A village 3 miles W. of Reading. The painter DORA CARRINGTON lived at the Old Mill at Tidmarsh with the writer and essayist Lytton Strachey, 1917–24. She had discovered the Mill which she extolled in terms of a Cézanne landscape, and with which she only tired after her European tour in 1923, when she suspected others saw it as 'flat and provincial'. But Carrington produced her best landscapes here, vividly coloured with her own brand of poetry, and continued her intermittent affair with MARK GERTLER while remaining devoted to the homosexual Lytton Strachey. In 1924 she and Strachey moved to Ham Spray House, Wiltshire.

Tintern Abbey
Gwent

Situated on a bend in the River Wye in meadowlands overlooked by steep wooded hills in Gwent, this abbey was founded in 1131 by the Cistercian Order and suppressed by Henry VIII in 1536.

During his trip down the Wye in 1770 the REV. WILLIAM GILPIN, amateur watercolour painter, collector and travel writer, found the only thing to mar Tintern was its 'excessive regularity' – its ruined walls were not quite unequal enough in height and shape to be truly 'picturesque'. Artists invariably altered it accordingly. JOHN VARLEY and NICHOLAS POCOCK visited it and 'adjusted' it slightly, and so did JOHN 'WARWICK' SMITH and CORNELIUS VARLEY near the turn of the century. MICHAEL ANGELO ROOKER did similarly in the 1780s, when he also produced images of ruins in Shropshire, Hereford and Worcester. During the 1790s PHILIPPE JACQUES DE LOUTHERBOURG painted extensively in the area. In 1805 his oil *The River Wye at Tintern Abbey* all but hides the ruins in trees and rocks, making it even more overgrown than it was in 1805, and making the ruins more irregular than before.

J. M. W. TURNER pictured Tintern, with an exaggeratedly high interior, plumed with overgrowth: dreamy halls of desertion. He also sketched variants for his unfulfilled project *The Rivers of England*, which would have included the Wye. In 1835 SAMUEL PALMER produced what is probably the best-known watercolour of Tintern (V.&A.) showing the ruins almost hidden by trees from which the graceful stonework rises like carved bone encrusted with bark. DAVID COX painted along the Wye here, while teaching in Hereford; he popularized a view of the Wye which he continued to polish throughout his career, but particularly from 1816 to '27. JOHN LINNELL painted here as did THOMAS CRESWICK.

In the late nineteenth century the area was 'rediscovered' by the painters of the New English Art Club, particularly PHILIP WILSON STEER who worked here, 1890–1910, when his style was less open and fluid than before. Between 1910 and '30 WALTER RICHARD SICKERT, CHARLES GERE and EDWARD SOUTHALL worked here, the tempera painters interested in recapturing the atmosphere of the work of Calvert and Palmer. PHILIP CONNARD produced some of his characteristically debonair pictures in the vicinity before and after the Great War, as did BERNARD SLEIGH and LESLIE MOFFAT WARD. ALAN SORRELL made reconstruction drawings of the area for the National Museum of Wales, 1937–40. KEITH VAUGHAN painted here while building roads with the Pioneer Corps in the 1940s.

OPPOSITE Edward Burra (1905–76) *Wye Valley II*
Watercolour 52⅜in × 31¼in (Lefevre Gallery, London)

Torquay

Devon

Once a fishing port and now a flourishing holiday resort. The illustrator, designer and teacher WALTER CRANE was born here in 1845, and lived here for 12 years until his family moved to London in 1857. He made his name with sensitive pictures of the Derbyshire area during the early 1860s, after which he worked in N. Wales.

Trematon

Cornwall

Village approx. 1 mile W. of Saltash. J. M. W. TURNER visited the village, 1812–13, while working in the Plymouth area, and produced a finished watercolour for his *England and Wales* series, 1825–28, showing a serene scene by the bridge over the River Lynher and the village and remains of the ruined castle on a wooded mound, while boats lie at rest on the water.

Trossachs (The)

Central Region

A belt of mountains, birch-woods, fast streams and moorland form magnificent scenery separating Lochs Katrine, Achray and Venachar from the lowlands of what used to be Perthshire and Stirling. Popularized by Sir Walter Scott.

Brig o' Turk – Bridge over the Finglas or Turk Water – is a village of white-walled cottages surrounded by hillside woods, 6 miles W. of Callander. In 1853 JOHN RUSKIN, the art critic and champion of the Pre-Raphaelites, stayed here with his wife and the young painter JOHN EVERETT MILLAIS, and walked and drew in the region. Millais rewarded Ruskin by seducing his wife, whom he subsequently married, completed a landscape portrait of Ruskin in 1854 after this holiday, standing on the rocks by the falling waters in Glenfinlas. WILLIAM HENRY MILLAIS, John Millais's younger brother, also accompanied the party and painted in the region. He returned to the Trossachs in the 1860s and although he never became a professional painter his work was superior to that of many who were.

In 1866 HORATIO McCULLOCH came here, painting the lochs and mountains in a style which owed much to the Dutch seventeenth-century landscapists, and took its 'mood' from the romances of Walter Scott. Probably his most famous landscape, *Loch Katrine* (1866) became a symbol of the Scottish landscape which has remained a tourist image ever since. McCulloch died the following year, having produced this Scottish archetype. John Everett Millais continued to visit the area after he had moved to the vicinity of Perth in 1854.

JOHN MACWHIRTER visited the area during the 1870s, travelling widely around Scotland. In 1880 EDWARD ARTHUR WALTON, JOSEPH CRAWHALL and JAMES GUTHRIE 'discovered' Brig o' Turk, and in 1881 they were joined there for the summer by GEORGE HENRY. In 1882 the 'Glasgow Boys' congregated for the summer at Brig o' Turk: James Guthrie, Joseph Crawhall, George Henry, E. A. Walton, ARTHUR MELVILLE, E. A. HORNEL, ALEXANDER ROCHE and JOHN LAVERY, under the leadership of WILLIAM YORK MACGREGOR. Here in 1882 James Guthrie observed

the subject for his painting *Highland Funeral*, which made the group's reputation. The Glasgow painter JOHN QUINTON PRINGLE made excursions here in the late 1880s and early 1890s, and DAVID YOUNG CAMERON during the early 1900s.

After the Great War, the Trossachs became a focal point in the advertising campaigns of the railways. In the early 1920s NORMAN WILKINSON, a highly successful poster designer, illustrator, and later marine artist, visited the region and produced designs of the mountains and lochs for the London, Midland and Scottish Railway; in 1924 he launched the London, Midland and Scottish posters by artists scheme, which included work by David Young Cameron, Algernon Talmage, George Henry, George Clausen and Arnesby Brown. In the 1920s and 1930s SIR WILLIAM GILLIES painted the area as did LEONARD RUSSELL SQUIRRELL, who also worked for railway companies, his Cotmanesque style well-suited to the landscape and the light. The restless and disorganized LESLIE HUNTER, painting along Loch Lomond, also came here in the mid-1920s. The poster designer FRANK NEWBOULD worked here as did SIR WILLIAM RUSSELL FLINT during the 1930s.

Trottiscliffe
Kent

A small village 7 miles S.W. of Rochester, in a wooded tract of land near the Pilgrim's Way, at the foot of the N. Downs, and not far from the megalithic Long Barrow of Coldrum Stones, dating from about 2000 B.C. GRAHAM SUTHERLAND and his wife Kathleen lived here from 1936 until they moved permanently abroad in the late 1950s. Here his work became more involved with the 'strangeness' of landscape which he had explored in Pembrokeshire until the outbreak of the Second World War, and the Kent landscape affected his work relatively little. Human figures played an increasingly minor part in his landscapes, usually only as accents, and human qualities were assumed by trees and rocks, such as *Association of Oaks* (1940), in which the trees resemble or evoke two boxers.

Upper Basildon
Berkshire

A village in the Thames Valley, 2 miles W. of Pangbourne, the landscape described in Kenneth Grahame's *The Wind in the Willows*. In 1931 GILBERT SPENCER bought a cottage here, and returned to it despite enforced absences thereafter until the death of his wife and daughter, 30 years later. Here he painted two types of landscape: assemblages of many features brought together from particular neighbourhoods, or pictures of particular places begun and completed on the spot.

Valle Crucis Abbey
Clwyd

A ruined Cistercian abbey 1½ miles N. of Llangollen. J. M. W. TURNER visited these ruins in 1808, and produced finished watercolour work c.1825, showing them beneath the sun-bathed heights of Eglwyseg Mountain with a bare-foot girl shepherding sheep in the foreground. She is interesting for the record of her working clothes of calf-length skirt, bare legs and 'Welsh' hat: not the tall 'witch's' variety but a man's bell-topped top hat, sometimes tarred like a sailor's.

Wakefield
W. Yorkshire

Formerly the county town of the W. Riding, on the River Calder. VIVIAN PITCHFORTH, marine and landscape oil and watercolourist, was born here in 1895.

Wallingford
Oxfordshire

A market town beside the Thames, approx. 14 miles N.W. of Reading. The sixteenth-century town hall, mounted on pillars, has several Gainsborough portraits.

PAUL NASH when visiting an uncle near Wallingford in 1909 first saw Wittenham Clumps, two tree-surmounted hills on either side of an iron-age hill fort, 3 miles to the N.W. of the town. The image of these clumps of trees on the bare undulating hills became a constantly recurring motif in his work. At the time he called them 'the Pyramids of my small world'.

Wallington
Northumberland

WILLIAM BELL SCOTT, the Pre-Raphaelite and Director of the Government School of Design at Newcastle,

executed a series of murals in the central hall of Wallington House during the late 1850s and early '60s, for Lady Pauline Trevelyan, patron of the Pre-Raphaelite movement. Scott's paintings represented scenes from Northumbrian history – the best known of them being *Iron and Coal* (1861) – showing the industrial Tyne waterfront. Each figure in the murals was a portrait of a particular living individual.

Walsham-le-Willows
Suffolk
A village of timber-framed and weather-boarded cottages set in woodland, 10 miles N.E. of Bury St Edmunds. After his wife's death in 1959, and his daughter's soon after, GILBERT SPENCER moved here, where he painted some late portraits as well as landscape, and also wrote *Stanley Spencer* (1961) and *Memoirs of a Painter* (1974). He died in 1979.

Walton-on-Thames
Surrey
Now a residential area just beyond the boundary of Greater London, S. of the river and 3 miles W. of Kingston-upon-Thames. J. M. W. TURNER produced

Joseph Mallord William Turner (1775–1851) *The Thames near Walton Bridge* Oil on wood 14⅜in × 29in (Tate Gallery, London)

paintings and drawings here, particularly between 1810 and 1816. Some, c.1812, were summary oil sketches and there were 3 finished oil pictures, one echoing Cuyp. All showed the bridge over the river: *Walton Bridge, Surrey*, and an oil giving the bridge a fantasy Italianate character, reproduced as *Landscape with Walton Bridge*. In 1825–28 he produced a finished watercolour for the *England and Wales* series showing the true bridge with horses passing across it and flocks of sheep watering in the river under a windswept sky.

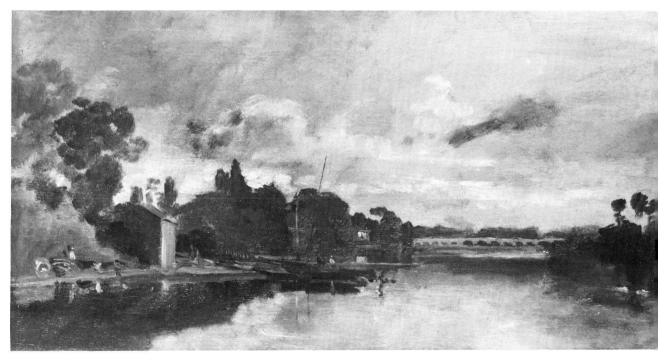

Warleggan
Cornwall
A village on the S. edge of Bodmin Moor. In the mid-1970s the Ruralist painter GRAHAM OVENDEN took Barleysplatt, near Warleggan and proceeded to turn it into a castle painted in vivid pinks and blues. Ovenden's painting was part of the great reappraisal of Victorian art which gathered momentum in the early 1970s, which was more broadly based than just among the Ruralist Brotherhood.

Warlingham
Surrey

A residential town 2½ miles S.E. of Purley. VICTOR PASMORE was born here in 1908, the son of a mental specialist attached to nearby Chelsham Hospital. His family lived here until his father's premature death caused them to move to Hammersmith in 1927, and him to withdraw from Harrow School.

Warrington
Cheshire

An industrial town which grew up around a ford on the Mersey and then the trade of the Manchester Ship Canal. GEORGE SHEFFIELD lived here during the mid-1840s, before becoming apprenticed to a pattern designer in Manchester. During the 1850s he painted much in the N. Cheshire area, and in the Alderley Edge district, 14 miles S.E. of Warrington in the late 1860s. In the early 1880s he returned to Warrington from the Isle of Man. JAMES CHARLES was born in Warrington in 1851, and was later trained at Heatherley's School of Art, and the R.A. schools, London, before coming under the influence of *plein-air* painting in Paris. He returned to Warrington, exhibiting with the New English Art Club all his life, practising an Impressionist style of rustic landscape.

Warton-in-Carnforth
Lancashire

A village approx. 1 mile N. of Carnforth. DANIEL ALEXANDER WILLIAMSON, the Liverpool Pre-Raphaelite landscapist, lived here 1861–64, painting with intense colour and minute impasto technique.

Warwick
Warwickshire

A commercial town, with an inhabited medieval castle containing paintings by Van Dyck, Velasquez and Rubens.

The watercolour painter JOHN 'WARWICK' SMITH was born in the area in 1749. Smith made a considerable name for himself with pictures of the English and Italian landscape, which he exhibited in London with the Old Watercolour Society, some of whose members he annoyed by the excessive number of pictures he displayed, saturating the market. It was a vice he shared with Copley Fielding. OLIVIA SERRES (née Wilmot) was born in Warwick in 1772. Her prime claim on posterity is her marriage to JOHN THOMAS SERRES, the accomplished marine (and to a lesser degree landscape) artist who like his father Dominic Serres became marine painter to the king. Olivia was a painter of some talent in Romantic landscape tradition and a voluminous writer of Romantic drivel; this was heightened by her fatuous claim to the title Princess of Cumberland, in pursuit of which she ruined her husband in legal costs, and sent him to prison as a debtor. The massive fourteenth-century castle was the prime subject for J. M. W. TURNER's lyrical watercolour of 1830–31, a gold-tinted composition, viewing the castle across the River Avon while cloud and sunbeams cause sloping violet strokes overhead.

Washford
Somerset

A village, 2 miles inland from the coast and Watchet, on Bridgwater Bay. A quarter of a mile S. is the ruin of Cleeve Abbey, founded c.1198. JOHN WILLIAM NORTH, friend and colleague of Frederick Walker with whom he was apprenticed to J. W. Whymper, lived here from 1868 at Halsway Farm. Although he left the area c.1870, he continued to regard Somerset as his 'spiritual home'.

Wellow
Avon

A village formerly in Somerset, 2½ miles S. of Bath. PETER BLAKE, a founder-member of the Brotherhood of Ruralists, took Wellow railway station as his home in the mid-1970s, converting it and restoring it while using a nearby chapel as his studio. By then Blake's early work, picturing rock musicians and boxers as though from child or adolescent nostalgia, had given way to a deep admiration for the Pre-Raphaelites, particularly Millais.

Westhampnett
W. Sussex

Now a suburb of Chichester. JOHN DUNSTALL, who described himself as a 'small professor and teacher of

drawings', established in The Strand, London, exe-cuted one of the earliest extant landscape pictures in England here, c.1660: a pollard oak tree drawn in opaque colour on vellum or fine parchment. Behind rises a black-and-white wood-and-plaster frame mill and a manor house on the horizon within walled grounds.

Wetley Abbey
Staffordshire

Three miles E. of Stoke-on-Trent. This was the family home of GEORGE HEMING MASON, who settled here after his marriage in 1857. He was depressed by economic and family worries until GIOVANNI COSTA visited him here in 1863, and encouraged him to paint the local landscape, with successful results. Later on this popular artist specialized in twilight and sunset subjects, with figures spread along the foreground in a frieze.

Whitehaven
Cumbria

A coastal town which expanded by exporting coal: the first deliberately planned town in Britain since the middle ages and built on a grid-pattern. MATTHIAS READ, born in London in 1669, settled in Whitehaven, c.1695, probably having returned from Ireland where it is thought he became involved with the troubles of 1689–90. He was a friend of the painter YAN WYCK who worked for the local Lowther family, and was probably his protégé. Wyck died in 1702; Read married a Whitehaven woman that year, and afterwards worked extensively for the Lowthers. He made at least 4 large, bird's-eye views of the town. The earlier versions, painted c.1730–33 and the later by 1736, showing new almshouses erected along Duke St in 1736, steadily become more sophisticated. The final view was the basis of a 1738 engraving of the town by Richard Parr.

Wigan
Greater Manchester

An industrial town, in origin one of the oldest in Lancashire, whose back-to-back tenement houses and slag-heaps were selected for somewhat Gothic treat-ment by George Orwell in his *Road to Wigan Pier*.

LAURENCE STEPHEN LOWRY painted numerous pic-tures of this town, with a cooler, almost Bruegel-like narrative vision which lacked Orwell's voyeuristic harshness, giving an air of Hades on holiday. His work is now a period-piece as the decline in heavy industry on N.W. England has left Wigan without ranks of smoking chimneys and belching cooling towers, and canal-areas are reclaimed for recreation.

Wigton
Cumbria

A small town 9 miles S.W. of Carlisle. The landscape watercolourist GEORGE SHEFFIELD was born here in 1839. His family moved to Warrington, near Man-chester, during the early 1840s.

Windsor
Berkshire

A residential town which has grown up round the Royal residence of Windsor Castle. The gardens and grounds of Windsor Great Park extend S. 4 miles to Virginia Water.

In c.1746 the watercolourist THOMAS SANDBY, brother of the topographer and watercolourist PAUL SANDBY became unofficial Deputy Ranger of Windsor Forest, under the Duke of Cumberland, for whom his brother Paul had mapped much of the Scottish High-lands. Thomas was responsible for major landscaping scenes including the creation of Virginia Water. Both brothers painted extensively in the area. From c.1795 until c.1825, J. M. W. TURNER frequently depicted Windsor Castle and environs of Windsor. During 1795 he produced drawings of Windsor from the Thames for *The Pocket Magazine*. In c.1800 he made a number of large oils showing the castle silhouetted in evening or afternoon light, and georgic images of farmwork and harvesting with the castle in the far distance. After 1809 his interest in the subject de-clined, but he continued to make pictures of the area, and c.1827–29 painted the castle and parklands from the river in hazy morning sunlight.

The Worksop-born artist THOMAS HOFLAND painted along the Thames here during the first two decades of the nineteenth century. A number of his oils of the countryside around Windsor show the castle as a background silhouette and the river as a reflecting idyll, its banks displaying a georgic rural calm. However, the symmetry of these pictures is

distinctive, the forms often stressing a rectangular design and the strong, low afternoon light creating unusually stark and dramatic shadows.

Thomas Hofland (1777–1843) *View of Windsor Castle from the East* (detail), 1816 Oil on canvas 25in × 35in (Governing Body of Westminster School)

Witley
Surrey

A spruce linear village 3 miles S. of Godalming.

The illustrator and watercolour painter MYLES BIRKET FOSTER lived here, 1863–93. His house (now gone) was decorated by WILLIAM MORRIS and EDWARD BURNE-JONES as well as by Foster's own water-colours. Many friends came to stay, including HELEN ALLINGHAM and FREDERICK WALKER, and the marine and landscape artist JAMES CLARK HOOK. Hook lived here from 1858 to 1866. Helen Allingham lived at Sandhills, just 1 mile away, from 1881. Foster is chiefly remembered for the images of the Surrey countryside he painted here.

Wivenhoe
Essex

A quayside town with a narrow main street of old houses, 2 miles S.E. of Colchester on the Colne estuary. JOHN CONSTABLE painted Wivenhoe Park (now the site of Essex University) as it once was, in 1816, looking across the landscaped lake in a superb piece of *plein air* observation about 50 years ahead of his contemporaries. As an exercise in harmonious variety and the adjustment of human building scale to natural flora and fauna translated through paint, the picture and subject are an object lesson in aesthetic coherence. Constable almost certainly painted here with no sketch, on the spot, straight on to the canvas.

Worcester
Hereford and Worcester

A cathedral, industrial and commercial town on the River Severn.

In 1830 J. M. W. TURNER visited Worcester and c.1833–34 made a watercolour for engraving in the *England and Wales* series viewing the city from the Severn, S. of the cathedral which dominates the upper R. skyline. To the L., rain and sunbeams fall from the district of St Johns and Henwick, on the L. bank of the river. On the water in the foreground two young women fish for eels from a boat, while barges behind recall the importance of Worcester as a focus of canal and river traffic from the Midlands and S.W. This is archetypically a picture of the 'harmonious' England synthesized in Constable's *Flatford Mill*.

BENJAMIN WILLIAMS LEADER was born in Worcester in 1831. He was the son of a distinguished civil engineer, and trained at Worcester School of Design before going to the R.A. Schools in London in 1854. During the later 1850s he painted in Scotland and Wales, and in 1862 moved to Whittington, now ½ mile S.E. of Worcester, where he lived until 1890.

Worksop
Nottinghamshire
A town on the edge of the Midlands' coalfields, with low hills known as 'The Dukeries' to the S. From Clumber Park southward Sherwood Forest extends in a scattered belt for 16 miles.

THOMAS HOFLAND was born here (see Windsor).

The Impressionist STANLEY ROYLE settled here in 1938, on his return from Canada. For the next 22 years Royle painted the Derbyshire landscape, particularly under snow, working from the Sheffield area to the S. and E., to the Peak District and S.E. toward Mansfield. He travelled on a 2-stroke motorbike, with his palette on the back.

Wormingford
Essex
A village 6 miles N.W. of Colchester, near the S. bank of the River Stour on the Suffolk border. In 1944 JOHN NASH and his wife took Bottengoms Farm here, where they lived for the rest of their lives. Many of Nash's most notable pieces of work were created in the Stour valley, although he travelled elsewhere during the summer. Many of them are winter scenes, and most contain reflecting water. One of the finest is *Frozen Pools* (1958) of the garden at Bottengoms and *Snow at Wormingford* (1946). He also illustrated *English Garden Flowers* (1948) and Gilbert White's *The Natural History of Selborne*. While here Nash received an honorary doctorate from Essex University and was created a C.B.E. in 1957, and in 1967 a retrospective exhibition of 263 watercolours, pen-and-ink drawings and illustrated books was accorded him by the R.A. He died in 1977 and was buried in Wormingford churchyard beside his wife.

York
N. Yorkshire
Once a Roman fortress on the Ouse, later a Danish colony, a Norman fortified town, and a medieval city that grew rich on the wool trade, York is still dominated by its superb Minster, built 1220–1470.

FRANCIS PLACE, the pioneer watercolourist and virtuoso, attended the meetings of the 'York Virtuosi' at Henry Gyles's house in York during the 1680s. Gyles was a glass painter and members of this group included a Dr Martin Lister, Lord Halifax, and a merchant from Leeds. Place settled in York in 1692, producing many watercolour views of the city, published in Francis Drake's *Eboracum*. The topographical artist JOHN SETTERINGTON painted here, 1728–50. His work had a semi-naïve quality, best displayed in his picture *A View of Malton*. BALTHASAR NEBOT, a painter of Spanish origin, was engaged in views of the county, 1760–70; he painted 7 of the Park at Studley Royal and worked at Fountains Abbey. GEORGE STUBBS worked in York, 1744–53, as a portraitist and lecturer on human and animal anatomy.

WILLIAM ETTY, normally associated with paintings of the female nude, was born here in 1787, the son of a confectioner. He painted a number of pictures of York and landscapes of the N. and S. of Britain, most of which are small. Some of York date from the late 1830s. He was very active in setting up the School of Design in York, which opened in 1842.

Ystradgynlais
Powys
A mining village 11 miles N.E. of Swansea on the River Tawe. JOSEF HERMAN, by birth a Polish Jew, settled here in 1944, having arrived in Britain in 1940, and become friends with Jankel Adler and Joan Eardley in Glasgow. He shared an exhibition with LAURENCE STEPHEN LOWRY in London in 1943. He set up a studio at Pen-y-Bont inn, later in a small disused factory, and painted here until 1955. His pictures were usually set at twilight or the autumn; the mining valley with its workers and its mixture of melancholia and natural beauty occupied his pictures for a decade. He now lives in W. London.

Zennor
Cornwall
A hamlet perched on a headland about 300 feet above the sea. In 1947 DAVID BOMBERG with his wife Lilian camped near Zennor in a large tent. Bomberg produced some of his best landscape painting on this expedition, such as *Tendrine in Sun* and *Sea, Sunshine and Rain*. He was accompanied on this trip by LESLIE MARR, his daughter and wife, all artists who were primarily responsible for supporting him. The painter BRYAN WYNTER settled here during the early 1950s. He described the landscape which he painted as bare of houses, trees and people, and dominated by winds, changes of weather and moods of the sea, sometimes devastated, and blackened by fire.

Index

Figures in italics refer to illustrations